After-affects | After-images

Manchester University Press

rethinking
art's histories

SERIES EDITORS
Amelia G. Jones, Marsha Meskimmon

Rethinking Art's Histories aims to open out art history from its most basic structures by foregrounding work that challenges the conventional periodisation and geographical subfields of traditional art history, and addressing a wide range of visual cultural forms from the early modern period to the present.

These books will acknowledge the impact of recent scholarship on our understanding of the complex temporalities and cartographies that have emerged through centuries of world-wide trade, political colonisation and the diasporic movement of people and ideas across national and continental borders.

After-affects | After-images

Trauma and aesthetic transformation
in the virtual feminist museum

Griselda Pollock

Manchester University Press

Published by Manchester University Press
Altrincham Street, Manchester M1 7JA, UK
www.manchesteruniversitypress.co.uk

British Library Cataloguing-in-Publication Data
A catalogue record for this book is available from the British Library

Library of Congress Cataloguing-in-Publication Data applied for

ISBN 978 0 7190 8797 4 *hardback*
ISBN 978 0 7190 8798 1 *paperback*

First published 2013

The publisher has no responsibility for the persistence or accuracy of URLs for any external or third-party internet websites referred to in this book, and does not guarantee that any content on such websites is, or will remain, accurate or appropriate.

Typeset in Minion with Myriad display by
Koinonia, Manchester
Printed in Great Britain by
TJ International Ltd, Padstow

In Loving Memory

Rozsika Parker 1945–2010
Feminist, Art Writer, Novelist, Psychoanalyst

She, above all, would have understood where this book came from,
why it was necessary and whether it had anything useful to say.

Contents

List of illustrations

Plates

1 Bracha Ettinger (b. 1948) *Ophelia and Eurydice no. 1*, 2002–09, oil on paper mounted on canvas, 51.5×20 cm. Courtesy of the Artist.
2 Gian Lorenzo Bernini (1598–1680) *Apollo and Daphne*, 1622–25, rear view, marble, 243 cm. Rome: Galleria Borghese. © 2011 Photo Scala, Florence – courtesy of the Ministero Beni e Att. Culturali.
3 Gian Lorenzo Bernini (1598–1680) *Apollo and Daphne*, 1622–25, front view, marble, 243 cm. Rome: Galleria Borghese. © Photo Scala, Florence – courtesy of the Ministero Beni e Att. Culturali.
4 Ana Mendieta (1948–85) *Tree of Life*, 1976, 35 mm colour slide. © The Estate of Ana Mendieta Collection. Courtesy Galerie Lelong, New York.
5 Diego Rodríguez de Silva y Velasquez (1599–1660) *The Fable of Arachne*, or *Los Hilanderas/The Spinners* (*c*.1657–58), oil on canvas, 220×289 cm, Madrid, Museo del Prado. Photo: Bridgeman Art Library 2012.
6 Louise Bourgeois (1911–2010) *The Blind Leading the Blind*, 1947–49, wood, painted red and black, 170.4×163.5×41.2 cm. © Louise Bourgeois Trust/DACS London/VAGA New York 2012.
7 Louise Bourgeois (1911–2010) *Maman*, 1999, installation of bronze cast. Wanås Foundation, Sweden, winter 2006. Photo courtesy of Wanås Foundation, Knislinge, Sweden. DACS, London 2012.
8 Louise Bourgeois (1911–2010) *Maman* 1999, installation of bronze cast, Wanås Foundation, Sweden, summer 2007. Photo courtesy of Wanås Foundation, Knislinge, Sweden. DACS, London 2012.
9 Anna Maria Maiolino (b. 1942), *Modelled Earth*, installation, Fundació Antoni Tàpies, Barcelona, October 2010. Photography: Lluís Bover. © Fundació Antoni Tàpies. CC BY-NC-SA license. In addition to *Modelled Earth* can be seen *They Are*, 1994, *Emanated*

Figures

Chapter 1

Chapter 3

Acknowledgements

This book began as a series of lectures given when I was the Slade Professor of Fine Arts at the University of Cambridge in 2007/08. I want to thank the Electors of the Slade Professorship and the Department of Art and Archaeology at the University of Cambridge and above all Professor Deborah Howard for her support during the lectures.

I was also enabled to complete the writing of the revisions by a Fellowship at the Sterling and Francine Clark Art Institute, Williamstown. I am extremely grateful to the Director and Deputy Director and all the staff of the Research Programme and the Library at the Clark for an extraordinarily stimulating and supportive environment in which to research and write.

I gratefully acknowledge the support provided by a Fellowship from the Arts and Humanities Research Council for the completion of the final chapters of the book as well as the generosity of the School of Fine Art, History of Art and Cultural Studies for the necessary periods of research leave.

Books emerge over many years through conversations with artists, and I would like to acknowledge the generosity and thoughtfulness of those artists in this book who gave me time in the form of interviews or access to their archives. Wendy Williams and Jerry Gorovny of the Louise Bourgeois Studio have been constantly helpful during my research and I am grateful for the generous assistance of Vera Frenkel, Anna Maria Maiolino and the Marion Goodman Gallery. I am deeply grateful to Piotr Stanisławski and to Hervé Loevenbrack for their generous assistance with illustrations of the work of Alina Szapocznikow.

My deepest thanks go to the series editors Amelia Jones and Marsha Meskimmon and editor Emma Brennan of Manchester University Press for their astute guidance of this book into publication. I thank my readers for their helpful comments on the original manuscript and to the various communities of listeners and respondents who have engaged with this work during its genesis at the Jawaharlal Nehru University, New Delhi, the Hammer Museum, Los Angeles, UNISA, Pretoria and The Freud Museum London. I want to thank Adrian Rifkin for his constant openness to exchange and discussion

about Warburg and his wise advice on various chapters.

Always, the tolerance and true encouragement to think, write and find the spaces for both comes from the ever-wonderful Antony Bryant. The humour and compassionate interest of Ben Bryant and Hester Bloom provide a grounding in reality and human relations that, with their father's love, endless kindness and excellent food, make writing about trauma and about art possible. My infinite thanks go to all three true and beloved friends.

Preface

> Artists continually introduce into culture all sorts of Trojan horses from the margins of their consciousness; in that way, the limits of the Symbolic are transgressed all the time by art. It is quite possible that many work-products carry subjective traces of their creators, but the specificity of works of art is that their materiality cannot be detached from ideas, perceptions, emotions, consciousness, cultural meanings, etc., and that being interpreted and reinterpreted is their cultural destiny. This is one of the reasons why works of art are symbologenic.
>
> Bracha Ettinger[1]

Do artists affected by, or obligated to haunting pasts, journey away from or towards an encounter with traumatic residues?

Some artists carry the traces of politically caused, horrific historical experiences; others bear the burdens of secrets, shame, guilt, morbidity, bereavement, exile and abuse. Some artists are in turn sensitized by personal affliction to the calamities of the undoubtedly catastrophic dimensions of imperial, fascist, colonial and post-colonial modernity and the extreme suffering of others vicariously transmitted by mediatized information systems.[2] Hence a second question arises: can aesthetic practices, the creation of *after-images*, bring about *transformation* – this does not imply cure or resolution – of the traces, the *after-affects* of trauma, personal or historical, inhabiting the world that artists also process as participants in and sensors for our life-worlds and troubled histories? Finally, what modes of reading aesthetic practices might be mobilized to answer such questions?

This book presents a series of encounters with art works, Baroque, modernist and contemporary. All of them have arrested me. Reflecting the ethics of feminist epistemology, my readings are 'situated knowledge'. Understanding is always partial, perspectival and inflected by the social formation and personal histories of the researcher.[3] This is not, however, an excuse for relativism. Research is answerable to its subjects. Based on evidence, any analysis must make clear the grounds of the argument. I cannot pretend to a

false universalism, neutrality or detachment. These works affect me, prompting me to undertake close readings. Specific artworks by Gian Lorenzo Bernini, Ana Mendieta, Louise Bourgeois, Anna Maria Maiolino, Alina Szapocznikow, Vera Frenkel, Sarah Kofman and Chantal Akerman are my case studies. Some names will be familiar; others deserve to be so, coming, however, from formerly marginalized countries, practices, histories: Cuba, Poland, Brazil-Italy and Canada-Czechoslovakia.

These works do not constitute a new genre of trauma art. They do not share time-frames, locations, subject matter, stylistic features or media. I stand before them in what Bracha Ettinger, artist and theorist of aesthetics and trauma, calls *fascinance* – a prolonged, aesthetically affecting and learning encounter – not aiming to master meaning or stamp an interpretation upon them.[4] I remain with the artworks to encounter certain movements or pressures within them that I identify as *traces of trauma*: events or experiences excessive to the capacity of the psyche to 'digest' and the existing resources of representation to encompass.

This book offers a series of impassioned, fascinated readings of selected artworks and art practices that touch on profound and intense events in lives intersecting with histories that are at once ordinary – some of the traumatic events befall many of us like losing parents or falling ill – and extraordinary – historically precipitated by the unprecedented or the horrific. Dying of cancer, being bereaved, living in exile, even being a woman in a phallocentric order, these are not exceptional but tragically normal, yet they can still be considered traumatic.[5] Surviving genocide, however, may be considered so, as it participates in an event that, while impinging on individuals, is now considered to have massive ramifications for humanity's future itself.

In a transdisciplinary *encounter* between feminist theory, psychoanalytical aesthetics and the cultural processing of personal and historical traumas, notably but not exclusively the Holocaust, I want to lay out the case for a feminist intervention in trauma studies through/with art. The purpose is to *think with the artworks*, to propose ways of understanding what 'aesthetic practices' (to stress both semiotic and psycho-symbolic operations as opposed to the idealization of art and fetishization of the artist) can offer to a culturally post-traumatic condition overwhelmed with unbearable or encrypted memories as well as shaped by the voids of traumatic amnesia.[6] Through careful readings of the trajectories within each artist's practice over time, I shall be identifying the radically varied effects – and affects – of different psychic economies *working* in the processing of trauma or *failing* to unlock the encrypting of trauma. In some cases it seems that the artists set out to journey away from a traumatic experience that happened in the past. In most cases that is not possible; the repressed resurfaces. In other instances, a lifetime of work prepares a pathway towards the always belated encounter with a trauma that may, *or may not*, be

transformed by forms created to process it. Both movements or directions are often at work simultaneously.

The secondary or belated arrival of the encounter with traumatic residues or traces may, however, be *the* moment of encounter with non-experienced trauma that, in some senses, never happened until this new encounter. It can only do so in displaced and secondary forms; as such this (re)encounter can be dangerous because it is happening in the present. Chapter 6 deals with a literary text rich with its own imagery and scenarios that I think encountered such a danger. The moment of articulation became psychically menacing for the writer and can be shattering for the viewer/reader who comes to meet it. Some forms of aesthetic encapsulation, therefore, become deadly. It is not possible to predict the manner in which the traumatic will emerge, invited or uninvited, pursued or escaped, through an artistic practice. Some seek to touch it; others cannot help but be reclaimed by it. It is never known in advance what it will do even when seemingly contained in a form of image, narrative or words. On the other hand, some artworks find, and some even give rise to, formal or material means of shaping hitherto unacknowledged psychic economies that enable encounters with traumatic moments that can be processed transitively, hence be shared, transported and passed into another bearer, be that the artwork or the willing partner who comes to meet it. The work becomes a subjectively shared occasion that does not forget or obliterate the trauma, but holds fast to its witness, or perhaps, like the mother who takes on her afflicted infant's distress and detoxifies it on the infant's behalf, processes its traces.[7]

As the resource for trauma theory, psychoanalysis argues that all human subjects are afflicted by founding – or, as I shall name it, *structural* – trauma in terms of separation and cleavage: birth, weaning, loss of the loved object, loss of the loved object's love, all retroactively caught up in symbolic castration which signals the formation of the unconscious and severance from infantile intensities and corporalities focused on the imagined source of life and nurture: the maternal body, voice, gaze, breast and touch. One radicalizing feminist theory, however, reveals another dimension in human subjectivity, also *structurally* traumatic, that is not based on loss and separation. Instead it discloses parallel strings of yearning for connectivity and an inescapable potential for hospitality and compassion towards the other. Bracha Ettinger has articulated Matrixial theory over twenty-five years, situating this capacity as the 'traumatic' legacy of the specificity of a non-phallic feminine sexual difference that affects us all, irrespective of gender and sexuality. The Matrixial is the mark of the shared manner of all human becoming in prolonged prenatality that traumatically, namely non-cognitively, shapes postnatal subjectivity, ethics and aesthetics with another non-phallic potentiality. I draw on this intervention as it speaks specifically to the intimacy between trauma and the aesthetic zone.

An artist working with historical and personal trauma, Ettinger expands the range of the founding traumas of subjectivity identified by psychoanalysis – these undigested shocks and affecting impacts that are not necessarily destructive – by identifying in human subjectivity a primordial sense of becoming a humanized being that is, from its earliest inklings and (aesthetic) sensations, a co-emergence *with* a co-other in a prolonged but notably late prenatal-prematernal connectivity. Such connectivity-in-difference has nothing to do with symbiosis or fusion. Not characterized by the phallic opposition of fusion-versus-separation, it represents a proto-ethical and *aesthetically* experienced durational co-emergence, a nonfusional trans-subjectivity built upon the asymmetrical pairing of hospitality (prematernal) and compassion (prenatal).

Ettinger invites us to acknowledge the implications for thinking about subjectivity through this expanded proposition about a sexual difference *of/from* the Matrixial feminine that is not a difference between masculine and feminine. As a theory of relations to the unknown but co-human other, Matrix enlarges our understanding of human ethical capacities, and hence even politics, by recognizing that the traumatic legacy of the prolonged process of becoming human breaches the border between prenatality and postnatality, and thus it bears the imprint of the durational subjectivizing partnership of prenatality/prematernity. This partnership, I must stress, does not place any limitation on women's right to chose the destiny of their own bodies or that of unborn foetuses; precisely the opposite is the case since the adult in the duality alone can and must take responsibility for full human rather than physiological life. Matrix theorizes the 'traumatic' *after-affect* in all of us who have been born, and born with non-conscious knowledge of what must be acknowledged as the specificity of feminine sexuality and subjectivity in that complex, traumatic – hence uncognized but felt and affected – interface with an-other being, corporality and transsubjectivity. Matrixial theory recasts thinking about our relations to, hence capacities for compassion and hospitality towards, others as well as offering another pathway to understanding contemporary aesthetics in its formal artistic or literary practices as a site of transformational encounter. It has ramifications for contemporary aesthetic theory and hence rethinking art's histories.

Freud offered a double thesis on trauma. Trauma may index something horrible, hence buried, that is nonetheless compulsively acted out. There is also what is compulsively repeated in search of its original *jouissance* (intensities undecidably both painful and pleasurable). Thus, we can argue, in our concern to engage with art that courageously, or even against the artist's will, allows traumatic impressions to rise to the surface and be *formulated* through creative articulations in art, there is a trace of a traumatic imprint of a yearning for reconnection with unknown otherness that was once, prenatally, encountered

in co-emergence and co-affection. Postnatally, such a traumatic (in the second Freudian sense) longing for *withness* can become an ethical foundation and even be actively made into a politically conscious act of human solidarity that itself will have both cultural and subjective effects.

This book studies the presence and effects of the differing psychic economies, Phallic and Matrixial, on the aesthetic negotiation of the entwined affects of structural trauma and of historically induced trauma by offering readings of artworks drawing on Ettinger's key concepts of *aesthetic wit(h)nessing, fascinance, compassion* and *transcryptum*. (I will explain these terms in the Introduction.) While indicating ways of reading the processes of artistic creation, the Matrixial focus on moments of transsubjective encounter also alters our understanding of viewing, reading, responding not 'to' so much as 'with' *artworking* which traverses artist and world, work and viewer.

I hope, furthermore to perform what Eve Kosofsky Sedgwick named 'reparative' rather than 'paranoid' reading practices. In queer, feminist and post-colonial critical theory and cultural analysis, Sedgwick identified a trend, justified by history, but theoretically impoverishing, towards paranoia. This involves the normalization, as the only method, of a paranoid stance that anticipates and identifies systemic oppression. The pairing hidden/exposed becomes the axis of what philosopher Paul Ricoeur has named the 'hermeneutics of suspicion'.[8] To seek other than such paranoid methods does not lead to a denial of the reality of enmity or the gravity of oppression caused by class, race, sexuality, ethnicity, disability; it might lead to at least the possibility of imaginative transformation.

Sedgwick draws on the psychoanalytic theory of Melanie Klein. Klein argued that all subjects oscillate between the paranoid/schizoid and the depressive positions. These positions emerge in infancy but become recurrent features of adult psychic formation. The paranoid/schizoid position, characterized by hatred, envy and anxiety, is a form of 'terrible alertness to the dangers posed by the hateful and envious part-objects that one defensively projects onto, carves out of, and ingests from the world around'. On the other hand, the depressive position mitigates anxiety by attempting to 'repair' the damaged part-objects and to create new wholes: 'Once assembled to one's own specifications, the more satisfying object is available both to be identified with and to offer nourishment and comfort in return. Among Klein's names for the reparative process is love.'[9]

Critical readings dominated by the paranoid position know in advance that all culture will be marked and deformed by relations of power. Often justified, paranoid readings anticipate the worst, exposing oppression again and again. Affectively, this orientation has profound effects on our struggle for change. Reading reparatively might allow the reader to be surprised by the possibility of, and desire for, counter and creative possibilities in texts

or histories which, of course, carry the marks of patriarchal, classed, racist or heteronormative oppressiveness, but also fashion the signs of resistance: this Sedgwick called queering works through the use of 'weak theory' and, above all, attention to the ways our cultural analysis generates different kinds of affect. Revisioning her own field of queer studies, Sedgwick offers important suggestions for related projects in feminist studies in terms of daring to seek pleasure rather than merely forestalling pain.

> The desire of the reparative impulse … is additive and accretive. Its fear, a realistic one, is that the culture surrounding it is inadequate or inimical to its nurture; it wants to assemble and confer plenitude on an object that will then have resources to offer to an inchoate self.[10]

Thus we have dedicated so much work to a kind of denunciation of the deformations effected by intersecting axes of power and oppression, and rightly so.

> No less acute than a paranoid position, no less realistic, no less attached to a project of survival, and neither less nor more delusional nor fantasmatic, the reparative reading position undertakes a different range of affects, ambitions, and risks. What we can learn best from such practices are, perhaps, the many ways selves and communities succeed in extracting sustenance from the objects of a culture–even of a culture whose avowed desire has often been not to sustain them.[11]

Can we affectively reconfigure ourselves by reparative readings, engaging with transformations of the trauma and injuries of class, race, ethnicity, sexuality, gender and sexual difference effected by aesthetic operations? This book explores through both Matrixial and reparative modes the possibilities, and failures, of aesthetic transformation in the face of trauma.

The questions I shall be asking of my texts and artworks are these: Is trauma that which is encrypted, locked untouchably yet hauntingly within the psyche, an unreachable but shaping void, hence beyond all representation while still being a phantom within so that our reading for its affects is structural to human subjectivity? Or if its *after-affects* are encountered in art or literature, do artworks create what Ettinger names a 'transport-station of trauma', hence a passage to a future through *after-images* that attempt the transformation of the traces of individual trauma?[12] In my studies, I repeatedly stress the significance of *form, formulation, transformation* in order to explore the mediation between *after-affect* and *after-image*, that moves from the psychic intimacy between aesthesis and trauma, structurally, to the role of artworking in touching and thus offering a novel, poietically generated form for the encounter with that which, by definition, is not yet in the grasp of representation.

As what Ettinger has named 'Trojan horses' smuggling shifted meanings and affective possibilities into culture via psychically infused materialities,

can artworks deliver a shared encounter with the unknown and unremembered not-yet-past that can thus shift the burden of historically traumatic events whose legacies transitively inhabit the world, but whose traces responsive artists may also process as they cross-inscribe individual and cultural resonances of catastrophe across generations, time and space? Can thinking trauma with artworking address our responsibility to the traumatic residues of our recent histories that sustain continuing violations of human life in widespread suffering and exposure to terror and horror?

In the thirty-five years of my work as a feminist cultural analyst, I have plotted my course by generating concepts for thinking difference: *old mistresses, vision and difference, generations and geographies, differencing the canon*. Concepts serve as thinking apparatuses. I am working now with the concept of the *Virtual Feminist Museum* (VFM), the performative space for *differencing the canon*. It deals with time, space and archive.[13] Virtual not in the cybernetic but the philosophical sense of always becoming and as yet incompletely unharvested, the Virtual Feminist Museum focuses on *encounters*. It challenges the linear time, nationalized spaces and categories of art history that classifies art objects through period, style, medium and author. Rather than finding out what art is *about*, which often leads back to the artistic subject in whom art is thought to originate or to some other anterior explanation, we need to ask *what artistic practice is doing* and *where* as well as *when* that doing occurs. What are its occasions and its temporalities? Thus a study of trauma and the aesthetic in the VFM focuses on time. Philosopher Jean-François Lyotard identified painting's multiple temporalities:

> A distinction should be made between the time it takes a painter to paint the picture (the time of production), the time required to look at and understand the work (the time of consumption), the time to which the work refers (a moment, a scene, a situation, a sequence of events: the time of the diegetic referent, of the story told by the picture), the time it takes to reach the viewer once it has been created (the time of circulation) and finally, perhaps the time the painting *is*. This principle, childish as its ambitions may be, should allow us to isolate different 'sites of time'.[14]

To these 'sites of time' I want to add trauma's timelessness. Trauma is not an anterior source from which imagery is generated by a knowing subject. Trauma is the not-yet-experienced non-thing *towards* which a lifetime of making art might be unknowingly journeying.[15] If trauma is ever encountered, its traces risk a secondary traumatization unless the gesture of its becoming can be trans*form*ed by a receptive discourse, a compassionate hospitality that can structure it. Witnessing – hospitable participatory responsiveness – is a reciprocal act allowing the offered trace to be processed in the encounter by another – individually or by the culture that shares in a moment of co-affectivity.

The Virtual Feminist Museum works with psychoanalytical time rather than art history's linear narratives. Psychoanalytically, time is layered, archaeological, recursive. The accumulated past remains an active force even when transformed from infantile urgencies to sublimated creative acts. Psychoanalysis also theorizes delay, repetition and the return of the repressed. Freud's perplexing but wonderful concept of *Nachträglichkeit*, 'afterwardness' as Jean Laplanche usefully translates it, reminds us that, when studying culture in general or an artistic practice in particular, what may happen in chronological time as succession may in fact be the working through of such afterwardness, a belated arrival on the scene of inscription of that which was always working, determining, shaping and energizing from the other scene, the unconscious or pressing from traumatic non-conscious space.[16] Thus our view of a work, or a body of work, or of a practice's place in a larger cultural field, involves a different kind of historical research and different ways of writing it up that avoid teleological, cause and effect, unidirectional development.

In the theory room of the Virtual Feminist Museum, Freud meets Hamburg cultural analyst Aby Warburg (1866–1929) who was an analyst of time in the image. Warburg's concept is *Nachleben*, variously translated as 'persistence' or 'survival' but meaning after-life or remaining lively after. This has a haunting quality, but also involves a capacity to recharge an originary energy in a later time or place. Warburg defined the image as *pathosformula* – the formulation for affect – that encodes what was once a living movement, a gesture in a performed ritual that had expressive freight in terms of affect and emotion when people enacted their anxieties and ecstasies before the fragile and dangerous questions of life, death and social interaction. The image functions as a mnemonic device that can transport, via its iconic afterliving, into other times and places, something of that original energy, hence of subjective intensity and affect, when its formulae are re-ignited by contact with a different cultural moment that needs this charge. Warburg worked with a specific classical *pathos formula*, the running Nympha, a female figure with windswept air and agitated drapery, which was reclaimed during the Renaissance to signify and generate emotional energy.

I am arguing here that, in the aftermath of Modernity's traumatic ruptures and as a result of modernism's specific revelation of the potency of form, materiality and process, the artists I am discussing do not look back and reclaim older *pathos formulae*. They have generated new, post-traumatic *pathos formulae*, using diverse media and technical procedures that seek to transmit and transform traumatic intensities and after-affects. I do not seek, as Warburg did, persistent or recurring tropes or formulae. Historical trauma, such as the Holocaust, ruptured the entire classical tradition, changing fundamentally the real status of the body and its image. Nevertheless, Warburg's reading of that tradition can be used to enable us to discern, after the modernist turn to form,

materiality and process, how artists are currently inventing formulations of pathos for post-traumatic conditions.

A Warburgian art historian is not tied to period specializations, national frontiers, stylistic particularities. The entire book of the history of art is open to trace specific moments of reconnection and *Nachleben* between pasts and presents, and the processes of historically contingent transformations of image-legacies in novel historico-political and cultural circumstances. Hence I can place Cuban-American artist Ana Mendieta in conversation with Botticelli and Bernini or Szapocznikow with Holbein without losing the specific coordinates – generations and geographies, another of my thinking concepts – of their moments or practices.

Warburgian art history is acutely attentive to historical and documentary specificity while positing the longer duration – persistence – of tendencies in human culture towards both symbolization and imagistic mimesis motivated by profound human emotion and need. Julia Kristeva's place in the Virtual Feminist Museum complements Warburg through her theories of 'aesthetic practices' and women's time. Kristeva distinguishes linear time of national and political histories from the longer, monumental duration of psycho-symbolic formations such as phallocentrism (which concerns sexuality, reproduction, sexual difference) as well as what it represses and hence carries as it structuring other: the feminine with its other, sometimes cyclical temporalities relating specifically to women's bodies as the hinge between life, death and meaning. These latter temporalities regulate our sexualities and the temporal rhythms of life and death as well as the imaginary and symbolic meanings invested in human reproduction: not biology but the life of social humanity and hence history at its hinge with the unthinkable Real of what lies beyond the human.[17]

If Warburg, Freud, and Kristeva open up the study of art's histories to the interface of subjective intensity and cultural modes of *formulation* through image and symbol, how do they take their place in a specifically feminist project? The midwife for this is a painter who is also at home in psychoanalysis, Bracha Ettinger. In her primary activity as a painter, Ettinger's artwork articulates history, memory and subjectivity through expanded painting in a lifelong encounter with and reflection upon art and trauma that links her parents' *Shoah* trauma with the mutually imbricating trauma of currently co-inhabited Israel/Palestine. Her work traverses Modernity itself as a trauma, a shocking assault on existing modes of experience and representation through constant industrial and technological change, urbanization, transport, military technologies and communication networking that also register, traumatically, in art's own technologies. But Modernity's self-image as a rational progress towards humanly engineered betterment was shattered by its own deadly and often dominant forces for exploitation and greed, social inequality and, above all, violence: technological (in warfare notably) and ultimately industrially

enacted genocidal racism. From colonial and imperial racism to religiously and racially targeted genocides, the solidarity of all that wears a human face has been catastrophically exploded. We live its post-traumatic effects. Art – serious and responsible – has, Ettinger argues, slowly come to know this and brings these issues to the surface of our attention by its singular means. Even without knowing it, many trends in twentieth century art ultimately bear witness, symptomatically, to the catastrophe that is ours to process. Ettinger's art practice, founded in history and attentive to issues of memory, archive and difference, was the seedbed of what she theoretically articulated as Matrixial dimensions within subjectivity in the only other language she knew: psychoanalysis. Matrix names a different sexual difference 'from the feminine' and makes knowable the relations between *aesthetic wit(h)nessing* and trauma. Matrixial theory forms one of the foundations for this book's proposition that feminist aesthetics has something profound to say about our post-traumatic and traumatizing human condition now.

After-affect knowingly corrupts a proper English word to signal the temporal displacement of trauma, perpetually present, yet absented from memory that bequeaths unbound affects to later events. *After-image*, suggesting a different kind of secondariness, may contradict the understanding of a postmodern 'return [from high modernist abstraction] to representation' typified in new media. I read artistic practices of the later twentieth century as post-iconographic, hence the stress on form /formulation rather than on representation/ content. They are not, however, post-iconological in the Warburgian sense of the image having both a symbolic and an affective function. They also perform/engage with the inescapable after-effects of modernist preoccupations with process, materiality, temporality and spatiality beyond the image's iconicity. The Virtual Feminist Museum assembles new configurations to rework the relations of time, space and archive, now under the sign of trauma and its Matrixial artworking.

The book begins with a long chapter on trauma theory and Matrixial aesthetics, laying out my understanding of trauma and introducing the key concepts from Ettinger's work that enable me to develop a specifically feminist intervention in art's histories and trauma studies. The introduction seeks to make accessible the range of theoretical resources for thinking about trauma, aesthetics and sexual difference that have been prompted by my encounter with the artworks themselves. The learning occurs in that encounter and the theories I shall use emerge from the necessity to make sense of the real of historical and personal trauma as they surface in the novel *pathos formulae* generated by artists as makers of forms. Divided into three sections, *Sounds of Subjectivity, Memorial Bodies, Passage through the Object*, the book initially explores sculpture as the site of invocation and language as well as the place of dissolution of form

and resistance to it. It moves from sculpture as a form of making about, and imbued with, bodiliness and tangible materiality to explorations of memory through video, literature and film. If these tend toward the virtual, the final chapters equally reclaim the body through a metonymic relation to a missing person mediated through a material object. The final chapters stage most dramatically by their shared relation to the Holocaust and the function of the surviving object the uncertainty of outcome when re-encountering traces of trauma as well as the different psychic economies released in the moment of aesthetic encounter with trauma.

Griselda Pollock

Leeds 2012

Notes

1 Bracha L. Ettinger, 'Matrix and Metramorphosis', *Differences: A Journal of Feminist Cultural Studies*, 4:5 (1992), 195–6.

2 Geoffrey Hartman, 'Memory.com: Tele-Suffering and Testimony in the Dot Com Era', *Raritan*, 19:3 (2000), 1–18. Luc Boltanski, *Distant Suffering: Morality, Media and Politics* (Cambridge: Cambridge University Press, 1999).

3 Donna Haraway, 'Situated Knowledges: The Science Question in Feminism and the Privilege of the Partial Perspective', *Feminist Studies*, 14:3 (1988), 575–99.

4 Bracha Ettinger, '*Fascinance* and the Girl-to-M/Other Matrixial Feminine Difference', in Griselda Pollock (ed.), *Psychoanalysis and the Image: Transdisciplinary Perspectives* (Boston and Oxford: Blackwell, 2006), 60–93.

5 Laura S. Brown, 'Not Outside the Range: One Feminist Perspective on Psychic Trauma', in Cathy Caruth (ed.), *Trauma: Explorations in Memory* (Baltimore, MD: Johns Hopkins University Press, 1995), 100–12.

6 Julia Kristeva, 'Women's Time'(1979), trans. Alice Jardine and Henry Blake, in Toril Moi (ed.), *The Kristeva Reader* (Oxford: Blackwell, 1986), 210. Kristeva names aesthetic practices (art, music, dance, poetry) as signifying processes energized by proximity to the drives and hence the corporeal, which transgress and renew the existing symbolic system and its current uniformity. On the side of heterogeneity and transformation, they also touch upon what is outside of signification allowing the pressure of psychic resources through sub-symbolic dimensions such as rhythm, pulse, movement, colour and hence affect.

7 British psychoanalyst Wilfrid Bion developed a unique theory of thinking by suggesting that there are beta elements (unmetabolized psyche/soma/affective experience) which can be transformed into alpha elements (thoughts that can be thought by the thinker) assisted by the reverie of the mother (or later analyst) who processes the beta elements returning them to the infant as alpha materials. For an account of Bion's theories see Mary Jacobus, *The Poetics of Psychoanalysis* (London: Oxford University Press, 2005).

8 Paul Ricoeur, *Freud and Philosophy: An Essay on Interpretation* (New Haven, CT: Yale University Press, 1970).

9 Eve Kosofsky Sedgwick, 'Paranoid Reading and Reparative Reading', in *Touching, Feeling: Affect, Pedagogy and Performativity* (Durham, NC: Duke University Press, 2003), 128.

10 Sedgwick, 'Paranoid Reading and Reparative Reading', 149.

11 Sedgwick, 'Paranoid Reading and Reparative Reading', 150.

12 Bracha L. Ettinger, 'Art as a Transport-Station of Trauma', in *Bracha Ettinger: Artworking 1985–1999* (Gent: Ludion, 2000), 91–116.

13 Griselda Pollock, *Encounters in the Virtual Feminist Museum: Time, Space and the Archive* (London: Routledge, 2007), and *Differencing the Canon; Feminist Desire and the Writing of Art's Histories* (London: Routledge, 1999).

14 Jean-François Lyotard, 'Newman: The Instant', in Andrew Benjamin (ed.), *The Lyotard Reader* (Oxford: Blackwell, 1992), 240.

15 Griselda Pollock, 'The Long Journey: Maternal Trauma, Tears and Kisses in a Work by Chantal Akerman', *Studies in the Maternal*, 2:1 (2010), n.p.

16 Jean Laplanche, 'Notes on Afterwardness', in John Fletcher (ed.), *Essays on Otherness* (London: Routledge, 1999), 260–5.

17 Julia Kristeva, 'Women's Time'(1979), 187–213.

Introduction:
trauma and artworking

The abundance of suffering tolerates no forgetting; …Yet this suffering, what Hegel called the consciousness of adversity, also demands the continued existence of art even while it prohibits it; it is now virtually in art alone that suffering can still find its own voice, consolation, without being immediately betrayed by it.

Theodor Adorno(1962)[1]

This book, like trauma itself, arrives belatedly on the expanded but contested field of trauma studies in the humanities although the journey to its writing has taken almost twenty years.[2] Swiftly taken up in literary, historiographical and cultural theory from the early 1990s, the engagement with trauma as a concept in art history and visual culture has been slower and more varied. Initiated in the 1990s by Kristine Stiles, Hal Foster and Ernst van Alphen, and elaborated since 2000 by Jill Bennett, Lisa Saltzman and others, each scholar, however, approaches trauma and visual art from a different theoretical foundation.[3] Arguing against the notion that we are done with trauma as a topic, I aim to introduce a specifically feminist-psychoanalytical and feminist-aesthetical dimension into still vibrant debates.

We are accustomed to think about trauma with the model of cure. Bad things happen to individuals. We should try to get over them. Time will heal. They are in the past. We must move on and let go. Or, if the event is historical, we build a monument, set up a memorial day, make a movie and leave our burden to them. The problem is that trauma, as we now understand the wounding of the psyche by an extreme event or by accumulated suffering, is not like that. When we borrow trauma as a term for personally affecting psychological shocks or as a metaphor for historical events that exceed existing representational resources, we also confront a problem that will not sort itself out by itself. The point of trauma studies is the necessity for individuals and for cultures, in different ways, to confront the 'wounding' that, according to our theories of trauma, engenders symptomologies such as the compulsion to repeat and acting out. Trauma possesses and inhabits us.

Originating in the Greek word for what pierces the body, *trauma* originates as a medical term. Adopted by psychology at the end of the nineteenth century, the concept of trauma was needed to convey the shattering experiences typical not only of modern life in the city and the railway age but, notably, of warfare – shell-shock in the First World War, for example – that 'pierced' the psychological mechanisms established to shield the psyche from excessive external stimuli.[4] Events and assaults that cannot be processed, or 'digested' by the psychic apparatus are thus considered traumatic; they function as piercing but *psychological* woundings. Unlike physical wounds, trauma is not subject to organic healing. As a psychological problematic, even if there is evidence of physiological changes in the brain because of severe shocks, trauma becomes a form of subjective non-experience that nevertheless, like a virus, becomes a structural part of the subject in ways which by inhabiting the psyche in uncognizable ways, *de-in-habit* the subject. Bracha Ettinger explains trauma with reference to a Freudian-Lacanian term for that which is beyond thinking that may also be tied closely to the pressure from which art emerges.

> Psychoanalytical thought concerning both art and repetition revolves around the impossibility of annulling originary repression and accessing a psychic *Thing* encapsulated and hiding in an 'outside' captured inside in an unconscious 'extimate' space. The *Thing* is traumatic and aching, and we do not know where it hurts and that *it* hurts. It struggles unsuccessfully to re-approach psychic awareness, but only finds momentary relief in symptomatic repetitions.[5]

Given the difficulty of trauma itself, I propose that we can approach its implications for studies of art through five defining features: perpetual presentness, permanent absence, irrepresentability, belatedness and transmissibility.

Trauma's no-time-space

Psychic trauma knows no time. It is a perpetual present, lodged like a foreign resident in the psyche. Trauma colonizes its hosts by its persistent inhabitation of a subject who does not, and cannot, know *it*. *It* happened but *I* do not know *it* – that it happened or what it was that happened. It is the eventless event, unremembered because, being never known, it could not be forgotten. This happening is not in the past, since it knows no release from its perpetual but evaded present. No words or images are attached to this 'Thing'.

The passage from trauma might best be understood as a move into a narrativity that institutes time, into the pause in which memory forms, hence spatializes the subject's relation to its own place in time as a subject with a history. Or perhaps, we should speak of a passage into the temporality of narrative that encases, but also mutes, trauma's perpetually haunting force by

means of giving it a structuration that representation delivers as a spacing, that allows momentary dispossession of a possessed subject.

In this model, repression is a relief. It functions as delivery from overwhelming affects of an anxiety that remains over-present and unmanaged for the very lack of representation (spacing and temporalizing) that serves to structure it in encounter with the other's words, words of culture. Thus repression is needed, to distance the subject from the unsignified and unknown proximity to the 'trauma' of the insistence of the unmediated *corpo-Real*. Some kind of representational formation offers deliverance that *returns* the 'event' to the subject changed through temporizing and spatializing – all the effects we understand to be the effect of what Derrida called 'writing'. We benefit, therefore, from what I name 'the relief of signification' which manufactures both a distance from the overwhelming, undigested thingness of trauma as perpetual but unsignified presentness.[6]

Ettinger's aesthetic theory points us beyond Lacan's relay between Thing (trauma) and Object (psychic representative) to another kind of complex wherein there can be no direct substitution or displacement from the Real to the Imaginary. Instead, a certain compulsion or activity indexes both a presence of the unknown and unknowable and the subject's actions as the symptomatic site of its pressure and the struggle for translation. Thus Ettinger directs us aesthetically away from content towards *gesture*. The performative processes in the artwork both take and index their own time to create a new space of encounter, that may become the place of a transformative registration of the *movement* between trauma and phantasy which does not knock out either end of the always vibrating string between them. Artworking itself becomes significant.

Absence

Trauma is also to be grasped as a permanent absence. Like the molecules that comprise the air inside a molded vase, trauma exerts its invisible pressure on psychic life. Or we might call it a shadow without a form we do not know. Yet its work produces affects such as melancholia, anxiety and depression, and in some cases flashbacks that crack the continuity and logic of time with moments of literal intensity, witness to permanent presentness unassimilated into temporal and syntactical memories on which we build our known personalities. The work with and on trauma, a structural aporia, therefore, is to create an apprehensible form within the structures of time – that is, inside the grammar of representation and hence of subjectivity. Artworking also, however, tries to touch its voidedness with a virtual presence in some form that is not a representation of a knowable content, but is the after-affect of representational *work*, through what become paramount in twentieth-century

art: effects created by the art process itself that echoes but transforms the pressure indexed by symptomatic repetition.[7] By definition trauma cannot be represented. But it can be approached, moved and trans*form*ed. This is not cure; it is *poiesis*: making.

Irrepresentability

Herein lies the confusion at the heart of any discussion linking art, trauma and representation: trauma is the radical and irreducible other of representation, the other of the subject and, linked to the unsignifiable traumatic Thing, cannot thus become something. We try to think of it as an effect, a condition, even a shadow that will never be identical to that which might be its displaced narration or transforming representation, both of them always being a passage away from trauma, a transformation – a working in Freud's sense of the psyche as economy: *Arbeit* (dreamwork, mourning work, working-through) – into a memory, henceforward into the psychic apparatus. So the purpose of art in attempting to engage with trauma is different from the purposes of representation, which is very different for the traumatized victim who may well wish to be delivered of the unbearable ab/presence of the traumatic by means of the structuring discourse of the other through which traumatic experience is recast as painful memory, owned as part of the narrative that now secures the subject as the subject of his/her own memory and knowledge in a communicative exchange. Beyond testimonial or witness practices that have been so significant in literary trauma studies and psychotherapeutic work, what might be the value for us of an aesthetics of trauma as an engagement with history and politics of traumatized times in which art reaches out to others' events and makes spaces for the encounter with them for yet other others that is not testimonial? Is there a way to think about artistic processes precipitating a passage through co-emergent, transsubjective transformation by its creating the occasion of encounter when passage might occur through the work of the many partners – events suffered, mediated by the artist-transmitter and mediator, viewers as those open to sharing the trauma of the other?

I suggest we think about trauma, not in terms of event (which we cannot know), but in terms of *encounter with its traces* that assumes some kind of space and time, and makes some kind of gap as well as a different kind of participating otherness. We might then be able to distinguish for the aesthetic process of both the making-encounter itself (between the artist, the world and her/his others), and the viewing-, reading-, seeing- or listening-encounter for the viewer/reader, a specific relation to the destructuring void that is trauma but which ceases to be trauma once transformed by the structuring of aesthetic translation of after-affect into after-image while still carrying, as both words suggest, traces of trauma.

Psychoanalysis is a theory of time and of affect, both intimately connected. The temporalities of subjectivity do not follow the logic of linear development. Repetition is a key concept. Differing times are also embedded in subjectivity through coexistent processes that manifest themselves not only in repetition, but in return and retroaction. This is the Freudian concept of *Nachträglichkeit* best retranslated as 'afterwardness' rather than deferred action.[8] The practice of analysis is an afterward working-through, in the present, in a transferential encounter in the now, a process without a fixed goal that, nonetheless, brings about shifts and transformations in the psychic dispositions of both partners in asymmetrical ways, depending on the unconscious workings of both parties.

Yet how can a formal, intentional act of creation of knowledge address trauma: that which is unknown, unremembered and without time? Why would artists be inclined to do so? In an essay 'On Traumatic Knowledge and Literary Studies', literary theorist, Geoffrey Hartman writes:

> Traumatic knowledge would seem to be a contradiction in terms. It is as close to nescience [unknowing] as to knowledge. Any description or modelling of trauma, therefore, risks being figurative itself, to the point of mythic fantasmagoria.[9]

Trauma belongs to the 'Real' (in the Lacanian sense) – but

> the real is not the real, in the sense of specific, identifiable thing or cause; ... the encounter with the real takes place, on the part of both analyst and analysand, with a world of death-feelings, lost objects, and drives. It might be described, in fact, as a 'missing encounter' (the *troumatique*, Lacan puns) or an unmedi-ated shock.[10]

In Lacanian terminology the *Real* – the domain of trauma – lies behind and beyond phantasy: the Imaginary and beyond thought: the Symbolic. It happens, but 'it' occurs before the still-to-become subject has developed a psychic apparatus by means of which to metabolize the incoming event, to translate it, to process it, to imagine with it and to think about it. Trauma is thus a *structural* term for a condition of human receptivity to, and for the non-verbal intensities and affectivities resulting from, incoming stimuli from the world outside and from inside: the proto-subject's own organic and proto-psychic events. For Lacan, this is the realm of the Thing before the world can become an object (psychically represented) within the psychic system of drives and interpersonal relations.

In the later stages of his thinking, however, Lacan recognized the possi-bility for psychoanalytical reflection on what lies between trauma (the Real) and phantasy (the Imaginary), an expanse that Bracha Ettinger suggests has become a key field of research in contemporary artistic practice, and for deeply historical reasons.[11] We live, historically, in a post-traumatic era. That is to say, we come after events of such an extremity that they challenge all

existing modes of understanding and representation; 'we' are the late-coming witnesses to events that are not our own, through time or geopolitical difference. Yet such traumas inhabit our cultures surcharged with their unprocessed and unbound affects, culture itself become a source of traumatic marking of subjectivities born into haunted worlds. The traces of these disturbances resonate across culture: in how we think about human sociality and ethico-political living together after accumulating atrocities against humanity.

Let me explain a key distinction. According to psychoanalysis, trauma is a *structural* property of the formation of human subjectivity. Trauma is an inevitable condition for human subjectivity because in our primary formation we are impacted by events the proto-subject cannot yet imagine (phantasy) or know (thought). Events such as birth or the encounter with the other, with sexuality, with sexual difference, carve grooves or cavities into the emergent psyche around loss of the matrixial prenatal web and postnatally of the breast, loss of love, abandonment, engulfment mutilation (castration). This, *structural*, foundation of psychic trauma must, however, be distinguished from *historical* trauma.

Once formed as subjects, we may, in the course of our life-histories encounter overwhelming, and thus traumatizing, shocks such as sexual abuse, bereavement, torture, violence or life-threatening illness, whose psychological and affective 'amplitude' not only overwhelms the psyche's capacity to handle the immediate event. Its profundity is overdetermined by the degree to which this 'historic' event mimes or echoes the unremembered/unforgotten, structural traumas of loss, abandonment and fear of mutilation that it now, *afterwardly*, reignites. From the *structural* formation of the subject in relation to the archaic Real, the new, *historical* event may unevenly inherit haloes of unbound affects. The secondary, *historical* event paradoxically, becomes, retroactively and simultaneously, both a repetition of an unknown past and, incomprehensibly, the originary moment of the traumatic *nachträglich* load, and for the first time; afterwardness is the condition for the impact of the *structurally* traumatic into *historical* time. The event – created between both the structural and the new, historical traumatic assault – is now experienced for the first time in this dual, afterwardly structure, even while the nature of trauma is, fundamentally, ever to be *non-experienced*. The historical traumatizing shock itself may also be void and over-present, only reappearing belatedly, symptomatically re-ignited by its own deferred, secondary event forming a relay of trauma, unremembered, deferred and retrospectively inherited. It is here that what the painter Ettinger names *artworking*, or what Hartmann proposes as form-making in literature, enables us to understand how this retroactive chain of the non-experienced traumatic can become known to us, not as a therapeutic cure for an individual analysand in abreaction (Pierre Janet's term for curing traumatic shock), but as a cultural process of coming, belatedly and

differently, and in a shared encounter, to a knowledge that is affective rather than only cognitive because of the gap created by its passage to an aesthetically fashioned, not fully symbolic, form in which we can otherwise begin to work with the event and its affective freight.[12]

Geoffrey Hartman, therefore, names a process he calls *literary knowledge* that he says 'finds the "real", identifies with it'. Hartman emphasizes the possibility of creating, through art or literature, a form of figuration, which is a rhetorical means by which the unknown and unexperienced may, none the less, be introduced in an indirect, non-represented form into the realm of cultural knowledge, 'in the negative'. The manner suspends the desire to see and to have an image of 'it', while also deflecting the will to master through cognitive knowing. The traumatic event or its affects are not represented; yet through art or literature that can aesthetically affect – that is, perform more than representation – something of trauma's radical otherness may be intimated and hence encountered aesthetically and affectively. *Something* is the key word here. Not everything, but some aspects may be allusively *encountered*, but never mastered and not fully seen. Thus artworking in the space *between* trauma and phantasy is also a possibility precisely because of the potentialities created by expanded, contemporary artistic practices that have the freedom to work with so many processes without being confined by critical orthodoxies and formalist constraints that hitherto seemed to prescribe a singular path of modernist legitimacy as either the over-visualized or the non-visualized. The originating, creative gesture of art becomes a belatedly originary site for an encounter with the affective ripples around the non-experienced, hence, absent traumatic pool, so that we intimate traumatic residues rather than reducing it to a representation it cannot but evade. Riddling and playing – both suggesting repetition and time – emerge as a perplexing mode of access to a negative knowledge of the unknowable, which does not raise the traumatic to some sublime inexpressibility before which we declare we cannot know anything. When aesthetic or literary activity creates its forms, these are not a repetition of that which already exists as a memory or a known event in the subject or in culture. They are occasions for potentially transformative encounter marked by the potentiality of the aesthetic to touch, identify with and formulate trauma as trace, as tracing.

There cannot be repetition because that to which art or literature is giving a form, *and is doing so for the first time*, creating a form by means of which to know it affectively is, in fact, a negative moment in experience. Art/Literature creates what has neither yet nor ever entered into experience, that being the definition of trauma. Hence it is creative, poietic. Art does this by being periphrastic rather than constative, moving around, evoking, seeking to touch the elusive 'something' that structures subjectivity, and yet is impossible to know while being affecting and making its own kind of sense. It molds anew

the vase to sense the shaping pressure. Trauma is the exceptional non-experience that, nevertheless, certain kinds of aesthetic practices may 'find' through creating new modes for encounter with its traces, remnants or scenes.

Artworking about trauma risks, however, being traumatic; but it can also stage at one and the same time both a passage to the encounter with its traces and a passage away from it – precisely when, through the processes it offers to the viewer to experience and the gazing it invites, the artwork disrupts the hunger for mastery (*epistemophilia*) and sadism or voyeurism (*scopophilia*) and the viewer becomes a partner-in-difference (Ettinger).

If we focus on the negative moment in experience – the traumatic, the Real – which apparently is encountered, again, but effectively for the first time, in the art work as its *formulation*, in the *pathos formula*, in Warburg's terms, the image-formulation for intense feeling, we need to ask: What is the relation of aesthetic practice to the structural trauma of the archaic encounter and to historically traumatic events that may determine the subject's later actions which then become the sites of the created memory of the unremembered? Such a new form of non-memory, involving duration and reflection, opens then onto a future, a passage with the trauma that has remained latently at work for the lack of such delivery into forms by which we can work with its legacies and challenges.

Yet, of course, people who have been abused, tortured or raped, bereaved, diagnosed with mortal illness, forced into exile, imprisoned in a ghetto or concentration camp, usually know that these events have happened to them. Thinking with trauma, however, attends to those dimensions of such extremity or suffering that 'wound' in ways that remain beyond conscious recuperation as memory, that persist as 'non-experience' either through a form of immediate repression or through a different kind of psychic entombment. For instance, I can say: 'my mother died in 1964'. But the meaning, and, more importantly, the affect of that event is not contained or experienced by saying it, or naming the date. The excessive nature of the traumatic rupture of bereavement gives rise to prolonged affects that happen perpetually, making the bereaved person subject to recurrent feelings and even symptoms that plunge her/him down wormholes of time and surface vividly and unchanged at any moment.

Belatedness

The third key aspect of trauma is thus belatedness, also understood as latency. Freud formulated this aspect in his final text, *Moses and Monotheism*, written between 1933 and 1938 under traumatic historical circumstances when he was dying of cancer and threatened with extinction by the conquering Nazis. The book is about trauma and marked by it. Freud describes as traumas 'those impressions experienced early and later forgotten, to which we attach great

importance in the aetiology of neuroses'.[13] Trauma can either be *positive* – impelling us to repeat its originary situations in the search for repeated gratifications or *negative*, causing us to bury all traces. But it *returns*. Freud gives the example of a man who is in a train accident and apparently walks away unharmed, only to fall prey to a series of inexplicable symptoms somewhat later. The period between the event and the symptoms reveals a key characteristic of trauma: latency.[14]

The gap is critical to trauma theory. The most influential reader of Freud's thesis is Cathy Caruth, who transfers the theory of latency to render history itself as trauma.

> The historical power of the trauma is not just that the experience is repeated after its forgetting, but that it is only and through its inherent forgetting that it is first experienced at all. And it is this inherent latency of the event that paradoxically explains the peculiar, temporal structure, the belatedness of historical experience; since the traumatic event is not experienced as it occurs, it is fully evident only in connection with another place, and in another time.[15]

If there is a gap of latency, there is also always the return. Since trauma does not occur in its own moment, the unbound affects generated by traumatic impact, like ripples in a pond in which the originating stone is deep and unseen, can be inherited by later events, similar or associated. A later occurrence, even a trivial one, can trigger the displacement of the unassimilated anxiety which surcharges the secondary event with more intensity that it itself warrants. By the same token, there can be a certain capture in the second event of that which resonates as the unknown affects of originary trauma which can be structured into a representation of another event that is at once not the trauma itself and the secondary but initial experiential site of its *encounter*. Thus any form of separation, itself quite manageable, may trigger in a precociously bereaved person more anxiety than can be accounted for by the current event. In representing the secondary event, the shadow of the former can acquire a body that nevertheless veils the originary source of its excess pain. The traumatic is at once out of time but ever inserting itself into other times as a promiscuously repeating excess of affective intensity. This has implications for the analysis of art works in terms of latency and return through secondary situations: cause and effect or direct connection are thus displaced.

Transmissibility

Whose trauma? Can trauma be transmitted intergenerationally? Is it even generically transsubjective?

All children absorb many things from their parents through non-verbal and non-intentional communication. This is acculturation. Latent trauma of

afflicted parents can, however, also be transmitted to the extent that a child's psychological present is pre-occupied by a past s/he never directly experienced, and of whose undischarged affects as well as sensorial and imagistic links it may become the locus. Such transmissibility forms secondary trauma that can also become more than affliction; it offers a means to transform, on the traumatized other's behalf, those traumatic residues. The subject opens itself to a displaced and belated grieving or a working through not available to those who suffered the actual traumatic event or to the victim at the moment of suffering.

Furthermore, through such individual mechanisms of transmissibility, trauma can become culturally transitive, affecting a society as a whole through recurring accumulation and generational transmission. Typically trauma refers to individuals' events and or a personal psychic shattering. Yet trauma has been taken up in cultural analysis because certain kinds of historical events are of order of extremity that they may be said to 'traumatize', not collectively, but culturally. How?

Obviously, the mechanisms of an individual psyche are not present in a 'culture'; there is no collective psyche or unconscious to account for what we can theorize as the traumatic wounding at the level of the individual or of what might be transmitted in intimate familial relations.[16] If trauma refers to events that cannot be processed by existing mechanisms for making sense of them, we can extrapolate metaphorically that extreme historical events can shatter prevailing schemes of representation – cultural digestion so to speak – so that some dimension of real events remains unknowable for lack of cultural metabolization, and as such persists, shadows and engenders certain reactions or affects, even tendencies to repeat because they have not been processed into self-reflective knowledge.[17] Especially here it is vital to maintain a theoretical distinction between the study of the psychological impact of trauma and the cultural problematic of representation of events that occasion trauma, notably the representation of violence and violation, which have ethical and political consequences, and the legacies, hence responsibilities, of perpetration.[18] If trauma is overgeneralized as an undifferentiating condition of traumatic suffering from extreme events, we lose all political purchase.[19]

It is at this difficult intersection of what we might call the ethical turn in trauma studies to the question of suffering, transmitted, inherited, witnessed, and the philosophical issue of representability of extremity that the atrocious crimes against humanity of the modern era from enslavement to genocide can be considered under the rubric of trauma without removing questions of responsibility and agonistic conflict. Trauma is not now the general condition of humankind in modernity; it must mark specific sufferings that have roots in and leave traces in historical time even whole that may be overdetermined by structural – hence general – psychic predispositions, themselves evidently culturally sensitive and variable.

After-affects as well as real effects persist, however, in cultures that have not addressed their legacies – not merely with empty gestures of commemoration – and they persist because it appears that individual trauma is transmissible down the generations not only by the exposure of individual subjects in typical intersubjective relays but also what has been named encryptment, which imagines trauma not only as extreme suffering but also as the legacy of guilt, shame and other side-effects of compromised existence caused by extremes of oppression and violence/violation. To explain this, I need to digress to elaborate more fully on Matrixial theory itself.

From studies with children of Holocaust and other atrocity survivors, there is consistent evidence that a second generation, and beyond, are vulnerable to the affective impact of the traumatic suffering of their parents, and that each generation is itself already a historical carrier of unprocessed pasts often elaborated by projective phantasies.[20] Matrixial theory advanced by Bracha Ettinger contributes specifically to our expanded understanding of the mechanisms for such transmissibility. Matrixial theory raises the ethical and potentially political implications of our vulnerability to both the pain and the crimes of the past in the struggle against the cultures that persist in committing atrocities against human life.

So what is happening in artworks made by artists who may be marked by personal tragedy or who are engaged with historical calamity that has the quality of trauma: unknownness, presentness, absence, belatedness and transmissibility? In both making and viewing, what is it for one subject to incline towards or attempt to register that which marks an other? Can we share and shift through aesthetic mediation the pain of others from other times, places and cultures, when that pain is psychological rather than physical?[21]

What has art – what I am calling the aesthetic, not as the pacifyingly beautiful in the traditional sense, but as creative, poietic, affective formalization that may induce internal, subjective transformation in the affected participants in the encounter (these include the artist as well as later viewers) – to do with horror, pain, suffering, violence? What can it *do*? How does the aesthetic work in relation to the now contested field of trauma and cultural studies, between philosophy and the questions of representability and psychology with the thesis that trauma is that which happens but remains beyond imagining or knowing? How does it deal with the timelessness of trauma and the permanence of an absence that both presses upon us affectively and yet seeks to be processed, somehow, in words and images, in order to generate movement from blocked stasis, to allow a future to flow from the interior frozen lake of trauma? What have such questions to do with a political rage against suffering and a compassionate hope for a future? How are these feminist questions?

Aesthetic wit(h)nessing and matrixial theory

> In art today we are moving from phantasy to trauma.[22]

Reflecting on trauma, transmissibility and the role of the aesthetic, painter Bracha Ettinger registers a shift in contemporary art towards aesthetic engagements with traumatic residues of twentieth-century catastrophes and continuing conflicts from Cambodia, Rwanda, the Middle East back to the Armenian genocide and the Holocaust. Working with Lacanian terms in which the Real is synonymous with structural psychic trauma, the unthinkable and the unimaginable, and with Lacan's suggestion of a possible access via art to the relay between trauma (the Real) and phantasy (the Imaginary) and specifically aesthetic processes associated with that interval, Ettinger suggests that artistic process, understood as generating aesthetic transformation, can negotiate a passage away from trauma that, however, we must first be willing to encounter. Ettinger's contribution to the field of trauma studies in general and that of trauma and aesthetics in particular is her emphasis on the very early emergence of psycho-aesthetic and trans-subjective processes to facilitate transmission and transformation of residues and traces of traumatic events personal and historical, premised on a specific human capacity that is primordially (in the Real) linked to a *non-phallic feminine difference*. Feminism has been wary of claims for any specific definition of a feminine difference since the risk lies in reconfirming an essential – i.e., naturally given – femaleness derived from a sexual morphology, founded in the biological body. Ettinger, however, refuses to be scared off into abstracted constructionist notions of gender. Her rigorously psychoanalytical aesthetic theory has nothing to do with such risks of essentializing or naturalizing male/female difference. Matrixial theory of trauma, aesthetics and non-phallic feminine difference emerged in the face of trauma and art. Ettinger introduces two key concepts:

> We are carrying into the [the twenty-first century] enormous traumatic weight, and *aesthetic wit(h)nessing* in art brings its awareness to culture's surface.

> Certain contemporary art practices bring into light *matrixial alliances* in confronting the limits of shareability in the trauma and jouissance of the Other.[23]

Ettinger suggests that whether or not we are personally victims or perpetrators of such events, 'we' are collectively carrying residues of transitive trauma dispersed through time and space, rendering ours a post-traumatic era. This era raises the 'pain of others' and our ethical responsibility to human suffering to the surface of cultural attention via philosophy and political thought, but also through what Ettinger names, extending Freud's economic metaphor of *Arbeit/ work* – dreamwork, working through, the work of mourning – *artworking*.[24] Artworking draws fully on the legacy of modernist understanding of the

effects of self-conscious aesthetic practice. Through a proto-ethical concept of beauty arising from trauma, Ettinger explains how aesthetics addresses this condition:

> The beautiful accessed via artworks in our era – and I emphasize again our era since we are living through massive effects of transitive trauma, and it is captured and illuminated by different art works – carries new possibilities for *affective apprehending* and produces new artistic effects, where aesthetics approaches ethics beyond the artist's conscious control.

'Affective apprehending' recalls Hartman's notion of literary knowledge as nescience. If ethics, the orientation towards the other, approaches the affective-aesthetic, it is not at the level of conscious intention or commitment of an engaged artist. This is not relational aesthetics or political commitment. Unlike many current trauma theorists who perceive our response to catastrophic history in terms of obligatory mourning and loss, Ettinger considers art as potentially creative transformation premised on the intimate relation between aesthetic process/sensibility and com-passionate (hyphenated to stress the sharing with of pain or feeling) relations to the other.[25] In response to the deep ethical questions about human suffering and our historically inflicted injuries that urgently surface in art and in philosophy, aesthetic practice may perform a mode of *aesthetic wit(h)nessing*.

Into the legal figure of the *witness* whose presence, or testimony, guarantees from outside the veracity of the victim's experience or the event, Ettinger inserts the momentarily suspended letter 'h'. This graphic move shifts the term witness to *withness*, suggesting being with, being beside, sharing. The brackets, however, keep both meanings in play and create mutually inflected positions.[26] *Aesthetic wit(h)nessing* can be an effect of the artwork and its processes or of the viewer's openness to what the art work itself has remained 'with' in its own encounter-event during the making of the work which itself took time and perhaps encapsulates even longer temporalities of memory and immemory. For instance, in her own paintings, Ettinger works with an archive of freighted photographs and documents that carry traces of lost worlds, modern warfare, surveillance, psychiatric violence and perpetration of mass murder. Her process involves remaining with the indexical traces left in the archive, which she transforms by initially passing the document or image incompletely through an interrupted photocopier. This translates the readymades of history into granular apparitional traces because the photocopier deposits what its blind light has translated electromagnetically as ashen grains that have not yet been heat-sealed to replicate the original. Onto this fragile ground of disappearing appearance of the traumatic trace the artists works in oil and glazed colour, repeatedly traversing surfaces with abstract hand gestures that build membranes of aching colour veiling the virtual space of encounter with this

residual haunting past that cannot be grasped but must never be abandoned (Plate 1). Each painting evolves over years. It takes time and is materialized time, building its coloured layers as sediments of her prolonged reverie at the threshold of the then and the now she has invoked. What is encountered in the completed painting is not a resolved composition but a Lyotardian palimpsest of times charged with the affectivity of apparitional colour that lures a metramorphic or Matrixial gaze. This gaze never centres or masters but traverses and pauses, opening and self-fragilizing to the pulse of colour and the rhythm of touch that aesthetically wit(h)nesses what is both lost and found and neither lost nor found. This process is metramorphosis, a specific forming (morphology) relating to the legacies of feminine sexual difference experienced not organically but itself as a psychic trace of a primordial – but not frightening – trauma.

> Metramorphosis is a co-poetic activity in a web that 'remembers' [these] swerves and relations, inscribes affective traces of *jouissance* and imprints of trauma and encounter, and conducts such traces from *non-I* to *I*, from one encounter to further encounters. Metramorphosis transfers knowledge of these events with-in-to the matrixial psychic sphere. Through art's metramorphic activity, these traces are transmitted into culture and open it boundaries … The matrixial gaze corresponding to these transgressive processes is not relegated to the level of invisible figurality or unintelligibility, due to metramorphic cross-inscriptions that *impregnate subjectivity with partial-objects and objectivity with partial-subjects*. Sub-symbolic tunings that do not function on the level of distinct units of signification nevertheless make sense here. Artworking makes this meaning available for later conceptual elaboration.[27]

Aesthetic wit(h)nessing fosters *matrixial alliances* that do not refer to sympathy or even empathy between fully formed human subjects, but indicate another level of the fragilization of parts of a partial self, opened by the aesthetic processes, to share in, to carry something of, to be a transsubjective partner in transformation, whatever the affective cost, for the trauma and jouissance of the Other. This possibility is founded in and re-solicits the recurrence of what Ettinger daringly conceives of as a primordial human capacity for co-affection and transsubjective sharing that she names *Matrixial*.

Pregnancy has a medical, physiological, even biological ring. But it is one of the great human mysteries that even those who experience pregnancy and birth can hardly conceptualize or speak. It is the join of life and meaning. Every born person is its product and hence the bearer of its traces. Move away from physiological preconceptions and think its significance conceptually. What does it mean on a human, psychological or philosophical level that human becoming is premised on a prolonged subjective and potentially subjectivizing *intimacy of the several* in which the proto-subject senses an already-human

subjectivity across a shared, aesthetically sensed borderspace? For Ettinger, the time of human becoming involves a mutually inflecting jointness: prenatality with prematernity, when a functioning, sensate proto-subject matures in almost incestuous proximity to a phantasizing already-formed subject, rich with nonconscious echoes of her own traumatic joint becoming belatedly reanimated in this inverted severality. This severality of jointness-in-difference generates the potentiality of a matrixial dimension in all subjectivities long before birth and before Oedipal gendering begins a parallel but differentiating process in a phallic logic of the cut. Matrixial capacity is the gift to humanity of our singular and humanizing co-becoming 'with' an unknown but sensed other. Its archaic, hence traumatic, transsubjectivity may be re-awakened in several postnatal instances. One is transference in the analytical scenario. The other is the aesthetic encounter, already Matrixial and transsubjective.

If I am 'moved' or touched or changed by an encounter with/through an artwork, I am being changed within myself by an unknown event that is not mine. I let it happen. I want this change. I am not merely a witness to the existence of this artwork as the object created by an other. When it has an effect, I participate in wit(h)nessing, as it were, when I allow myself to be transformed through feeling or recognition, pleasure or pain by this otherness that I cannot know fully, yet which I internalize and process on its behalf through a mechanism otherwise not yet theorized. I am not merely a passive recipient of a coded message. Nor am I the mastering interpreter of a code. When we think of the specifically aesthetic event and its poignancy – from piercing in a pleasurably traumatic sense – there is a mechanism at work which Ettinger's concept of *aesthetic wit(h)nessing at a shared borderspace becoming a threshold* might momentarily capture. If this openness is part of the normal event-encounter that can occur when we meet art, can this be extended to the situation of artworking with achingly traumatic residues?

Transport station of trauma

I have already cites Ettinger's key concept for this book:

> The place of art is for me the *transport-station of trauma*; a transport station that, more than a place, is rather a space that allows for certain occasions of occurrence and encounter, which will become the realization of what I call *borderlinking* and *borderspacing* in a *matrixial trans-subjective space* by way of experiencing with an object or process of creation.[28]

Ettinger thus proposes a specific operation effected by the aesthetic process that is not concerned only with witnessing or testifying to trauma which has become the dominant thesis in the Caruth/Felman field of trauma studies. Neither is she talking about art as a *representation* or testimonial document of

a traumatic memory or event, or its phantasy-coloured reconfiguration.[29] The issue is 'transport', a term already heavy with historical horror in the context of genocide, but equally evocative of other kinds of transformations in jouissance that shift subjectivity at its loosened boundaries. We speak of transports of delight.

The encounter may not always happen; it is contingent on the viewer's openness to resonance with the artworking. Aesthetics are thus not therapeutic; they do not aim at a cure and are not about expression. But they can contribute to change by poignancy as opposed to puncture, and one that is not only intersubjective but is *transsubjective* across time and space, across differences of real incomprehensibility.

The traumatic event *is*: it has happened. It marks the surfaces of individual psyches and impresses itself in cultural forms of (im)memory: *a memory of oblivion* in Ettinger's own words.[30] It leaves traces in individuals and, when it has occurred on a mass scale, it can resonate through whole cultures, challenging cultural memory because of the rupture with existing modes of representation and collective commemoration. Unprocessed, the event haunts. Having happened, it demands acknowledgement without which we may, like the neurotic, be compelled to repeat or act out effects whose source we do not know. The potentialities of art, as a result of the specific histories of its modernist practices and changing postmodern conditions, can become occasions for encounter with and transport beyond the haunting traumas of Modernity in general and notably of the horrific events of the twentieth century in particular, many of which persist, unresolved, into the present. To do so, we must discover *through aesthetics* the nature of the subjective capacity we have as human beings to share in the trauma – the events – of the other without confusing ourselves with the actual suffering victims, to encounter, and perhaps even to process some of the remnants of their traumas that circulate in our cultures, on behalf of others, by means of a transsubjective capacity, in which opened borderspaces can become thresholds of transport/transformation. Ettinger explains:

> The transport is expected at the station, and it is possible, but the transport station does not promise that the passage of the remnants of trauma will actually take place in it; it only supplies the space for this occasion. The passage is expected but uncertain, the transport does not happen in each encounter and for every gazing subject.[31]

Contemporary art creates occasions – stations – at which a transport may arrive and may enable passage. The encounter is not ruled by a sociolect, by common sense or general assumptions. Response is possible, invited, solicited, but it cannot be predetermined. Responsiveness – response-ability – lies within our singularity, what we already bring, what we may not know but find vibrating through the event of the other in the intensity of aesthetically solicited

affects. We lend our own lives and traumatic residues to animate otherness encountered and that inflects the potential of such otherness to animate itself in us. The transport hopes that we will allow ourselves to be fragilized so that our armoured selves are loosened and passage may take place across the trans-subjective transferential threshold of the aesthetic encounter. Such art incites compassionate hospitality that does not pathologize or abject the suffering of others, but recognizes a deeply humanizing creative dimension for such co-affection already latent within us in the gift of the Matrixial feminine to humanity that is now more than ever important for us to acknowledge as a source for changed orientation to the excessive pain of our worlds.

Ettinger hopes that '*Contemporary aesthetics is moving from phallic structure to matrixial sphere.*' As symbol and signifier of an order of meaning, affects and phantasies, Matrix challenges the exclusive hegemony of Phallus as the only arbiter of meaning, subjectivity and a logic of sexual difference that renders the feminine merely the negated other of the one sex.[32] In classical psychoanalytical theory and underpinned by a much longer tradition of binary thought, the feminine is defined only in negative relation to the masculine: sun/moon, sky/earth, day/night, man/woman.[33]

The challenge of Matrixial theory of the feminine as a sexual difference is to grasp a difference that is not a difference from the masculine and is not derived from any opposition between masculine and feminine. Matrixially, feminine sexual difference is a non-gendered structure of difference between partial subjects – for example, the severality of differentiated but co-emerging prematernal and prenatal partial subjects. It is feminine insofar as it derives as a psychic apparatus or dimension from human becoming which involves a sexed subject and body in relation to a non-yet gendered/sexed other. Matrix signals a sexual difference that is non-Oedipal and non-gendered even while it is sexuated. This structure generates the proto-ethical capacity donated from a matrixial sphere of feminine difference to sustain human compassionality.

Matrix differs from phallocentric thought insofar as it arises in and persists from an even more archaic zone of the Real that occurs before birth, the traditional limit imposed by Lacan on psychoanalytical theory and also policed by feminist theory for a false fear that anything of the prenatal can only be physiological. Deeply in tune with Freud's psychologization of the corporeal in terms of drives, Matrixial theory of prenatal/prematernal severality is a 'thinking apparatus' that 'thinks' for us a primordial connectivity in which all human subjects are, traumatically, in the Real, formed in an intimacy with an unknown, co-affecting other, an *unknowable* and humanizing *partner-in-difference*, hence a co-other that installs a proto-ethical familiar strangeness at the heart of anything a human subject becomes. This Matrixial potentiality is brutally crushed after birth when conditions of survival necessitate other relations to the world and the familiar elements of aggressivity, narcissism

and object relations take over. But it is not obliterated. We already sub-know it and affectively use or abuse it. We are susceptible to specific forms of trauma as a result of it.

When operating on a Matrixial thread of subjectivity that plays alongside the necessary phallic pathway to language and Oedipal sexual positions, we relate to the pain or trauma of the other because, from this primordial potentiality, we cannot but share it, bear it, transport it, and potentially create a future precisely by such sharing, by recognizing co-humanity rather than anxiously policing the boundaries of difference, expelling the foreign other, fearing the confusion of difference. We can abuse or kill this capacity through disavowal.

The Matrixial is a space of sharing within difference: its partners are radically unknown to each other, yet they share events and are imprinted with the traces of the other. Matrix signifies a shared subjectivizing borderspace. But since the originary event of Matrixial borderspacing occurs for the becoming human infant in the Real, traumatically, before it has an apparatus to absorb and metabolize the event-encounter, we must understand this not as an experience. It was fundamentally an aesthetic event, and is linked forever with aesthesis, with resonance, movement, rhythm, affect. Aesthesis also refers to a transformation of the inner worlds of each partner by the impact of a co-emergence and co-affection with an other. The Matrix thus refers to a shared borderspace between co-affecting subjective entities that completely explodes the phallic myth of human gestation as a pre-human biological oven in which the mother becomes momentarily psychotic and the baby is physiologically cooked before the single moment of human origin: birth – i.e., severance from the maternal feminine. This is then mythically reduced to having been merely an organ, womb, or body as if the subjectivity of prematernity freighted with its own memories and memories of memories can be rendered utterly devoid of human significance. The obliteration from thought of the possibility that the feminine-maternal has any meaning for humanity in the face of obvious enormity of its inevitable and prolonged subjective significance indexes the phallic narcissistic neurosis we must explode.

Borderspacing is the psychological inscription of this sense of co-emergence that creates a capacity for, even a yearning for *borderlinking*. Defying the phallic notions of subjectivity as a necessarily severed, individuated, territorialized entity, scarred, however, by a series of losses (objet a) for which it perpetually mourns, confronting the world as its substitutive other, borderlinking suggests that in addition to the phallic track of separated subjectivity, human subjects also acquire, as the traumatic legacy of our prolonged prenatal encounters with a primordial co-emerging human otherness, a capacity for and even a pleasure in linking with an-other, for sharing and processing with or on behalf of the other. Postnatally we desire the lost object; but we also yearn matrixially for instances of connectivity.

The primordial, traumatic Real of the originary Matrixial severality is re-animated postnatally, in phantasy and in thought, as a proto-ethical resource for enacting but also theorizing ethical responses to the historical suffering of others, to the trauma of the world. A new way of understanding aesthetic practices, themselves already deeply Matrixial in their affective and transferential potential, becomes the bridge inclining artistic practice from its classic individualized image of self-expression and from its collectively explored function as articulating or even disrupting ideological formations towards a different understanding of its cultural implicatedness and capacity for transformation. The encounter with an artwork, itself registering a prolonged encounter with trauma, can foster subjective openness that may become ethical and then, through conscious decision and commitment, can also be moved from this sphere into that of the political action.

Certain contemporary art practices ask us to consider the trauma of the Other – other people, other times, other histories – namely, what is not already mine, familiar and my own. But there are limits to the degree to which the Other's trauma can be shared. It is ineradicably other. Art can, however, seek to create *matrixial alliances*, to bring human subjects closer to the possibility of recognizing and being affected by the pain that is other, and to assenting to receive and hence transform some of its burden. This does not make the viewer feel a good or better person, or a more sensitive one. The aesthetic encounter created by art practice can open up the borderspace to become a threshold between now and then, us and them, to create a shared borderspace that acknowledges the gap between different beings, times and places – difference – while ethically making each partner compassionately vulnerable to the other's trauma and *making us want to know it and even process it*.[34]

For Lacan, beauty arises to shield us from the encounter with death.[35] For Ettinger, beauty arises in the moment of connection to life. Hence beauty is the ethical capacity of the art experience, its ability to stimulate what Ettinger names *response-ability*, the ability to respond compassionately to the human vulnerability of the other, and to any risk or threat to her humanness compromised by the cruelty of violence. This is not the product of the artist's intentions, her good will, her politics (as Sartrean commitment aspired to and Lacanian concepts of the Imaginary exposed as compromised); instead this ethical capacity to respond to the other is a result of the way in which formal and aesthetic processes can re-generate in the present encounter Matrixial affects that solicit sharing founded in, and afterwardly reclaimed from, our archaic, traumatic formation in the Real of co-emergent humanizing life.

Encryption and transcryptum

To summarize: trauma is a no-thing that is itself never representable; but that does not make it ineffable, only a structural gap. It impresses itself in the rhythm between silence and words. Its traces, *after-affects*, may thus be processed aesthetically. I now want to introduce a different theory of trauma that points to why transport might fail. This too solicits a Matrixial revision.

For Lacan the psyche is shaped negatively by what he names *objet a*: traces of the loss of part-objects, traces of the severance from the subject's bodily orifices and from the mother's body. Meaning is generated by a rhythm of disappearance and appearance of what Ettinger has named the *archaic m/Other* so that the meaning of mother, for Lacan, lies only in the compulsive repetition of this rhythm of the interval between appearance and disappearance. The Lacanian subject mourns perpetually its losses and separations and its trauma is a constitutive, intrapsychic condition in which what is lost never was possessed. Loss itself forms the foundational 'hole' or void Lacan calls *troumatique* – word-playing on trauma and the French word for hole: *trou*.

In contrast to this vision of the subject as a discrete psyche scarred by the lineaments of the imagined missing things (not even thinkable as actual objects that an other could satisfy: so we are thinking about voice, gaze, milk, breast etc.) from which it had to be severed in order to emerge as a distinct subject, Maria Torok and Nicholas Abraham postulate a different kind of internal space: an intrapsychic crypt inhabited by a phantom. This space is included in the unconscious not by primary repression but by conservator repression. 'The self has no relation to its secretly crypted phantom that does, however, haunt the transference and countertransference psychoanaytical relations and all other relationships of love.' [36] What is important is that the phantom traverses the generations.

To this intergenerational scenario, André Green added a further dimension by exploring a form of narcissistic wound that comes about not through the phantasized loss of a real object or an actual loss. It is the effect on the forming subject of the *psychological* absence of the mother when she is depressed and thus not psychically available to her child because she is absorbed by her own trauma. Inexplicably the child is forced to grieve for a lost relationship that itself becomes encapsulated within. The subject at the same time identifies with a 'dead mother' and traces of her trauma are thus invested within the subject itself as it is formed in this nexus.

Drawing on the work of psychoanalysts with children of Holocaust survivors – the second generation as it has come to be known – Bracha Ettinger then asks us to ponder the phenomenon of subjects who carry and sense a trauma that is not their own. The survivor (first generation) lives in a chronic

traumatic state, where only the denial of suffering and the perseverance of amnesia and oblivion allow the continuity of psychic life. The survivor's child (the second generation) carries the weight of the buried unknown knowledge of and for the survivor-parent while being recathected by the survivor as a carrier (memorial candle) of both the survivor's lost objects and encrypted phantoms. The question for such a second-generation subject is about how to come into contact with and get rid of the weight of the trauma inside itself, a trauma not directly experienced, whose story was untold, and which was neither incorporated nor introjected by the survivor, and was not directly included and isolated either. Here we realize the necessity for a subject who carries its others' (parents') crypt in their place.

Let me elaborate the theory of encryption.

Unfettered by Freudian attachment to the structural trauma of castration and all it encapsulates of the psycho-sexual Oedipal model as the only formation of subjectivity, psychoanalysts Nicholas Abraham and Maria Torok argue that neurotic distress may be traced back to something more historical and contingent that occurs *between the generations*. They suggest that what is experienced as this unknown, haunting, *after-affect* may be the *after-image* of a transmitted but *encrypted* secret, often shameful or guilty, passed from generation to generation. It is a coded secret and thus undecipherable to the subject it lies within, and it is entombed in the subject as a cold, dead haunting presence. Thus some trauma may be encrypted, unavailable for the *working* because it is not connected with Freud's notion of libidinal energy invested in the love object or cause or country that must be detached, decathected and resumed by the subject for new investments in the world.

How does this extraordinary condition of encryption come about?

First, Abraham and Torok imagine the formation of subjectivity from a 'dual unity'. They propose that subjects are formed by processes of self-differentiation from the primary post-natal union with the mother. In the early post-natal state before the formation of the child's own conscious and unconscious, in a condition of constant play, the child interacts with the mother's thoughts and gestures and does not distinguish its mother's conscious and unconscious. This only comes about when the child uses words to designate events beyond the mother's unconscious. So Abraham and Torok invite us already to register the mother as a psychic being, a subjectivizing presence, but they still argue that subjectivity demands individuation – i.e., separation from this psychic confusion of the child's not-yet-individuated unconscious and the mother's. Yet 'the maternal unconscious becomes part of the child's language. Communicated without ever having been spoken, it resides as a silent presence within the newly formed unconscious of the child'.[37] The child's singularity arises in a permanent symbolic relation with the mother, and the child becomes itself by the negation of its previous unity. This leads to a radical

displacement of the phallocentric myth at the heart of Freudian and Lacanian psychoanalysis, namely the Oedipus Complex.

For Abraham and Torok, the Oedipus myth is an alibi with which culture furnishes the child a means to detach from the mother while simultaneously asserting continuing love for her. Neither fear of incest nor of castration precipitates detachment from the mother, thus dethroning the phallus as the only arbiter of becoming speaking, sexed subjects. For Freud and Lacan, the mother is that dark engulfing symbiotic space from which the intervention of the father alone saves the child. For Abraham and Torok, a child 'gives birth to itself' dyadically by differentiating from the mother and becoming 'not the mother'. Yet this process is precisely the means by which all children receive a transmission across the generational divide and become part of the family history. Thus subjectivity begins in a primordial psychic interface from which differentiation occurs in a manner that nevertheless establishes joint pathways through which the past leaks into and becomes embedded in the future at this intersubjective level. If the parents are themselves already bearers of such transmissions, or were themselves the locus of some unspeakable and unspoken traumatic event, the emerging subject carries it within itself as a *phantom*.

> Should a child have parents 'with secrets' … the child will receive from them a gap in the unconscious, an unknown, unrecognized knowledge – a *nescience*. The buried speech of the parent will be [a] dead gap without a burial place in the child. This unknown phantom returns from the unconscious to haunt its host and may lead to phobias, madness, obsessions.[38]

In addition to the term phantom, Abraham and Torok theorize the crypt using again their specialized theoretical vocabulary:

> The crypt is neither the dynamic Unconscious nor the ego of introjections. Rather it is an enclave between the two, a kind of artificial unconscious, lodged in the very midst of the ego. Such a tomb has the effect of sealing up the semi-permeable walls of the dynamic Unconscious. Nothing at all must filter to the outside world. The ego is given the task of a cemetery guard.[39]

Abraham and Torok worked with analysands to assist those they called *crypto-fores*: bearers of such encrypted secrets that were in fact not their own. Using Shakespeare's Hamlet as a case study, Abraham also showed how cultural narratives and works of art exhibit this structure of encrypted secrets or guilt and can be deconstructed. But the process is not the usual one of interpretation. Abraham and Torok introduce a specific way of understanding the function of the symbol, and symbolization: any speaking or representing. The word 'symbol' refers to an ancient practice of breaking a single piece of pottery in two so that a traveller, carrying one part, might be recognized on his/her

return. The noun comes from the Greek word *symballein*, which means to put together or to unite. Thus it is not about substitution but about connection.

> We are used to treating symbols like archaeologists who attempt to decipher written documents in an unknown language. What is given is 'something' with a meaning. Many of us live with the convenient misconception that in order to decipher [the document] it is sufficient to add meaning to the 'thing' or the hieroglyphs … Yet in doing so we merely convert one system of symbols into another and this latter system still stops short of laying open its secret. Actually the reading of a symbolic text cannot be content with registering one-to-one equivalence between two terms. The work of deciphering will be completed only if we restore the entire circuit of functions involving a multiplicity of subjects and in which the symbol-thing is simply a relay.[40]

Thus inscription leads us towards the idea that symbolic mediation, saying, writing, painting and so forth can performatively process and even register in the negative the presence of the unknowable yet haunting trauma. Abraham's and Torok's thesis on encryption (secret coding) and encryptment (entombing) take us back from the intervention of symbols to a different psychic mechanism in that what is said or written – the symbolization – betrays a missing element that must be read across a relay of fragments that circulate but point to the relations, between past and present, self and others, that are the invisible network in which they travel. Translating from the scene of psychoanalysis to the scene of cultural analysis, I hear in the following statement a guideline for a method:

> Whereas we are normally given meanings, the analyst is given symbols. Symbols are data that are missing an as yet undetermined part, but that which can, in principle, be determined. The special aim of … listening is to find the symbol's complement, in other words, the fragment that 'symbolizes with' – or, we might say, that 'co-symbolizes'.[41]

Reading works of art that may be shaped by trauma, may passage trauma, may encrypt traumatic secrets, is not a matter of conventional decoding a source, biographical or historical interpretation. It involves acute attention to the aesthetic and formal movements of that which symbolization is attempting to touch, connect with and transform while registering that there is always another dimension, not available for symbolization but not, therefore, entirely beyond its negative referencing. There is a co-symbolization that may then be operating on several different registers in which making artworks, films, written texts becomes element of the travelling away from and towards.

Abraham and Torok, define trauma thus:

> An event too painful to be absorbed by the ego whose stability it would threaten, trauma drives the individual to speak and behave in ways that simultaneously

conceal and reveal their catastrophic source. Implicit in this view is the idea that the content of an event does not in itself classify it as traumatic. *The manner in which it is 'lived' or experienced psychically by the individual renders it a trauma.* This perspective removes trauma from external moral or ethical taxonomies to situate it as a function of the specific mental configuration and psychic history of an individual.[42] (my emphasis)

Trauma is thus clothed by Abraham and Torok in always singular histories; it is 'lived' in unpredictable ways determined by particularity and experience. For this process of analysis they created the term *anasemia*, from *ana* meaning 'back up towards' and *semia* meaning signification. If, as Esther Rashkin puts it, 'Anasemia allows [the analysts] to construe an individual's existence as constituted by the constant creation of symbols in response to trauma' and to 'read these symbols – and thus the individual's life – as a series of tell-tale symptoms that tacitly speak of their founding silence beyond perception', could I propose a form of art historical and cultural analysis that construes an artistic practice or oeuvre as constituted by the constant creation of symbolic forms in response to trauma as a pressing but unknown urgency, so that the work of analysis is a reading for that which speaks of a founding silence, a trauma, beyond perception and thus neither a cause nor a content, and never an explanation, but rather a condition that is at work constantly? What Bracha Ettinger names *artworking* delivers the visible scene upon which these rhythms of symbolic inscription and haunting encryption can be traced but also through which they can either be inscribed or become re-encrypted.

In the light of Abraham and Torok's brave and radical re-reading of classic psychoanalytical theories of the autonomous individual created only by cutting out from and abjecting the maternal through the mediation of the phallically empowered father, and their theorization of transgenerational unconscious sharing of traumatic material and repressed and uncanny affects, it may become easier to locate the theoretical and feminist intervention offered by Bracha Ettinger into this field of transsubjectivity, time and the archive. She too is working with a non-Oedipal understanding of transsubjective, transgenerational and hence intercultural encounters.

Matrixial theory, however, differs in turn and radically from that of Abraham and Torok. Ettinger does not displace the phallocentric formation of subjectivity by the Oedipus complex entirely. She *supplements* this still effective track in the formation of subjectivity with a supplementary one that brings about a shift in the conception of trauma/the Real, the Imaginary and the Symbolic. Her naming stresses a Matrix as a mathematical structure, something abstract and formal, while also engaging with the embodied, carnal, corporeal and sexual location of subjectivity that is lived through a sexuated (but that does not imply a gendered) body, with and without organs, and invests its body parts phantasmatically with meanings and affects. Freudian psychoanalysis

teaches us how the becoming human subject 'thinks' with its body: orally, anally, genitally, though vision and skin, touch and sound. Lacanian psychoanalysis recast the classic Freudian tropes by passing them through the prism of structuralism and its linguistic matrix. For both systems the question of femininity remained indecipherable.

The difficulty of femininity expresses itself as hysteria: a body in trouble with language as the offered terms of being sexed and gendered, or a body whose phantasmatic elements become a kind of corporeal alphabet displacing words onto feelings, pains, anaesthesias, physical symptoms. So bodies are part and parcel of subjectivity and its [traumatic] articulations. We accept Freudian understanding of how the actual oral experiences of feeding give rise to pleasures and investments that may enhance our capacity to speak as well as to take in ideas, to digest different materials the world offers us conceptually and imaginatively. The real may be transmuted, sublimated from physical to psychological. Ettinger uses such fundamental psychoanalytical terms to bring into view a different moment of coexistence than that which Abraham and Torok posit only in order to insist once again on separation.

Ettinger proposes *transcryptum* as a new form of memory work performed by art:

> I am proposing that the crypt – with its buried unknown knowledge, with what could not be admitted and signified by the mother as loss and was buried alive in an isolated nonconscious intrapsychic cavity together with the trauma that caused it, the signifiers that could have told the story, but remain detached and isolated, the images that could have held together the scene and the affect that accompanied it – this crypt, transmitted from m/Other to the subject can be further transmitted from the subject to yet another subject.[43]

Arising psychoanalytically at the level of the intergenerational and familial, Matrixiality adds this transsubjective mechanism to other kinds of historical, diachronic and lateral transmissibility:

> A crypt, transmissible in a psychic sphere we call Matrixial, can become in a subject a lacuna that corresponds to an unsymbolized ancestral event – an event not of its parents, but of its parents' parent. Thus, we can conceive of a chain of transmission, where a subject 'crypts' an object/other/m/Other, who in turn had crypted her own object/other/m/Other, so that *the traumatic Thing inside my mother's other is aching in me*. We are now going to propose that in a similar vein the traumatic Thing of the world is aching in artworking.[44]

The artist or, rather, the artworking as a space of encounter between art and the world and the viewer of that world mediated via the art is a 'transport station of trauma'. This is a sign of our times that are never pre- but indelibly post-traumatic:

The creation of an intrapsychic crypt and the identification with it (endocryptic identification) are considered psychotic phenomena. I propose that they are such only in what can be looked at as a pre-traumatic era; but in our era, which I consider post-traumatic, where there is no pre-traumatic psychic reality, and where no 'innocence' can be presumed, such a psychic reality cannot only remain psychotic. It is contemporary art as transcryptum that gives body to this 'knowledge of the Real' and generates symbols for what would otherwise remain foreclosed from the transmitted trauma of the world. Such a post-traumatic era becomes, then, trans-traumatic.[45]

Ettinger's theorization of the matrixial capacity for transsubjective sharing enables the transgression of the boundaries of the individuated subject to be understood as non-psychotic. Matrix reveals the means by which we might transport the trauma of the other, while also revealing how such a capacity, specifically animated by a form of ethical aesthetic operations, might serve to de-psychoticize our current post-traumatic era.

Post-traumatic art

Spurred on by Jean-François Lyotard's profound reading of Ettinger's own aesthetic practice, Jacques Rancière entered this field to challenge Lyotard's linking of art, trauma and the sublime. Lyotard suggests that selected artworks confront – bear witness to – a novel and real (rather than natural) immensity, in history, for which all existing means of measurement have been destroyed so that art must register, but cannot hope to master, what it has, nonetheless, faithfully to confront seeking to phrase what he called '*le différend*': that which has yet to be phrased and thus causes a perpetual search.[46] Arguing against what he takes to be Lyotard's position on the sublime as the privileged mode of post-traumatic art, Jacques Rancière refutes the notion that recent history produces a kind of traumatic sublime beyond representation. He argues that there is nothing inherently unrepresentable about, for instance, the Holocaust. Creating, as does Lanzmann's nine-hour film *Shoah* (1985), a negative impression such as absence is itself a representation: of absence.[47]

Rancière's irritation with Lyotard, however, misses entirely Lyotard's subtle point that does not render trauma and catastrophe ineffably unrepresentable. Lyotard suggests that certain events by virtue of their extremity may be effectively *forgotten* by being *remembered*, that is, when mastered by a mode of representation inadequate to the uncontained nature of the challenge such events should continuously pose to any form of obliviating representation. Post-traumatic art pays tribute to the shattering of existing means of comprehension and representation resulting from real historical outrages by a constant fidelity, by working towards a phrasing – not merely linguistic, but gestural, sonic or graphic – a touching or encountering of some affective

elements capable of shifting us both subjectively and collectively that do not arrive at containing the event in finite forms.[48] The aesthetic performs a shattering awakening into sensate thought and incites continual research for ways to say what remains out of our cognitive reach.

I seek to enquire into how, if and when, aesthetic formulations emerge through the specificity of their formally generated affective processes that enable encounter with and *aesthetic wit(h)nessing* of traces or residues of what could not be immediately represented: hence they bear *after-affects*. These may create what we need to name *after-images* as formulations or frames within which the *after-affects* are held at the station of potential transport of trauma. Both accept their afterwardness as a painful or perhaps *jouissant* necessity at the point where aesthetic specificity inclines towards and fosters ethical humanizing compassion. Affect is not the same as emotion. Affect is as intense as it is without shape or focus: grief, anxiety, melancholy, *jouissance*. Affect is more like a colouring of our whole being; an opening towards something or a complete enclosure in its grip such as depression. Thus affect can be transmitted via mediated experience of the aesthetic.

The chapters that follow are reparative readings of a singular range of art works whose diversity bears witness both to different forms of traumatic experience and very different psychic and aesthetic economies in their artworking. Enriched by psychoanalytical theory, the book also aims to allow artists and artworks to teach us from their processes something beyond what our theories already hypothesize about trauma and aesthetic transformation.

The book

A book informed by Matrixial theory paradoxically begins with hysteria. 'Gasping at violence' begins with my hysterical mimicry before one of the most arresting statues of the Baroque period by Gian Lorenzo Bernini in the Galleria Borghese, *Apollo and Daphne*. My bodily response initiated a reading of a work that indexes the trauma of gender culturally encoded in mythology, lodged in the museum and the canon. In wondering how to read the opened mouth of a woman offered rape or death by becoming a tree, I set off on a journey to meet Ana Mendieta and Anne Brigman who otherwise rework the mythic entwinement of femininity, life and death through the trope of the tree. What is the meaning of metamorphosis in all these works and what could be a reparative feminist re-reading?

The Ovidian tale of Arachne leads to Chapter 2's reflection on the magnificent arachnid created out of New York heating pipes and marble and known as *Maman* (1999) by Louise Bourgeois that is, I argue, linked to Daphne's opened mouth by sharing the notion of invocation. Through close readings of one of Bourgeois's earliest sculptures, and her own pre-1982 and post-1982

statements, which insist upon the formal geometry of her work, I plot a path to my reading of *Maman* as *Maman!* a form for a bereaved feminine subjectivity calling out to the missing *m/Other*. Refuting reductive biographical readings of this artist's oeuvre, I seek instead to trace the genealogy of this arachnid *pathos formula* across the double scene of seduction and bereavement.

Completing a trilogy on sound and subjectivity in sculpture, 'Being and language: Anna Maria Maiolino's gestures of exile and connection' links the mouth to language and the hand to trauma. Childhood terrors of starvation in wartime Italy, multiple migrations, dictatorship and the fragile hopes for democracy in Brazil inform Anna Maria Maiolino's multi-media sculptural practice. I draw upon both phenomenology and Deleuzian concepts of difference and creativity to examine the works and the words of the artist – her poetic parallel to her formal search for a language for being – into the response to the challenge that repetition in her work in unfired moulded clay poses.

Section II, 'Memorial bodies', focuses on two works touched by the reality and the shadow of the Holocaust. In 'Traumatic encryption: the sculptural dissolutions of Alina Szapocznikow', I study the works of a Polish-Jewish artist who died in 1973 just on the cusp of an emerging feminist art movement that might have recognized her novel carnal aesthetics but would have missed the legacies of still hardly recognized Holocaust trauma. In her sculpture I discern a movement from an initial reparative forming of integral and even, under socialism, heroic bodies, to the engagement with the painful intersection of fragile body and machine that suggests encrypted – unmourned – losses that progressively melted and dissolved Szapocznikow's sculptural forms, until remnants of the past archived in photography surfaced, dissipating into abject materials, infused with image-traces that almost tattoo the genocidal past into a new artificial residue that mimics skin.

In 'Fictions of fact: memory in transit in Vera Frenkel's video installations', I turn to the vidéothèque of the virtual feminist museum, and consider the specificity of the medium of video and installation as the site of transformative encounters with trauma as it is being formed as multi-centred memory. Vera Frenkel, born in what was once briefly Czechoslovakia in 1939, is now one of Canada's most distinguished video artists and one of the major pioneers and elaborators of this medium. In her installations of the early 1990s she resumed the broken threads of memory of the Holocaust in order to weave a polyvocal pattern of memories of forced migration that had contemporary resonances in an era of resurgent racism and xenophobia. Reading Frenkel's creation of fictional spaces such as '… from the Transit Bar' (Documenta IX, 1992) and her installation *Body Missing* (1994) evoking Hitler's aesthetic and cultural policies and the looting of European treasures for the Linz museum project, I identify her imaginative and ultimately web-based anticipation of what Michael Rothberg only recently identified as multi-directional memory.[49]

The final section, 'Passage through the object', works with text and video, words having been a constant object of study so far, to explore the function of objects as 'transport stations of trauma' and to explore contrasting aesthetic and psychic economies with radically different outcomes as the encounter with trauma finds its secondary moment through filming and writing. 'Deadly objects and dangerous confessions: the tale of Sarah Kofman's father's pen' analyses philosopher Sarah Kofman's memoir as a hidden Jewish child in Occupied Paris. Identifying its structuring rhymes, topographies and primal scenes, I detect an encrypted trauma that became unsurvivable. In '"…that again!": *pathos formula* as transport station of trauma in the cinematic journey of Chantal Akerman' I discern across the making of a film and an installation a transformative and transgenerational psychic economy. Crossing Warburg with Ettinger in a study of a *pathos formula*, I respond to a gesture, a kiss, occurring in two different forms of films made in 2004 by Akerman which led to a reappraisal of the entire trajectory of Akerman's work from independent, feminist cinema to time-based art installation and sought an ultimately creative passage from and for her mother's trauma. It is here that the opening questions about journeys towards the encounter with trauma and their varying outcomes find their origin and thus function as a conclusion when autobiographical exchanges are acknowledged between this writer and her chosen topics of analysis. Is writing also part of a journey towards what I meet riddled in these artworks?

Notes

1 Theodor Adorno, 'Commitment' [1962], in Andrew Arato and Eike Gebhardt (eds), *The Essential Frankfurt School Reader* (Oxford: Basil Blackwell, 1978), 312.

2 The key texts include Shoshana Felman and Dori Laub (eds), *Testimony: Crises of Witnessing in Literature, Psychoanalysis and History* (London: Routledge, 1992); Cathy Caruth (ed.), *Trauma: Explorations in Memory* (Baltimore, MD: Johns Hopkins University Press, 1995); Cathy Caruth (ed.), *Unclaimed Experience: Trauma, Narrative and History* (Baltimore, MD: Johns Hopkins University Press, 1996). A counter model appeared in Ruth Leys, *Trauma: A Genealogy* (Chicago: University of Chicago Press, 2000). See also the keen defence in Shoshana Felman, *The Juridical Unconscious: Trials and Traumas in the Twentieth Century* (Cambridge, MA: Harvard University Press, 2002), 171–83. For trauma and history see Dominick LaCapra, *Representing the Holocaust: History, Theory, Trauma* (Ithaca, NY: Cornell University Press, 1994) and *Writing History: Writing Trauma* (Baltimore, MD: Johns Hopkins University Press, 2000). Critical readings of this new trend include Mark Selzer, 'Wound Culture: Trauma in the Pathological Cultural Sphere', *October*, 80 (1997), 3–26; John Mowitt, 'Trauma Envy', in *Theorizing Trauma: The Cultural Politics of Affect in and beyond Psychoanalysis* (New York: Other Press, 2007), 349–76.

On trauma as a feature of post-colonial societies, see Hal Foster, *The Return of the Real: The Avant-Garde at the End of the Century* (Cambridge, MA: MIT Press, 1996).

3 Kristine Stiles, 'Shaved Heads and Marked Bodies: Representations from Cultures of Trauma' [1993], in Jean O'Barr et al. (eds), *Talking Gender: Public Images, Personal Journeys and Political Critiques* (Chapel Hill, NC: University of North Carolina Press, 1996), 36–94; Jill Bennett, 'The Aesthetics of Sense Memory: Theorising Trauma through the Visual Arts', in Peter Weibel (ed.), *Trauma and Memory: Cross-Cultural Perspectives* (Vienna: Passagen Verlag, 2000), 81–96; Ernst van Alphen, *Caught by History: Holocaust Effects in Art, Literature and Theory* (Stanford, CA: Stanford University Press, 1997); Lisa Saltzman and Eric Rosenberg, *Trauma and Visuality in Modernity* (Dartmouth College, 2006).

4 For a curative model of trauma and a medico-psychological genealogy see Judith Lewis Herman, *Trauma and Recovery: From Domestic Abuse to Political Terror* (New York: Basic Books, 1992). A comprehensive genealogy of the term is offered in Roger Luckhurst, *The Trauma Question* (London: Routledge, 2008).

5 Bracha L. Ettinger, 'Traumatic Wit(h)ness-Thing and Matrixial Co/in-habituating' *parallax*, 5:1 (1999), 89.

6 Griselda Pollock, 'Gleaning in History or Coming After/Behind the Reapers: the Feminine, the Stranger and the Matrix in the Work and Theory of Bracha Ettinger', in Griselda Pollock (ed.), *Generations and Geographies in the Visual Arts: Feminist Readings* (London: Routledge, 1996), 274.

7 On the paradoxes of representation as making something present in its essential character and of finding 'a scheme of intelligibility equal to its material power', see Jacques Rancière, 'Are Some Things Unrepresentable?' in *The Future of the Image* (London: Verso, 2007), 109–13.

8 Jean Laplanche, 'Notes on Afterwardness' in John Fletcher (ed.), *Essays on Otherness* (London: Routledge, 1999), 260–5.

9 Geoffrey Hartman, 'On Traumatic Knowledge and Literary Studies', *New Literary History*, 26:3 (1995), 537.

10 Geoffrey Hartman: 'On Traumatic Knowledge and Literary Studies', 539.

11 In 'The Matrixial Gaze' (1995), reprinted in Bracha Ettinger, *Matrixial Borderspace*, ed. Brian Massumi (Minneapolis: University of Minnesota Press, 2006), 73–80, Ettinger identifies research in this archaic domain in the varied works of Pierre Fédida, Jean-François Lyotard (*Figure/Discours*), Christopher Bollas (*The Shadow of the Object*) and others in object relations such as Donald Meltzer.

12 Griselda Pollock, 'Art/Trauma/Representation', *parallax*, Issue 50 (January–March 2009), 40–54. This formulation mirrors, but not quite, a similar distinction between structural trauma of loss to which all are subject, trans-historically, and historical trauma which is the specific experience of particular victims, made by Dominick LaCapra in 'Trauma, Absence, Loss', in *Writing History, Writing Trauma* (Baltimore, MD: Jon Hopkins University Press, 2001),

76–8. LaCapra focuses on absence and loss, and on empathy in order to avoid rendering traumatic loss 'in hyperbolic terms or immediately equating it with loss or lack'. My purpose is not to distinguish the two in such terms, since trauma may also refer to any overwhelming incoming, unmediated event, including pleasure or contact, and in order to propose the structural trauma as a primary sculpting of psychic susceptibility into whose grooves historical events nestle giving rise to the personal specificity of the manner in which historical events impact on individual subjects whose structural formations are also subject to the archaic and early infantile relations in familial history.

13 Sigmund Freud, 'Moses and Monotheism'[1939], Pelican Freud Library, Vol. 13: *Origins of Religion* (Harmondsworth: Penguin, 1985), 315.

14 Freud: 'Moses and Monotheism'[1939], 308–23.

15 Caruth, 'Introduction', *Trauma: Explorations in Memory*, 8.

16 See Jeffrey C. Alexander et al., *Cultural Trauma and Collective Identity* (Berkeley: University of California Press, 2004). For the strongest case against cultural trauma see Wulf Kansteiner, 'Genealogy of a Category Mistake: A Critical Intellectual History of the Cultural Trauma Metaphor', *Rethinking History*, 8:2 (2004), 193–221.

17 For an important argument against the grain of Caruthian trauma studies that focuses on the continuing issue of Germany's troubled relation to its traumatizing perpetrator past, see Sigrid Weigel, 'The Symptomatology of a Universalized Concept of Trauma: On the Failing of Freud's reading of Tasso in the Trauma of History', *New German Critique*, 90 (2003), 85–94.

18 Kansteiner, 'Genealogy of a Category Mistake', 193–222.

19 For an important explication of this issue, see Felman, *Juridical Unconscious*, 171–83.

20 For instance Dina Wardi, *Memorial Candles: Children of the Holocaust* (London: Routledge, 1992). On transmission of trauma see also Louise J. Kaplan, 'Images of Absence: Voices of Silence', in *Lost Children: Separation and Loss Between Children and Parents* (London: HarperCollins, 1995), 216–39.

21 Elaine Scarry, *The Body in Pain: The Making and Unmaking of the World* (Oxford: Oxford University Press, 1987); Susan Sontag, *Regarding the Pain of Others* (London; Penguin, 2003).

22 Ettinger: 'Wit(h)nessing Trauma and the Matrixial Gaze', 147–8. For a fuller introduction to Ettinger as painter, see Catherine de Zegher and Griselda Pollock (eds), *Bracha L. Ettinger: Art as Compassion* (Brussels: ASA, 2011).

23 Ettinger: 'Wit(h)nessing Trauma and the Matrixial Gaze', 148.

24 Sontag, *Regarding the Pain of Others*; Judith Butler, *Precarious Lives: The Power of Mourning and Violence* (London: Verso Books, 2004); Bracha L. Ettinger, *Bracha Lichtenberg Ettinger: Artworking 1985–1999* with essays by Brian Massumi, Christine Buci-Glucksman and Griselda Pollock (Gent: Ludion, 2000).

25 LaCapra, *Writing History, Writing Trauma*; Sigmund Freud [1914g]. 'Errinern, Wiederholen und Durcharbeiten (Weitere Ratschläge zur Technik der Psychoanalyse, II)'. *Internationale Zeitschrift für ärztliche Psychoanalyse*, 2,

485–91; 'Remembering, repeating and working-through'. *Standard Edition of the Complete Psychological Works* (London: Hogarth, 1958) 12, 147–56; 'Mourning and Melancholia' [1915], *Standard Edition of the Complete Psychological Works*, 14 (London: Hogarth, 1957), 237–58.

26 On this neologism see Anna Johnson, 'Nomad Words', in Anthony Bryant and Griselda Pollock (eds), *Digital and Other Virtualities* (London: I.B. Tauris, 2010), 217–36.

27 Bracha L. Ettinger, 'Wit(h)nessing Trauma and the Matrixial Gaze', in *Matrixial Borderspace*, 143.

28 Bracha L. Ettinger, 'Art as the Transport-Station of Trauma', in *Bracha Lichtenberg Ettinger: Artworking 1985–1999* (Gent: Ludion, 2000), 91.

29 Susannah Radstone, 'Screening Trauma: *Forrest Gump*', in Susannah Radstone (ed.), *Memory and Methodology* (New York: Berg, 2000), 79–107.

30 Bracha L. Ettinger, *Matrix Halal(a)-Lapsus: Notes on Painting* (Oxford: Oxford Museum of Modern Art, 1992), 11.

31 Ettinger, 'Art as the Transport-Station of Trauma', 91.

32 Bracha L. Ettinger, 'Matrix and Metramorphosis', *Differences: Journal of Feminist Cultural Studies*, 4:3 (1992), 176–208; See also Griselda Pollock, 'Thinking the Feminine: Aesthetic Practice as Introduction to Bracha Ettinger and the Concepts of Matrix and Metramorphosis', *Theory, Culture and Society*, 21 (2004), 5–64.

33 For an excellent analysis of gender as long-standing figure of binary thinking independent of human sexes, see Clare Colebrook, *Gender* (Basingstoke: Palgrave Macmillan, 2003).

34 Ettinger, *Matrixial Borderspace*, 140–154.

35 Jacques Lacan, *The Ethics of Psychoanalysis Book VII 1959–60*, trans. Dennis Potter (London: Routledge, 1992).

36 Esther Rashkin, *Family Secrets and the Psychoanalysis of Narrative* (Princeton, NJ: Princeton University Press, 1992), 253.

37 Esther Rashkin, *Family Secrets and the Psychoanalysis of Narrative*, 17.

38 Nicholas Abraham and Maria Torok, 'A Poetics of Psychoanalysis: "The Lost Object – Me"', *SubStance*, 43 (1984), 17, note 1; also in ' "The Lost Object – Me": Notes on Endocryptic Identification' (1975), in Nicholas Abraham and Maria Torok, *The Shell and the Kernel*, trans. Nicholas T. Rand (Chicago: University of Chicago Press, 1994), 140, note 1.

39 Abraham and Torok, 'The Topography of Reality' (1971), in *The Shell and the Kernel*, 159.

40 Nicholas Abraham and Maria Torok, 'The Symbol or Beyond Phenomena' (1961), translated cited in Rashkin, *Family Secrets*, 38.

41 Nicholas Abraham and Maria Torok, *The Wolfman's Magic Word*, trans. Nicholas Rand (Minneapolis: Minnesota University Press, 1989), 79.

42 Rashkin, *Family Secrets*, 42.

43 Bracha L. Ettinger, 'Transcryptum', in Linda Belau and Petar Ramadanovic (eds), *Topologies of Trauma: Essays on the Limits of Knowledge and Memory* (New York: Other Press, 2002), 255.

44 Ettinger, 'Transcryptum', 55.

45 Ettinger, 'Transcryptum', 256.

46 Jean-François Lyotard, *The Differend: Phrases in Dispute* [1983], trans. Georges Van Den Abeele (Minnesota: University of Minnesota Press, 1999).

47 Rancière, 'Are Some Things Unrepresentable?', 109–38.

48 Jean-François Lyotard, *Heidegger and "the jews"*, trans M.S. Roberts (Minneapolis: University of Minnesota Press, 1990); *Postmodern Fables*, trans. Georges Van Den Abeele (Minneapolis: University of Minnesota Press, 1999).

49 Michael Rothberg, *Multi-directional Memory: Remembering the Holocaust in the Age of Decolonization* (Stanford, CA: Stanford University Press, 2009).

Part I
Sounds of subjectivity

Gasping at violence: Daphne's open mouth and the trauma of gender **1**

Captions to chapter 1

1 Gian Lorenzo Bernini (1598–1680) *Apollo and Daphne*, 1622–25, detail of Daphne, marble, 243 cm.

2 Antonio del Pollaiolo (*c*.1432–98) *Apollo and Daphne*, *c*.1470–80, oil on wood, 29.5×20 cm.

3 Michelangelo Merisi da Caravaggio (1571–1610) *The Head of Medusa*, 1597, oil on canvas mounted on wood, 60×55 cm.

4 Aby Warburg (1866–1929) *Mnemosyne Atlas*, 1929: *Nympha Plate 39*.

5 Ana Mendieta (1948–1985) *Untitled* (*Silhueta* Series, Mexico: *Imagen de Yagul*), 1973, Estate Print 1991. Colour photograph.

6 Ana Mendieta *Untitled* (*Silhueta* Series, Mexico), 1976. Colour Photograph, 25.4×20.3 cm.

7 Sandro Botticelli (1445–1510) *Primavera* or *The Realm of Venus*, *c*.1482, tempera on wood panel, 203×314 cm.

8 Sandro Botticelli *Primavera* or *The Realm of Venus*, detail: Venus, Flora and Zephyr and Chloris.

9 Sandro Botticelli *Primavera* or *The Realm of Venus*, detail: Chloris.

10 Anne Brigman (1869–1950) *Via Dolorosa 1911*, *c*.1940, reworked from earlier negative gelatin silver glass interpositive, 12.2×9.4 cm.

11 Anne Brigman *The Soul Of The Blasted Pine*, in 'Book 2, Anne Brigman', 1907, gelatin silver nitrocellulose sheet film interpositive, 9.6×12.3 cm.

12 Montage of close-ups from a) Gian Lorenzo Bernini (1598–1680) *Pluto and Proserpina*, 1622, detail of the face of Proserpina, Rome, Borghese Gallery, and b) detail from Gian Lorenzo Bernini (1598–1680) *Ecstasy of St. Teresa*, 1647–52 (Cornaro Chapel, Santa Maria della Vittoria, Rome).

13 Gian Lorenzo Bernini (1598–1680) *Apollo and Daphne*, detail of Daphne, 1622–25, marble, 243 cm.

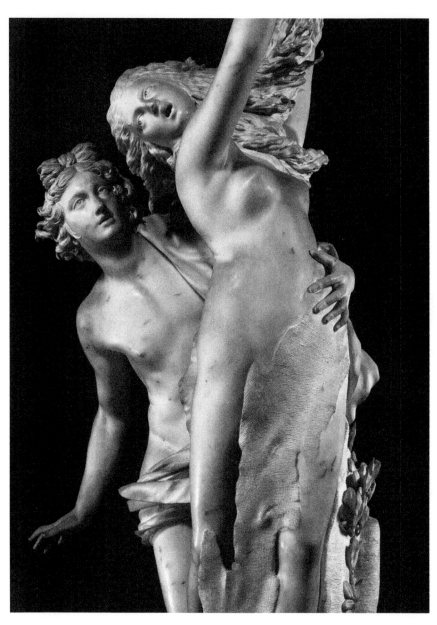

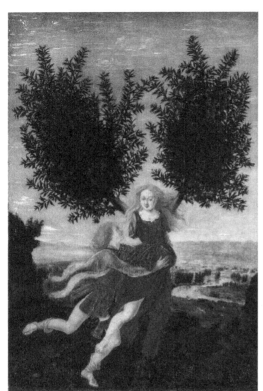

2

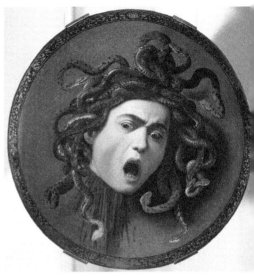

3

4

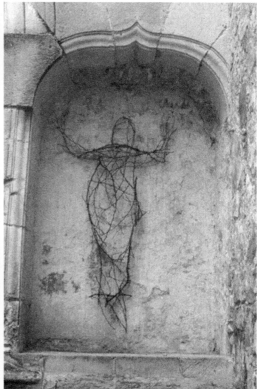

5

6

7

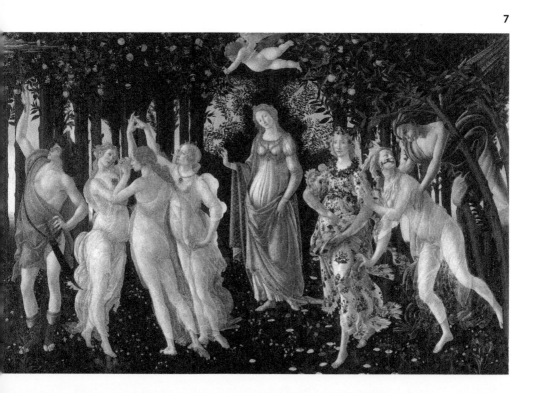

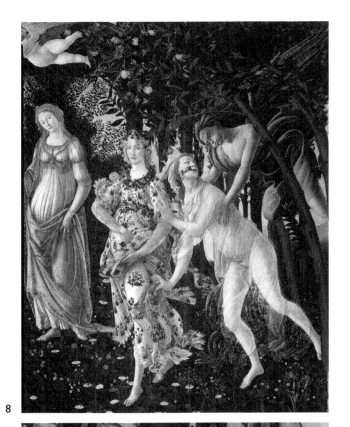

8

9

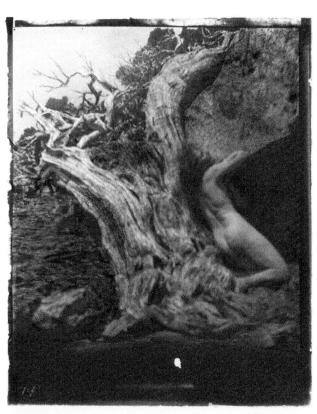

11 10

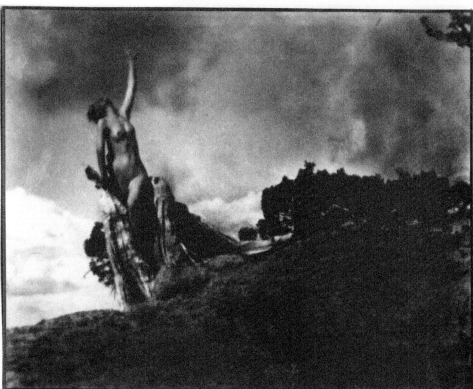

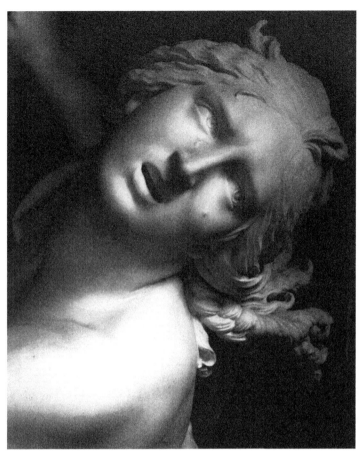

12a

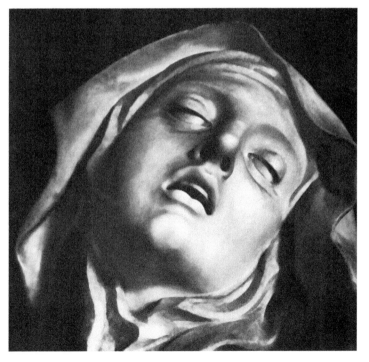

12b

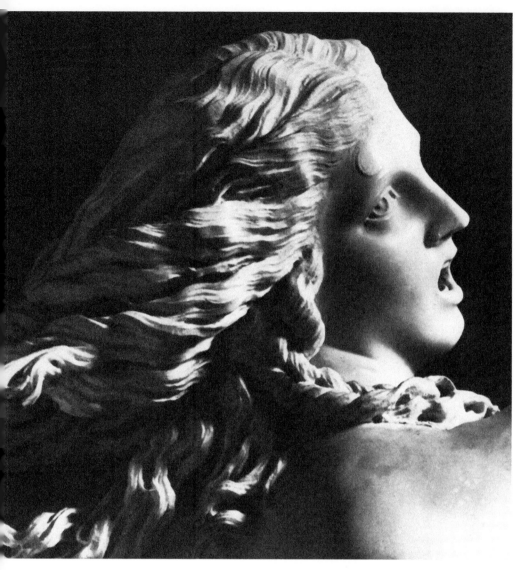

13

I gasped.

A gasp is a sudden, involuntary intake of breath. The mouth opens. Air is dragged down the opened throat. Resonating within the body, the gasp is *a sound of subjectivity* as it registers a shocking, sudden, unexpectedly affecting encounter with something seen, felt or done to the body.[1] An acoustic *after-affect,* it sonorously registers the piercing of what Freud, in his theorization of trauma, described as the 'protective shield' of consciousness.[2] Consciousness is like a lookout on the fortifications of the psyche, watching for external danger in order to prepare the psyche for any assault.[3] Trauma, according to Freud, is what happens when the watching consciousness is bypassed and the psyche is invaded by a shock against which it cannot mobilize defensive gestures. Trauma is a surprise attack, foiling the constantly vigilant defences that would enable the psyche to generate anxiety with which to anticipate the shock. With breached psychic defences, and consciousness knocked out, the subject does know what has happened. The body acts it out *affectively.*

My gasp signalled, therefore, a moment of potential trauma. But whose?

I start this book with my encounter with a sculpture dating from 1622–25, thus wildly out of sync with my subsequent focus on trauma, modern histories and aesthetic transformation. One justification is that the social and imaginative processes of gendering femininity are themselves traumatic within the *longue durée* of phallocentric culture. Paradoxically this disqualifies women's experience from being considered traumatic. Trauma is considered the exceptional event. But many feminists will argue that existence 'in the feminine', the world that women inhabit, is itself regularly traumatizing in general and certain excessive acts of violence and violation such as rape, an act Mieke Bal defines as a 'murder of the self', are embedded tropes if not a founding mythos of phallocentric culture.[4] I want to explore ways of reading the cultural inscription of the trauma of phallocentric logic in major art works which, against the grain of preferred interpretations, allow what

I name 'differencing the canon', a shifting of dominant understanding of canonical works for other possible perspectives.

Secondly, in the Virtual Feminist Museum, an exploration of a sculpture before which I gasped in sympathetic horror enables me to travel across the visual archive outside of the boundaries set by canonical art history: those of period, oeuvre, style, nationality and so forth. My invocation of Warburg's concepts of *Nachleben* and *Pathosformel* demonstrate the feminist reconfiguring of notions of time, space and the archive. Thirdly, it is a very modern perspective – I am thinking of Warburg, Freud, Lévi-Strauss and Barthes – to acknowledge the function and continuing presence of myth, itself constantly transformed but always registering a struggle to resolve contradictions arising from both lived and imaginative conflicts in our life-worlds. Finally, the Virtual Feminist Museum allows me to plot new journeys through the visual archive, forging eccentric if not – in Mieke Bal's terms for reclaiming the Baroque as not a period in art but an attitude towards the body and time – *preposterous* links across time.[5] These explode art history's enclosing classifications so that the dynamic work of artmaking becomes more visible while the ground of such remaking – formations of subjectivities and relations of difference – are experienced as integral to all culture rather than the speciality of those effectively excluded by being named their special agents: women and feminists. In such a plotting, the engaged spectator, the affected reader and critical analyst of artworking takes responsibility for the readings.

My body made a sound before a figurative Baroque sculpture. Can an artwork have a traumatizing effect? Or was I performatively mimicking through this bodily sounding-out what Aby Warburg named a *pathos formula*, an iconic formulation of suffering and extreme emotion, an image, therefore, registering the affective signs of the trauma of the other who stood before me in stony silence? Warburg denounced 'aestheticizing art history' that idealizes art and treats the artist as its imagined source to pacify and delude us through narratives about genius and beauty. The record of art, understood by Warburg as affectively charged and thought-provoking images (not mere objects), simultaneously formal and symbolic, holding thought and affect together, is not the tale of edifying cultural creation and unbridled human enlightenment. Images tell us instead profound and disturbing things about human passions and their continuing dangers, about the re-surfacing of violence and possible, momentary deflections through symbolization. Images demand, therefore, intense attention to both the economy of worked material and their symbolic potential that traverses the boundaries of single artworks, disciplines, forms, cultures and epochs. They call for culturally and historically informed analysis of their traumatic load rather than mere aestheticizing or eroticizing viewing.

I gasped. I was encountering *Apollo and Daphne*, carved by Gian Lorenzo Bernini (1598–1680) between 1622 and 1625, and commissioned by Cardinal

Scipione Borghese, papal nephew to Pope Paul V, for a specially built villa on the Pincea, designed to display as a 'theatre for art' his antique and contemporary collections of art.[6] (Plate 2) I met the sculpture, however, almost face to face with the nymph Daphne in the precise moment of her arrested flight from the pursuing god Apollo, just as the bark of the tree into which she is being metamorphosed begins to encircle and claim her lower body (Plate 3). Her toes begin to extend into roots, digging into the earth; her fingers sprout twigs and leaves. Her upstretched arms reach across her body while head and neck twist backwards in the opposing direction of her legs and lower body still moving forwards and yet brutally arrested by becoming 'rooted' to the spot. Her head falls backwards as her eyes slew sideways and upwards to catch sight of the persecutor whose hand has encircled her waist, meeting at once the forbidding bark and still bare skin. Her entire torso and breasts are thus exposed fully. Entering the room unprepared, I was, however, arrested myself, rooted to the spot, and precipitated down a dark cavity in the sculpture that is the open mouth of *Daphne* (Figure 1).

What is this sculpture doing? What has been introduced into art and into the sphere of meanings the artwork reworks by this detail of hollowed space that is at once an opened mouth calling for narrative interpretation and a formally shocking cavity in its sculptural form? Is this dark hole the void of trauma? Whose? Hers? Culture's? What kinds of working with this arresting element might move from merely reiterating a paranoid interpretation of violation and death which is present in the pre-textual myth to a reparative, transformative reading that defied the killing of woman to which the sculpture is making us witnesses, or worse, collaborators?

Finally, Bernini's sculpture engages aesthetically through sculpture with the concept of metamorphosis, transformation, whose deeper cultural significance we need to plumb before being able to engage with the kinds of transformative aesthetic practices which form the core of the following studies in an era in which the figurative tradition which Bernini so brilliantly animated was ruptured by atrocious events and the technological traumas of modernity.

I want to open this book, therefore, with a series of gestures that play with the idea of the traumatic opening of this sculpture in order to open up its field of meanings and affects and create a context against which the work of the following chapters can be set.

Can pain be beautiful? How should we look at sculpture?

In 1781, a series of letters were published as *A View of Society and Manners in Italy* by an Englishman, John Moore (1729–1802). Letter XLV recorded Moore's ambivalent response when he encountered Bernini's *Apollo e Daphne* in the Villa Borghese in Rome. Apollo frankly disappointed. His posture was affected;

his expression of astonishment merely theatrical and not convincing. The figure of Daphne, however, was troubling. Moore starts positively: 'The form and shape of Daphne are delicately executed.' He continues: '… but in her face, beauty is, to some degree sacrificed to the expression of terror; her features are too much distorted by fear'. Moore judged *Daphne* an aesthetic failure.

> An antique artist would have made her less afraid, and she might have been more beautiful. In expressing terror, pain and other expressions there is a point where the beauty of the finest countenance ends, and deformity begins.[7]

Drawing on John Locke, Moore adds: 'Passions in their extreme, instead of producing sympathy, generally excite feelings diametrically opposed'.[8] Thus Pierre Puget's statue of *Milo* roaring with pain has destroyed sympathy, while the classical sculpture of *Niobe* in the Villa Medici is praised for knowing precisely where 'distress cooperated with beauty, and where our pity met our love'.[9] Recognizing full well the potential criticism of gendered 'interest' and even bias in the matter of aesthetic encounters with representations of the passions, Moore addresses an imaginary, and I feel feminist, interlocutor.

> It is unjust you will say, that men should not sympathize with homely women in distress, in the same degree as they with the beautiful. That is very true; but it is the business of the sculptor to apply his art to men as he finds them, not as they ought to be.[10]

Moore acknowledges that it is men, *qua* men, and not as a dispassionate human generality, who look at art works and need this balance between scopophilic pleasure and the demand for sympathy for an imagined other in their passion or suffering.

What relation can there be between aesthetics and suffering if the former is conceived in terms of a form of visual beauty that is understood not only to appeal to, but must allay any anxiety within a heterosexual, masculine concept of what is beautiful to look upon, namely what can be tolerated when encountered visually, which must thus be infused with the carefully calibrated relation between aesthetics and desire on the one hand, and sympathy and distortion on the other.

As a feminist, I neither judge nor condemn Moore. Indeed we all look and we all respond from within situated subjectivities, textured by many factors that relate us both to certain larger collectivities we name class, gender, ethnicity and sexuality, and to our singularities within such groupings where each particular viewer/reader is constituted by unique and local patterns in turn contingent on personal histories. Yet, unlike Moore, feminists, allied with others seeking to 'difference' hegemonic assumptions that colonize cultural analysis and interpretation, have argued that we cannot just accept the ways things are.

There is more than a matter of varied viewpoints at stake. Whether or not Bernini's *Daphne* is 'beautiful' or 'deformed with terror' is not a mere matter of aesthetic judgement of the finely crafted object. The work, its reception and accumulating canonical readings over centuries now, play their part in a performative theatre of cultural inscriptions of meanings. By repetition, these in turn contribute to the formation of our gendered subjectivities within specific, limited bounds. We seek to breach such bounds when we wish to challenge dominant cultural narratives and visual representations that constantly normalize specific formations of sexual difference and cloak its foundational violence against women in distracting erotically appealing aestheticization. Indeed, the pagan classical stories, resumed by a dominantly Christian Western European culture in painting, theatre, music, literature, sculpture and opera – often quaintly called the 'loves of the gods' – enshrine powerful myths about the formation of patriarchal cultures and obliterated precedents that are again and again premised on heterosexual rape as their predominant metaphor for conquest, and on the death or similarly dehumanizing transformations of a woman as the necessary sacrifice in the process of social and cultural reconsolidation of male-gendered dominance.

In the Virtual Feminist Museum, however, such works can be re-read reparatively, against that grain, differencing this set of stories, seeking to hear the sounds of subjectivity also echoing down the mythic chain that might shift the phallic mould in which Moore confidently and honestly declared his anxiety before the grief and suffering of this anguished face of *Daphne*.

At first sight, therefore, as I entered the second room in the Borghese gallery, before the specific angle of my encounter with the face and body of the sculpted Daphne, I gasped – *hysterically* (Figure 1). I mimetically identified in my own affected body with what this sculpted body appeared to be doing. Symptomatically, therefore, I was reading a visual signified as '*Daphne* is gasping'. The imagined sound that opened this marmorean body implied an interior bodily space that is, in turn, a metaphor for a psychological interiority. Yet, from the myth of Daphne and Apollo I also know that her mouth should logically indicate its inverse: '*Daphne* is crying out'. A cry occurs when the body forcefully expels air, and with the voice calls to an other in a moment of desperate, life-threatened appeal. Both gasp and cry are the sounds of extreme emotion. Yet they have very different implications.

So what is happening here in this sculpture? Is the female figure's open mouth a narrative signifier telling the well-informed viewer that the frightened nymph Daphne is calling out to her father Peneus, the river god, to save her from her divine pursuer Apollo? Why would she cry out? Because, in deadly fear, she is fleeing from imminent rape. But her cry has already been answered. She is being saved by being transformed into a tree. The sculpture incorporates a series of moments and shifts.

What would it mean to experience, in the visual sound-space of the gasp, the opened and vulnerable feminine body, registered in aesthetic form even as the sculpture appears to deliver the known story of her being turned into a tree by showing the bark evolving as a sheath around her vulnerably, yet still sexually exposed nakedness? Unlike so many representations which either show Daphne as a woman's body with arboreal extensions (Figure 2) or show her already a tree with some human attributes (a trunk topped with a woman's face or torso), Bernini's strategy is to offer to his viewers the still completely human female body, but to capture it, literally and figuratively, at the moment of its being *imprisoned*, inside the growing sheaths of hardening bark.[11] At the 'moment' the sculpture seizes from its narrative source, this bark is enclosing this female body at the level of her genitals. Yet female genitals are always already sealed in the conventions of Western classical sculpture. The classical female nude is a closed body. Bernini's encroaching bark functions as a chastity belt doubling but also underlining the Western sealing of feminine genitals, even while the narrative is premised on this body's open vulnerability to violent possession through penetration.

From the woman's point of view, *Daphne* might be gasping at the uncanny process of her own sudden metamorphosis from mobile warm-blooded flesh to wooden stillness, a stilled coldness like that of sculpted marble and also, of course, of death. The fear of being caught gives way to the dawning horror of the means of her escape. In this dramatic sculpture of an encounter between two figures in motion captured at different moments of emotional intensity that is, for the woman, a disastrous moment of radical destruction, how does the sculpture propose varying subjectivities to its viewers through the created dialectical energy that is Bernini's magnificent intervention in Baroque sculpture that can be read around its many viewing positions?

The marvellously many-sided sculpture was commissioned as one of three major works by the still young Bernini (he made these works in his early twenties) for the Villa Borghese. As a theatre for art, the Borghese performed, according to art historian Genevieve Warwick, as a stage set, soliciting comments and inciting conversation from the viewers as they moved through it and around the many works there displayed. Bernini's latest sculpture, *Apollo and Daphne* created an immediate problem for early visitors Cardinals Maffeo Barberini and d'Escobleau de Sourdis, who, as representatives of the Church with its teachings forbidding concupiscence, were troubled by the potentially erotic effects on viewers of the display of 'a lovely naked girl'. Their concern led to addition of cartouche, 'attempting a cure', by carrying moralizing lines to the effect that whoever pursues earthly joys will forever be disappointed and end up only with a bitter taste.

> The lover, who would fleeting beauty clasp
> Finds bitter fruit, dry leaves are all that he will grasp.[12]

Thus was the risk of concupiscence (erotic desire incited by a sight) before the erotic body sculpted with such virtuosity contained by verbal framing whose significance allows the momentary pleasure afforded by initial vision to be moralized into an appropriately Christian warning. A bit like having one's cake and eating it, perhaps. The verses, however, unequivocally establish the gender and sexual orientation of the presumed addressee, a desiring hetero-sexual man, like Apollo, even while the words are apparently placed in the mouth of Daphne: turning the dangerously desirable woman into the moral-izing mouthpiece. Apollo who longs to kiss will only taste dry, bitter leaves.

Drawing on sources contemporary with the sculpture's creation, which indicate viewing practices that involved animating, even dramatizing, the still sculptures or paintings by mimetic enactment, Warwick writes:

> The visual summoned forth verbal response; the cardinals' social performance before the sculpture in turn gave the marbled figure a voice. Daphne cries out; what does she say? Did the viewers other than Maffeo compose verse for her? Did they declaim the scene, extemporizing Daphne's appeal to her father and his reply, and Apollo's disappointment at her transformation? The sculpture acts upon its audience who variously participate in its enactment: thus it may be called performative.[13]

I agree. For it seems that I spontaneously demonstrated a performative res-ponse to what I saw, but not with clever words and an imagined script to contain a theologically troubling nudity.

I gasped. I take that response to suggest that at some level of what the sculpture offers to a viewer, this 'she' is gasping, not speaking well-turned lines to deflect the masculine erotic gaze towards disappointment registered by Apollo's mouth dropping slightly – 'What the...???' – in defeat.

Some scholars believe that in its original installation in the Villa Borghese in 1625, the viewing point was less ambiguous. They think the work was originally positioned not in the centre of the room it currently occupies, free standing, but against a wall from which it could be viewed by three different entrances to the room. Rudolph Wittkower argues that Bernini's sculpture is betrayed by its current free-standing display. Renaissance theory argued that the drama of a theme, the climax of the action, could be read from only one position. The Mannerists contested this with multiple viewpoints. Wittkower places Bernini as combining both single-viewpoint theory and the new Mannerist freedom so as to create a new conception of sculpture encompassing a viewpoint with transitoriness and energy. The effect was to make the beholder an emotional participant in the spectacle before his eyes which was focused, however, on the stages of *Apollo's* experience.[14]

Joy Kenseth contests Wittkower's argument, showing that even its expon-ents cannot agree on what was in fact the single aspect of Bernini's Villa

Borghese statues including that of *Apollo*. Kenseth insists that Bernini did not intend to have the meanings of these statues revealed in a sudden or dramatic moment.[15] Drawing on two early guidebooks to the Villa Borghese that had generally been overlooked by art historians attempting to establish the original installation of Bernini's sculptures, Kenseth suggests that the sculptures were positioned so as to draw the viewer through a passage or an arc of about 180° that traversed the sculpture starting with an encounter with the rear view of the god (Plate 2), all fluttering drapery in his swift pursuit of his prey, moving around to experience the chase, the imminent capture and then the dawning realization of what is happening to Daphne that culminates with arriving at the point of seeing Apollo's hand clasping Daphne's abdomen and realizing – hence his facial expression – that he is touching the bark that is moving up swiftly to encase the young woman and to prevent his longed-for possession of her body (Plates 2 and 3). Thus the sculpture would be experienced as a sequence of moments in a narrative that moves from movement to stasis, from traversing space to an arrested immobility, from animation to fixity, all of which, however, serve to establish Apollo as the subject of the experiences being unfolded in space as the visitor moves curiously around the sculpture. My response located the sculpture's *punctum* (Barthes's concept of a traumatic detail catching a specific viewer's attention) in the figure, and indeed the mouth, of *Daphne*.

Ovid, fabula and myth

The topic of Bernini's sculpture is a complex and condensed myth retold by the Roman poet Ovid (Publius Ovidius Naso, 43 BCE–17/18 CE) in Book I of his *Metamorphoses* (lines 452–567). In her fascinating re-reading of both Ovid and the trends in contemporary interpretation, *Ovid's Lovers: Desire, Difference and the Poetic Imagination*, classicist Victoria Rimmel identifies two key strands in Ovid: rape and specularization, the two often linked as it seems a particular kind of scopophilia lies at the source of the rapishly uncontrolled desire.[16] All of Ovid's key works, Rimmel argues, 'open with acts of rape.'[17]

The story of Apollo and Daphne is strategically placed early on following the stories of the origin of the cosmos, the re-creation of humans by Deucalion and Pyrrha from stones, and the slaying of a vast serpent-monster, Python, by Apollo. Andrea Bolland considers the Daphne episode a mere digression from this grand narrative, inserted to explain the origins of Apollo's attribute: the crown of laurel (*Daphne* being the Greek for laurel).[18] Yves Giraud's analysis of the myth, however, discovers a much deeper significance.[19] But first let me lay out the Ovidian version.

The sun god Phoebus-Apollo, having gloriously vanquished the vast, earth-covering serpent Python (already referencing a cosmic conflict between

earth and sky), meets up with Cupid who is playing with arrows, Apollo's favoured weapon.[20] The bigger god scorns Cupid's puny strength. Affronted, Cupid decides to take revenge. He shoots two arrows. One is sharp and golden and instantaneously incites love (desire, lust); the other is blunt and leaden, causing an equally powerful but negative retreat from love (sex, desire). The leaden arrow strikes a young nymph, daughter of the river god Peneus, who has already expressed the queer desire to be free of men, in honour of the huntress Diana (quaintly translated in most texts as the desire for perpetual virginity!). The golden arrow strikes Apollo, who is smitten with love for the uninterested Daphne who has scorned heterosexual love and its womanly submission. 'Phoebus [Apollo] loves Daphne *at sight* and longs to wed her' (490). Sight is now the virtual arrow of desire seeking to pierce the woman. Endlessly gazing at her, longing to bind her free-flowing maidenly hair into nuptial order, Apollo initially pursues Daphne with poetry and music. Then in frustration he *hunts* her with violence in mind. He almost catches up with her, getting so close as to breathe upon her flowing locks streaming behind as she swiftly seeks to escape. As she feels herself about to be overtaken and raped, Daphne calls out to her father, Peneus, and her unnamed mother – 'O mother earth' – to save her by destroying the beauty that drives her pursuer to hunt her. Peneus then transforms the fleet-footed maiden into a laurel tree who becomes fixed and wooden. She is still beloved enough for Apollo to take the leaves of the laurel for his crown and as the reward for all poets. Poetry flourishes on the trace of the destroyed woman.

Yves Giraud undertakes a structural analysis of the myth focusing, however, not on Apollo but on Daphne, identifying the key moments in the myth's structure. Myth is a complex of conflicted or contradictory elements undergoing transformation. These elements, *mythemes*, are represented by moments that can appear as scenes in narrative, some of which must be incorporated by Bernini sculpture into either *the* single, climatic monument or into a narrative passage that at once condenses the story and allegorizes the elements that myth struggles to resolve. Mythos intervenes to deal with what reason, logos, cannot explain. It often does so in a fabulous manner. Myth is, however, at root a fable of the tensions in culture, translating into stories the rules of conduct of a social group or a cultural formation. Both are themselves derived from even more ancient moments when culture was instituted by means of the sacred, understood as attempting to negotiate, on a human plane, the hinge between life and meaning: namely how we survive the exigencies of daily and species reproduction and do so under forms that symbolically make sense of the conditions of life which we do not understand or cannot control.

Transformation – metamorphoses – are central to mythopoetics. Indeed the latter exists to manage a means of understanding both the dynamics of cultural formation and their sometimes radical rupture. Thus myth presents

many instances of animate beings undergoing transformations into vegetal forms, the better to release their symbolic significance. Giraud argues that among the many forms of metamorphosis those into vegetal forms are among the most culturally significant for they signify, in mythic terms, fusion between two natures stretched across the living and the immortal. Transformation thus often signifies both death and resurrection. In this domain, the tree is one of the most telling and persistent elements. It is often, interestingly, a feminine figure. The tree is particularly significant in pre-Christian Mediterranean and European cultures linked with the sacred from the most archaic times, notably the non-decipherous trees like laurel, myrtle, lotus and pine.[21]

In Ovid, Giraud notes, there are twenty-two episodes of metamorphosis into the vegetal category. He suggests that they are linked to the most ancient of legends and represent the most archaic forms of religion. The Daphne myth appears in Greece in the second part of the third century BCE, carrying into Greek culture even more ancient Egyptian and Eastern components. Via the Sanskrit origins of the name-word, Daphne is linked with solar cults. I will come back to this dimension that sets up a contest between two solar beings, Daphne and Apollo, representing two different cultures, but first we need to consider Giraud's analysis of Ovid's version of this mythic material, which was the version in circulation in Italian culture since the fifteenth century. Girard identifies six elements in the Ovidian story:

> **I The Exposition:** Daphne's hatred of men/Apollo's offending of Cupid: problems with love; Apollo, full of himself having killed Python, mocks the tiny Cupid for his apparently puny weapons. Cupid decides to teach Apollo a lesson.
> **II The Knot**: Cupid shoots two arrows: one gold and pointed, hot and burning, the other blunt, leaden and frigidifying. The arrow of desire is scopophiliac: *Hot* Apollo loves Daphne because she is beautiful exhibiting the wild allure of an uncultivated, nature-dwelling huntress. Daphne is made *cold* and resistant.
> **III The Exhortation**: Apollo tries to win Daphne with poetry.
> **IV The Pursuit**: metaphor of hound and hare. When exhausted Daphne calls out to her father and mother to save her from the beauty of her form that draws on these unwanted divine attentions.
> **V The Metamorphosis:** First, she is immobilized. Secondly, every element of her body is to be transformed into a tree.
> **VI The Epilogue**: Apollo embraces the tree, feeling its still beating heart beneath the bark and takes its leaves for a coronet for his own head and those who will replay his victory over Python during the Pythic games celebrated at Delphi.[22]

The sculpture by Bernini, dynamic as it is, handles only **IV** *The Pursuit* and **V** *The Metamorphosis*. We can assume that the elite viewers of the work

in seventeenth-century Rome would supplement what they saw with the back-story and that the added cartouche brought in **VI** *The Epilogue* verbally. But if myth is a system by means of which contradictions are fictively resolved, is this sculpture mythic or could it be read as anti-mythic, undoing its mytho-poetic purpose?

In noting the counterpoints of touch and vision in Bernini's sculptural solution, Andrea Bolland notes, however, that Bernini has added an element not to be found in Ovid.[23] 'Daphne turns her head and gazes back toward her would-be captor even as she begins to turn into a new substance, the laurel.'[24] This gesture radically reformulates the pre-textual source and poten-tially subjectifies the eroticized object. The specific configuration of her face as it turns back suggests a calling out that invokes others not included in the sculptural group, not only supposed by the myth, but present whenever the sculpture is viewed. The sculpture acquires a perpetual presentness in any encounter with it. If Bolland thus endows *Daphne* with a gaze, I also respond to its voice: a sound of subjectivity.

Freud's dark continent or the deep space of memory

I gasped when before the open mouth of *Daphne*. Shockingly, I felt as if I were falling down an astonishing dark hole excavated from the solid block of stone. This opened a chain of associations. I thought of Freud's founding 'dream of Irma's injection' that involves his peering down a woman's throat and which, according to Shoshana Felman, is the dream that gave birth to psycho-analysis.[25] In *The Interpretation of Dreams*, Freud analyses his own specimen dream about a woman patient (Emma Eckstein) who had been mistreated by his idealized colleague Fliess and almost bled to death. The dream is described:

> [She] looked pale and puffy. I thought to myself that after all I must be missing some organic trouble. I took her to the window and looked down her throat, and she showed signs of recalcitrance, like women with artificial dentures. I thought to myself that there was really no need for her to do that. – She then opened her mouth properly and on the right I found a big white patch; at another place I saw extensive whitish grey scabs upon some remarkable curly structures which were evidently modelled on the turbinal bones of the nose.[26]

As he works through the dream, it becomes clear that the woman in the dream is not one person, but in fact is a condensation of several women including his own, then pregnant wife, Marthe. But Freud finally declares there is a point beyond which he could not, or would not analyse further. Tellingly, he called it the navel of the dream. Exploration of female corporeal interiority – visually peering into her body via her opened mouth (which cannot but displace a more vaginal curiosity) – reveals a medical investigation that sublimates

the infantile erotics of research into the sexual difference of the generative feminine body. This curiosity, however, meets a blockage beyond which Freud will not proceed in his analysis. His closing down of the investigative chain is linked with the question of human origins in sexual difference, in maternal femininity which has had to be transformed into an *invisible* enigma – the dark continent – for masculine subjectivity.

I ask myself, therefore, would I also experience an invocation of feminine sexual interiority (via the oral displacement of the generative and sexual) as the impenetrable, unknowable, darkest core of unconscious meaning? Might the fact that as a subject 'in the feminine', I might have access to different forms of phantasy about and real relations to feminine sexual interiority that would render any visual evocation not at all 'frightening', render it even voluptuous, even if feminine sexual corporality remains difficult to imagine and to image because it is not a matter purely of canals and organs, but of a repeatable memory of the co-emergence, and subjectivizing severality of the prenatal/prematernal joint subjectivizing encounter that Bracha Ettinger has named the Matrixial dimension of subjectivity.[27] So using my own physiological register of a deeply disturbed response to the sight of Bernini's figuration of *Daphne*'s open mouth, I suggest we need to push the question once again: what is *Daphne* doing?

In the story, Daphne is a woman fleeing rape. In the sculpture, Daphne is a woman dying before our eyes. She is thus a woman caught between two equally traumatic fates. She can be raped or she can cease to exist as a living woman. Both options seem to me to be but two sides of one phallocentric coin. The trap sets in motion another chain of associations back to Freud's case study of a young woman he named 'Dora'. Ida Bauer was a young woman who also felt herself caught within a modern scenario of two or three men's games that stifled her desires, or left them no space to emerge. Freud argued that, when an older man made an unanticipated sexual advance, not at all unimaginable as desirable, 'Dora' reacted *hysterically* rather than *erotically*, by displacing to her throat the memory of a man with an erection pressing against her abdomen. Hysterically regressing to infantile orality, she developed difficulties with swallowing and a perpetual cough, as well as becoming suicidal.[28] My gasp, miming the sculpture's opened space, might also, therefore, have been a hysterically mimetic reading that registered the virtual fear of sexual assault in a similar traumatic displacement. In a Freudian vein, but reversing the gender of the symptomatic relocation to the man who made the sculpture for men who would view it, we could as easily read the cavity carved into Daphne's face as the unconscious, but not hysterical, displacement upward from the now igneously sealed female genitals: the desired space of entry by the rapishly phallic pursuer with whose frustrated desire for touch and penetration the supposed masculine viewer might be imagined virtually

to identify.[29] We could easily invoke the blow-up dolls that function as sexual aids whose key feature is not a penetrable vagina so much as an open mouth to relocate the erotics of this sign to contemporary sex toys. Such transpositions also bring to mind an art historical reference equally imbued with Freudian transposition, Caravaggio's gasping *Medusa* (Figure 3).

If Bernini's sculpture registers visually a heterosexual masculine unconscious, safely veiled by a classical narrative of an ancient myth that identifies ultimately with the rapist, does its field of meaning shift if I, a feminist viewer, spontaneously identify with and then read the gasping mouth as a visual sign of intense pathos/passion 'in the feminine'?

In her keen reading of rape as a prevalent cultural trope in Western art and culture, Mieke Bal also advocates a reading that enters via such a disturbing detail. She names the method needed to deal both with the trauma of rape, itself unspeakable, and the unspokenness of women's experience, *hysterics*. 'What kind of semiotic do we need to apply in order to read the unsaid, to recover the repressed, to interpret the distorting sign of unspeakable experience ... Such a poetics is a hysterics.'[30] What Bal proposes is a process of reading artworks not for the plot, but for the image, not for the main line of the narrative, but for the detail, not for the hero, but for the victim. This is an act that undoes the violence not only of the scenes we are asked to witness in art and literature, but challenges the rhetoric in which that violence is occluded in art historical or literary writing that aestheticizes the artwork. The source of counter-reading is, then, a reasoned and acknowledged interpretation taking place in the *present* of *identification*.

Thus the opened mouth of Daphne seems to me to be art historically (*studium*) as well as psychologically (*punctum*) traumatic. The sculptor has literally had to carve deeply into the marble to excavate a possibility of the mouth and the throat from which the virtual sound emanates. The throat is the necessary space for gasping or crying out; it formally suggests physical interiority and metaphorically creates psychological interiority for this figure. Bernini invented, therefore, the visual space for the unheard sound of *her* subjectivity.

On the other hand, assisted by a Freudian interpretation, this opening performs as a displaced sexual space and opens a potential entry into her trapped body as well as suggesting oral forms of sexual penetration or pleasuring. Two economies, therefore, collide for me at that shocking vision of the opened sculpted body of a distressed woman: the image of woman as captured sexual space for a heterosexual masculine other, and the image of woman as 'the site of her own proceedings', sounding out her subjectivity under traumatic duress, calling to her culture for another destiny than the two offered her by the myth: rape or non-death.[31]

Joined by women: contemporary artistic transformations of myth

Does Daphne have an after-life, or generate after-images in the Virtual Feminist Museum? In his *Mnemosyne-Atlas*, Warburg created a series of canvas screens onto which he hung photographs of images through whose juxtaposition he wanted to trace the uncanny movement and persistence of certain formal tropes that encoded and transmitted affect – the *pathos formulae* – the formulations of intensity of pain and passion through time and across cultures (Figure 4). Only by bringing many images into conversation, or neighbourliness across time, thus defying classification by periodization and national school, would this deep track of cultural memory disclose itself. The point was to see in the repetition not merely iconographic types, but the knot of repeating anxiety and passion carried by a *pathos formula* travelling as a memory-bearer that was variously reclaimed and reworked because what it did was needed by later cultures. Having collected as many images as I could of the Apollo and Daphne myth in Western painting and sculpture down the ages, I found few artistic resolutions of the complex materials that held much interest until I shifted from the literal imaging into configurations of the mythic material by modern and contemporary artists. Tracing the formula of open-mouthed anguish, I fell upon like Picasso's screaming women in *Guernica* (1937, Madrid, Museo Reina Sofia), or even Francis Bacon's *Study after Velasquez' Portrait of Innocent X* (1953, Des Moines Art Center, Iowa). But what of Daphne's other meanings?

French art historian Anne Creissels first drew my attention to the resur-facing of myth in contemporary art by women in the twentieth century and to the potential for reading the work of Cuban-born and American-educated artist Ana Mendieta (1948–1985) in relation to the Daphne myth in particular.[32] In a photograph (hence an after-image) of a performance by Ana Mendieta, in her *Silhueta* series in Mexico in 1973 (Figure 5), blossoming foliage appears to sprout from, or at least lie upon, the naked body of a woman, linking, in some intimate form, organic vegetation and a human being. The woman's body lies in a formal pose, on her back, hands at her sides, legs together. It has a ritual quality. It is the posture of death. She lies in the cavity of what might be called a stone tomb. It might also suggest the opening of the rocky earth to receive and take back the body. Although its lack of movement connects the laid-out body with death and burial, a return to the earth after death, the freshly sprouting branches which lightly cover the still vividly coloured body suggest, on the other hand, regeneration, that might lead us to link it across the imaginary museum of images with a previous performance work by Swiss surrealist Meret Oppenheim titled *Spring Banquet* which was staged in 1959 in Bern, and again in Paris. In that event, a gilded, but naked living model lay upon a table; she was covered with fresh fruits and vegetables. Three places

were set and three diners were solicited to eat from this banquet of fruity woman.

By means of conjugating richly resonant motifs and elements, Mendieta's work obliges us to name the symbolic axes on which the performance is enacted: life and death, death and regeneration, burial and seeding, human form and vegetal process. These oscillating combinations and oppositions we encounter, however, by means of a single, static, photographic documentation of an artistic process that once was an action in time, but which is now invisible and lost: namely what was phenomenologically experienced over time in the persona and body of the performing artist, as she moved, metamorphosed from standing to lying, from being clothed to nakedness, from being uncovered to being overlaid with flowering branches. We, the viewers, cannot access that experience. We are presented with an after-image. Do we also thereby get an after-affect? Regarding the 'pathos' of this dramatic self-positioning between a willing return to the earth and the attempted enactment through such intimate identification with the symbolically freighted elements of the natural world that were once the core language of an archaic, or shall we say mythic, human understanding of human self and non-human – dying and persisting – other, can it produce in us something more than intellectual recognition, art historical interpretation, as we do this work of associative deduction and genealogical tracing?

In two other performances by Mendieta, similar procedures occur of placing the artist's own body in physically transformed intimacy with a natural object that is at the same time a mythic – potentially sacred – other: a tree (Figure 6). The pose, of course, repeats that associated with the ancient female goddesses of the Mediterranean, pre-classical world, of Minoan culture for instance, where the bare-breasted priestess-goddess holds both hands aloft, and holds, in each hand, another image linking the earth and regeneration: serpents. Yet another cultural memory begins to surface here in the repetition of the arboreal identification of a woman and a tree – with very different connotations in each case. In two other images from this series of *Silhueta/ Silhouettes* performed 1973–78 in various remote spots around Iowa whither the artist had been sent as a child from post-revolutionary Cuba, a different strategy appears, in which the evocation of the female body is created by means of using either bent twigs, again placed against stone, or flowering plants placed as if the ghostly outline of a standing figure against a tree in a verdant setting, green with returning life (Plate 4).

Across time, Mendieta's works curve time to call to *Primavera* (1482) by the Florentine Sandro Botticelli (Figure 7), a work that Aby Warburg convincingly argued should be known as the *Realm of Venus*.[33] Venus is the Zodiacal sign for Spring and thus, in an astrological imaginary, the goddess is associated with both death and rebirth (Freud also suggested in his analysis of the silence

of Venus in the infamous Judgement of Paris).[34] Aby Warburg elaborated his method of iconological analysis by interpreting contradictory elements at work in Botticelli's painting that drew its novel visual vocabulary from the learnèd revival of Latin poetics, led by the Renaissance scholar Poliziano (1454–94) at the court of Lorenzo de Medici in fifteenth-century Florence in which metaphors of movement, such as running figures or agitated accoutrements, signify emotional forces that animate traumatized subjectivity. Far from simply using his erudition to establish a link between Botticelli's painting's recondite Neoplatonic symbolism and an intellectual revival of pagan antiquity in a Christian culture in process of radical self-transformation, Warburg identified the *work* performed by Botticelli's puzzling painting as akin to Freud's *Trauerarbeit:* the *work of mourning.* In 1476, the much admired Simonetta Vespucci, beloved by Giuliano de Medici, the younger brother of Lorenzo de Medici, had died aged only twenty-two and was mourned by the entire court. Botticelli's painting was painted six years later, but it addresses her loss. The painting evokes and transforms the trauma of bereavement.

> It may be – and this is offered by way of hypothesis – that to Lorenzo and his friends, the *image* of the *personified* spring, the companion of Venus, who recalls the earth to life, the consolatory personification of renewal, represented the *memory* of 'la bella Simonetta'.[35]

Warburg indicates how a pagan imaginary with its different ways of mythopoetically thinking regeneration and resurrection shifted a Christian imaginary. Within Christianity, the tree becomes the masculinized Cross and the man-god the sole figure of resurrection, overlaying the ancient associations of trees with feminine generative life that Giraud has suggested were elements of archaic ways of negotiating the problem presented to human thought by finitude and mortality. For Warburg, Botticelli's paganized image – made evocative and emotively affecting by means of its vividly visual and animated personification of processes of life after death – dramatically performed a consolatory function, assisting in the subjective passage from grief for a beloved woman to the sad acceptance of that person via an image into memory. In this sense, the *after-image* of the much beloved and prematurely dead Simonetta Vespucci – for it is she who appears as the figure Warburg identified as Spring/Flora (Figure 8) – produces an *after-affect* that enables and figures a process of mourning in the face of loss. This image is a *pathos formula:* an affect, that Julia Kristeva defines for us as 'psychic representations of energy displacements caused by external or internal traumas'. Sadness, for Kristeva, is such an affect.[36]

Warburg sought to understand the affectivity of the image as a cultural bearer of bodily encoded memory of traumatic intensities. He proposed an *iconology of the interval,* a method for tracing a dimension of the image that is more than its semantic aspect. It concerns its affect that flows around the

image within and beyond its function as a symbol. Affect can be inscribed formally as a vibration of the sign that renders the sign itself generative of meaning. The image is thus a space for giving us access to this interval that lies between but also holds in tension both symbolic and affective registers. That is why we make images – to produce and hold open that interval, at once being structured and touching on what lies beyond the logos.

The iconology of the interval – *Zwischenraum* – is a method of tracing that which occurs in art beyond its signifying capacity that we can decode through the affective capacities to which we respond with a complex weave of psychological memories and physical gestures. The *Zwischenraum* – literally the space between spaces – attained by aesthetic processes, means an interval lying between the inchoate, unarticulated pressure of feeling, affect or trauma and the mastering of symbolically articulated understanding, necessary to the transformation of overwhelming affect into knowledge and memory. In that passage, nonetheless, something of the originary *jouissance*, the painful yet pleasurable intensity of affect on the verge of becoming a known and knowable emotion, is lost, *for our own safety*, without being suppressed entirely. The aesthetic affect in art practice was this sense of a *Zwischenraum* between the known and unknown, the said and the not-said, that betrays and transports a psychic, or psychological freight that Warburg felt contemporary, mortifyingly intellectual or formalist art history not only failed to register but dangerously refused to acknowledge. He regretted that its studiousness substituted for this dimension of the image at work the more comfortable but mythic projection of the *idea* or personality of the artist as the mystical cause of the 'magic' surplus that is art. In the hands of his followers, iconography thus became a placid, humanizing activity losing the force of Warburg's darker, deeper vision that was closer to Freud's more fractured, divided and disturbing sense of subjectivity's perpetual conflicts and our dangerous passions.

Warburg's challenge to us today is, therefore, to plait together the sense of historical specificity in the making and reception of artworks with the anthropological mythopoetic dimension, itself feeding into the modern psychoanalytical and cultural sense of more persistent structural tendencies in human cultures, despite their myriad historical diversities and constant changes. It is not an either/or situation, either historical and hence semiotic specificity or structural, ahistorical psycho-poetic generality. Psychoanalysis and art historical study are not opposites. The nature of the art as image demands their intersection and mutual challenge.

Thus Creissels's suggestion that we might use myth to explore contemporary works by women artists embedded in specific historical and cultural situations does not lead me to collapse the temporal and historical difference between Mendieta and Botticelli. The Virtual Feminist Museum becomes its own *Zwischenraum* or space in which to hold difference in view while allowing

the conversation to reveal shared levels of deeper persistence in the icono-logical and aesthetic work of the image. Far from explaining art by inventing from it a 'Bernini' or a 'Mendieta' or a 'Botticelli' to contain the after-affect of the after-image as genius or as victimage, Warburg struggled to trace through precise and close readings of specific works what he called the *Zwischenraum* 'in which the incessant symbolic work of social memory is carried out'.[37]

For Warburg, the artistic character he discerned in Botticelli's work involved a natural disposition to paint stilled and melancholic figures. In some of his paintings, however, we see uncharacteristic animation in the flowing draperies of several figures who themselves are in movement of pursuit, flight or dance. The still centre of the so-called *Primavera* is the Queen of Love, Death and Renewal (Figure 8). In Botticellian fashion, Venus stands motionless and melancholic in the centre as death, flanked, however by the dancing figures of the *Three Graces*, who are also archaically associated with the passage across the threshold between life and death.[38] On the right hand side of the painting, however, there is a much more violent, rapish scene: Zephyr is pursuing and has caught Chloris who is being transformed into a third figure, the tripping Flora (Figure 8). (This is an instance of a metamorphosis in which the raped woman is rewarded with perpetual life. Flora is, according to Warburg, then the cipher for the mourned Simonetta re-emerging as an image of constant regeneration.) The couple of Zephyr with his forward movement and intent gaze of determined capture and the backward glance of the captured Chloris, arrested in her forward flight, has strong resonances with the formulation for *Apollo and Daphne* upon which Bernini would settle. Chloris' mouth is also opened in fright, but it emits the trail of flowers into which she will be trans-formed in the personification of the dancing Flora. It is as if her metamor-phosis erupts from within. Her opened eyes register her horror as she is being literally engulfed in the air blown from the mouth of her pursuer (Figure 9).

According to Creissels, the oeuvre of Mendieta also traces an internal shift from an early focus on rape and violence to later work binding her own body with trees and other natural elements that bridge death and regeneration. She replays Chloris to Flora. Mendieta had herself addressed the topic of rape in a profoundly anti-mythic mode in one of her earliest performances, where she invited her visitors to her own apartment. On entering the visitors encoun-tered her bloodied body draped across a kitchen table in the position of a victim of anal rape.[39] She created a traumatizing encounter for her viewers through presenting her own apparently wounded and violated body in order to make them experience as vivid and shocking the fact of rape. This is the violent aspect of Mendieta's Daphne association made explicit while later *Silhueta* works draw more life-enhancing meanings from her identification with regenerative and long-suffering igneous nature. Creissels plots out a passage from the early themes of sacrifice and violation associated with rape

and animalization in Mendieta's evocation of the myth of Leda and the Swan to the safety of virginity and vegetalization in the myth of Apollo and Daphne that she suggests underlies the *Silhueta* series. Yet I want to draw out from her use of the Daphne myth an opposite trajectory. Any dreams of safety offered by being turned into a natural form, a tree, are shattered by the eruption of rapish violence, because becoming a natural form, a tree, is in effect, in the Daphne myth, just another form of being murdered.[40]

Mendieta's work is usually interpreted by art historians as referencing her experience of exile from her Cuban homeland which explains her longing to be reunited with a mother-earth from which she was untimely ripped by the Cuban Revolution and the subsequent dispatch by her parents to live, along with her older sister, in the United States in Catholic foster families. Other interpretations suggest that Mendieta's invocation of various religious cultures demonstrates her engagement with an American feminist tendency during the 1970s that nostalgically resurrected ancient cults of the earth or mother Goddess as symptoms of women's generic sense of exile in patriarchal cultures and the active reclamation of a counter-iconography of the Earth-Goddess. Finally some see Mendieta's work performing rituals of reconnection and re-identification in which the political fall-out of a socialist revolution on a Catholic middle-class Cuban family is lived and comes to be represented by its suffering subject in deeply mythical terms drawn from African-derived syncretic traces of Yoruba and other religious myth systems present in Latin American culture.

Such terms exceed the personal and pre-exist the person. I suggest knowing of these varied resources enables us to read in Mendieta's practice the effects of the symbolic means by which the otherwise inexpressible sense of loss and need for reinstallation 'in the world' could be articulated into a form, as in Botticelli's painting, that is capable of consoling in the face of loss. This means transforming the inner world traumatized by unspeakable loss (exile from family, language, homeland) into an aesthetically performed action that permits identification with both a sense of being dead and a concurrent one of still being or coming alive. Through performance as a visual art ritual, enacting in the body of the artist a newly created *pathos formula*, some dimensions of encrypted psychological wounding could be shifted in the register of transformation and renewal of connection with life. They could be contained by and signified through aesthetic inscription that also opened up an interval between affect and sign that is the space for psychic play, for affective *movement*, for the transformation of potentially petrified, traumatic affect.

By placing Mendieta's mid-1970s conjugation of the archetypal body linked with the entombing earth and regenerative nature's vegetal, recurrent liveliness, and with the tree in particular, in conversation with Florentine Botticelli's uncharacteristic mourning painting *Primavera*, I perform a Warburgian

move to see the persistence and recurrence of the motifs or visual formulae that symbolically encode the once phenomenological memory of intense affect in actions and gestures in the supplementary behaviours of agitated, animated accessories: *bewegte Beiwerke*. In Botticelli's moment of artmaking, these remain on the representational level of the painted image. In Mendieta's twentieth-century, post-catastrophic moment, the performative body registered by mechanical photo-reproduction becomes both agent and site. Images bearing memories are re-animated by the needs of certain artists and cultures for such modes of expression, notably in face of trauma, at different epochs, which nonetheless share certain existential human anxieties around life, death and loss.

What Mendieta and Botticelli share is, therefore, a form of *artworking*. The common ground between Botticelli as read by Warburg, and Mendieta as read by Creissels, is the evocation of a mythic dimension in the process of such aesthetic working: a cultural form already encoding primary anxiety through symbolic interpretation, itself undergoing repeated interpretations by the ever more rhetorically refined modes of poetic translation and aesthetic refashioning.[41]

Into the conversation between Botticelli and Mendieta, the Virtual Feminist Museum introduces American photographer Anne Brigman (1869–1950), a member of the select Photo-Secession founded by Alfred Stieglitz in the early twentieth century in New York to foster understanding of photography as an art. A subtly unfocused photographic image from 1911 presents us with an intimate juxtaposition of a female body and a blasted tree against whose dynamic lines and outstretched branches the vulnerably naked woman nestles, her own body almost merging by means of the pictorialist manipulation of the photographic processing with its writhing forms. Brigman's work was reproduced in his important photography journal *Camerawork*. It bears the puzzling title *Via Dolorosa* which is associated in Christian narrative with Christ carrying his 'tree', the cross (Figure 10).[42] Other images taken in the Californian desert by Brigman repeat this placement of the photographer's own body against trees such as *The Soul Of The Blasted Pine* (Figure 11). The photographs not only remind us of the power of the figure of the tree in the modernist poetic and artistic imagination, but bring to mind, perhaps, the ancient association of trees and feminine forms produced by dramatic metamorphoses, such as we encounter in the story of Daphne and Apollo. Female nudity, soft skin stretched over its bony architecture repeats but also contrasts with the solid exoskeletal verticality of the tree as Ur-figure of verticality and up-reach from the earth, and the roughness of its encasing bark. This contrast is the imaginative essence of the myth of Daphne's dual identity as soft desired, and living flesh and safely encased woodiness. The duality is explored here by Brigman without the violent threat of masculine lust, and as

the artistic elaboration of a singular and feminine imagining of a relation to the natural world as both other and 'm/Other' (the matrixial phrasing created by Bracha Ettinger to signal not the Mother, but the archaic, unknown, feminine other with whom human life co-emerges).

Bernini's mouths

It was before a carved mouth I gasped. Bernini used the mouth expressively all his career. For Cardinal Scipione Borghese, Bernini had sculpted another classical rape, *Pluto's Rape of Proserpine*, which shows the opposition of violence and terror, the one encoded in the masculine body's strength and hands plunging into the soft flesh of the captive woman; the other signalled in the violent pressure of Proserpine's resisting hand against Pluto's incoming head and the tears that streak her appalled and tragic face (Figure 12a). Compared to Proserpine's grief, the face of Daphne, however, is far more active and energised (Figure 1). At the other end of his career Bernini created the ecstatic face of the swooning Saint Teresa for the Cornaro Chapel ensemble in 1647–52 (Figure 12b). But, in contrast to the open-mouthed figure of *Daphne*, the mouth of St Teresa falls passively open, clearly to emit a sigh so radically different from Daphne's gasping, crying or calling.

Daphne is a much deeper mythical subject than any image of Christian ecstasy. As I have mentioned already, Yves Giraud places the myth of Apollo and Daphne with the twenty-two episodes in Ovid of vegetable metamorphosis which are linked most closely to the most ancient myths and the most archaic origins of and forms of religious rite.[43] The tree is a female figuration linked to the later personification as nymphs who then come to dwell in the forests. *Daphne* is more importantly linked linguistically to solar cults and crises over domination. Her name's origin in Sanskrit is connected to words that give us 'burning' and 'dawning'. Thus, we might interpret the myth as follows: Aurora/Daphne/Becoming Light is burned by the Sun/Apollo/Light. The myth functions as a dramatization not only of a binary displacement of older chthonic, female-centred cults by the solar cult of Apollo, but also of a competition between two solar – light as generative – cults differentially gendered.

This shift is clearest in the Arcadian version of the myth. There, Daphne is the daughter of Ladon–Sea–and Ge–Earth. Like Diana, Daphne's intense misogamy (hatred of marriage) links with other stories of huntresses such as Atalanta, Callisto and Arethusa who may well have been subjects of same-sex desire, but also function as figures of feminine resistance to possessive, heterosexual patriarchy. In the Arcadian version, Daphne calls out to her mother to be saved and Ge symbolically (re-)opens a crevice in the earth (mother's body) into which Daphne disappears; a laurel tree grows to mark the umbilical space.

This is evocative of Mendieta's imaginary enactments of return, burial, substitution and rebirth. Ladon is also known as Oceanus, and thus Daphne appears to be a primal child of the cosmic union of water (Oceanus) of and earth (Ge).

The Thessalian version appearing in Ovid removes all traces of the earth mother and makes Daphne the daughter of Peneus, a tame river god running though the valley of Tempe, close to Delphi. Delphi was archaically the sanctuary of Gaia, and Python was her servant. Apollo's victory over Python mythically represents a violent displacement of that earth-mother cult with a sky-god cult. Ovid's version of the story is entirely centred on Apollo, fresh from his victory over Python, the snake that emerges out of the post-Deluge ooze, the symbolically-freighted snake later tracked with such fascination by Warburg in his lecture of the Serpent Ritual, the snake that links us back to issues of life and death, resurrection and transformation in so many world cultures.[44] Thus the ancient elements register a long-term displacement of the original worship at Delphi of Gaia with the chthonic emissary the serpent, Python, whose funerary monument is the Omphalos. The later Alexandrines and Anacreontic poets represent the transformation in Ovid's treatment of such seismic cultural shifts by relocating them pathetically in the field of love and sexual difference at the intersubjective and gendered level, thus losing or veiling the historic cultural rupture and eroticizing its political violence.

The Ovidian writing of the myth thus diminishes and even eradicates the ancient Daphne, freighted with archaic associations of life, death and regeneration. She is replaced by a laurel tree that becomes a signifier of Apollonian victory. She is not eaten but is otherwise assimilated to a patriarchal imaginary and symbolic. That is why rape is a murder, an effacement of subjectivity and a form of dehumanizing horror. Apollo, from his dynamic positioning in the sculpture (Plate 2) to the representation of his face as a moment of set-back, reflection and transformation of his emotions (Plate 3) is the official, preferred *subject* of Bernini's sculpture, when Bernini is being entirely true to the Ovidian reformulation of the myth and its cultured reception in seventeenth-century Counter-Reformatory Rome. But in its visual telling, and the possibility of our movement, physical and imaginative, around its complex intertwining forms as created by Bernini, I suggest that in this sculpture as a *pathos formula, Daphne* generates for some viewers a counter-subjectivity that we can encounter, that we can desire to hear, that I am tracing from my own body back to hers. That counter-subjectivity inheres in sound.

Far from merely gasping in horror, I now find, in another photographic angle, a powerful sense of a voice. It then seems highly significant that the first European opera of modern times dating from 1598 was in fact, *Daphne* with music composed by Jacopo Peri and a libretto by Ottavio Rinuccini.[45] Perhaps, in the light of that Rinuccini and Peri opera whose subject was Daphne's cry and call, we might conclude that Bernini's Daphne is, in fact,

singing (Figure 13). Opera was born at the beginning of modern culture in the late sixteenth and early seventeenth century. As American comedian Ed Gardner once pithily declared: 'Opera is when a guy gets stabbed in the back, and, instead of bleeding, sings'. Death is usually associated with silence; but modern opera, contemporary with Bernini's agitating sculpture, gave voice and time to even mortal pathos.

What art form but opera could convey the sounds of subjectivity better than the unique combination of sound, gesture, performance and music shaped by the renewal of pagan antiquity at the turn of the seventeenth century?[46] Before such singing of emotion, did the mouth ever open aesthetically to allow the voice its own register of affect in relation to a face intense with emotion so that the beauty created is not scopophilic but empathic? In Bernini's work a woman dies as she is being remade as a tree, stifling the very life the archaic feminine association with trees had symbolized. Placing it in an expanded, feminist atlas of visual memory, I finally confront the difference between Bernini's rich and ambiguous work, in identification with whose trauma I gasped at the sight of its opened mouth, and the mythically tragic or affirmative identifications by Ana Mendieta and Anne Brigman with the tree of life, claimed as rugged or withstanding, full of fascinating forms and a potential symbol of protective strength lodged in a cycle of life and death, a metaphor for femininity that is not a metamorphosed annihilation of woman.

I gasped at a sculpture that appeared to be gasping. The exerted body seemed opened in horror. But then, narratively, I sensed that the sculpture might in fact show a woman calling out either to her father to be encased and stilled in wood or, more interestingly, to her mother to be reclaimed by the earth in which she would regain refuge. Yet again, she might be shrieking in terror at the threat of imminent rape, crying out against the grasping hand pressing into what remains of her living flesh. Or perhaps, she is but gasping at the horror of the sudden, shocking and rapid metamorphosis of her living human body into vegetable form. Whatever are the multiple registers brilliantly suggested by the sculpture, it either penetrates into or rushes forth from the body, inviting us, on seeing it, to give sound to its momentary institution of subjectivity and, in doing so, to recognize the space that this sculpture potentially created for a specifically feminine subjectivity even within a dominant cultural formation servicing heterosexual masculinity.[47] This is a reparative reading.

A canonical sculpture that officially represents a woman's trauma as a man's momentary defeat is opened to a reparative, feminist-Warburgian reading that will not seal its mouth or fix its meanings in learned historical reconstruction of the intellectual culture or personality of the artist or his commissioners. My gesture is a critique of the conventions of art history by offering the means to do it otherwise. What follows shares the interest in sounds of subjectivity

but also the *mise en scène* that I call the Virtual Feminist Museum in which the reading of artworks plays on multiple levels that have to be enmeshed and put to work in order for their artworking to become visible. The artworkings that form the topics of the following chapters track the intersection of the accumulating, gendered traumas of 'feminine existence' with the exceptional traumas of personally contingent or extreme historical events. If we do not keep this doubled field in view, we will lose the ever urgent relevance of feminist-attentiveness to the mix of gender, ethnic, historical, cultural, linguistic, sexual specificities that shape both art making and art reading, let alone life itself.

Notes

1 See Nicholas Chare and Griselda Pollock (eds), *The Sounds of Subjectivity* (London: Routledge, forthcoming).
2 For a Warburgian reading of the gestures of gasping during 9/11 see Sharon Sliwinski, 'New York Transfixed: Notes on the Expression of Fear', *Review of Education, Pedagogy, and Cultural Studies*, 30:3 (2008), 232–52.
3 Sigmund Freud, 'Beyond the Pleasure Principle' [1920], *Penguin Freud Library*, Vol. 11: *On Metapsychology and the Theory of Psychoanalysis* (Harmondsworth: Penguin, 1984), 299 and 301.
4 Laura S. Brown, 'Not Outside the Range: One Feminist Perspective on Psychic Trauma', in Cathy Caruth (ed.), *Trauma: Explorations in Memory* (Baltimore, MD: Johns Hopkins University Press, 1995), 100–12; In her study of representations of myths and legends of rape in the visual arts, Mieke Bal has argued that rape is both a language and a form of murder; rape may not kill, but it effectively murders the person. 'The goal of rape is the destruction of the victim's subjectivity' and 'the victim internalises the message of annihilation completely'. Mieke Bal, *Reading Rembrandt: Beyond the Word-Image Opposition* (Cambridge and New York: Cambridge University Press, 1991), 91.
5 Mieke Bal, *Quoting Caravaggio: Contemporary Art, Preposterous History* (Chicago: University of Chicago Press, 2001).
6 The phrase is from Genevieve Warwick, 'Speaking Statues: Bernini's *Apollo and Daphne* at the Villa Borghese', *Art History*, 27:3 (2004), 355.
7 John Moore, *A View of Society and Manners in Italy* [1781], 6th edn (London: A. Strahan and T. Cadell, 1795), 440–1.
8 Moore, *A View of Society and Manners in Italy*, 442.
9 Moore, *A View of Society and Manners in Italy*, 444.
10 Moore, *A View of Society and Manners in Italy*, 444.
11 The most comprehensive catalogue of images of the Apollo and Daphne myth in Western visual art was created by Wolfgang Stechow, *Apollo und Daphne* (Leipzig-Berlin 1932; Studien der Bibliothek Warburg, ed. F. Saxl, XXIII; reprinted with appendix, Darmstadt 1965).
12 Paul Préart de Chantelou, *Diary of the Cavalieri Bernini's Visit to France*, ed. Anthony Blunt, trans. Margery Corbett (Princeton: Princeton University Press, 1958), 30; Warwick, 'Speaking Statues', 358–9.

13 Warwick, 'Speaking Statues', 360.

14 Rudolf Wittkower, *Gian Lorenzo Bernini: The Sculptor of the Roman Baroque* (Oxford: Phaidon, 1981), 7. H. Wölfflin, 'Wie Man Skulpturen Aufnehmen Soll [Pt. I]', *Zeitschrift für bildende Kunst* (1896), 224–8.

15 Joy Kenseth, 'Bernini's Borghese Sculptures: Another View', *Art Bulletin*, 63:2 (1981), 191–210, 192.

16 Victoria Rimmel, *Ovid's Lovers: Desire, Difference and the Poetic Imagination* (Cambridge: Cambridge University Press, 2006). I thank Adrian Rifkin for this reference.

17 Rimmel, *Ovid's Lovers*, 13.

18 Andrea Bolland, '*Desiderio* and *Diletto*: Vision, Touch and the Poetics of Bernini's *Apollo and Daphne*', Art Bulletin, 82:2 (2000), 312.

19 Yves Giraud, *La Fable de Daphné* (Geneva: Droz, 1968).

20 Python is generally understood to represent a chthonic representative of the earth Goddess Gaia, the centre of whose cult was at Delphi. She is represented as a serpent. See Jane Harrison, *Themis: A Study of the Social Origins of Greek Religion* (Cambridge: Cambridge University Press, 1912), ch. IX, notably 329.

21 Giraud, *La Fable de Daphné*, 23.

22 Giraud, *La Fable de Daphné*.

23 Bolland, '*Desiderio* and *Diletto*', 312, as are the following phrases I cite.

24 Bolland, '*Desiderio* and *Diletto*', 312.

25 Sigmund Freud, *The Interpretation of Dreams* [1900] *Penguin Freud Library*, Vol. 4 (Harmondsworth: Penguin, 1976), 181–98 *et passim*. For an analysis of this dream see Shoshana Felman, 'Competing Pregnancies: The Dream from which Psychoanalysis Proceeds', *What does a Woman Want: Reading and Sexual Difference* (Baltimore, MD: Johns Hopkins University Press, 1993), 68–120.

26 Freud, *Interpretation of Dreams* [1900], Vol. 4, 181.

27 One of the great debates between Freud and Ernest Jones and Karen Horney arose from the dispute over whether little girls have any phantasmatic sense of their own interior sexual morphology or whether all libidinal sensation derives 'phallically' from penis and clitoris which are so close in small children and the source of immediate auto-eroticism. The Freud-Jones debate was revisited in the 1960s in France around J. Chasseguet-Smirgel's *Sexualité féminine* (1964) and Lacan's rereading of Freud in *Ecrits* (1966). For a fine reading see Michèle Montrelay, 'Inquiry into Femininity', *m/f*, no.1 (1978), 83–102.

28 This formulation is derived from the insights of Monique Ménard-David, *Hysteria from Freud to Lacan: Body and Language in Psychoanalysis,* trans. Catherine Porter (Ithaca, NY: Cornell University Press, 1989), who identifies two potential tracks, one that eroticizes the body and the other blocking access to eroticization, which thus hystericizes the body. Dora's response of disgust expressed by relocating sensation to the oral and digestive track is indicative of such deflection of erotic sensation that registers a knot of psychic difficulties in accessing the sites and resources of pleasure in the sexual body caused by traumatic dislocation.

29 Sigmund Freud, 'Fragments of a Case of Hysteria ("Dora")' [1905], The Penguin Freud Library, Vol. 8, *Case Histories I* (Harmondsworth: Penguin, 1977), 31–166.

30 Mieke Bal, 'The Visual Semiotics of Rape', in *Reading Rembrandt*, 63.

31 Julia Kristeva, 'Motherhood according to Bellini', *Desire in Language* (New York: Columbia University Press 1980), 237; elaborated in Paul Smith, 'Mother as Site of Her Proceedings: Mary Kelly's *Post-Partum Document*', *Parachute*, no. 26 (1982), 29–30.

32 See Anne Creissels, 'From Leda to Daphne: Sacrifice and Virginity in the Work of Ana Mendieta', in Griselda Pollock and Victoria Turvey Sauron (eds), *The Sacred and the Feminine: Imagination and Sexual Difference* (London: I.B. Tauris, 2007), 178–88; Anne Creissels, *Prêter son corps au mythe: Le féminin et l'art contemporain* (Paris: Editions de Félin, 2009).

33 Aby Warburg, 'Sandro Botticelli's *Birth of Venus* and *Spring* (1893)' in Kurt Forster (ed.), *Aby Warburg: The Renewal of Pagan Antiquity: Contributions to the Cultural History of the European Renaissance*, trans. David Britt (Los Angeles: Getty Research Institute Publications 1999), 89–156.

34 Sigmund Freud, 'The Theme of the Three Caskets' [1913], *The Standard Edition of the Complete Psychological Works of Sigmund Freud*, Vol. XII (1911–13), 291–301.

35 Warburg, 'Sandro Botticelli's *Birth of Venus* and *Spring*', 139.

36 Julia Kristeva, *Black Sun: Depression and Melancholia*, trans. Leon S. Roudiez (New York: Columbia University Press, 1992), 21.

37 Giorgio Agamben, 'Aby Warburg and the Nameless Science', *Potentialities: Collected Essays in Philosophy*, trans. Daniel Heller-Roazen (Stanford, CA; Stanford University Press, 2000), 89–103, 100.

38 Griselda Pollock, 'The Grace of Time', in *Encounters in the Virtual Feminist Museum* (London: Routledge, 2007), 39–66.

39 A performance for the artist's Intermedia class; documented as *Untitled (Rape Scene)* 1973, Lifetime colour photograph, Estate of Ana Mendieta Collection. Original documentation, 35 mm slide.

40 Mieke Bal has argued that we need to understand rape as both a language and a form of murder; rape may not kill, but it effectively murders the person. 'The goal of rape is the destruction of the victim's subjectivity' and 'the victim internalises the message of annihilation completely'. Bal, *Reading Rembrandt*, 91.

41 In plate 39 from Warburg's *Mnemosyne Atlas*, one element of Botticelli's painting is specifically connected to the memory of re-animation of the Ovidian metamorphoses in the 'quotation' of a painting that represents Apollo pursuing the nymph Daphne by Antonio Pollaiuolo (1470–80, London, National Gallery); Aby Warburg, *Der Bilderatlas Mnemosyne*, ed. Martin Warnke (Berlin: Akademie Verlag, 2003), pl. 39.

42 I owe my encounter with the work of Anne Brigman to Patricia Briggs and thank her warmly here.

43 Giraud, *La Fable de Daphné*.

44 Aby Warburg, 'Images from the Region of the Pueblo Indians of North America', lecture presented 21 April, 1923 at Ludwig Binswanger's Clinic at Kreuzlingen. First published in English translation in *The Journal of the Warburg Institute*, 2 (1938–39), 277–92. The full German text appeared, edited by Ulrich Raulff, *Schlangenritual: Eine Reisebericht*, Berlin: Klaus Wagenbach, 1988). For an analysis see Aby Warburg, *Images from the Region of the Pueblo Indians of North America*, ed. and trans. Michael Steinberg (Ithaca, NY: Cornell Univeristy Press, 1995).

45 Gary A. Tomlinson, 'Ancora su Ottavio Rinuccini', *Journal of the American Musico-logical Society*, 28:2 (1975), 351–6. Tomlinson argues that the original libretto of 1598 was not satisfactory. Undergoing some additional development, the libretto was substantially reworked by Gagliano, finally being performed in 1608.

46 Warwick reminds us that Bernini was deeply involved in theatre himself; see her 'Speaking Statues', 353–81.

47 I am very grateful to Carmen Mörsch for her recommendation of Eve Kosofsky Sedgwick.

Seduction, mourning and invocation: the geometry of absence in works by Louise Bourgeois

Captions to chapter 2

14 Louise Bourgeois (1911–2001) *Maman*, 1999, in Tate Turbine Hall, 2000, steel and marble, 927.1×891.5×1023.6 cm.

15 Gustave Doré *Arachne*, from illustrations to Dante's *Purgatorio*.

16 Louise Bourgeois *Partial Recall*, 1979, wood, 274.3×228.6×167.6 cm. Private collection.

17 Meret Oppenheim (1913–1985) *Ma Gouvernante*, 1936, shoes, silver platter.

18 Louise Bourgeois in 1966 with *The Blind Leading the Blind* (1947–49). Louise Bourgeois Trust.

19 Louise Bourgeois *Maisons Fragiles*, 1978, steel, two units, 213.4×68.6×35.6 cm.

20 Louise Bourgeois *Spider*, 1947, ink and charcoal on tan paper, 29.2×22.2 cm. Bourg-0398.

21 Louise Bourgeois *Spider*, 1947, ink, charcoal on tan paper, 29.2×19.1 cm. Bour-0584.

22 ©*Art Forum*, December 1982: 'Child Abuse: A Project by Louise Bourgeois'. Four-page spread.

23 ©*Art Forum*, December 1982: 'Child Abuse: A Project by Louise Bourgeois'. Four-page spread.

24 ©*Art Forum*, December 1982: 'Child Abuse: A Project by Louise Bourgeois'. Four-page spread.

25 ©*Art Forum*, December 1982: 'Child Abuse: A Project by Louise Bourgeois'. Four-page spread.

26 *Oedipus and Antigone*, marble, Lycée Fénelon, *c*.1920.

27 Louise Bourgeois *Ode à ma mère*, suite of nine etchings, Paris: Editions du Solstice, 1995, 32×31.5 cm. Louise Bourgeois Trust.

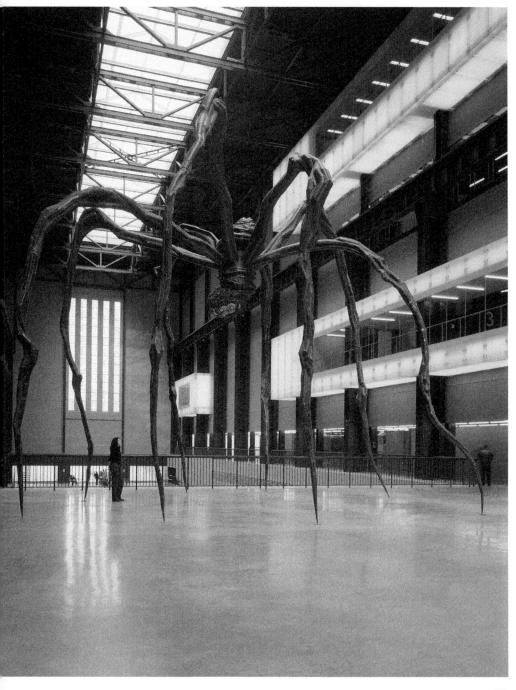

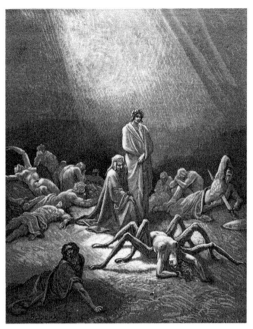

15

16

17

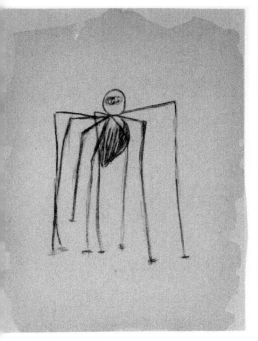

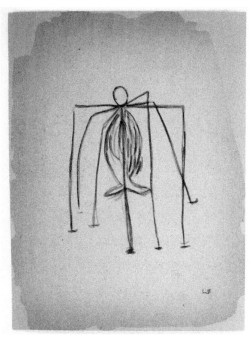

20

21

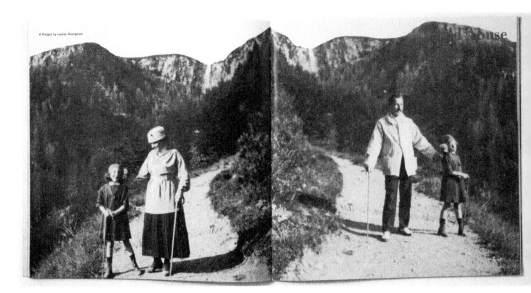

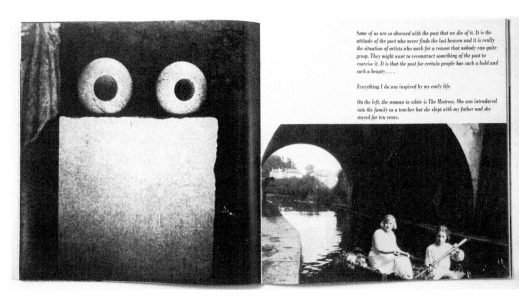

Some of us are so obsessed with the past that we die of it. It is the attitude of the poet who never finds the lost heaven and it is really the situation of artists who work for a reason that nobody can quite grasp. They might want to reconstruct something of the past to exorcise it. It is that the past for certain people has such a hold and such a beauty

Everything I do was inspired by my early life.

On the left, the woman in white is *The Mistress*. She was introduced into the family as a teacher but she slept with my father and she stayed for ten years.

Now you will ask me, how is it that in a middle class family a mistress was a standard piece of furniture? Well, the reason is that my mother tolerated it and that is the mystery. Why did she?

So what role do I play in this game? I am a pawn. Sadie is supposed to be there as my teacher and actually you, mother, are using me to keep track of your husband. This is child abuse.

Because Sadie, if you don't mind, was mine. She was engaged to teach me English. I thought she was going to like me. Instead of which she betrayed me. I was betrayed not only by my father, damn it, but by her too. It was a double betrayal. There are rules of the game. You cannot have people breaking them right and left. In a family a minimum of conformity is expected.

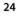

I am sorry to get so excited but I still react to it.

Concerning Sadie, for too many years I had been frustrated in my terrific desire to twist the neck of this person.

Everyday you have to abandon your past or accept it and then if you cannot accept it you become a sculptor.

26

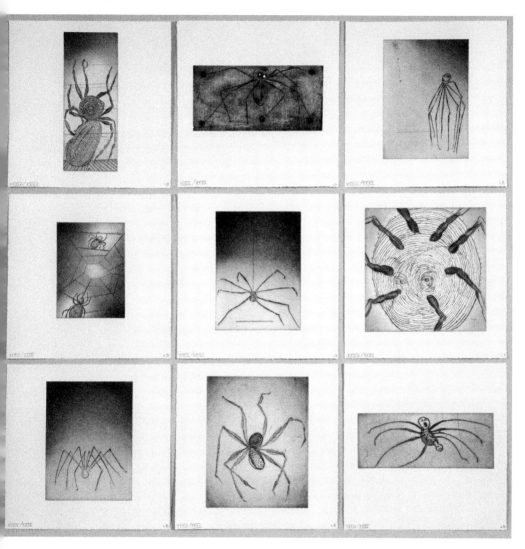

In Ovid's *Metamorphosis*, we also find the story of the origin of the spider and its relation to weaving in the tale of metamorphosis resulting from a competition between women. 'Arachne' is the tale of the tapestry-weaving contest that took place between the Goddess Minerva (Athena is her Greek counterpart) and a creatively gifted mortal, Arachne.[1] If Louise Bourgeois's work in general can be said *preposterously* to beckon to Bernini – Mieke Bal's beautiful argument – its spider themes (Figure 14) also invoke in so many overdetermined ways, the most impressive engagements with the fable of Arachne, and the origins of the spider and its metaphorical relations with weaving/femininity/violence: the painting by Diego Velasquez, sometimes known as *Las Hilanderas (The Spinners)* but properly titled *The Fable of Arachne* of c.1648 (Plate 5).[2]

Minerva/Pallas Athena was the Greek goddess of wisdom, of household arts and crafts, of spinning, weaving and textiles. 'Born' fully grown and armoured from the head of her father Zeus who had swallowed his first wife, Metis, so that she would not bear a child stronger than he, Athena identified in all crucial matters of justice and law with a patriarchal order, marking, by her curious birth and paternal identification, the cultural shift from pre-patriarchal gylandric cultures to full-fledged father-right of the Olympian Greek imagination.[3]

Athena was challenged to a weaving contest by a young mortal from Lydia, Arachne, reputed as a superb weaver. Athena first visits the young woman disguised as an old woman (see the beautiful leg exposed in the foreground of Velasquez's painting [Plate 5] of Athena as an old woman) warning her against her presumption of claiming to be a greater weaver than the goddess-creator of arts and crafts. Arachne is unbowed and the contest begins. Athena weaves four marvellous tapestries that tell the story of her battle with Poseidon for divine authority over the city of Athens, a battle that Athena won by creating the olive tree. Arachne weaves tapestries that represent three scenes of mortals bringing about the submission of the gods; unfortunately, these tales expose Athena's father, Zeus, in his recurrent sexual infidelities: with Leda disguised as a swan, with Europa disguised as a bull and with Danae disguised as a

golden shower. Arachne's skill was indeed superior, so beautiful were the weavings considered. Athena was enraged at the exposure of her own divine father's extramarital sexual exploits. In fury she destroys the tapestries, and slaps Arachne's face. In shame and guilt, Arachne hanged herself. She is resurrected by Athena, but not in human form. Sprinkled with the juice of aconite, Arachne becomes a spider, destined to hang from threads of her own bodily making and to weave delicate webs of death. The dead young woman artist returns as a spider.

This fable tells the story of a daughter's shame and anger. Arachne publishes Athena's father's sexuality, making visible the father-lover's self-transmogrification into animal and other forms to perform his varied rapes. His transformations are significantly mirrored, in reverse, in Athena's metamorphosis of the young woman weaver, Arachne, into a spider, imagined so horrifically by Gustave Doré (Figure 15) through the literal addition of limbs to a human body and by its debasement to crawling horizontality.[4] Thus the myth creates a narrative form for telling of competition and sexuality, rage and shame, and revenge and remorse, destruction and reparation, themes we know to be important in the imaginative world of Louise Bourgeois's art. I aim to spin a tale not only about fathers, sexual seduction and shame, but also about grief and mothers with the figure of the spider in both abstract and figurative forms weaving the connecting threads (Figure 14).[5]

Writing in 1965, Louise Bourgeois stated:

> This theme of symbolic abstraction through the creation of forms that suggest both the structure of geometry and human individuality has been a consistent preoccupation of my work.[6]

Writing in 2003 in the exhibition catalogue *Louise Bourgeois: Geometry of Desire* at Zachęta Gallery, Warsaw, Pawel Leszkowicz offers this brilliant but very different characterization of the artist:

> Louise Bourgeois is … an artist of the unconscious, and the most consistent artist of the unconscious produced by modern culture at that – the culture that discovered, affirmed and ultimately extinguished the unconscious. At the beginning of this modernity we find Sigmund Freud and Marcel Proust – at its end there is Louise Bourgeois. At the beginning there are men – at the end there is a woman. They all worked in the realm of secrets and traps of inner life.[7]

An artist 'discovered' by Lucy Lippard at that now very archaic moment in the mid-1960s of 'eccentric abstraction', then claimed for the Museum of Modern Art in 1982 through quite formal works such as *Partial Recall* (1979, Figure 16) which was on the cover of the 1982 catalogue, Bourgeois is discussed by 2003 in a postmodern, feminist and psychoanalytical vocabulary, being astutely positioned in the company of Freud and Proust, all artists of memory, the

unconscious and subjectivity's cultural inscription. To extend Leszkowicz's gesture, Bourgeois also belongs alongside Colette (1873–1954) and Virginia Woolf (1882–1941), Carol Rama (b. 1918), Meret Oppenheim(1913–85; Figure 17) and Frida Kahlo (1907–54), all of whom dared to conjugate the personal and the historical, the bodily and the symbolic across the available forms of early twentieth-century visual or literary culture.[8]

Leszkowicz places the engagement in Louise Bourgeois' work with the psychic, the unconscious and subjectivity on a non-autobiographical plane yet – and this is the important point – without avoiding the articulation of the subjective, itself not synonymous with the personal or the autobiographical. Rather than treating Louise Bourgeois's work as a kind of self-administered therapy by whose cathartically confessional means she abreacts her obsessive memories of childhood that generate relentless anger and aggression, I propose that her work can be approached analytically as a long-term creative structuring that only afterwardly produced narratable and retroactive understanding for the anguishing pressure of traumatic anxiety seeking the interval that delivers 'the relief of signification' while remaining faithful to its affective foundations.

The publication *The Return of the Repressed* (2012) provides access to the notes and diaries of the sculptor Louise Bourgeois about her psychoanalytical sessions.[9] Both as analysand and potential student of child analysis, not only does Bourgeois reveal more about her own shifting psychic life, anguish and struggle to master depression, food-loathing and anxieties about abandonment, but also she disallows projective speculation about her psychic life derived from biographically reductive reading of her sculptures as forms of psychic notation. So what new approaches to her work result from this situation?

I aim to have my cake and eat it. I want to approach the sculptor through selected works whose formal continuities across many decades need to be discerned despite their apparent differences (abstract/figurative) while their differentiations register significant ruptures in the conditions of her artmaking, notably because of the emergence of feminism in the sphere of art and what it specifically made possible in the shift from geometrically encoded *pathos formulae* into invocative and fabulous forms hospitable, culturally, to the tensions Bourgeois had indicated between obligations for form and engagement with psychic dimensions.

On the other hand, I want to offer interpretations of the intersection of her formal experiments and creations by means of three distinct psychoanalytical perspectives (Laplanche, Ettinger, Montrelay). I am proposing seduction and mourning as concepts with which to read how Bourgeois creates, through a psychically infused geometry, her novel *pathos formulae* for traumatically imprinted but aesthetically transformed psychic experience. The method mimics analysis itself through afterwardness, revisioning and revising,

transforming formerly uncognized traces into memories by means of forms, not expressing but *form*ulating a passage towards the trauma which registers as an insistent and disturbing affective pressure constantly seeking form. Thus I want to listen to Louise Bourgeois's intelligent words treating them not as explanations or confessions but as texts to be deciphered alongside the cultural elaboration of a network of relations within which her often condensed, highly economic and materially as well as formally conceived sculptures and prints become vivid, dense, suggestive.

The sculptor Louise Bourgeois speaks

In an interview with art critic Marsha Pels in 1979, on the cusp of her insertion into modern American art history by the show at the Museum of Modern Art in 1982, Louise Bourgeois explains:

> LB: The titles come after the piece. The emotional content is unconscious, that is why it appears afterwards. The serious work is done before.
> MP: You can't put it into words until you have seen it for yourself.
> LB: Right, until I am satisfied with the formal aspect of it. The sculpture comes first and the titles are a kind of privilege … But it has to do with the symbol. Geometrical shapes and proportions are rhythms and all rhythms are symbols to me, even though in sculpture it is less obvious than music. But they are private symbols, not public ones. But you cannot use your own psychological make-up as an excuse for doing sculpture.[10]

Marsha Pels wants to clarify this seemingly adamant refusal of psychological priority:

> MP: But the need to make sculpture is in some ways the need to get beyond one's own psychological make-up.
> LB: Oh, absolutely. But the psychological make-up is only an excuse for making the sculpture. First you make the sculpture and then you find the reason for why you have done it: the fact is that you cannot live without doing it. But once the sculpture is made and it is standing in front of you, it is a good sculpture or a sentimental one.
> MP: Sentimental is as bad as decorative.
> LB: They're both shallow. Either it is successful or it has to be scrapped and done over again.[11]

The risk, therefore, is sentimentality, which is equated with allowing a certain psychological dimension priority over the making of a sculpture, even while the making may be driven by an inner necessity, which has no specific form save that which leads to the repeated act of making itself.

LB: ... at the beginning there is panic. And there is an absolute survival instinct to put order around you in order to escape the panic. And this is the origin of my sculpture. Now when the order has been found, which is completely abstract, it is a matter of shapes that fit together. When this is achieved, the panic disappears, that's it. And then by God, the panic comes back and it has to be started again. And after that, if you want to do all kinds of explanations, you are entitled to it. But first it is a psychological necessity expressed in a formal mode.[12] (my emphasis)

The conversation has turned to Minimalism, which Bourgeois deflects to a more generic economy in her making.

LB: My minimalism came from my love of geometry. Sometimes it is inherently dynamic; a study of conflicting forces which is never static. Density, gravity, and equilibrium coupled with minimalism. All the pieces were subject to a precarious balance. And that point comes to the fact that they are not grounded; they come to the floor on a point.[13]

The fact of sculptures that delicately taper to points that compromise their ability to stand and their relation to conventions of sculpture and its foundations, the pedestal and so forth, blends here into the metaphorics of existentially being grounded or not. This can then open out onto the political atmosphere during the 1940s with war and the intense experience of separation from family in Europe, being French in New York, being a woman amidst the European machismo of the art exiles. Of her standing sculptures and their tenuous hold, some of which had to have bases added as the galleries would not allow her to drill into the floor to allow them to stand on their pins, Bourgeois states:

It was not grounded ... during that period things were not grounded. They expressed a great fragility and uncertainty and they were placed, just like that. If I pushed them, they would have fallen.[14]

The affective quality arises from the structural or formal properties of the sculptures by means of which a certain tenor, mood or reference to states of instability can be invoked. Bourgeois will later talk of her delight in discovering steel which enabled her to create the sculptures that could thus sustain this precariousness of the pointed contact with the ground, this play of density, gravity and precariousness: the spider sculptures will embody and explore this quality in many variations.

Then Bourgeois adds in another affective level that coloured the mood of works in the 1940s: unacknowledged post-partum depression. Louise Bourgeois had suffered the agonies of thinking she was unable to conceive, only to fall pregnant once she had adopted her first son. Two pregnancies during this decade seem to have aggravated a sense of loss and separation as she bore her children without her mother or any other family support. Thus

she speaks of the affective mood of her standing sculptures of this period and their assemblages of them she created as environments in her shows in terms of mourning.

> LB: I don't know why the mourning came so frequently in my work, since I didn't actually lose anybody, nobody died. Today this has been recognized as a frequent occurrence – that mothers with young children develop depression.[15]

For me, this interview is profoundly telling. It dictates infinite subtlety and sensitivity in approaching Bourgeois's work, indicating the many registers on which she works. The concept of *after-affect* captures the powerful affective charge arising, for her, from making, and from the made work's formal resolutions, its finding of a form to hold before her that which was mere driving and shapeless intensity before it was made. The concept of *after-image* enables us to recognize that formalization produces an image as a dense network created to carry subjective significance, which acquires its urgency from the 'truthfulness' of the self who made it through formal research and from the resonances its affects have for those who encounter *their own histories* by means of what Louise Bourgeois's aesthetic inscription places in culture and before us. This is crucial; it prevents us from projecting excessive emotionality or psychic disorder onto the author-subject Louise Bourgeois by forcing us to recognize what her *pathos formulae* mirror back as a fidelity to the intensity of potential human pain in ordinary situations of family, marriage, maternity, bereavement, professional life and so forth.

Seduction: *The Blind Leading the Blind* (1947–49)

One of Bourgeois's earliest major sculptures in wood was conceived during the later 1940s when she first got 'studio space' on the roof of her apartment building, the Stuyvesant Folly. Originated as *Blind Vigils*, later titled *The Blind Leading the Blind* (1947–49), the sculpture stands approximately six feet feet high (Plate 6). Its importance to Louise Bourgeois is evidenced by several reworkings in wood and bronze, varying the number of 'legs', inking some legs black, red and purple, some entirely flesh pink (renamed *C.O.Y.O.T.E* which stands for *Call Off Your Tired Old Ethics*: the title of the union of sex-workers) and casting one version in bronze. According to Lucy Lippard, the sculpture was first conceived as a 'blue "windowless house" on four stilts'.[16] Lippard states that Bourgeois planned but did not execute a version composed of fourteen 'pregnant' women. The theme continued to interest Bourgeois, and Lippard mentions a version where the legs (looking more like animal limbs) hang from a lintel (*The Quartered Ones*, 1978), which has been linked to *Destruction of the Father* (1974). *The Blind Leading the Blind* indicates both instability and groundedness. Unable to maintain themselves, nonetheless, these struts are

held together at the top by being inserted into a double lintel atop which is a dorsal spine of a horizontally laid wood strut. One of her earliest works, its form was clearly deeply resonant for the sculptor and I see it as a door to *Maman* (1999, Figure 14).

Bourgeois offered different associations for this sculpture. The all or partially black versions bear the mark of mourning that prevailed during the 1940s for both political-historical reasons of the war, and for personal-intimate reasons of feeling intensely the separation from the rest of her family in France. In Camille Guichard's film made in 1993 for the Centre Pompidou, Bourgeois speaks of her intense homesickness during the 1940s and how her longing for those she missed fed into the sculptural forms she created in that decade. This reveals a vital key for understanding a relation between space, structure and affect.

On another occasion, speaking of the exiled members of the Parisian avant-garde, Bourgeois suggested the sculpture represented old men leading you over the precipice.[17] Yet later, she invoked the idea of having to look away and be blind to the profligacy of her father, to the pain of her mother and to the disturbing adult relations within her family.[18] There are other stories told of this work. When renamed *C.O.Y.O.T.E* with reference to the title of a union of sex-workers, Louise Bourgeois suggested that the work indicated the solidarity of standing together. On other occasions, the menace felt by Bourgeois and her friends being investigated by the House Committee on Un-American Activities, suggested yet another possible association in terms of more desperate needs for mutual support and reinforcement. Such variations are typical, not of forgetfulness or phantasy, but of the productiveness of Bourgeois's ultimately abstract forms that are fluidly open to many associations. The structure suggests both standing and falling, both grouping and huddling, both forced bonding and common purpose, both following the leader and joining forces. The artist's own associations are contingent and in several instances cited above they are responsive to immediate politics: feminist and anti-anti-Communist.

The work (Plate 6), however, solicited this memory from the sculptor in 1979.

> It represents an army of legs, two by two, that holds together. Eight pairs of legs (sic). The reason this blind army of legs does not fall, even though the legs are always afraid of falling, since they come to a point, is that they hold on to each other. This is exactly what I felt when I was a child, when I was hiding under the table. My brother was following me like a shadow; I was blind with fear and so was he ... I don't know what we were looking at. But I was watching the feet of my father and mother from under the table, while they were preparing the meal. And I thought to myself, What are they doing? What is their game?

What is their purpose? How do I relate to them? And in the end I considered that they were not friendly. I decided that the outside was not friendly. And I was afraid, simply afraid. I couldn't understand their purpose, which was to prepare lunch. I didn't understand why they were walking around the table. Why would one pair of legs interfere with the other visually, physically? There were their legs and the table's legs. It really just made me wonder where I fitted in.[19]

This memory of childhood is not truer than the other associations. It is a reading of a memory in relation to a non-narrative sculptural form that produces not meaning but affect. Affect suggests working on recurring traumatic material, which in the nature of trauma is not yet a known narrative. It is a void around which surges undischarged anxiety that compels many returns. Such affects and their causes are personal to Louise Bourgeois and her history. Insofar as she transforms her own materials into aesthetic inscriptions through abstract formulations, however, they become screens as much for the viewers as for the artist herself, alternating between projections of social situations and evocations of the psychodynamic foundations of subjectivity itself.

Bourgeois offers a *scenario* that captures and condenses a psychoanalytical understanding of the enigma that adult sexuality presents to the child: where do I fit in, where do I come from, what am I to be in relation to these figures who represent adulthood, sexual difference and sexuality? Translated into a formal organization of wood that in no sense illustrates the memory, the telling of the memory as an association does not explain the form we encounter in space. The latter houses its possibility of emerging. The words of Louise Bourgeois, spoken about her sculpture, set up a register that enables us to sense the *after-affect* of this *after-image* in a scenario that evokes the traumatic foundations of subjectivity and sexual difference which the sculptor persistently explored obliquely through geometry and space. One of these traumas is seduction.

French psychoanalyst Jean Laplanche has reclaimed for psychoanalysis the concept of seduction, which Freud had initially identified in his work in the 1890s as the initiating factor in hysteria and then rejected in favour of his structural theory of phantasy and of the Oedipus Complex. Redefining it for his general theory of the formation of the drive and the unconscious rather than as a specific, neurosis-inducing event, Laplanche understands seduction as the general effect of the dissymmetry between the infant and the adult world. The newborn is initially without a psychic apparatus to process incoming 'events', which therefore remain traumatic, overwhelming and excessively affecting. The infant is the recipient of 'stimulation' from the outside world in the daily form of the care and attention of its parents or caretakers. Yet the parents, by virtue of being so, are adult sexual beings, already themselves complexly

formed unconsciously within the processes of sexuality and its traumatically enigmatic formations which, *unconsciously*, they cannot but project in their perfectly normal asexual care for the child. The child confronts the enigma of this *unconscious* dimension of sexuality that Laplanche argues is what precipitates the emergence of the psychic mechanisms necessary for 'digesting' the enigmatic signifier, for metabolizing the messages the infant cannot yet decode. The 'engimatic signifier' itself – the unconscious sexuality of the world – according to Laplanche, is the generator of the drive.

Laplanche, therefore, also modifies Freud's theories of the drives. Freud divided the pleasure or life drive (*eros*) from the death drive (*thanatos*), the latter indexed by compulsive repetitions associated with trauma. Laplanche hypothesizes that the death drive is that dimension of the single life or sexual drive thus instituted in the encounter with the adult world that cannot be fully metabolized or digested, and constitutes the unconscious dimension of sexuality with which in turn that child, become an adult, will 'traumatize' his or her own child.[20]

Laplanche's formulations resonate with the memory Bourgeois offers to Pels, with this proviso. Her account is already a highly structured and drama-tized *scenario*. It translates into a childhood scene elements heavy with struc-turally traumatic echoes, that Laplanche's theories illuminate. In Bourgeois's memory-story, there are the points of view of a boy and a girl, one passive and following, the other alert and intensely curious, longing and afraid to understand. Both are 'blinded' by being under the table; they are unable to see/know. But they are also blind with fear because they are presented with an enigma they cannot fathom and may not want to know: adult sexuality. This event does not excite the children. It makes them fearful. But it sets in motion the relation of the child(ren) to the parental couple, cooking and relating in a way they imagine to be unwitnessed by children.

The manner in which Louise Bourgeois recounts actual memories takes on, therefore, a deeper, structural significance insofar as memories of actual childhood events become installed as 'key' memories not because the single event was so memorable in a specific life, but because a possible, even banal, occasion takes on, by displacement, the function of enacting an unconscious structure. It becomes the scenario, as in a dream, that condenses and holds together in a single form many threads: what can be said or recognized inherits what is seeking, from beyond signification, to be registered and which can only do so as an affective charge investing other situations or feeding into related memories. What is experienced by a child is staged as a memory of a scene infiltrated by anxiety remaining from the archaic and enigmatic confrontation between the child and adult sexuality in which it is implicated by having been born from a sexual act, and by sensing that it is growing up into being a sexual entity in a manner it cannot yet imagine.

Laplanche argues that primal phantasies identified in psychoanalysis such as that of the primal scene of adult copulation or phantasies of castration are generated retrospectively (not being primordial memories) as imaginary explanations of these enigmas that children preverbally confront: where do I come from, why is there sexual difference, what am I to become?[21] We can hear the echoes of these phantasies of origins in Louise Bourgeois's already highly astute and analytical narration of a childhood scene that functions as a screen memory (a scenario from a later stage in childhood that screens while retrospectively incorporating more archaic psychic material that left traumatic impact without being graspable at the time). The artist's story suggests children of a certain age while the traumatic charge of the scenario is, psychically, the playing out of unconscious phantasies and the residues of even earlier 'encounters' with the enigmas of sexuality.

Blind the children were, because of being hidden, while yet watching. Sight and sightlessness are part of this scenario. Blindness is the terror associated with castration: it reverses the desire to see and know into a fear of seeing and being seen seeing and wanting. Blindness is a punishing mutilation of sight when seeing has become an eroticized organ in the infantile modes of sexuality: invested with pleasure and its reverse, sadism. Bourgeois's 'memory' is a story that probably contains seeds of a real reminiscence; it is surcharged, however, to remain in the memory and return now as a reading of an artwork, after the event, because it is overdetermined by a web of psychic significance it encodes and allegorizes as a safe, domestic scene (parents in the kitchen preparing food) within which another sexual scene is hallucinated, half glimpsed by voyeuristic children whose affective register for the enigma they blindly sense is fear.

The sculpture (Plate 6) is neither the memory nor the allegory; it cannot be reduced to either. It is a created art form that performs a multivalent aesthetic distillation of elements that we retrospectively encounter in the sculptor's story of a remembered scene: multiple pairs of legs, at once wooden hence table-like and human, forming a kind of forest (itself rich in sexual associations) of legs that introduces repetition, time and the group (of replicated couples). In a photograph of Louise Bourgeois herself, seen through this sculpture, we get a better sense of the scale of the work, for the diminutive artist stands barefoot underneath it (Figure 18). That which was once a table is now a tall, also house-like structure under which a standing body can shelter or can hide, while the multiple struts, delicately and uncertainly balanced on points that would not allow them to stand were they not all bonded together with the crossbeams above, function also as a kind of screening device, obstructing vision. The relation between the story of the scene and the sculptural realization is mediated by the work the viewer must do in thinking through what is before him/her: wood (later cast as bronze), painted red and black (important colours of pure opposition in Louise Bourgeois's vocabulary) or fleshly pink,

teetering struts, only held together architecturally by a horizontal beam whose simple carpentry suggests both a construction and a piece of furniture, both an exterior shelter and an interior space. As such these struts/legs create a space – within, beneath and between – that is both figures and a house.

There is a thread running from this formative sculpture from 1947–48 to the major works of Louise Bourgeois in the 1990s: the scenario-like *Cells* and the *Spiders*. They do not exhibit so abstract a formal language yet they share the fundamental formal properties of combining structure and space, opening onto more explicitly narrative arrangements of objects within.[22] There is plenty of evidence in Bourgeois's practice for this relay.[23] The *Cells*, walk-in-sized independent structures created from industrial relics of the city, window screens, old doors and other building elements found in the industrial space in Brooklyn that was Bourgeois's studio after 1980, displaced the earlier, empty structures and are filled with found, carved, cast and personal elements. The *Cells* created the real space for staging scenarios enacted by these assembled elements that suggest the family scene of sexual, subjective becoming, family meal-times as well as school gatherings while also generating a space charged with the affective quality of social encounters between isolated, non-communicating dislocated subjects that relate to the artist's sense of dispossession as both child and home-sick migrant-exile.[24]

The earliest 'spider' motif appears in two small drawings of ink and charcoal on tan paper from 1947 (Figures 20 and 21). I link these spidery feather-thoughts with *The Blind Leading the Blind*. In the drawings, the spider's eight legs create its own forest, structure, or environment, not unlike the formal effects of the more linear *Blind Leading the Blind*. The artist has stood the spider up, and its legs are attached at a 'neck' between the suspended abdomen and a round 'head' with either a very Freudian Cyclops eye or a vast mouth. In a second drawing, there is an oval 'head', and suspended is a form that appears almost to be feathered with folding wings. Curious and funny creatures, these drawn spiders are already anthropomorphic hybrids, as well as portraits of an anxious, ill-fitting body schema. Thus the initial spider motif with its eight legs, tapering to delicate points, bonded at the top, coincides in the late 1940s with *The Blind Leading the Blind*. I am suggesting that this link enables us to attempt to think both the formal structure and the sense of its being a formalization of a charged, overdetermined scenario that requires non-reductive 'interpretation' in the analytical sense. That is to say, no sculpture has a cause to which it can be reduced; many disparate threads converge, are condensed and overdetermined to produce a form that is a non-iconographical image, like a kaleidoscope, offering many facets with no decidable point. But two poles emerge: one is to do with figures in space and the other concerns space as an environment. Both concern relations and non-relating elements, gaps and the invocation of absence.

In addition to suggesting that Bourgeois's singularity lies in staging in artistic practice the register of a Laplanchean anxiety before the enigmas of sexuality whose resonance in the child-subject are the affects of fear and rage, I am also sensing absence and mourning.

Looking into the family album

When Deborah Wye curated the first major museum retrospective of Bourgeois's oeuvre at the Museum of Modern Art, New York (6 November 1982 to 8 February 1983), she assembled and carefully historicized the works of a slightly eccentric and surrealistic modernist with major formalist concerns, who had begun to explore non-standard media like latex in the early 1960s, who had created her first 'cell' for a happening/performance created in 1978.[25] Wye's catalogue essay is typical of writing of that moment of the early 1980s, conferring on Bourgeois a proper – art historically conceived – trajectory of formal experimentation, evolving decade by decade, derived from in-depth conversations with the artist and careful research of her practice over forty years. Yet in the introduction, Wye noted that the then new responsiveness to Bourgeois's work was symptomatic of a deeper cultural shift clearly visible by 1982.

> The overriding emphasis on stylistic analysis, prevalent for so long, no longer satisfied the intellectual and emotional needs of the art public. Instead, personal content and deeply felt themes were sought and explored. Bourgeois's work spoke directly to these new needs, which welcomed stylistic diversity and deeply expressionist content.[26]

This account polarizes (modernist) form versus (postmodernist) content, style versus expression, in ways that were typical of the unresolved tensions in art and art history at that date. According to that polarity, emergent feminist work was often placed simplistically on the side of content and expression; seeming to exhibit no proper formal concerns, it could be easily exiled altogether from 'art' proper and certainly from understanding a history modernism in its own terms. This simplification fails the complexity of the art gener-ated in dialogue with a new feminist consciousness and, in the case of Louise Bourgeois, mistakes a cultural shift towards a moment of postmodern anti-modernism for the continuing dialectic in all artmaking between its materiali-ties and necessarily formal operations and the ways in which we think through the connections between 'aesthetic inscription', its affects and its prompts to thought.

Firmly arguing against splitting form from content, I think that feminism changed Louise Bourgeois into the artist the world embraced after 1982 and is now canonizing since her death in 2010. However much art historians, just

as I have demonstrated myself above, justly seek to create continuities that trace the threads of the later Louise Bourgeois of the 1990s back to her earlier, more obviously modernist work, there are moments of significant rupture and poetic leaps in her work, notably in the mid-1960s, and certainly after 1982 and again after 1992, all of which mark significant moments in feminist practice which were digested and transformed by Bourgeois into singular and innovative modes of artistic practice. Between the ages of 71 and 98, a somewhat different, if always recognizable, artist emerged in which expanded modalities of art and culturally authorized memories and life-narratives colluded and collided. It was not that a ready-made feminism impacted on the visual arts: it was the moment that conceptual art coincided with the critique of representation and the turn to theorization of subjectivity and sexual difference that marked the distinctiveness of the later twentieth-century phase of feminist thought's cultural and aesthetic turn.

For the artist's retrospective exhibition in 1982, Wye asked her for an illustrated biography. Bourgeois reviewed her extensive and atmospheric photographic family album, rich with the staged photographs of the family, its homes, workshops and holiday sites. There, like Barthes who wrote in his book *Camera Obscura* (just published and translated in 1981) about the Winter Garden photograph of his mother as a child, Bourgeois became 're-acquainted' at this moment with the stilled traces of a disturbing family dynamic held before in photographs from the family album. These moments of her past classically involved the child's precocious but not yet conscious encounter with the complexities of adult sexuality.[27] The publication in 2012 of the psychoanalytical diaries and writings enable us to know when and how Louise Bourgeois began to recognize aspects of her childhood and familial dysfunction of which she was hitherto not fully conscious. Juliet Mitchell quotes a passage from November 1957 noting the discovery of unexpected feelings only during analysis:

> Suddenly I perceived my jalousy (sic) and hate of Sadie which was never conscious. I would have to watch this earea (sic) of Sadie very carefully because I have never been aware of disliking her. This jalousy (sic) was utterly repressed.[28]

There was a specifically feminist context, however, for 'seeing' hidden relations and anxieties in photographs. Since 1979, when British artist Jo Spence exhibited her photo-memory work *Beyond the Family Album*, private photographs and family mementoes have been transformed by feminist and other post-memory studies into a resource through which to trace the marks and lines of hitherto unrecognized histories of power relations and ambivalent plays of desire and the unremembered across this ubiquitous and domesticated form of visual image culture.[29]

Louise Bourgeois revisited her family album in 1982, and remade what she saw there in the structured form of a new kind of art work – the four-page artist's project created for *Art Forum* – and as a slide show for the exhibition (for which the album was taken from its function as family record to become a refashioned mirror in which memory was returned with the Proustian vividness of the never-forgotten intensity). But, I suggest, until she made both, Bourgeois did not *know*, in this structured form, the precise contours of the childhood experiences whose exigencies may have unconsciously and abstractly fuelled the making of sculptures and drawings.

Do we really know what we experienced in our childhoods until we are told or later tell the past in narratives – to an analyst or in our literary or visual work? In retrospective tellings we produce the messy past of jumbled emotions as memory, placing fragments and affective traces into sequences that capture their significance beyond the everyday events. Photographs – snap-shots – store up such shards as freeze-frames, and allow us to revisit events of the past which we come to know, for the first time, through these mirrored scenes that give memory both shape and setting. Memory is a product of *Nachträglichkeit*: an afterwardness or retrospective revisioning that makes the past into scenarios of pre-scripted meanings.

In the encounter with the juxtaposed photographs reviewed, and in the presence of others, the Bourgeois family's singularly difficult reconfiguration of the Oedipal triangle into a traumatizing quadrangle emerged into stark, even public, visibility. Bourgeois could formally then name what the photographs now projected *on the screen of images* as 'Child Abuse': the title of her scripto-visual project for *Art Forum* (Figures 22–5).[30] I suggest that the photographs performed sculpturally, setting intersubjective relations into space and configuration. I want to perform a close reading of the *Art Forum* project as a work precisely to avoid rendering it transparent, as a mere confession that provides the explanation for the charge of Bourgeois's art that formalist analysis alone never could. Its abstract uncanniness too easily is reduced to a reductive, anterior narrative explanation.

Child Abuse performs as an artwork, uniquely combining the voice (through a mode of address in the written text) and carefully selected, altered and juxtaposed images from an archive of photographs with contemporary photographs of Bourgeois's sculptures. Composed of four double page spreads, four pairings unevenly combine word and image.

On the first double page spread (an unusual design decision to start any article on the left-hand side) there are two photographs taken on the same holiday in Mont Doré in 1922; mountain air was good for Madame Bourgeois's chronic emphysema. (Figure 22) The left-hand image shows a smiling Louise happily with her mother, the right-hand one a scowling Louise squirming away from her father. Bourgeois has flipped the photograph of mother and

daughter to create a symmetrical pattern with the child placed alternatively to the left and the right of each parent. On the opening the limited text places the title *A Project by Louise Bourgeois* to the left and in pink-purple lettering *Child Abuse* in the upper right of the photograph of child and father.

A statement of divided loyalties, the spine splits the traditional Oedipal triad into two pairs. Working under Bourgeois's instructions, French artist Mâkhi Xenakis photographed the sites of Louise Bourgeois's childhood and school years. Mâkhi Xenakis photographed the architecture and spaces of the Lycée Fénelon attended by Louise Bourgeois as a child in Paris, including a large sculpture standing at the foot of the staircase in the school of self-blinded Oedipus supported by his daughter-sister Antigone.[31] (Figure 26) Xenakis herself makes the association with the photograph of Louise Bourgeois and her father in *Child Abuse*, which is at once totally coincidental and suggestive because of the overlay of memory and myth and the chance figurations that we find in the family album of the bourgeois/Bourgeois family. Onto the photographs of her childhood, the septuagenerian artist imposed a retrospective reading, selecting her double layout to dramatize and articulate what she made visible as a structure in a divided Oedipal structure, presented with formal symmetry in order to point up emotional dissymmetry.

The project's voice enters in the second spread (Figure 23). On the left page is a photograph of a Bourgeois sculpture titled *Eyes* (1972), a monolith topped by two round, hollowed stones which function as images of enlarged and exaggerated eyes, signifying both sight and vision; being unseeing, they also signify blindness.[32] The abstract form is sufficient to suggest a human body, upright and solid, while the circles stand for intensified vision, like a representation of a Freudian baby in which the eyes function as the mastering of a world the otherwise incapable body cannot control. This image is also one of stern judgement and is paired with an idyllic photograph of a woman in summer white and a child in a boat sliding under a bridge on a river. The text declares:

> Some of us are so obsessed with the past that we die of it …
>
> Everything I do was inspired by my early life.
>
> On the left the woman in white is The Mistress. She was introduced into the family as a teacher but she slept with my father and she stayed for ten years.

The Mistress is cast as agent. 'She slept with my father.' Brought in as a second mother and older sister, she betrays the children. Rather than being seduced, however, by the employer, which was the traditional risk to vulnerable women entering into bourgeois and aristocratic households and the source of both literature – *Jane Eyre* by Charlotte Bronte being the most romanticized and moralized version – and psychoanalytical case studies, The Mistress 'sleeps' with the father.

The governess, seduced by the father, occurs in Freud's infamous case study of a young hysteric whom Freud named 'Dora' (Ida Bauer), and is the source of Dora's precocious sexual knowledge as well as a source of identification as a used woman when she imperiously gives Freud 'two weeks' notice'.[33] I am not the first to make this connection. Mignon Nixon suggests Bourgeois knowingly played with the positions of both 'Dora' and Freud.[34] I read the potential echo somewhat differently. The Freudian case study offered a structure through which to read the psychodynamics of the Bourgeois household. Its difference, however, lies in the prolongation of the situation. The key phrase here is: *ten years.*

As I mentioned above, during her analysis in the 1950s, Bourgeois discovered her repressed anger towards her hitherto 'loved' governess. In 1982, in conscious retrospect of this formulation with photographs and sculptures, she reclaims as a burden a kind of sub-knowledge that had been endured on a daily basis, so that now in retrospect each exchange with Sadie Richmond in her role as English teacher is coloured with an uncanny sense of her nightly role as Mistress in the father's bed which went over the years that Louise Bourgeois was eleven to eighteen – that is, throughout the years of becoming an adolescent and a young woman. Is it only in the present that the artist is *seeing* the import of this now corrupted time, made different through fuller, afterward understanding of the betrayal? Is the later recognition of this history, discovered as an adult in analysis, now rewriting unacknowledged but sensed disturbances of those years? The event is happening in the now of the artmaking.[35]

Bourgeois tells us that one of Sadie Richmond's roles was to drive the family car. Only when Bourgeois herself was eighteen and got her licence were *she and her mother* finally able to be alone when driving – i.e., free from the unspoken, awkward and endlessly troubling relations between the trio of women, two of whom as adults knew well enough what was going on. So we must imagine two triangles: father-mistress-daughter and mother-daughter-mistress, each as disturbing or disturbed as the other and both occurring over a prolonged period of the daily life of the artist's adolescence but surfacing in the artist's intellectual and aesthetic maturity, as potential knowledge rather than childhood's enigmatic and unbound affect.

The third spread (Figure 24) pairs a misty photograph of an architectural gateway to a mansion/chateau flanked by two sculptural pillars topped with carved female heads (the inversion of the *femme maison* drawings with houses as heads and human bodies as these have sculptural bodies and human heads). In the light of the preceding image, an entry between two stone women guardians generates many possible analytical associations of both two *éminences grises féminines* as well as entries into female bodies, into femininity itself. The text reads:

> Now you will ask me how is it in a middle-class family a mistress was a standard piece of furniture? Well, the reason is that my mother tolerated it and that is the mystery. Why did she?

> So what role do I play in this game? I am a pawn. Sadie is supposed to be there as my teacher and actually, you, mother, are using me to keep track of your husband. This is child abuse.

'You' – an addressee, an interlocutor enters the textual scene as outsider and interrogator. Statements become questions, as if we have shifted to an analytical, dialogical scenario. The stoniness implies permanence, a perpetual splitting of the feminine figuration in order to enter into the building/house/home/identity. The complaint is made also that she – the *I* of the text – was a go-between, called to experience the adults' negotiations and conflicts.[36] 'Dora' also complained of being a pawn in the negotiations between her father and Frau K, his possible lover. It is the psychic position of the masochist. The text also introduces the mother's knowingness, hence hers is a betrayal as well.

This image of the two figures, on the vertical axis, is juxtaposed with a photograph of a smaller version of a sculpture with a female head, *Fallen Woman* (1981) in white marble on a horizontal axis: standing and dominating versus helpless and fallen. The size suggests a child in relation to the monumental stone figures opposite, but she is utterly impotent without limbs. Fallen woman is the term for a seduced woman in moralizing, classed and sexist nineteenth-century terminology. This text reads:

> Because Sadie, if you don't mind, was mine. She was engaged to teach me English. I thought she was going to like me. Instead of which she betrayed me. I was betrayed not only by my father, damn it, but by her too. It was a double betrayal. There are rules of the game. You cannot have them breaking them right and left. In a family, a minimum of conformity is expected.

This is the voice of both the betrayed child and the analytically aware adult reconsidering the situation in terms of a judgement about adult responsibility towards the vulnerable. Adults should be steadfast guardians, not wayward and treacherous fallen women, ultimately cruel in robbing a child of her childhood trust in adults as carers, and forcing her into a precocious sub-knowledge of sexuality: seduction from all sides.

The final spread (Figure 25) is architectural as both photographs are of interiors with staircases, one looking up and one looking down. Staircases will figure in two very powerful *Cells – No Exit* and *No Escape* of 1989. Both images show the home or work spaces of the sculptor's house in New York, and both show works by the sculptor. On the left the viewpoint is a downward gaze at one of the steel components of a double sculpture named *Maisons Fragiles*

(1978, Figure 19) clearly related to *The Blind Leading the Blind* (Plate 6) and onto the spaces of the *Cells* in the 1990s, in which emptiness will be otherwise generated through assemblages of things. On the right, suspended by a vicious-looking hook, dangles the rough version of the sculpture named *Fillette* (1968) in latex and plaster. One of the most overtly sexual and phallic of Bourgeois's works, *Fillette* is a tall shafted object with two bulbous round forms at its base and an outer sheath from which emerges a second sheath and finally an egg-like 'head' of different texture. The title switchbacks us from the evidently masculine, phallic object we cannot but 'see' – an erect, uncircumsized penis with balls – and what is obviously not an erect penis since this is not an anatomical representation of genitalia. In this presentation, we do not know its titling 'in the feminine': *fillette: little girl*. The mother of three sons, Louise Bourgeois made many tender evocations of the masculine body and its pre-sexual organs. These resonate with any mother of sons, whose penises and testicles have been tenderly cleansed with care because of their vulnerability and later significance to the boy who will become a man and potentially a father. Much of Bourgeois's abstract exploration of the masculine body is done in marble, and is marvellously sensual and tender, and utterly maternal while infused with much else that is not adult heterosexuality. But *Fillette* is an ugly thing, made with latex and plaster and still very rough-surfaced, hung up helplessly and viciously by a butcher's hook through its slightly retracted 'foreskin'.

One reading might be that somehow something so abject and yet significant in mythology that its symbol, the phallus, rules our phallocentric cultures – the penis – was the almost detached site of untamed needs that 'ruined' the life of the girl, the *fillette*, the little girl, the little daughter forced precociously into knowledge of its desires and its places. Such forced knowledge should have been veiled for the daughter to pass through childhood latency and enter into her own sexuality as a discovery for herself. The little girl was too exposed precisely in that period of transition from latency to puberty, forcing the daughter, named for the father, bearing both parents' names, and offered as the son he had desired because she resembled her father, into an anxiety-ladened sub-knowledge of sex as something done between others rather than something aroused and felt in herself. Thus the voice of the text rises to a crescendo:

> I am sorry to get so excited but I still react to it.
>
> Concerning Sadie, for too many years I had been frustrated in my terrific desire to twist the neck of this person.
>
> Everyday you have to abandon your past or accept it and then if you cannot accept it you become a sculptor.

These two images are, therefore, examples of what it means to become a sculptor because you can neither abandon nor accept your past. This does not make the past the explanation or make the sculpture autobiographical. The opposite. There is a past which, in effect, involved a kind of murder: retrospectively recognized murder of the child's innocence and secured space within the frame of the family that should abide by some rules sufficient to enable the passage into adulthood and sexuality without incapacitating hindrance. Instead there was a trauma, which is a trauma precisely insofar as it leaves an undigested trace: the past, that cannot be mastered and become structured as a bearable memory. Some dimension of that past is so excessive that it only registers as dangerous rage. There is also the perplexity: Why? How? Did no one take responsibility for what it was doing to me – mother, father, mistress? Once confronted with its emotional aftermath during analysis, this betrayal by all three adults must have felt annihilating.

Juliet Mitchell has recently returned to hysteria, almost a century after Freud's 'Dora' case study and the disappearance of hysteria as a key term or analytical category in twentieth-century psychoanalysis. Mitchell's radical move turns our attention to siblings – that is, to the lateral relations within a family that psychoanalysis has almost exclusively thought through vertical, generational structures.[37] Mitchell shares with Elisabeth Bronfen's earlier feminist return to the field the understanding that hysteria is, at its core, not about sexuality, but about the trauma of mortality.[38] According to Mitchell, however, the arrival of a sibling has a mortifying effect on the child it displaces from the breast, from the mother's attention, which is akin to dying. If a thing like me – another loved one – arrives, deposing me from the sense of total absorption in and by the Big Other/Mother, the event is experienced by the child as a kind of death: I, still in the process of emerging as a singular self-recognizing subject, feel as if I, who can be replaced, am, therefore, nothing. Bourgeois was the third daughter and second surviving child, followed by a longed-for brother who did not take on the full role of the wished-for son. That is one structural complexity in this family to consider. As she was growing into her own femininity, she was displaced again by a different kind of 'like me' – a young woman, not of her mother's generation, but within spitting distance of her own and her older sister's. Sadie Richmond was about eighteen when she arrived. We must thus move beyond patronizing or condescending acknowledgement that Bourgeois's family story was troubling. I am sure that the event created many symptoms as means to manage the crisis Sadie's coming and staying for ten years created. But as trauma, the prolonged endurance of the continuing dysfunction was hysterogenic. Hysteria is a register of trauma because what is at its core is radically unthinkable: non-being, being nothing while not dead, since the subject has to live on with the feeling of having become nothing.

So many of the actual anecdotes told by Bourgeois return to annihilation by words or deeds, situations which left her with little to build upon – being taken out of school to work for the family, being belittled at table by Louis Bourgeois, being patronized by masculine avant-gardists. The deepest question the hysteric lives with is 'am I alive or dead?'. This is overdetermined in relation to gender and sexual difference: 'am I a man or a woman?' For Louise Bourgeois in 1982, the answer to the inevitable living with the 'return' as known memories of a traumatic past that is about a virtual murder of the child, and hence the desire to murder in revenge the other child who took her place – just like Freud who wished away his young sibling – is to become a sculptor: to fashion forms, carving, cutting, moulding, joining, casting, sawing, sewing, adding, removing, hollowing, building up, staging, returning, reworking. This sounds very Kleinian; art as aggression and reparation. But I am suggesting that making art creates a passage for trauma through the processes of aesthetic transformation, which is not and cannot be *expression* of a known content, for there is nothing with any shape to express or represent. But there is a kind of journeying away from the traumatic emptiness of hysterical (non-)being into an assertion of being through the physical manipulation of the world of things, the building of spaces and forcing relations between them that will remember the scenario to house the moods of time lived in the space of these relations.

Bourgeois's sculpture formally produces a geometry of dislocation, separation, absence and endows its forms with a feeling of deathliness that is sometimes otherwise affectively coloured with something less drastic: longing and the image of possible connection via the fragility of the web. I suggest that we can now trace the journey towards the trauma that was re-encountered in a photographic display at the very point of the retrospective assemblage of her work to date that affirmed her visibility as the sculptor she had become. The retrospective mirrored Louise Bourgeois the sculptor, but the attendant revisiting of the past through the photographic record held before her eyes again as *pathos formulae* the primal scenarios that she had always known in her muscles and moods, as it were, and for which an abstract or semi-abstract, allusive visual vocabulary had served, or been the only possible one, *up to this point.*

Bourgeois was too sophisticated to imagine that suddenly, in 1982, she had found the truth of her troubled past which she had always sensed and even spoken of as being the source of the pain in her life which drove her to make art each day. But in 1982, she had re-encountered and artistically identified the *photographically mediated scene*, or setting for emotions and pressures that were henceforward to fuel a whole new phase of her creative practice, because of an enabling encounter that introduced into her environmentally conceived sculptures a newly acknowledged psychoanalytical understanding of the affective lining of her geometry. Sustaining but never performing narrative, her *Cells* might be called cinematic melodramas were they not in fact closer

to the still-frozen momentariness and depth of the photographic still or freeze frame. What evolves was, therefore, not merely a matter of emotions and memories, which were rather clumsily recognized by a still perplexed Lucy Lippard in 1975 as fundamental but almost excessive to the intensity of the work of Louise Bourgeois.[39] The potential significance for her artmaking of this 'becoming re-acquainted' with a past that was disclosed anew by means of photographs (rather than what had been lived as an incessant anxiety and sense of defenceless isolation of which Louise Bourgeois talked in interviews before 1982), coincided with cultural shifts generated by emergent feminist culture. Louise Bourgeois would benefit from this coincidence between her own looking back and emergent feminist culture in becoming, despite her age, one of its most potent artistic practitioners.

Far from considering this project in *Art Forum*, therefore, as a confession and an explanation, I read it as the vocalization of subjectivity in crisis, speaking in its shifting voices, addressing Sadie, the mother, the parental couple and the world to whom the 'speaker' apologizes for her agitation and to whom she formally addresses the issue of how art practice and a past that will not go away are related in the *act of making*, not in the image that is made.

It is also a written text. Louise Bourgeois was a reader of Françoise Sagan's novels. *Bonjour tristesse* (1954), for instance, is a book which is claimed as the initiator of what would later become a river of woman's writings which explored psychological dramas based on family dysfunction.[40] Think also of Simone de Beauvoir's powerful novel *She Came to Stay* (1943) and others in which the normally self-possessed philosopher writes through and acknowledges the unbearable and murderous rage of jealousy. Thus the nature of the shifts we see in the work of Louise Bourgeois after 1982, building up to the works that are rightly called the *Locus of Memory*: the *Cells* of the 1990s, are the product of a major historical coincidence. At once, they became possible when the artist moved into a large industrial space as a studio, finding in it new materials there were the remnants of a sewing factory. Equally, feminist and other postmodern aesthetic and cultural reorientations enabled Louise Bourgeois to reshape, in this expanded space and new resources, her *artistic* vocabulary to parallel what it had already been possible for Sagan and de Beauvoir to say in novels in the 1940s–50s, a time when it had been impossible to imagine translating what they were saying in literature into visual art under the hegemony of formalism and abstraction.

The creative feminist environment became belatedly more hospitable to the genius of Bourgeois as she grew into the *fin de siècle* culture for which she then created such memorable monuments as much out of the industrial detritus of the great city she made her second home as out of the texture of memories of a lost French childhood spent in the shadow of the First World War at the end of a particular era of gendered culture.

Webs and spiders: the geometry of loss

Louise Bourgeois has made statements about spiders.

> The theme of spiders is a double theme. First of all, the spider as guardian, a guardian against mosquitoes. I've lived in houses in Connecticut where the sky was black with mosquitoes. So the house became unliveable. But spiders ate them. The metaphor has assumed enormous proportions. When I travelled in Africa, fear of mosquitoes was enormous … The theme has much more to do with fear of mosquitoes, AIDS or infection than with spiders. It is a defence against evil. It is an eternal battle between good and evil whose ubiquitous dimension is obvious. And the evil is really AIDS. The other metaphor is that the spider represents the mother.[41]

Alongside the composite of woman and home of the *femme-maison* pieces – which evoke both homesickness and a calling out to be rescued – and the isolated standing figures in non-communicating crowds of the *person-ages*, the spider was a long-standing motif for Louise Bourgeois. First used in drawings of the 1940s, it was abandoned to be reclaimed in 1995, culminating in the most monumental sculpture of the arachnid series, created in 1999 for the opening of the Tate Modern at Bankside in London in May 2000. Titled provocatively *Maman*, the steel sculpture weighs 11,000 kg and stands 10 metres high. (Figure 14).[42] Jerry Gorovoy confirms that Bourgeois created a work on this scale because of the commission to create for the Turbine Hall. Placing *Maman* on the bridge that divides the large hall, *Maman* was visible at the height of the other three towers, I DO, I UNDO, I REDO, forming the fourth 'tower', and further elaborating the guiding theme of the installation, 'the Good Mother'.[43]

I encountered *Maman* in an installation of one of the bronze casts in 2006 at the contemporary art foundation at Wanås in Sweden. The sculpture 'stood' on the edge of the woods surrounding a medieval Swedish castle, changing with the seasons. In winter the bare branches echoed the spidery legs on the point on lumbering out of the forest (Plate 7). In summer verdant greenery engulfed the sculpture, while setting off each dark limb, intensifying the effect of imminent movement while returning this creature to a natural habitat (Plate 8).[44]

When I confronted this the largest and most monumental of Bourgeois's free-standing sculptures in all its majesty, mystery and intriguing presence, questions tumbled around my mind. I did not yet know the precise details of its commission. Its presence made me ask: How did she imagine this creature, with each leg placed exactly in these specific positions? How should I respond to the soldered cut steel tubes (now cast in bronze) that created the effect of a lean human musculature on the arachnid legs? Why did she seek a great architectural space whose struts are these knotted and musculated legs that

almost form a perfect circle except for one dainty pointed leg that steps outside the ideal geometry? Did she see both whole structure and the inner space it would create in her mind? What is the experience of the dialectic between a hospitable, encircling and protective interior and a vast open structure of self-contained and radical alterity? Should we stand beneath its legs, feeling its mighty form as a kind of home, resting under the sagging underbelly of the nest containing its load of marble eggs? Or should we remain outside the limits that its eight gigantic legs establish as its 'space', delimiting its menacing otherness as a monumental sculptural presence?

Is it a monument to a creature much respected by the sculptor for its destruction of dangerous insects? Is it a surreal self-portrait of the artist created, in the manner of La Fontaine's fables, by condensing fears, phantasies, memories and identifications into a mythic insect? Is a composite portrait of the maternal *Other* best revealed in a fabulous and uncanny metamorphosis from the human to the arachnid?

Is its title *Maman* its subject? Or might it not be nominative but vocative, a calling out: *Maman!*?[45] The sculpture gives a geometry of space to the sound of subjectivity. That indexes its reading to both *maternal absence* and Matrixial yearning.

Since beginning sculpture in the late 1940s Louise Bourgeois explored the space between architecture and sculpture. Her spaces are simultaneously structures and evocations of bodies, of relations and of the dramas that occur between people when there is both interaction and isolation. These formed Bourgeois's evolving language for the exploration in art of aspects of intensely affecting but intersubjective experience: desire, rage, tenderness, humour, shame, isolation, depression, betrayal, jealousy, anger, defencelesness and its defence, aggression. But I do not feel that these are the tenor of *Maman*.

The spiders are easily associated with the artist's mother, Joséphine Faurriaux Bourgeois who was a professional repairer of antique tapestries. But Madame Bourgeois died in 1932 when her daughter was only twenty-one. This was a catastrophic loss, reaffirmed by the artist herself repeatedly. In an interview in 2003 Bourgeois responded to Paulo Herkenhoff's question: 'What were the biggest losses in your life?' with the answer: 'The death of my husband and the death of my mother. So 1932 and 1973 are dates that I cannot forget.'[46] Bourgeois was widowed at the age I am now as I write: sixty-two. She outlived her husband by thirty-seven years.

Reductive biographical explanation becomes banal in the face of the existence, at this scale, in this form, in this material, made in this manner, of this sculptured object, which is at once an architectural and a mythic object, holding in its forms unspecific traces of trauma. Many Bourgeois sculptures attest to an abiding fear of abandonment and pain at separation. But how is either inscribed psychically or aesthetically? As I have already argued, trauma

is not available to be expressed; it cannot be represented. The effects of structural traumas of subjectivity (separation, primal scene, loss of the loved object and loss of the object's love, castration) are constant. They bequeath to later, historical events like bereavement (abandonment, loss of the loved object) the intensifying affectivity of something that has not yet been experienced but which inchoately colonizes secondary events with a surcharge of unbound anxiety that registers the archaic impacts. Thus being divorced or widowed may precipitate the emergence of the unbound affects – anxieties associated with earlier, ungrievable losses that are the result of a death as well as inheriting the legacies of structural separations which all of us experience as the price of becoming a subject but also the historical traumas such as the premature death of a mother or father or other losses of innocence. The betrayals and formative separations of infancy carve into the psyche the grooves through which later historical separations and abandonments will course, each deepening these pathways and being themselves deepened by inherited affects. Losing Robert Goldwater and widowhood in 1973 could have been the precipitating event that made other, earlier events such as the orphaning death of both of the artists' parents, and her exile, become more acute, and at the same time, become the material for measured aesthetic inscriptions offering the relief of signification. The power of art to transform was sustained by both new directions in sculptural form and materials investigated by the artist and by new legitimations of artistic possibilities for dealing affectively with loss, offered by the emerging feminist cultures that dared to reconnect art to lived experience.

To re-encounter *Maman* as an invocation of the missing matrixial *m/Other* (Ettinger) cannot identify the sculpture with any single person or image. That which functions as what is 'the missing something' is not what traditional phallic theories of subjectivity propose as the lost object that becomes the missing origin of a chain of substitutions, namely the maternal body of infancy or Mother. A supplementary psycho-subjective dimension also lines our longings for the Matrixial web of connectivity.

Classic psychoanalysis from Freud to Lacan plots the story of the formation of the human from speechless if noisy and helpless *infans* to sexed and speaking subject, through a series of separations and cuts, culminating in castration, which precipitates the subject from its pre-Oedipal corporeal intensities and phantasies into the realm of the Symbolic, that is, of the signifier, severing the subject from all the preceding corporeal passions of the archaic field of infancy. Thus that which makes us able to articulate ourselves through the linguistic signifier 'I' exiles us from what is thence produced, at/by this moment of castration, as *the* condensed lost object of desire, an object (person or substitute) that is imagined as that which might make us – marked by castrative schism – 'whole' again, that which can repair our severed form, that which might assuage our lack, because, of course, the price of becoming

a subject under the law of the Father is that we must give up what we primordially want/need (which was contact with the Mother). The lost object retrospectively becomes a condensed image of the pre-Oedipal mother (not a person but a function, a space, a source of nourishment and nurture) which is, however, thus retroactively posited equally as a kind of deadly fusion prior to and excluded from the differentiating, syntactic Symbolic register upon which individuated subjectivity is formed. Since Woman/Mother is the sign of this lost object, in classic psychoanalysis, Woman/Mother is effectively identified with fusion and hence asubjective non-being, with a death that came before and which awaits us. Desire, created by the cut of castration, propels us to locate the phantasized Mother of the pre-Oedipal period as that which will elusively function, in a delusory fashion, as the forever-before-us lost object through which to become whole again, one with the world, while nonetheless aligning that maternal with non-being, death.

Ettinger's Matrixial theory shifts without displacing this phallocentric account. The Matrix, a signifier-symbol like the Phallus, and hence not an organ or a place but a logic, counters phallocentrism's identification of Woman as Other and Thing exiled utterly beyond the Symbolic, without being except as lost and, beyond that, death. The Matrix, on the contrary, supposes a maternal-feminine logic of severality as foundational for life-desiring aspects of subjectivity and sexual difference, not substituting mother for father, feminine for masculine, but shifting the phallocentric logic of +/- by proposing an earlier but persistent Matrixial logic of severality in which there is indeed difference and loss, but never absolute as the phallic logic decrees. Ettinger theorizes *subjectivity as encounter* and a matrixial Eros seeks connection and living beside.

The Matrix thus inserts into our self-understanding a Matrixial web of shared events resonating differentially in each partner-in-difference in their prolonged *co-in-habit(u)ation*. This dimension emerges in phantasies that are paradoxical for phallic ordering of meaning but make sense in terms of what Ettinger formulates as *shared borderspace* and *borderlinking*:

> Intra-uterine fantasies in adults and children point to a primary recognition of an outside to the me, which is composed of the inside of an-other … In my view these are traces of joint recordings of experience related to the feminine invisible bodily specificity and to late prenatal conditions, emanating from joint bodily contacts and joint psychic borderspace. I have hypothesized that a certain awareness of a borderspace shared with an intimate stranger and a joint co-emergence in difference is a feminine dimension in subjectivity.[47]

This primordial subjective dimension registers its time and space through specific kinds of aesthetic registers: resonance, rhythm, vibration, intimation of otherness, which we have recognized as being sought and generated specifi-

cally in the researches of modernist art that transcended the predominant model of opticality.

As a result of the Matrixial dimension's prolonged process of shared eventing, birth is experienced, however, as a traumatizing expulsion, not from undifferentiated fusion within a merely corporeal container – the mother's body – but as an exile from a prolonged proto-psychic '*fascinance*', the condition of co-eventing with an unknown otherness in shared borderspace by traumatically jouissant means of sensations, attunements, dissonances and impressions.[48] As Freud already acknowledged, interuterine existence and pregnancy are not merely biological hence non-psychological processes; they return as phantasies and through the very key aspect of the aesthetic experience itself, the uncanny, defined as the return of the once familiar that should remain repressed.

Thus this primordial structure may be retroactively recovered in phantasies and thoughts including the making of and experiencing via aesthetic events if appropriate forms, spaces or signifiers are generated to catch its traces and resonate on its specific sub-symbolic, sensory and affective wavelengths. The Matrixial as psychic structure is defined by a sharing of a borderspace between subjective elements that are, for its duration, outside of the post-natal subject/object dichotomy. As a subjectivizing situation, the Matrixial, however, may produce its own trauma (by which I mean both a structural event which happens without the psychic apparatus to metabolize it, and also a specific kind of wounding of the potentiality for co-eventing and transsubjective responsiveness) and hence has its own patterns of loss, as well as its own forms of desire and of mourning. It also generates its own kind of Eros. Understanding the Matrixial can contribute to understanding the trauma of grief.

What is lost (desired and mourned) is not, therefore, the imaginary phallic object (that the pre-Oedipal mother becomes) that might make the castrated subject whole again. What is lost and hence desired or rather in Ettinger's terms *yearned* for, postnatally, is the traumatically inscribed web of *connectivity*. A sense of sharing differentiated events and affects inflects any sense of space with psychic significance in relation to being with an unknown and unknowable other sharing in a profound life-changing, life-giving *poietic* intimacy that is unlike others. To lose the mother of phallocentric formation is to lose the phantasized object which can be substituted eventually. To mourn, in the loss of the postnatal mother, the cessation of a living, unconsciously affecting psychic string with its archaic and uncognized origins in borderspacing, is to experience both phallic grief for a lost object and Matrixial grief for the shattered web of a primordial 'being with' in life.

The Matrixial maternal cannot be thought outside of the shared psychic borderspace and transsubjective connectivity which are a source of solace and a site of compassion as well as a potential site of specific kinds of trauma if it is

later damaged by violence, hatred or bereavement. Matrixial strings make us vulnerable. Losing the actual person who is a mother will operate according to phallic inscriptions of the loss of the loved object and support of all post-natally formed erotic attachment. It will also, however, activate a parallel Matrixial grief of a different order for the person, whose actual presence as a living mother in post-natal relations sustained and activated the archaic memories of the primordial Matrixial transsubjective severality in which all humans, irrespective of gender and later sexuality, intuited their most primary humanizing becoming *with* the m/Other. Ettinger distinguishes between the Mother – a post-natal imago, phantasy and presence that may be abjected or separated from under the law of Oedipalization and castration – and the *m/Other*, a sexually specific, feminine otherness in partial relation to which a non-gendered proto-subject will emerge, signalling our primary encounter with feminine, sexual difference.

Louise Bourgeois spoke of her grief for her mother whose body she could still 'feel', so intense was her 'memory' of the corporeal, hence aesthetic, intimacy.[49] She also spoke of her intense sensations when holding her own children skin to skin. She revealed her post-partum depression, the acute feminine grieving occurring on the point of becoming a mother that may have been activated in part by wounding to the Matrixial web, into which the new mother-subject re-entered phantasmatically in becoming the pre-maternal partner in a new Matrixial web of human becoming, caused by mourning for her own mother. One of the artist's very late drawings is entitled *Post Partum Depression of the Mother.*

Precisely because Matrixial theory does not traffic in objects or substitutes but in theorizing webs, strings, resonances, spaces, connectivities that we encounter aesthetically, it holds many potentialities for reading aesthetic processes which involve geometry, space and relationality and for non-reductive understandings of the affective field charged by a form of expanded sculptural work that forms spaces positively or negatively – forms in space or forms for space, hence for absence, and that thinks in geometries and rhythms, that works so often with both space and the intimation of a subjective experience *in* rather than *of* that space. In a sense, the radical affectivity of abstraction is rescued by this feminist theory from an overly cerebral model of disowning and transcending materiality or from one that plunges it simply into abjection.

My suggesting that *Maman* as a sculptural space and structure might be heard as *Maman!* – a call – does not identify the sculpture as a metaphor for a mother. Grandeur, strangeness, and scale indicates that any such a invocation must be 'heard' visually as an inner voice not just of a child, but from the pre-child within the woman, calling not only to its post-natal mother, but to its prematernal partner in prenatal becoming, the *m/Other*. Hearing the title in the vocative: *Maman!* thus invokes a sensitivity to loss lined with

a longing for reconnection with a primordial web of relations in difference, a repair to a fractured, initiating Matrixial web. This web has been lured into and trapped by the sculptured architecture and space that invokes a missing m/Other, while also endowing the characteristics of the sculptured form, its structures, its spaces, its scale, its dialectic of interior and gigantic otherness, with a range of associations both personal and generic not only to a mother, or even to *the* mother, but to the m/Other *as the site of a connection for which the subject of loss yearns.* The sculpture is hence never this or that, one or the other, and not even simply a confusing both. It must suspend that very kind of thinking of either/or, in order to hold us enthralled before an intensity that does not rest in it as sign. It can be a *pathos formula.*

Louise Bourgeois said that she lived the residues of her childhood in the daily fragility of her emotions and moods. She turned to different processes and planned different works according to their changing rhythms. The making itself soothes, releases or agitates because formalized space is the product of her artworking. Artworks may be driven into existence by certain forces and phantasies, but they are shaped aesthetically in their making processes into art objects, ensembles or spaces that, as Freud taught us, will only lure us in to share in them if they bribe us with a supplement of aesthetic pleasure, and disguise their own individual origins in something sufficiently structural to speak to the feelings, memories and unconscious pressures of others – all of us.[50] Why do we care about Louise Bourgeois and her mother-loss unless something of their (particular, culturally specific and historically placed) relations already marks a more structural complex of infant/parent, mother/daughter interaction, pathos and anger, love and desolation, in which we, in all our diversities, are also psychologically formed and to which her works invoke us too?

The bourgeois family romance is told to us. The artist tells us it holds her in its perpetual grasp; it is her childhood that is the source of her creative energies, the invitation to unplumbed resources. This is not a confession to release us from the work of wondering what her art is doing. It is a statement of the fundamental post-psychoanalytical, twentieth-century insight, not a private admission of retardation. Bourgeois's intelligent and often shifting statements too easily allow critics and others to offer this story by way of explanation, thus falling into the trap of believing that this traumatic childhood preceded the art work, *rather than only being revealed by it for the first time as an event when it was spoken or represented as a memory in the process of artmaking.*

For, of course, the story explains nothing. It is the storytelling, the artwork in itself, held before us by photographs whose significance we, even she, cannot really decipher. They support but also produce memory. Freud taught us that we must always look beyond the surface manifest content of the stories we tell

ourselves and even the dreams we remember. The elements of the story/dream must be analysed as a screen that holds its enigmatic forces in a latent form that can only be uncovered through tracking the relations between elements that unconscious censorship and repression force to stay apart, fragmented, displaced, condensed, hybridized with residues of daily life.

Memories are only the surface of what transpired, the fragments that become scenarios and anecdotes through which the slow, recurring, continuing unspoken pressure of emotionally loaded relations and anxieties were lived. The scenario of the dining room table at which Louise Bourgeois tells us that she moulded her overbearing father out of bread and then cut him up into pieces before phantasizing his consumption could be true. Yet such a classic Freudian/Kleinian scenario of aggressive cannibalism seems to me to be too wonderfully knowledgeable, too cannily recalling Sigmund Freud's troubling theories of the origins of religion in the totem meal eaten by the jealous and angry sons who rise up to revolt against the overbearing Primal Father who keeps all the women to himself.[51] The sons kill and consume the father, before, guilt-laden, setting him up as their totemic god – often in animal form. Surely, a woman who had spent her younger years among the literalist Surrealists reading Freud's more outrageous metapsychological papers would anticipate that we would pierce this homely tale of patricide and cannibalism at the family dinner table and see that it is both referring to a mythic precedent and reminding us, in frank psychoanalytical fashion, that Freud's hypothesis about such an origin of human culture and religion was, in fact, the result of his hearing the repetition, in phantasy, of such wishes daily in his consulting room. In everyday life, at the dinner table not just of the dysfunctional bourgeois Bourgeois household but in every household, phantasies of this order are at play. Louise Bourgeois entrances us by giving them both form and verbal articulation. In this context, I see *Maman* as the culmination of many years of research and experimentation in forms and media. Moreover, it delivers a counter-myth to Freud's tale, by fashioning a perfectly brilliant but *maternal* totem that at the same time defies the phallic logic by which totems emerge: fetishism. It is suspended mobility always ready to weave new webs and bear infinite fruit.

The title, *Maman!* situates the viewer in the position of the child – the child that must make sense of how the *one* comes from *two* as the sexed child from parents of different sexes. The child must also submit, in that terrible division which is sexual difference – the division between desire and identification (a division unknown in the pre-Oedipal moment) – to being aligned with a gender and a sexuality that are formed as both a psychically-differentiated linguistic and a socially-determined positionality in culture. In Louise Bourgeois's family romance, the axis of Oedipalization is made more complex, as I have elsewhere discussed it in terms of a colonial childhood, by

the presence of two women, mother and nanny.[52] This doubled-mother structure has already a place in Freudian theory, in his analysis of the men of his generation who, having been brought up by a physically proximate but socially lower-class nursemaid or nanny, idealized their remote and angelic, decorporealized mothers, causing them to split the eroticized and physical from the emotional and affectionate attachment to their angelic mothers. For many men, the attempt to reconnect the sensual and the affectionate streams in puberty fails, and Freud spoke of men who could not love where they desired and only desired where they could not love, leading to a tendency to debasement in the sphere of love, the classic masculine double standard.

In the case of girl children, however, the relative social status of the idealized mother versus the servant-nanny, especially if she is black or in any way othered by class or religion, as in the case of Freud's Catholic Czech peasant nanny, the social division repeats the Oedipal structure forcing upon the child an agonizing choice of identification across more than gender. The child must choose between the empowered white or bourgeois mother and the disempowered yet intimately and daily attentive nurse-maid.[53]

What psychologically sabotaged the Bourgeois household was the apparent negotiation of a triangle between the parents and the children that was impossible for the intuitive and analytical child Louise to comprehend and to accept. The mother's place seemed to be openly taken sexually by the non-French and lower-class nanny who thus had a privileged place as the father's object of sexual desire, while the mother with whom the daughter would align in identification and Oedipal rivalry for the father, remained the economic partner of this man, mother of his children, a permissive presence, visibly removed or removing herself from the realm of sexuality, yet active economically and creatively, and affectively significant for the daughter who had to find her way to adult femininity by means of this perplexing alteration of the formal Oedipal triangulation in which her imaginary place was so visibly taken over by Sadie.

Such an arrangement fails to provide the means of managing the child's latency period and exposes too early too much of the enigma of adult sexuality while offering no relief through the conventional domestic ordering of the family. What is it to be a woman coming from this *quadrangle* that unsettles the already traumatizing Oedipal triangulation through which we all pass to acquire gender and sexuality – delayed by the immediate onset of latency until puberty – becomes an ever more disturbing enigma that will resonate throughout a later life of anguished infertility and belated procreation precisely in the case of an adult woman living without the continuing presence of her own mother.

I want now to map this scenario onto the screen offered by the myth of Arachne in her confrontation with Athena. Athena is a goddess on her father's side, a father-identified daughter if ever there was one. Yet it is her rage at the

exposure of her father's sexual exploits that causes her to shame her rival in the arts of weaving and textiles, the womanly arts par excellence. The implicit feminine connotations of the goddess in her relation to arts and crafts are displaced by her phallic dress and identification with the law of the father. Yet the story of Arachne exposes Athena's shame at seeing her father's rampant sexuality visually exposed through a mere mortal's supreme skills in creating images in living, moving colour as only tapestry can do. Arachne is both the ambitious, over-proud artist convinced of her worth and ready to compete with the goddess herself: a rival for the place of Woman held by the adult female Other, the mother. This has overtones of a female rewriting of Oedipal rivalry. Arachne, importantly, does not lose the competition with the goddess. She is publicly punished because of what she has revealed in her weavings to the shame of her divine rival. In shame, she in turn kills herself. Arachne is thus a combination of ambition, pride and shame who accepts her submission to the Goddess's Law by suicide. It is the goddess's act of forgiveness that brings her back to life but gives her a life of perpetual weaving and hanging by a thread – not perpetual in herself but in the spider into which she is metamorphosed. Thus she is also the figure of a genealogy of women linked by handiwork.

At the intersection of the entomological study of spiders with their massive females and tiny males, their dangerous mating habits, and dominating or disappearing mothers, and the Arachne myth, we can create diverse but related scenarios that provide structures by which inchoate feelings from childhood traumas might be organized into something else. The whole lesson of psychoanalysis is not that we are the prisoners of our past histories; it is rather that the emotions generated in the inevitably complex negotiation of catastrophic infantile situations of intense love, hate, fear, need, vulnerability and aggression *are transformed* by the pressures of their own force into something else: love, desire, creativity, words, forms, music, phantasy scenarios through which the unspeakably traumatic becomes a displaced representation of 'an unthought known'.[54]

Maternal absence: she abandoned me!

When my mother died in 1932, this rage to understand took over me. I simply could not make out the why of her disappearance. Why my mother died and abandoned me would be clear if the question was perhaps a different one. If the question was replaced by why do I suffer so much from this loss, why am I so affected by this disappearance. Now these questions are impossible to answer. Do I feel guilty? Does it represent a danger? Does it repeat the trauma of abandonment? You fear abandonment, it keeps you in a state of dependency, which makes you feel you are unable to cope.

Louise Bourgeois[55]

Among its many resonances, *Maman!* is for me overdetermined by my own resonances with Louise Bourgeois's position as a bereaved and motherless daughter, the intimate calling out to a m/Other/Mother by a bereaved girl-child.

When Bourgeois made this work and thus called out *Maman!*, the artist was 88 years old. Her own mother had been dead for sixty-seven years, having died as her daughter graduated from university at the age of twenty-one in 1932. The artist Louise Bourgeois thus entered upon her adulthood as what Hope Edelman named in her 1994 study, a *motherless daughter* with many ambivalences unresolved.[56]

Inviting 154 women who had lost their mothers to participate in her survey, Edelman researched the myriad ways in which maternal loss affects women, noting the different impacts on women according to the age at which they lose their mothers: as child, adolescent or, for instance, young woman as she enters into the world of sex and in some cases motherhood, work, recognition or discrimination, her own bereavements and ultimately approaching mortality and ageing. Maternal bereavement is a life-long legacy of loss that both prematurely ages the bereaved feminine subject (she is precipitated often into new adult duties) and arrests some part of her at her age at her loss. This lays the foundations for life-long anxiety that cannot be alleviated because life must thereafter be lived in the absence of the actual woman/mother who represents the living guarantee of the archaic imago of the Mother, a figure for the complex of feelings of intense need, deep rivalry, identification and modelling of what the adult woman might be. The arrest also produces a permanent condition of feeling inadequate to the demands of the adult world into which the bereaved child or young woman has not had time and support to mature. Maternal loss can aggravate archaic and childhood conflicts and confusions which never have a chance to be worked through in adulthood. The woman who loses her mother also loses the friend/other/model who could help her through the shoals of adult femininity leaving her always feeling a childish inadequacy before the challenge of adult worlds for which she is not yet prepared and in which she feels internally unsupported. This is the source of the affliction of recurrent anxiety however old or experienced the woman herself becomes.

In the Bourgeois literature there are references to the historical person Joséphine Bourgeois who was the tapestry restorer, the artist who worked to make broken and tattered things whole again through the finesse of her needlework, her re-weaving of time-erased connections, to recreate the faded stories from legends and myths with coloured wools and cleverly concealed stitches. But little attention has been paid to the structural effects of and thence the artistic researches into such a still ambivalent 'legacy of maternal loss' that may provide another route into the nature of her culture's very belated recog-

nition of Louise Bourgeois as a sculptor only in her maturity.

In an insightful paper written in 1996 (republished in book form in 2007), feminist art historian Hilary Robinson queried the absence of attention to the mother in the literature on Louise Bourgeois up to that date.[57] Robinson recalled Donald Kuspit's concluding sentence to his article in *Art Forum* in 1987:

> Bourgeois's entanglement with her mother, not her father, is becoming clearer as the inner content of her work. She filled the void of the mother/artist in spirit as well as substance, an Oedipus replacing the mother instead of the father, a Sphinx whose guilt is that a story about a relationship to a father is really about a relationship to a mother.[58]

In her analysis of the *Cell*, recently curated in an exhibition in Paris, Robinson called upon Luce Irigaray's philosophy of sexual difference as a specific resource for thinking about the creation of space.[59] In 'The Gesture in Psychoanalysis', Irigaray revisits a classic essay by Freud in which he told the story of his young grandson playing repeatedly with a cotton reel that he threw away and retrieved, each action accompanied by a different vocalization that Freud interpreted as 'fort' and 'da': gone and here, indicating the founding function of symbolization to manage the anxiety occasioned by maternal absence. Irigaray, however, explores the particular ways in which the girl-child (as opposed to the neutral but implicitly masculine child of psychoanalytical theory in general) negotiates the challenging experience of the mother's absences. She posits, based on observations, a different economy that is not one of simple substitution: reel as object and alternating plays of expulsion and recuperation as the plane of mastery. In psychoanalysis, the mother's temporary absence has the effect of precipitating in the child hallucinatory and later symbolic substitutions that serve to hold the physically absent mother in the child's mind. The impetus for symbolization, which will lead to representation and ultimately language, lies in the necessity to cover over the traumatic gap created by the mother's absence – and hence the equation of the mother with the feeling of catastrophic emptiness – by means of play.

Irigaray notes three important differences in the ways in which little girls elaborate rituals to deal with this intimation of absence. First, she may throw herself down on the ground, feeling lost and powerless, refusing to eat or speak. This reminds me of *The Fallen Woman*. Secondly she plays with dolls, loving these substitutes in place of the missing love and creating scenarios of human interaction. Also suggestive. Another response is dancing or skipping and other such spatial games (often humming and spinning), creating 'vital subjective space' around the missing maternal other but 'open to the cosmic maternal world' with the movements of the child's own body weaving its patterns in space. Irigaray states:

A girl does not do the same things when her mother goes away. She does not play with a string and reel that symbolise her mother, because her mother is of the same sex as she and cannot have the object status of a reel. The mother is of the same subjective status as she is … The girl tries to reproduce around her and within her an energetic circular movement that protects her from abandonment, attack, depression, loss of self … There is no object here, in the strict sense of the word, no other that has to be introjected or incorporated.[60]

Drawing on Robinson's introduction of Irigaray, I suggest that instead of seeing the Mother in the Spider in a relation of object to substitute, we are called upon to see a daughter's negotiation of the loss of her subjectively similar/ identificatory yet rivalled other in the symbolic gestures of art, drawing its circles of symbolic space (remember the circle formed by the legs of *Maman* and the circle or spiral as a recurring motif in Bourgeois's drawings) as testimony to this negotiation of separation, making an architectural environment that is also freighted with emotional and characteristic associations through the correspondences of its fundamental shapes and elements to a structure recognizable as an arachnid. For Hilary Robinson, Bourgeois's works are not just installations, but are to be read as 'making manifest a self-determined architectural, material description of psychic space rather than the artist making manifest psychic space within a given architectural environment'.[61]

In 1995, as her fame grew exponentially, Louise Bourgeois was encouraged to return to print-making – as a means of satisfying a hungry art world desperate to ensure a place in their collections for this phenomenon of the 1990s. A suite of nine dry point etchings with a text in a box, size 76×76 cm, was produced for Editions du Solstice, Paris and one set is now owned by the Museum of Modern Art. The title is *Ode à ma mère* (Figure 27). This title makes explicit reference to '*ma mère*', claiming intimacy for this series of etchings. But it has to be grasped not as confessional but as aesthetic inscription, creating the space on the plates, creating related images, each of which is an opaque but suggestive sign, and interspersed with 'voice' in the form of writing that creates an address to a m/Other. The artwork is a poetic scripto-visual invocation of the missing maternal other. The imagery is arachnid on a scale and in graphic styles suited to the medium of the printed book.

The *écriture féminine* of the text also moves unexpectedly between French and English. French is literally the mother-tongue, the mother's tongue, while English was the language of, and was taught to the child Louise by Sadie Richmond, an English woman brought into the household who stayed for ten years as her father's mistress. The two languages might bring into play the two women in the difficult quadrangle of the Bourgeois household but they also index the condition of the artist's exile: a French woman living among Anglophone Americans or Spaniards (who spoke French badly, like Miró apparently). We know that the loss of homeland exacerbates the

unremembered but structuring and ordinary loss of the originary maternal home and the archaic mother's body to which we are all attached in infancy. Premature maternal bereavement, like that which Bourgeois experienced at the still tender age of only 21, combined with exile, may exacerbate the affects associated with ancient, unconscious traumas that afflict the rest of a life that is lived by the bereaved daughter, never knowing what else she might have been had her life been lived without this sudden and absolute loss of both childhood and of the phantasy of shelter provided by the continued existence of the adult mother.

The nine etchings of *Ode à ma mere* (Figure 27) present very different versions and visions of the spider, a form being explored in both its entomological and symbolic inscriptions, where the artist reworks the arachnid body to produce very varied effects and hence affects. In one image, the body seems too large and weighed down for the tiny legs; in another, the spider has only a ball for a body and stands high on long spindly appendages, echoing the earliest conceptions of arachnid forms in her drawings. In yet a third, two spiders chase each other across a web. Then a spider suspends itself with its legs spread wide. In another plate a spider carries an open egg sac. Yet another dips the body of the spider deep below the bent legs in postures explored on mammoth scales in sculpture at the time. Two images suggest more hybrid and metamorphosed references: a circular mass from which thick, human legs uselessly flail. Finally there is an image of a flying spider with two human faces attached to its body, one large and one small, both with opened mouth: crying, shouting, screeching, singing? Two faces share one body, but face in different directions. It might also be a scene of birth, a theme to which Bourgeois returned more figuratively in her gouaches of 2007.

The text begins – and my comments on each line are in italics beneath.

The friend (L'araignée – pourquoi l'araignée?)

Parce que my best friend was my mother and she was deliberate, clever, patient, soothing, reasonable, dainty, subtle, indispensable, neat, and useful as an araignée. She could also defend herself, and me, by refusing to answer 'stupid' inquisitive embarrassing personal questions.

Here is a portrait of the mother as a spider indicating the very qualities desired in the maternal other but lacking in the anxious and rageous daughter who will later in this text represent herself as changeable, uncertain and characterized by a litany of lack: she will write: I have no hope, no strength, no power, no interest, no time, no thoughts, no hopes, no feelings, no desires.

The text continues:

I shall never tire of representing her.

The artist does not say portraying her. Representation means finding a structure of forms through which to catch the qualities that characterize this endlessly interesting other – a bit too fastidious – but also so tired she leans against the wall.

Then comes the I of the enunciation and a dialogue:

> I want to: eat, sleep, argue, hurt, destroy
> –Why do you?
> – My reasons belong exclusively to me
> Le traitement de la Peur.
> …
> Caught in a web of fear.
> La toile de l'araignée.
> The deprived woman
> …
> Little mother tell me who is lying.
> I am getting tired of conjuring tricks. Who's lying?

It ends thus:

> Je m'excuse (oiseau bouffé) je ne savais où aller.
> Pardonne-moi, maman, qui ment, qui ment, je mens, je croyais savoir, je n'étais pas au courant, maman.
> Attends-moi, ne cours pas, j'arrive.
> J'ai besoin de toi.
>
> I am sorry (eaten bird) I didn't know where to go.
> Forgive me Maman, who lies, who lies, I lie, I thought I knew, I was out of it Maman. Wait for me, don't run, I'm coming.
> I need you.[62]

We should explore this writing as a text, to feel its movement through the signifiers and their fragmented, disjointed, shifting points of enunciation. We need to feel and respond to the kaleidoscope of emotional colours confided to this writing. Across it, a voice speaks – a voice calls, invokes *Maman*. It builds an image of a judged but needed Mother: the imaginary mother that is at once the actual woman and what no woman can be for her child's inordinate demand and need. This text is the voice of little Louise still inhabiting with untamed urgencies the 88-year-old artist calling out for Joséphine Bourgeois. But it is at the same time the self-analytical discourse whose very existence circumscribes with image and word, with its text woven of letters, the absence that is vocalized in the word *Maman!*. *Maman* is then the site of longing and needing, the confidante to which this 'I' – a she – confesses that she lies, that she did not understand, but that she needs her presence. The poignancy of

the final lines: *Wait for me, don't run, I'm coming. I need you* is not merely confessional. Few fully acknowledge the function of the presence of the post-childhood mother; only those of us who live a life without (and not by choice) face this hollowed space continually beside us. The statement of traumatically induced need is *structural*, and as such can only be translated into a form that combines geometry and fable: a stately, majestic, scary, comforting artwork of a huge spider poised for movement but stilled by the artist's making, and linked to this text by embodying the invocation: *Maman!*

Far from introducing this text to subject Louise Bourgeois once again to the closure of a psychoanalytical interpretation, I want to propose that we are in the presence of artwork composed here of both an iconic evocation of a Matrixial feminine signified by many aspects of spideriness and a textual invocation of a human maternal other, the needed, judged, puzzling, invoked and generic *Maman*.

Post-script: laughter

> By verbally (and or artistically) putting in place a representation of castration the analyst's word makes sexuality pass into discourse.
>
> Michèle Montrelay[63]

Louise Bourgeois is not self-analysing. But art as a form capable of massive condensation and transformation can function as a screen by means of which remnants of trauma pass into aesthetic inscription and hence enable, in the transsubjective space of the encounter between artist/viewer and the subjectivities to which the artwork opens links, transformation. Psychoanalysis is usually accused of failing women or of repressing their sexuality. But what we need to grasp is that its historic purpose is to allow the necessary repression (by the signifier–symbolization) that enables the corporeal intensities, otherwise experienced in anguish as overwhelmingly over-present to be sublimated by metaphor so that we become the subjects of symbolic discourse rather than the inarticulate sites of untrammelled plays of unprocessed anxiety. Feminist psychoanalyst Michèle Montrelay refers to Freud's work on jokes, and quotes analyst Maria Torok who found that her analysands often dreamt an orgasm after an interpretation had, as it were, touched home. Montrelay writes: 'The orgasm that accompanies like a burst of laughter, testifies to the meaning – insignificant [i.e., without specific content or meaning] – of the analyst's word. We must now try to discover the dimension of "wit" in pleasure and jouissance.'[64]

Could we thus approach the astonishing verbal and visual wit in Bourgeois's work? Condensed, economic and shocking, the encounter with her work produces the effects of the joke without necessarily making us laugh; it is not comic, but elements of its frankness, its outrageous honesty, its extraordinary combinations, have the quality of wit, of orgasmic laughter-inducing release

which occurs precisely because we do not exactly know what we are seeing but we sense that the art work is giving shape to forces in us that we also already 'know' in unthought ways. Montrelay writes:

> Consequently, pleasure, far from being reduced to the excitation of an organ, on the contrary, transports the woman into the field of the signifier. Sublimated pleasure, like the dream or hypnosis, *like the poetic act*, marks the moment when the unconscious representation takes on an absolute value: in other words, when the act of articulating on its own produces the meaning of discourse (meaning nothing). Sweeping away all signification, it lays hold of the woman and catches her in its progression and its rhythms. (my emphasis)[65]

This sounds to me like statements from Bourgeois about what she sought from the making of art which operated through rhythms of work itself and the rhythms that the finished work could formally achieve. From this proposition about seeing some kind of *transport*, from the anxiety of unarticulated and confused feminine relations to the body or to sexuality, to the pleasure produced by the act of articulation which is not to be confused with articulating something, or producing a specific meaning, which I think relates to the economy of Louise Bourgeois's work, we can return to the idea that this economy finds its realization in the event-encounter that is *Maman*, a vast egg-bearing spider-form that stands majestically and goes nowhere, offering its vast limb-structure as the shelter space of its not-quite perfect circular enclosure, the inheritor of the deepest of Bourgeois's sculptural explorations of space and geometry, form and rhythm, relations of emptiness and presence.

The spider motif thus becomes a *pathos formula*, like Warburg's *Nympha*, as it appeared and took on increasing imaginative variation and architectural grandeur at key dates in the work of Louise Bourgeois at its intersection with cultural shifts occasioned by feminist thought and aesthetic practice. In proposing arachnid thinking that can hold together in a created form (welded elements and assembled, engineered whole that is also a structure) multiple, even contradictory ideas, associations, and intense affects, I hope I have offered a feminist iconological study informed by various strands of contemporary feminist psychoanalysis. There is a natural form: the spider-motif. There is a connotational level: weaver, woman, Arachne, mother. But there is the interval between a theory of art's causation based 'in the image and the cause in the sign'.[66] That interval here is the sound of subjectivity, the vocative that visually and spatially emplots the call, the caller and the called, the past and death as well as the future, the created and creativity, and the dark rageous confusion of hurt and perplexity in a child struggling endlessly in the webs of love, rivalry, outrage, confusion and never-ending loss and longing. At both ends of a long artistic career, we find different modes for working out a recurring impulse that was always seeking a form for the geometry of absence.

My works are portraits of a relationship, and the most important one was my mother. Now how these feeling for her are brought into my interaction with other people, and how these feelings for her feed into my work is both complex and mysterious … I want to walk around and underneath her and feel her protection.

Louise Bourgeois (*The Observer*, 14 October 2007)

Notes

1 Ovid, *Metamorphoses* (VI.5–54 and 129–C145) and Virgil, *Georgics* (IV: 246).

2 Mieke Bal, 'Beckoning Bernini', in *Louise Bourgeois: Memory and Architecture* (Museo Nacional Centro de Arte Madrid Reina Sofía, 2000), 75–85.

3 On the Zeus-Metis myth, see Amber Jacobs, *On Matricide: Myth, Psychoanalysis and the Law of the Mother* (New York: Columbia University Press, 2007).

4 Gustave Doré imagined the process in his *de luxe* illustrations to Dante's *Inferno* in the mid-nineteenth century (Figure 15). More recently American artist Jan Dunning created a similar image in her pinhole photographic work *Arachne* (2003), exhibited in her series *Transmogrifications* in 2004.

5 For my fuller elaboration of this theme in Bourgeois's sculpture see Griselda Pollock, 'Maman! Invoking the m/Other in the web of the Spider', in Marika Wachtmeister (ed.), *Louise Bourgeois: Maman* (Wanås Foundation, Sweden, 2007), 65–110.

6 Louise Bourgeois, 'Brief Account of Career' [1965], in *Destruction of the Father/ Reconstruction of the Father: Writings and Interviews 1923–1997*, ed. Marie-Laure Bernadec and Hans-Ulrich Obrist (Cambridge, MA: MIT Press, 1998), 77.

7 Pawel Leszkowicz, 'In Search of Lost Space: à la recherche de l'espace perdu', in Agnieska Morawinska (ed.), *Louise Bourgeois: The Geometry of Desire*, (Warsaw: Zachęta Gallery, 2003), 249.

8 Carol Rama, Laura Mulvey and Peter Wollen, *Frida Kahlo and Tina Modotti* (London: Whitechapel Gallery, 1982); text reprinted in Laura Mulvey, *Visual and Other Pleasures* (Basingstoke: Macmillan, 1989), 81–110.

9 Philip Larratt-Smith (ed.), *Louise Bourgeois: The Return of the Repressed*, 2 vols (London: Violette Editions, 2012).

10 Marsha Pels, 'Louise Bourgeois: A Search for Gravity', *Art International*, 23:7 (October 1979), 46–7.

11 Pels: 'Louise Bourgeois', 47.

12 Pels: 'Louise Bourgeois', 48.

13 Pels: 'Louise Bourgeois', 47.

14 Pels: 'Louise Bourgeois', 50. I cannot in the context of this argument fully acknowledge the significance of a political dimension in Louise Bourgeois's work. It is an important corrective to the overprivatizing and overpersonalizing of her practice. See Ann Gibson, 'Louise Bourgeois's Retroactive Politics of Gender', *Art Journal* (Winter 1994), 44–7.

15 Pels: 'Louise Bourgeois', 50.

16 Lucy Lippard, 'The Blind Leading the Blind', *Bulletin of the Detroit Institute of the Arts*, 59:1 (1981), 25.

17 Bourgeois, *Destruction of the Father*, 230.

18 Bourgeois, *Destruction of the Father*, 179.

19 Donald Kuspit, *An Interview With Louise Bourgeois* (New York: Elizabeth Avedon Editions for Random House, 1988), 26–7.

20 Jean Laplanche, *New Foundations for Psychoanalysis*, trans. David Macey (Cambridge, MA/Oxford: Basil Blackwell, 1989).

21 Jean Laplanche and Bertrand Pontalis, 'Fantasy and the Origins of Sexuality', in Victor Burgin et al. (eds), *Formations of Fantasy* (London: Methuen, 1986), 5–28.

22 The issue of Louise Bourgeois's working space deserves close attention. Each change of direction or scale is related to new studio space.

23 'Drawings are thought-feathers, they are ideas that I seize in mid-flight and put down on paper. All my thoughts are visual. But the subjects of drawings are often not translated until several years later. As a result, there are lots of things that appear in drawings that are never explored further.' Louise Bourgeois, 'Interview with Marie-Laure Bernadec', in Bourgeois, *Destruction of the Father*, 292.

24 French artist Mâkhi Xenakis worked in partnership with Louise Bourgeois to photograph the scenes of Louise Bourgeois's childhood, photographing details of buildings, spaces, classrooms and a sculpture of blind Oedipus and his daughter Antigone standing in the Lycée Fénelon, all of which yielded intriguing references for certain motifs and also extended the range of memory-work in the sculpture. See Mâkhi Xenakis, *Louise Bourgeois: The Blind Leading the Blind* (Paris: Actes Sud, 2008).

25 *The Confrontation*, 1978, painted wood, latex and fabric, exhibited at the Hamilton Gallery of Contemporary Art, New York with the performance *A Banquet: A Fashion Show of Body Parts*. *The Confrontation* is now in the Solomon R. Guggenheim Museum, New York. The first acknowledged *Cell* is *Articulated Lair*, 1986 (New York, Museum of Modern Art).

26 Deborah Wye, 'Louise Bourgeois: "One and Others"', in *Louise Bourgeois* (New York: Museum of Modern Art, 1982), 12.

27 Roland Barthes, *Camera Lucida* [1980], trans. Richard Howard (New York: Hill and Wang, 1981). The coincidence of the publication of this influential and innovative text on the role of photography and the intense significance of the family photograph seems to me highly suggestive for the moment of Bourgeois's creation of a 'work' through revisiting the family album. From information provided by Wendy Williams of the Louise Bourgeois Studio, we can establish that archival material was explored in preparation for the catalogue and in order to identify images for a biographical section. The artist was 're-acquainted' with this material. A carousel of slides was prepared with the help of Robert Storr, Laura Tennen and Gerald Saldo, and Louise Bourgeois was recorded talking about the images. This produced a piece titled *Partial Recall* shown during the retrospective. This is now in DVD format and was shown at the Guggenheim installation of the retrospective in 2008. At the time of the 1982 retrospective, Ingrid Sischy invited Louise Bourgeois to do a project for *Art Forum*. The spread, *Child Abuse*, drew on the

family photographs and the text recorded for *Partial Recall* (*Art Forum*, December, 1982). I am grateful to Wendy Williams of the Louise Bourgeois Studio for clarifying these facts (Email correspondence, 11 September 2008).

28 LB 0113, 15 November 1957, cited by Juliet Mitchell, 'The Sublime Jealousy of Louise Bourgeois', in Larratt-Smith, *Return of the Repressed*, Vol. 1, 47.

29 Jo Spence's *Beyond the Family Album* was shown at the Hayward Photography Annual, *Three Perspectives on Photography* (London: Hayward Gallery, 1980), also reproduced in *Ten-8*, 4 (Spring 1980), 8–10.

30 'A Project by Louise Bourgeois: Child Abuse', *Art Forum*, XXI:4 (December, 1982), 40–7.

31 Xenakis, *Blind Leading the Blind*, 60–2.

32 In the interview with Donald Kuspit, Bourgeois states: 'The staring, unflinching eyes stand for scrutiny', 54. In 1982 Bourgeois reworked the piece, now in the Metropolitan Museum of Art.

33 The governess is described by Freud as '… an unmarried woman, no longer young, who was well-read and of advanced views. The teacher and her pupil were for a while upon excellent terms. Until suddenly Dora became hostile toward her and insisted upon her dismissal.' (p. 52) in Sigmund Freud, 'Fragments of an Analysis of a Case of Hysteria' (1905 [1901], *Standard Edition of the Psychological Works of Sigmund Freud*, ed. James Strachey, Vol.7 (London: Hogarth Press, 1975), 1–122. For a range of feminist readings see Charles Bernheimer and Claire Kahane (eds), *In Dora's Case: Freud-Hysteria-Feminism: Freud, Hysteria, Feminism*, 2nd edn (New York: Columbia University Press, 1990).

34 Mignon Nixon, *Fantastic Reality: Louise Bourgeois and A Story of Modern Art* (Cambridge, MA: MIT Press, 2005), 45.

35 It appears from the recently discovered notes on her analysis that the artist only came to recognize her ambivalence towards Sadie Richmond during analysis in 1957. Juliet Mitchell, 'The Sublime Jealousy of Louise Bourgeois', in Philip Larratt-Smith (ed.), *Louise Bourgeois: The Return of the Repressed*, Vol. 1 (London: Violette Editions, 2012), 47.

36 See L.P. Hartley, *The Go-Between* (1953) for a tragic story of such a situation.

37 Juliet Mitchell, *Mad Men and Medusas: Reclaiming Hysteria* (London: Basic Books, 2001) and *Siblings, Sex and Violence* (Cambridge: Polity Press, 2003).

38 Elisabeth Bronfen, *The Knotted Subject: Hysteria and its Discontents* (Princeton, NJ: Princeton University Press, 1998).

39 'Rarely has an abstract art been so directly and honestly informed by its maker's psyche', Lucy Lippard, 'Louise Bourgeois: From the Inside Out', *Artforum*, 13:7 (March, 1975), 27; reprinted in *From the Center: Feminist Essays on Women's Art*. (New York: Dutton, 1976), 238–49.

40 I made this suggestion to myself only to be confirmed when this very novel was the one selected and excerpted by Louise Bourgeois herself for the monograph by Robert Storr et al. (eds), *Louise Bourgeois* (London: Phaidon 2003), 104–12.

41 *Louise Bourgeois Recent Works* (London: Serpentine Gallery, 1998), 28.

42 Six editions were made in bronze cast from this steel original. Some three casts are fixed inside or outside several world museums such as Guggenheim Bilbao or

National Gallery of Canada, or the Samsung Museum of Modern Art in Seoul or the Hermitage in St Petersburg, and other casts sculpture wander the globe. The number of marble eggs in the baskets varies from 10 to 20.

43 Email communication, 19 June 2012.

44 I am deeply grateful for Marika Wachtmeister for inviting me to a symposium on *Maman*, through which this analysis emerged. An earlier and shorter version of the argument appeared in Wachtmeister, *Louise Bourgeois: Maman*, 65–102.

45 We also know that 'Maman' was the term used in the artist's diaries for her menstrual period, a powerful association with blood and femininity, that became such a rich seam in the multitude of large drawings in brilliant red gouache of her final years, many of which figured pregnant bodies and nurturing breasts.

46 Storr et al., 'Interview', *Louise Bourgeois*, 9.

47 Bracha L. Ettinger, 'The Becoming Thresholds of Matrixial Borderspace', in George Robertson et al. (eds), *Travellers' Tales* (London: Routledge, 1994), 41.

48 Bracha L. Ettinger, '*Fascinance* and the Girl-to m/Other Matrixial Feminine Difference', in Griselda Pollock (ed.), *Psychoanalysis and the Image* (Boston and Oxford: Blackwell, 2006), 60–93.

49 Affirmed in conversation with Deborah Wye in Bourgeois: *Destruction of the Father*, 128.

50 Sigmund Freud, 'Creative Writers and Day-Dreaming,' [1908] in *Art and Literature*, Penguin Freud Library, Vol. 14 (London: Penguin, 1990), 129–42.

51 Sigmund Freud, *Totem and Taboo* [1913], in *The Origins of Religion*, Penguin Freud Library, Vol. 13 (London: Penguin, 1985), 43–224.

52 Griselda Pollock, ' Territories of Desire: Memories of an African Childhood,' in George Robertson et al.(eds), *Traveller's Tales: Narratives of Home and Displacement* (London: Routledge, 1994), 63–92.

53 Sigmund Freud, 'On the Universal Tendency to Debasement in the Sphere of Love', in *On Sexuality*, Penguin Freud Library, Vol. 7 (London: Penguin, 1977), 243–60.

54 Christopher Bollas, *The Shadow of the Object: Psychoanalysis of the Unthought Known* (New York: Columbia University Press, 1987).

55 Bourgeois, *Destruction of the Father*, 207.

56 Hope Edelman, *Motherless Daughters: The Legacy of Loss* (New York: Delta, 1994).

57 Hilary Robinson, 'Louise Bourgeois's *Cells*: Looking at Bourgeois through Irigaray's Gesturing Towards the Mother', *N. Paradoxa*: 3 (May 1997); Ian Cole (ed.), *Louise Bourgeois* (Oxford: Museum of Modern Art, *Oxford Papers*, Vol. 1, 1996) 21–30; Hilary Robinson, *Reading Art: Reading Irigaray* (London: I.B. Tauris, 2007).

58 Donald Kuspit, 'Louise Bourgeois: Where Angels Fear to Tread', *Art Forum* (March 1987), 120–1.

59 Suzanne Pagé, *Louise Bourgeois: Sculptures, environnements, dessins: 1938–1995 [exposition, Paris]*, Paris: Musée d'Art moderne de la Ville de Paris, 23 juin–8 octobre 1995 (Paris: Paris musées: Editions de la Tempête, 1995).

60 Luce Irigaray, 'Gesture in Psychoanalysis', in *Sexes and Genealogies*, trans. Gillian C. Gill (New York; Columbia University Press, 1983), 97–8.

61 Robinson, 'Louise Bourgeois's *Cells*', 25.

62 Bourgeois, *Destruction of the Father*, 321–9.

63 Michèle Montrelay, 'Inquiry into Femininity', first published in *l'Ombre et le nom* (Paris: Editions de Minuit, 1977), trans. Parveen Adams, *m/f*, no. 1 (1978), 83–101, 96.
64 Montrelay, 'Inquiry into Femininity', 97.
65 Montrelay, 'Inquiry into Femininity', 98.
66 Matthew Rampley, 'Iconology of the Interval: Aby Warburg's Legacy', *Word and Image*, 17:4 (2001), 306.

Being and language: Anna Maria Maiolino's gestures of exile and connection 3

Captions to chapter 3

28 Anna Maria Maiolino (b. 1942) *Many* (Modelled Earth series), 1995, installation at the Beguinage, Kanaal Art Foundation, Kortrijk.

29 Anna Maria Maiolino (b. 1942) *Entrevidas, 2011*, Barcelona, Installation Fundació Antoni Tàpies.

30 Anna Maria Maiolino (b. 1942) Installation Shot Barcelona, Installation Fundació Antoni Tàpies. Including *Untitled* (from Continous series), 2004–08; *More than Fifty* (Prepositions series), 2008; suspended drawings from *Indexes and Vestiges* series, 2000.

31 Anna Maria Maiolino (b.1942) Installation Shot Barcelona, Installation Fundació Antoni Tàpies. With four video screens including *Ad Hoc* (extreme left), 1982 and *In and Out (Anthropophagy)*, 1973.

32 Anna Maria Maiolino (b. 1942) *Entrevidas* (*Between Lives*), photographic triptych from the series *Photopoemaction*, 1981. Black and white analogic photographs, 105×64.5 cm. Edition of 3.

33 Anna Maria Maiolino (b. 1942) *In and Out (Anthropophagy)*, 1973. 8′ 14″, 18 frames per second, colour super-8 film, transferred to video, 2000.

34 Replica of *Gradiva* ('The Woman who walks lightly'), Roman bas-relief based on Greek original (fourth century BCE), original in Rome: Vatican Museum Chiaramonti, Rome, replica in the collection of Sigmund Freud, London.

35 Anna Maria Maiolino (b. 1942) modelling clay. Photograph.

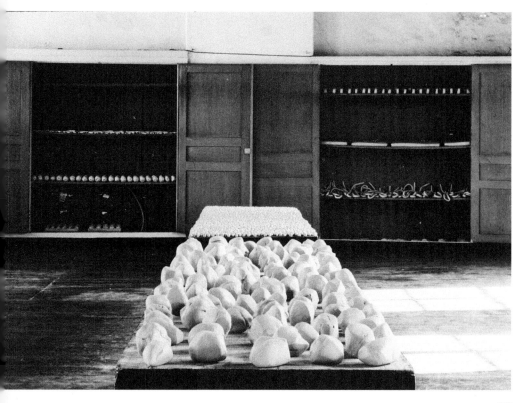

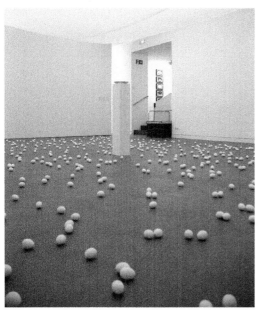

29

30

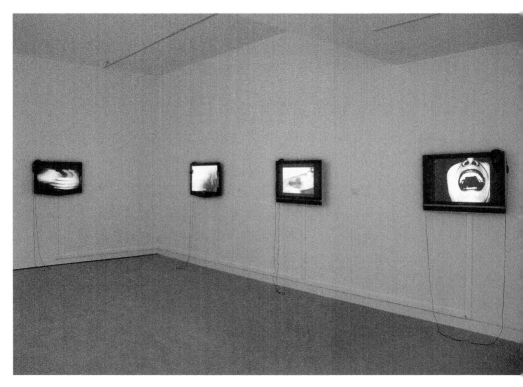

31

32

34

33

My first encounter with clay in 1989 provoked a storm inside me. Putting my hand in that wet mass of earth – dirt, matter – immediately a whole cosmos, a vision, presented itself. As material, clay is the perfect prototype. It carries within itself multi-form possibilities.

Anna Maria Maiolino, 1999[1]

My first *encounter* at an exhibition in 1996 with the work in clay by Italian-born Brazilian artist Anna Maria Maiolino (b.1942) provoked perplexity (Figure 28).[2] Piles of moulded clay shapes occupied the gallery space in repetitions that, nonetheless, generated endless difference. I did not know how to make sense of what I was seeing. Simple, almost primal, forms provoke both sensuous, childish pleasure but equally art historical perplexity. How was I to understand serial, modelled, clay sculptures, made in the last decade of the twentieth century, a decade so dominated by the *lingua franca* of conceptual art, by art practices working with digital technologies, so enthralled to the cinematic, and, above all, addressed to the gaze, the scopic rather than the haptic, the virtual rather than the material, the technological rather than the hand-made?

The clay installations, *Modelled Earth*, are now a signature of Maiolino's exhibitions, such as the most recent exhibitions curated by Helena Tatay in Barcelona, Galicia and Malmö, the first full retrospectives of the Maiolino's work in Europe (Plate 9). At each venue volunteers, often local art students, participate over the preceding weeks in the creation of these rolled clay works that are shown in rows of 'bun' shapes on tables or inserted into mesh structures that fill entire walls, or pile up in longer snakes on the floor.[3] Over the exhibition period the still damp clay will gradually dry out, change colour and finally be recycled.

In her monograph of 2002 on Maiolino, *Vida Afora: Life Line*, curator Catherine de Zegher identified Maiolino's oeuvre as a 'rigorous and congruent development that flows as a spiralling life line'.[4] *Vida Afora* is the title of photographic poems by Maiolino that place an egg or eggs in a variety of urban, and

often uncanny, situations which are then photographed. In a Maiolino exhibition there is also often a real space with eggs laid in an installation between which the visitors must carefully pick their way (Figure 29). There will also be paintings made with tychic flows of ink, drawings made by sewing thread through paper that produces a double work that must be suspended in space to show its recto and verso (Figure 30). There will be super 8mm films and video works as well as woodcuts and prints (Figure 31). There will be plaster and moulded sculptures. So what is this spiralling line of connection? How is line linked to the clay works and eggs? Is it a question of life? Is life the question of living, a body, a self, but also a community, a place, a world?

The *Modelled Earth* series, initiated in the late 1980s, first formed an installation at the Kanaal Art Foundation in Belgium in 1995 (Figure 28), about whose 'intimate minimalism', Paulo Venancio Filho wrote an article, 'The Doing Hand'. Filho notes a relation in the clay work and across Maiolino's oeuvre both to food and to language, to body and to thought. He further identifies Maiolino's investigation into community, proximity and togetherness, arguing that overall the artist's practice constitutes a humanized counterpoint to the scale and alienation typical of industrial, urban society.[5] We can thus begin to make sense of Maiolino's multimedia practice through the hand, the mouth and above all the role of form. Maiolino writes:

> Thus in the realm of creation, we are placed before a paradox: form limits the life force, imprisons it, but none the less permits it to organize itself. As the embodiment of discipline, form is at the same time the beginning of death. I was seduced by these reveries and ended up literally planting my feet on the ground and my head in matter, giving rise to a new series of works that considered these vital questions while putting process first.[6]

Form organizes but also limits life. Form makes it possible to grasp the life force, literally but also conceptually. But because form also disciplines that force into a form for knowing it, any formulation is the beginning of death, a stasis that arrests life's endless potential. Art not only confronts this paradox; it must live with it. In making works in clay through shapes formed by gesture, any participant is also invited into the deepest contemplation of the most primordial paradox that is art.

If form is both possibility and limit, the trick is to stay with the *becoming* of form. Art has thus to defy the apparent stranglehold of the binary opposition of life or death: either/or? Living, forming, dying might be held together in the encounter that is called art. Through an aesthetic practice that is deeply political in its relation to the human, the social and material worlds, Maiolino's project participates in current trends in contemporary philosophy and post-formalist aesthetics to overcome the representational/abstraction divide, emphasizing that art is a mode of both thought *and* affect but *beyond repre-*

sentation. It is on the side of life, not death, because it is seeking to keep virtuality – becoming – open. This is not formlessness as the antithesis of form, a phallic opposition that often collapses back into gendered metaphors of closed upright masculine bodies and leaky, prone, abject and uncontainable feminine ones. The attention to becoming means a different way of understanding the relations of making to the made, and of our aesthetic experience of the *encounter* with artworking in which art may function as a site of transformation that lies between the making, the moment of meeting and the reflections to which this forming gives rise in the participating viewer.

Catherine de Zegher placed the central image from Anna Maria Maiolino's triptych *Entrevidas* (1981) on the cover of *Inside the Visible: an Elliptical Traverse of the Twentieth Century in, of and from the Feminine* (Figure 32).[7] In the catalogue, Anna Maria Maiolino was situated in the final of four sections entitled 'Enjambment: "*La Donna è Mobile*"'. *Enjambment* is a technical term for the breaking of syntax. Literally, it means straddling, as, for instance, where meaning in a poem overflows its line and passes into the next. Catherine de Zegher links transformation, achieved by a refusal of fixed lines, completed statements or enclosed meanings and the practice of *straddling, passage, transgressed boundaries*, with the phrase from Verdi's opera *Rigoletto*: 'la donna è mobile'. Thus she introduces into these procedures an aesthetics of sexual difference.[8] For some, as in the operatic aria of this title, woman is fickle, unreliable, deceitful. For others, perhaps those of us who live as women, and feel the pride of women as feminists, 'woman' is the figure of liveliness, creative instability, who straddles beginning and ending, life and meaning. A dancing figure not at all macabre.

The invocation of this syntactical term, associated with both poetics and the innovative or transformative elements of poetry, perfectly accords with the life-making project of Maiolino. Why does life need to be made? How does art make life? Interviewed by Helena Tatay in 2010, Maiolino writes of her arrival aged eighteen in Brazil in 1960: 'I felt as though I was on shifting sands, permanently anxious, what kept me going was my obstinate search for my language, my obsession to become an artist.'[9]

One of the great questions of the twentieth century, the first century of women, was not only the significance of Being, from phenomenology and existentialism to deconstruction, but of being as embodiment, hence being and sexuality, and being within the human being itself a plural, differenced being. Human being involves language and sexuality, desire and the unconscious.[10] As Bergson, Proust, Freud and Levinas each in his different way suggested, it also concerns being and time, being in time, being present and, in terms of the past, remembering lost moments of being, childhood on the one hand, dreaming on the other. But it also involves *being different*, or rather being in relation to the mark of sexual difference, the phallic mark and, beyond the

phallus, to the potentiality of lived effects of sexual difference, imaginatively, symbolically, creatively.[11]

The deepest art of the twentieth century is that which moved beyond external analysis and theoretical knowledge to present us, through the aesthetic encounter, with Being and Difference, which can hardly be communicated, represented, pictured, imaged.[12] Difference is not encountered in the representation of an other who signifies, often negatively, difference *from* a dominant norm. Difference is process and hence creativity. Since it cannot be contained in representation or narrative, this condition must in some sense be encountered by means of artistic practice in the production of aesthetic experience. Here the term 'aesthetic' is being understood not in the Kantian sense of dispassionate judgement of beauty. I draw on the Kristevan sense of the ways in which avant-garde music, poetry, dance and visual art might be understood as the transgression of the bounded and fixed in the name of semiotic renovation and psychic heterogeneity.[13] In the context of increasing uniformity through the media and disciplinary uses of the information society, Kristeva identified a renewed and specifically ethical role for aesthetic practices. There alone the singularity of each person (not to be confused with the illusory and manufactured individualism of capitalist consumer society) contributes to our understanding of 'a life made of challenges and differences'.[14] For Kristeva, woman, the exile and the migrant have become privileged sites of this renegotiation of difference beyond the sign.

Autonomously echoing such a vision, the long career and fertile lifework of Maiolino straddles many media, practices and processes. Drawing, print-making, writing poetry, film, installation, painting, sculpture, performance, her practice takes place across the major areas of modernist experimentation, still working within the parameters of the rich possibilities of each field's constituent medium, and the radical expansion of artmaking after the 1960s. In that critical decade, art ceased to be defined by medium and creatively cannibalized the world and its sister arts for new resources. Thus artists felt free to draw on materials borrowed from industry and technology, to engage with the audio-visual, the filmic and the cinematic, as well as the popular and commercial cultural forms of rampant consumer capitalism. In this new field, truly radical art, sometimes seeking a critical relation to this expanded complexity of post-medium art, became a matter of activity (in contrast to what we might call the return to representation or the triumph of the gaze evident in so much work of the 1980s/1990s). The reading of such contemporary art therefore poses the question: what is this work doing, rather than what is this work about? How does it performatively invoke the thinking embodiment of a making subject with the invitation through the shared artworking to a viewer also to experience a critical difference through engagement with the activity? Activity involves the making, the traditional moment of art as a kind

of *poiesis* that is often undertaken in the space of a studio, a place of work and contemplation. As such this making involves reflexive contemplation of that process of making not as a means to an end, but as the thing itself, as process. But Maiolino's work is not process art, reifying process. She is performatively doing art and in so doing charging that which is made with some traces of the time, the actions, the bodies, the memory of its own becoming. It is also the instance in which the maker encounters a sense of being not as a given ontological essence but as a condition towards which aesthetic inscription may tend. It is in the presence of the traces of the process that the viewer becomes an invited partner in producing/opening the work, as an event that is not about objects to be contemplated, appraised and categorized. The event is an innovation that opens up consciousness to the world, and the world to consciousness by means of that which has been formed by an artist. It is also a contest with time, staying time, suspending it long enough to invite attention to being, being conscious, being alive.[15] But this activity can also take place outside the studio, in performances, installations, events, happenings, and in the access to the world the hand-held super 8mm camera (long before digital video) made possible for artists.

Any study of Anna Maria Maiolino's practice should trace its history from its early beginnings in woodcuts and prints in Brazil and then oblique but intense engagements with New York – she too was living in that city in 1968–70 as an artist's artistically invisible wife, speaking Spanish like other immigrant communities, Italian when she shopped in Little Italy, mothering two small children but not speaking English. When to save herself from an unhappy marriage she returned to Brazil, Maiolino worked with new trends in Brazilian avant-garde under the shadow of the long years of military dicta-torship, beginning the multimedia explorations that each bear the imprint of singular and distinctive aesthetic of purity, economy and justness whose aesthetic was also in tune with Italian *Arte Povera*.

I am profoundly drawn to the poetry and the poetic texts, which were published in Catherine de Zegher's monograph in 2002. Anna Maria Maiolino writes about her life experiences with a beauty and intensity that makes the writings a complementary text to the art practice. Like Louise Bourgeois, Maiolino draws a depth of feeling from memories of her childhood. Her traumas are those of poverty and war, aggravated by multiple migrations to countries and languages in which she would never be entirely at home. Of her foundational piece *GLU GLU GLU* (Plate 10) she speaks of it in relation to the hunger of her childhood and the hunger of the world.[16] While I do not want to displace the language of the art practice, I need to introduce the voice of the artist in another register as complement. Maiolino's art is built around a frank sense of embodiment but in a totally different conceptualization because of a different history: the body she refashions is starved and dislocated. So I want

to plot a passage through the mouth and the hand to Maiolino's writings: sites of the sound of subjectivity that then invest the materiality of the objects she makes with a hand that also writes.

Memory and moulded matter

Maiolino is an artist of the mouth (Figure 33). The mouth is the portal of the body where our bodily needs are fed by ingestion of food and our human needs are expressed as we configure the muscles, tongue and teeth to shape the sound created from our expulsion of air from deep inside the lungs across the taut strings of our vocal chords. The mouth is dry on the outside, continuous with the skin of the face, yet it softens, bows and takes on colour. It is elastic, stretching and joining. Yet behind this surface is a moist interior, damp, pink, in which the serpent form of the tongue is mobile and agile in its movements that can caress the hard calciate forms of our stumpy molars, pointed incisors and flat biting front teeth that perform the smile when skin is stretched tight to expose them. The mouth is one of the strangest elements of the body so freighted and charged from our earliest forms of post-natal contact: suckling for nourishment from the maternal body. The infant learns the world's thingness by putting things into its mouth long before its hand has the skill to discern texture and so forth. This activity of the tiny infant lays down the intense track that becomes orality expressed in childhood by sucking and eventually fostering the pleasures of sound-making and speech, itself to be understood as the direct descendant of infantile nursing, inheritor of all those inchoate sensations associated with primary nourishment, contact, senseless bliss, sensual repetition of motion. Lips, tongue, teeth, cavity, open, closed, clenched, relaxed, receiving, expelling. The mouth's multiple valencies are all explored by Maiolino by means of the use of super-8mm filming close-up, tightly framed to allow the camera to pay its inane attention to what we rarely see in our own faces, or even really attend to in the face of the other – so hooked are we to that other human link: the gaze.

Maiolino is, however, primarily the artist of the hand. The hand **makes** as we see in the films of her rolling and moulding that primordial substance of the earth, clay (Figure 35). The hand cuts, rolls, moulds, draws, marks, and in several of the artist's short films, talks its own expressive language. The hand, the primary mould and the first instrument for meeting the world, orients itself to the world, acting upon it, shaping the spaces before it, but also touching itself, doubling itself as it speaks otherwise in eloquent gesture. The importance of the hand and the artist's repeating engagements with the matter of the world, earth, clay, bear the imprint of trauma. She writes that

> [f]rom a tender age I yearned for death. Finding myself in the world was painful to me (6 July 1986).[17]

This is an affecting testimony both *to* a childhood memory and *of* a child susceptible to intense affect and a primordial sense of dislocation. Maiolino has said that in her infant distress, she would stay motionless in a disregarded corner of the house for hours, stilled in a kind of autistic dissociation. The artist then describes, tenderly, the persistent struggle for life in her large family in the impoverished, Southern Calabrese region of her desolated country, Italy, in the wake of the devastation of the Second World War. As the final, surviving child of a family of ten, the baby was often overlooked in the daily battle against immediate want, sometimes left behind when panic or air raids drove the rest to seek safety. Maiolino evokes her always distracted, active mother:

> Vivid in my memory are her hands, always white with flour, ever busy kneading bread dough for us, her children who were never properly sated. I was by her side as she worked, watching her closely with the hope that once she had washed her hands, she would take me in her arms, caress me. I waited in vain, for immediately her hands would be busy again, either sewing or washing clothes. My mother's hands were never free from work.[18]

This is not simply an autobiographical memory. Lyrically, the passage evokes a primal scene that becomes, in this retrospect, allegorical for the artist she became. In this vividly recalled situation of the child hungry for love and physical affection, staying close, watching, with attentive and yearning eyes, we note the work of maternal hands that shape the dough for bread and bind or repair the clothes to shield the family's bodies. Moulding, linking and binding will be hallmarks of Maiolino's diverse sites of practice. Hands are the instruments by which the caring mother moulds from the earth's product necessary if inadequate nourishment. They also promise, but withhold, an embrace, an equally necessary sustenance for emotional needs. Economic reality makes the working hands intimate with the struggle for what Walter Benjamin named *bare life – bloße Leben*. [19] Yet I want to stress in the image of the child watching the movements of the maternal hands a memory that forges an invisible thread, in and across space, and creates an image, in time, that might touch and bind, and become the string of connection as well as the passage for longed-for, missed connectivity and affection.

In a poem titled *Of Thee + Me*, written in 1995, at the time of *Modelled Earth* clay installations, Anna Maria Maiolino claims these working hands for herself, binding past and present, labour and art, care and creation.

> My hands work
> I weave with the threads of hope
> In my shriek together dwell pleasure
> Pain
> The call of the children …
>
> …

> My hands work
> They wash
> They cook
> They knead bread
> I mould clay
> And with my eyes I read philosophy
> I like poetry …
>
> 1995[20]

This *self-portrait* transgresses the boundaries of time and space. Who is the I? How many generations are in that pronoun? In a passage about 1990s, the artist writes that it is:

> …the emphasis on the EXPERIENCE OF MEMORY that approximates my work, particularly that of the 90s, to *arte povera* even more than to minimalist art, I think. For the *povera* revalues the processes and aspects of man's labor in his culture linked to the fields and to manual work. In addition to this feature, there are other issues shared in common, such as those of conceptual art, performance art; the utilization of worthless materials; the shunning of marketable art (here I refer particularly to the clay installations, which are perishable).[21]

From the generic *man's labour*, I draw out from her poem the specificity of *woman's labour*. *Maternal* hands evoke personal and cultural memories of time and place. They embody work as the struggle to maintain the life that, as a *mother*, a woman has also created. They are, however, also hands watched and remembered by an anxious *daughter*, with equal measures of anguished longing and creative identification. The combination of a personal recollection, recreating a childhood scene, with a measured reflection on late twentieth-century artistic allegiances to socially oriented *Arte Povera* rather than a cerebral minimalism, further linked with the deeper thoughts about form as both the realization of life but also its deadly limitation, delivers us into the challenging complexity of the world, the cosmos, the vision, created by Anna Maria Maiolino, artist/woman.

In a text written 20 May 1997, titled *Vir a 'Ser', Coming to 'Be'*, Anna Maria Maiolino wrote:

> I chose to accept all the destinies that had been traced out for me, without leaving anything out. Being an artist and being a woman have been part of a single repertory from the beginning.[22]

This statement involves many paradoxes arising from the choice of being an artist as a way of being a person in relation to reflections on the memories of place, of work, of attachment. *I chose*, she starts. This is the fundamental polit-

ical, ethical and human action. *I chose* means I am not merely the plaything of fate, life, destiny, family, society, convention. Faced with the realities of historical and political living, I can disentangle the *I* who makes a choice. That means, *I* take responsibility, and *I* take possession of what is before me, in the sense of both time and space. Yet what she *chose* to accept were destinies, already traced out for her. These involve the contingencies of a personal family history: being the youngest of ten children living in the struggling southern part of Italy, a history of a family and a country that is itself imprinted with major social, economic, cultural, linguistic, national determinations. It also means, we can see, accepting something of what it means to be that which is called 'a woman' in relation to all of the above: a woman, at this time of Italian, then Venezuelan and Brazilian history in the second half of the twentieth century because the family is a family of migration. Whatever is a destiny traced for a woman which may include partnerships, children, parenthood, separation, economic anxiety, vulnerability, responsibility, it is conjugated with another mode of being that, until the twentieth century, had more rarely, and without any kind of real social sanction or support, been associated with women. Of course, women have always made art in every culture and in every way. To choose to be a woman *and* an artist, an artist *and* a woman, and thus *not* to repudiate any aspect of femininity (such as so many women modernists had felt obliged to do for fear that being anything other than 'one of the boys' would compromise any chance of being recognized as an artist), to wash, clean, bake and feel/hear the call of children, as well as dedicating herself to becoming a self through the actions of a lifetime of being an artist is a historic declaration of immense resonance. The artist thus continues:

> My main project, *the attempt to construct myself as a person* was definitely a source of anguish, an anguish as thick as the stratification of all my interests. (my emphasis)[23]

Being an artist/woman means, therefore, construction of a self as a person. Such a sentence implies that one can exist, one can be born and live, but not necessarily be or feel oneself to be a person. As Simone de Beauvoir has written, the humanity of a woman is at odds with the cultural expectations of her femininity in ways that are not the case for men, masculinity and humanity being complementary.[24] Until we grasp the depth of this alienation in patriarchal culture of women from being a person, we will not have begun to make progress towards full humanity in sexual diversity. Being a person thus becomes a project, a lifework, that requires patience, dedication and above all, *work of a specific kind: artworking*. One builds a person, but, Maiolino insists, in anguish. This anguish is thick, like an archaeological site with its many layers/strata, compiled of interests which can lead to pain as they struggle in this composition, this multi-storeyed building that is a person, an artist,

a woman, a mother, a friend, a daughter, a lover, a politically aware citizen, a participant in the making of culture. Being an artist/woman constructing herself as a person is not a matter of image-making. It is not the mirror of self-portraiture. It concerns above all being able to speak in one's own voice: notice how often Anna Maria Maiolino makes work about the voice before speech, about the inarticulate yet expressive sounds we make as we try to convey what sometimes lies before or beyond words. To speak this newly created person-hood, therefore, requires the making of a new language. Being an artist is being an inventor of a language, though not a verbal one, to say the as yet unspoken or even yet unthought.

> My dedication to the formation of a language demanded a great deal of time, patience and work. At the beginning of my work as an artist, I believed that the formation of a language would come about only through the organization of my sensibility. It took years for me to discover that, besides sensibility, the formation of a language is also the result of a practice of interrelation with the things of the world.[25]

'Organization of sensibility' is perhaps a fundamental mode of training for the artist who must become aware of, and take ownership of, a specific and singular way of seeing and feeling which is offered to the world as but one of many sensibilities that can enlighten us, each from its own singularity, as to what it is to be, to be human and to feel, look, see and think. Organizing sensibility would result in choices about the materials to be used in making artworks, the scale, the aesthetics of mark-making, the gestures. Anyone visiting an exhibition of the work of Anna Maria Maiolino will feel the intensity of her unique and specific sensibility in every mode and form of her practice. Sometimes it feels very classical in its incredible justness. But it is not classical. Perhaps it is minimalist, as there is certainly no excess of romantic gesturing and display of any of that anguish. Intensity and anguish are contained because Maiolino has created an alphabet. Maiolino has created a language that registers, through the gesture of the mobile hand, the creative difference of the repeating becoming of form, life, death and the locus of memory of its fragile and affecting borderspace.[26] This is why the work appears so diverse, formally and materially, so unconfined to one specific medium, practice or problematic. Yet it has the imprint of a governing intel-ligence that makes each work recognizable without any superficial identity of form, style or statement.

Anna Maria Maiolino was born in Italy. When she was twelve, her family moved to Spanish-speaking Venezuela. They moved to Portuguese-speaking Brazil when she was eighteen. Thus in studying the work of this artist, we travel in the country of the homeless, expatriated, naturalized, nationally adopted but vivid and present Anna Maria Maiolino, artist/woman, and must learn the

language she created through art for her to become a person in both her sense of primordial detachment from the world and her cultural displacements and relocations and her sense of building passages to the world: lifelines. Not a hermetic artistic language, her work 'is also the result of a practice of inter-relation with the things of the world'.

Confronted with Maiolino's artworks/artworld, I find myself seeing a world stripped back to something beyond essentials– that would take us to early twentieth-century explorations in constructivism and abstraction, all of which robbed the world of what Merleau-Ponty called the flesh of the world. The opening sentence of that philosopher's essay 'Eye and Mind' (1961) declares: 'Science manipulates things and gives up living in them.'[27] Against this tendency, Merleau-Ponty will position art as he came to understand it through the study of modernist painting, notably Cézanne's. Merleau-Ponty died in 1963, just as a seismic upheaval would occur in the visual arts, which, harvesting those possibilities which modernism had pushed to the limits via fidelity to each medium, while only momentarily imagining how to break out entirely from their respective disciplinary confines, would open up to a kind of ethical phenomenology way beyond what Merleau-Ponty could conceive for and as art in 1963. Yet perhaps even in this limitation, Merleau-Ponty can provide me with a vocabulary through which to approach the event that is the work of Maiolino. Merleau-Ponty states:

> Scientific thinking, a thinking which looks on from above, and thinks of the object-in-general, must return to the 'there is' which precedes it; to the site, the soil of the sensible and humanly modified world such as it is in our lives and for our bodies – not that possible body which we may legitimately think of as an information machine but this actual body I call mine, this sentinel standing quietly at the command of my words and my acts.[28]

Maiolino's work is about this deep sense of 'there is' that we live through the sensibility of embodied subjectivity in the world. Merleau-Ponty continues in a different vein, intimating the co-presence of memory or intimations of others who share Being with us, past and present. Thus Being is not taken out of history, of memory, hence of the pain of loss and the pleasure of recall. Thus does Being transgress the borders and limits of the single, monistic subject, and link us across the many moments of time. Being in the world with the world, of which we are one in its flesh, is also being with the human world, a psychologically charged, affective and relational web.

> Further, *associated bodies* must be revived along with my body – 'others', not merely as my congeners, as the zoologist says, but others who haunt me and whom I haunt: 'others' along with whom I haunt a single, present and actual Being as no animal ever haunted those of his own species, territory or habitat.[29]

Almost matrixial in the recognition of transsubjective severality, Merleau-Ponty sees aesthetic practice as the privileged domain of our recognition of this humanly co-affecting, co-haunted Being in the world and Being with the others, creating both a moment of perpetual presentness and a moment in an invisible chain of connection both vertically and laterally, to the past and memory and to what lies beyond my own being.

> Now art, especially painting, draws upon this fabric of brute meaning which operationalism would prefer to ignore. Art and only art does this in full innocence.[30]

Art is thus neither science (one mode of abstracted knowledge) nor philosophy (the site of judgement and opinion). Art becomes a mode of paying attention to the world without ever allowing us to be outside it, looking on from above as in science, or not looking at all but knowing as in philosophy. 'Only the painter is entitled to look at everything without being obliged to appraise what he sees.'[31]

Merleau-Ponty discovered a potentiality for philosophy in modernist painting. He did not yet recognize the project that had exploded, since the end of the 1950s, and, with growing impetus during the 1960s would explode out of, that modernism to draw freely on any and every material, process, practice and medium in order to explore art and/with being, which is more usually discussed in terms of the Cagean idea of effacing the gap between art and life. *Enjambement*, straddling the distinction, is reclaimed by de Zegher for a history of women in twentieth-century art's byways.

I have a feeling that for Anna Maria Maiolino, the materials from which she makes her art, be it incised or polished wood, watercolour washes or paint, clay, cement, plaster, photographs, thread, or super 8mm film are importantly the 'things of the world'. The materials are linked not only with the otherness of what is not human – earth and other manufactured materials – out of which we humans make our humanized world, but with all made or found objects that can become the transports of memory, affect and meaning because they resonate: water, growing things, earth.

Writing on 7 July 1989 about 'my oldest recollection', Maiolino weaves into the story about her first, traumatically incised memory of leaving her childhood home in Scalea, in Italy, two objects: a lock of baby hair and a key to a breathless baby's coffin.[32] Both mark the brief non-life and already-death of a baby brother who did not live at birth. In a large family, of which the artist was the youngest of ten, the final, but always missing, other child was nonetheless preserved in name and in physical traces by his grieving mother. The box containing the once living hair and the key to his second, permanent home, a coffin, takes on talisman-like quality for both mother and daughter, the dead baby's still curious sibling. The appearance of the box from the

cupboard heralded major changes, and initiated family movement. But the artist also tells us that she loved playing with the things in that box, which was the box of her mother's memories. In sharing with her daughter the meaning of the preserved things, Maiolino writes 'she was called by the sight of these memories and the two of us became *immersed deep in life, inside* Mother's memories'. While listening and rehearing these memories were inimitable, Anna Maria Maiolino concludes: 'Nothing could be stronger, nothing could be compared, I felt, to that touch: Antoñio's fine hair and his tiny, cold key in my hands, tremulous receptacle of Mystery.'[33] The hand again is gesture and link even across a living/non-living borderline.

Anna Maria Maiolino's life has involved migration from a deeply formative childhood in the landscape of Southern Italy to new locations, adopted countries, naturalized citizenship, the passage from Italian to Spanish to Portuguese languages, living in Brazil, briefly and obliquely without language in the United States, then in Venezuela and Argentina. Much can be made of the immeasurable significance of such momentous displacements, repeated social and linguistic relocation and, always, the lining of new lives with older losses. We could see the life/work of Anna Maria Maiolino, as one long poem breaking the syntax of fixed location and (un)known identities.

Earth

After 1989, Anna Maria Maiolino began to work with the earth – clay. In Biblical Hebrew, earth – clay – is *adamah*. This gives rise to the concept of *Ha-Adamah*, the primordial, generic, ungendered, living human creature, who was *modelled* – the verb used in the original Hebrew text invokes the potter – from earth. His name, *Adam*, is derived from this earthy forming. His companion/other is *Chavvah*, from the root word for life. 'Eve' in English is life to Adam's earth. In repeating the originary gesture of primal modelling, the human hand shapes matter, which then, as Maiolino's poem quoted above suggests, elaborates itself into daily tasks that become freighted with social and gendered meanings: caring, relating, washing, cooking, kneading bread. Her poem says 'Minhas mãos trabalhan' – the Latin verb 'to work' in Portuguese appears in the English word 'travail', archaically used to refer to the labour of childbirth, the sacred site where life and meaning are made. Making and bringing forth, these words in the Bible register the double modes of creative genesis both appropriated by the paternal-masculinized God of the Abrahamic tradition in Genesis. The Hebrew secretes within the words themselves a making, a creation of life in, *of and from the feminine*. The artist's hands working the earth remember her mother's hands working the dough. They link a personal, localized family history of the Italian-born migrant artist with the mythologies of creation across a Bachelardian phenomenology of elemental matter: clay/earth/*adamah*.

The clay works, resisting marketability, are made afresh for each exhibition. Being unfired, raw, uncooked in the Lévi-Straussian sense, remade for each future venue, they take real time and energy. They testify to a performative dimension of making. But collectively they witness duration and hence becoming, which are the moments of the creative mind, according to Bergson, in its interplay with the matter of which the mind is a part, yet is set apart only by time, registered as memory: hesitation, and the possibility of a repetition that is always, each time, different.[34] The presence of the artist, the time taken to make, the evidence of the repetition yet difference of a human gesture because each moment and each movement registers humanly lived time which is never repeatable, hence living, is 'documented' by the objects as traces the viewer encounters in the 'exhibition'. Multitudes and variations of the basic forms of clay have been manipulated by the 'doing hand' and the remembering mind, bringing past and present together over time now accumulated and structured into present, visible forms.

Yet, they are not really formed into anything, into things, into objects of recognition that habit would allow us simply to know and affirm. Unknown, the moulded forms exist to register the *work* of the hand: in their physical and material present/presence, they, therefore, embody gesture, isolating its 'work' from the living body and remembering mind in a palpable and visible form still pregnant with possibility. The repeated forms are witnesses to difference. More than mere reference to *arte povera*'s invocation of manual labour, the creative investment through memory-impregnated manual labour challenges the world in which manual labour has been reduced to mindless, deadening repetition by the industrial system.

Coils that might be built up into great pots remain coils, snakes, ropes, strings and dampened, hand-moulded earth. Lumps that could be gouged to form a basic hollow and container – the bowl – wait, still lumpen and solid. Tiny balls of clay, thickened loaves of earth, circular biscuits sliced from a thick sausage of rolled clay, lie in cupboards or pile up on the floor. They have become nothing. They are nonetheless eloquent of the *becoming of form through the freighted human gesture* and of the potential closure that any forming brings. They convey sensation, movement and affect. The objects are indexical, not metaphorical, of the hand. They register the primordial action of making – the first human intervention in the material world – that the artist suggests can be understood as the beginnings of the human movement towards language and culture. These non-objects insist on that history of human making that involves both skill and labour, contact and energy, work and invention, but also memory as the action of human consciousness in what we do. They remind us of time, of duration, which is the interval for both memory and thought that does not divide us from the world, spirit from matter, but makes us the consciousness of that material world. These forms

await language but are its beginnings. They are pregnant, pregnancy being the image for such a human becoming in time.

> In the clay installation, as in the sculpture/installations, neither the symbolic nor the allegorical is utilized '*The intent is that of being in a real, not illusory space* for it is what it is. *LABOR:* productions of the hands' first actions in the ordering of the clay – basic forms, an accumulation of expended energy' … There is here an IMMANENT YEARNING FOR TOTALITY, reinforced by the obsessive reuniting of parts and extending of the process in time. In the space the process traverses, a potency of life, which is transformed in the course of time, is articulated. We could speak of the symbolic in these works if we can then view them as concretions of parts of an unattainable and incomprehensible whole and not as representations of a concept.[35]

Refusing the economy of representation and its Hegelian negation in abstraction, Maiolino goes beyond representation, and does not seek signification. Her writing offers reflections on time, memory, matter and totality, philosophical concerns that recur from Spinoza to Bergson, Levinas and Deleuze. Maiolino reports that after she made a clay work bearing the Pirandellian title *Um, Nenhum, Cem Mil* in 1993, her son suggested that she buy *Difference and Repetition* by Gilles Deleuze,

> …for the question I was raising in my work happened to be in line with the author's thinking. When I finished reading it, which was only recently (1999), I felt deeply moved. In some of the passages, I fully identified with what was expounded. Curiously, in my written reflections about my work, out of pure intuition and complete honesty, I had been timidly dealing with the same question …[36]

Brian Massumi opens his book, *Parables for the Virtual: Movement, Affect, Sensation* (2002) thus:

> When I think of my body and ask what it does to earn that name, two things stand out. It *moves*. It *feels*. In fact, it does both at the same time. It moves as it feels and it feels itself moving … The slightest, the most literal displacement convokes a qualitative difference, because as directly as it conducts itself, it beckons a feeling, and feelings have a way of folding into each other, resonating together, interfering with each other, mutually intensifying … Qualitative difference: immediately the issue is change. Felt and unforeseen.[37]

Challenging the dominance of linguistic models in semiotics and post-structuralism, Massumi reconsiders the body through the Deleuzian stress on memory, movement, sensation and affect. Deleuze insisted on the difference between *recognition*, based in what is already known, and *encounter* with the aesthetic object that opens up, ruptures, transforms, creates. The creativity

of change is brought about by difference as the effect of the humanness of any repetition – it can never be the same. Art practices generate *encounters* rather than (Kantian) objects.[38] In *Difference and Repetition*, Deleuze declares: 'Something in the world forces us to think. This something is an object not of recognition but of a fundamental encounter.'[39] *Occursus* – encounter – is Spinoza's fundamental concept. Deleuze invites us to understand the creativity of change brought about by difference and to think about certain practices in artmaking as generating encounters that have affects rather than objects. Such affecting encounters shock us into thought. The world is not the inert object of our autogenetic act of cognition. We think only because we are 'affected' in this phenomenological encounter. For Deleuze 'Difference is not diversity.'

> Every diversity, and every change refers to a difference which is its sufficient reason. Everything which happens and everything which appears is correlated with orders of differences: differences of level, temperature, pressure, tension, potential *difference of intensity*.[40]

Creativity in art is making things happen. Even as the artist sets out, even calculates, to make something, difference happens, creating something other than the repetition of the pre-planned, calculated, the identical to what already is. Here the new occurs and is encountered. This passage also echoes Maiolino's distinction between a calculated, mathematical seriality associated with the rigid forms of minimalism and the creative, unpredictably varying repetitions she undertakes as the actions of the human body at work on the material of the world that cannot rigidly repeat precisely because in every recurring action, time has intervened, memory has played a role, humanizing consciousness and unconscious determinations have been allowed to play. When Anna Maria Maiolino references *arte povera* instead of minimalism and lists several facets from performance to resistance to commodification, there are commonalities between the two modes of artmaking that emerged during the 1960s. But the deeper distinction we are seeking is between what I shall name the aesthetics of the death-drive, which involves a compulsion to repeat and is, therefore, the sign and rhythm of unresolved trauma, involved in the twentieth century's exploration of form which is repetition without difference: seeking law, order, the grid, system, anti-body, rationalistic and, on the other hand, the aesthetics of life, of a genesis, of becoming and transformation which is repetition with/as Deleuzian difference, repetition that delivers difference as an unpredictable virtuality and thus creates a path or transport for remnants of trauma.[41]

Virtuality, understood philosophically rather than cybernetically, is, according to Bergson, what gives rise to both a future, namely change, and to affects rather than statements. The virtual may be actualized, but the actual will always be heterogeneous vis-à-vis the still untapped potential of the ever-

virtual. Change is often posited between the real and the possible. The possible is, however, always already delimited by the real it might become. 'Be realistic! That's just not possible!' The existing real preconditions what is possible. Thinking politically, what is possible is always already anticipated and hence limited by the existing realities. The virtual, however, marks the creative break that is not predicted, or pre-determined. Thus virtuality as art becomes a force for the truly creative, which has no predictable mode of realization. When momentarily actualized, it will be heterogeneous to rather than homogeneous with its virtuality: that is the meaning of difference as creativity. It is here that certain kinds of contemporary art, as one of the many modes of such creative practice, coincides with both Bergsonian philosophy and a recent strand in feminist thought that constantly struggles to phrase the creative *poiesis* of a radical difference in relation to the body without falling into fixed categories of anatomies, essentialisms, even notions of gender, all of which appear known in advance and hence predetermine the very future that we are trying to create as different. Contemporary feminist thinkers are asking: how can we think *in, of and from the feminine* as a radical, life-oriented *poiesis* – a making of a real change, not just an adjustment of gender relations within existing concepts of social organization? Australian philosopher Elizabeth Grosz invokes both Deleuze and Bergson in the creation of a non-patriarchal future:

> What Bergson, through Deleuze, shows is that life and duration, and thus history and politics, are never a matter of unfolding an already worked out blueprint, or the gradual accretion of qualities which progress stage by stage or piecemeal over time. Duration proceeds not through the accumulation of information and the growing acquisition of knowledge, but through division, bifurcation, dissociation by difference, through sudden and unpredictable change, which overtakes us by surprise. It is the insertion of duration into matter that produces movement; it is the confrontation of duration with matter as its obstacle that produces the impetus for action, which is also the impetus to innovation and change, evolution and development.[42]

Inside the Visible where I first saw Maiolino's work was subtitled an *elliptical traverse of twentieth-century art, in, of and from the feminine.* Interlinking three moments of twentieth-century history, 1920s/30s (fascism), 1960s (social revolution) and the 1990s, de Zegher matched these moments to different conceptions of the 'feminine', all of which signalled a psycho-symbolic position – *le féminin* in Kristeva's terms – in language and a psycho-symbolic forma-tion of subjectivity marked by and equally enabled by sexual difference.[43] Reconnecting artists from the global margins and the bypassed alleyways of the twentieth century, she traced recurring engagements with fragmented and reformed bodies, blank pages and new language, traumatic histories and reclaimed lives, weavings and webbings, and mobility and poetics, words,

things, and making, all indexing histories of racism, class, ethnicity, sexuality, gender, generation and geography. De Zegher's curatorial position is that it is vital we know the world *in, of and from the feminine* delivered into culture from diversity among women. Being in the world means being in history, in time and in difference, sexual, linguistic, cultural, geographical. But difference does not mean being fixed as 'different from', the outsider, the foreigner, the exile. It means working with the necessity and creative potential of not entirely belonging, which is, to some extent, the condition of the feminine in phallocentric culture, as the double condition of anguish and jouissance, of burdened labour and poietic transformation. The feminine is also at a specific join of life and meaning, with woman so often reduced to being the body that makes and carries new life but is denied by stopped mouth and unheard words the possibility of giving birth to *meaning*.[44]

Life in the oval

The egg is a perfect, given form. But it is shaped by the bodily passage through which it must pass to emerge. It is the shape of its own transformation, its own birth. It also contains, non-identically, the promise of an entirely unique new life, which it protects, while remaining intensely fragile, and strangely intimate with the human hand it invites to hold it.

Entrevidas was initially a performance outside the artist's studio in Rio de Janiero in the politically fragile moment of 1981. Several dozen chicken eggs were laid on stones under an awning. The visitor had to walk across a field 'mined with fragility' towards a central plinth on which rested a single egg. The work responded to the moment of political opening towards democracy in Brazil for which 'the simplicity of the egg, the archetype of life' signified both the promise of a new freedom and its precariousness: we were 'literally walking on egg-shells'.[45] From this came a photographic triptych (Figure 32) that followed the path of one bare-foot woman walking through this field of eggs on the stony ground. Initially, the single photograph from the centre of the triptych sent me sliding down a chain of associations about the image of the rising instep of a walking woman back to Sigmund Freud in 1907 who wrote about dreams and delusions inspired by a classical sculpture of running woman that appeared in a novella *Gradiva* (1903, Wilhelm Jensen).[46] *Gradiva* means 'she of the swift step' (Figure 34). Many artists have since pondered her significance.[47] Gradiva is, in Warburg's sense, a Nympha, the *pathos formula* of agitated figurations and movement that animate as a mnemonic of intense feeling. Warburg suggested that a deep memory, of an emotion relating to life and death, once enacted in ritual and drama, has been remembered by the sculpted gesture become form that represents bodily movement so that the image 'remembers', on behalf of culture, by means of the representation of

physical motion, a state of *emotional* intensity, *pathos*, whose potential may be re-energized when a later culture has need of such forms to help to liberate it from its own aesthetic containment and ideological regimentation, from its alienation from affective intensities and deep meanings. Thus, the reappearance of the animated and affecting figure of the walking woman in classical sculpture in her uncanny double in the politically inspired performance in Rio de Janeiro by Maiolino's photopoem on the cusp of its own political moment of upheaval and anxiety suggests both transformation and borderlines between life and death.

Egg is a fundamental form. It is product of a living, maternal entity, carrying the potential for life, while remaining itself the antithesis of human moulding, in its formal perfection, the envy of every human imagination. Writing in 2007, in relation to a new series of works that bring together the human hand, the mechanical simulacrum of the human hand and the egg, Maiolino evoked Leonardo da Vinci as the title of the series.

I imagine that
Had Leonardo preceded the hen
He would have invented the EGG
Using extreme ratio and divine proportion
In the EGG nothing is in excess
It harmlessly comes out of a small body opening
It simply comes out into the world, for ever original
An Egg is an EGG
Prototype of wholeness
Even when broken and fried
…
I revere the hen and envy it. (2007: 8)

A perfect sculptural form, the egg can nestle in the hand or can balance on stone; it can be tough or fragile; it can nourish and promise; it can remain closed, still, self-contained; it is the feminine form of the thing, the shape, the object. Maiolino's performance and photographic triptych *Entrevidas* lays eggs across a cobbled, mossy street among which a woman walks barefooted, picking her way between what the poem of the same name calls 'a territory mined with the fragility of lives' and 'originary fullness [that] requires care' while there 'lies the threat of death in the false step that crushes'. The line between life and death, survival and disaster, the opening path and the false step is not as visible here as it is in her works where threads join generations of women, where threads are consumed and expelled from the mouth, or become fat, thick rolls of clay, or wander in paint across canvas or paper, or as in work since 2002, where threads are stitched to create drawings. Yet we can see that they are connected by the string of a deep personal and deeper

cultural memory maintained as the ethical ground for a practice of art in a world of unstable politics and now potential fatal consequences for the life on the earth itself.

The concluding line of Maiolino's poem *Entrevidas* uncannily evokes both Warburg's interest in the returning and remembered image of the running woman and Freud's reading of a novella inspired by the tension between her petrified image, the sculpture *Gradiva* and moving human body of woman called *Zoë*: Life. 'Thus we relive that which has been forgotten and step by step we recall that which is known.'[48] In *Entrevidas,* the invisible line of the 'she who treads lightly' – Gradiva – is a metaphor for a kind of ethico-political art, *in, of and from a feminine* that has been chosen as a retraced destiny, to be lived in active reflection, not passively suffered.

The ancient stones, the memory of the earth's becoming, the living moss, and the iconic eggs that any moment might be fertile and hatch or remain sealed and silent, these form the ground of things in and of the world between which the moving body plots its course. Fascinated when I first encountered *Entrevidas*, I re-encounter it now as almost emblematic of the life and work of Anna Maria Maiolino. It is a woman's journey without a destination, a journey through life, or rather between lives, between the living. It is grounded in ancient memories of the earth. It is a path that must be walked, slowly and with enormous care, attentive to the fragility of living and dying, to the meaning and effect of each gesture, each action, each thought that artistic attention can disclose to us.

Maiolino's pragmatic, materialist and creative transformation of, in and through artworking, refuses fixed lines, completed statements, enclosed meanings. It is *enjambement*: *straddling, passage, transgressed boundaries.* At once metonymic in its materiality and metaphoric in its poetic richness, Maiolino's work using all and subject to no media, is not metaphoric. In Bracha Ettinger's terms, it is *metramorphic* – that is, an aesthetic process produced to transmit the generative relationality of I and non-I, of an opened self fragilized towards the radical otherness of the other, the world, the non-I with which, however, meaning is co-created and affect co-emerges. In *metramorphosis* another kind of gaze arises, the matrixial gaze which is non-phallic. It seeks not to master but longs to encounter and share, even pain.

> Metramorphosis is a co-poetic activity in a web that 'remembers' [these] swerves and relations, inscribes affective traces of *jouissance* and imprints of trauma and encounter, and conducts such traces from *non-I* to *I*, from one encounter to further encounters. Metramorphosis transfers knowledge of these events with-in-to the matrixial psychic sphere.

Ettinger continues:

Through art's metramorphic activity, these traces are transmitted into culture and open it boundaries. An affected matrixial encounter creates diffuse traces of events un-thought-of but charged with some awareness … The matrixial gaze corresponding to these transgressive processes is not relegated to the level of invisible figurality or unintelligibility, due to metramorphic cross-inscriptions that *impregnate subjectivity with partial-objects and objectivity with partial-subjects*. Sub-symbolic tunings that do not function on the level of distinct units of signification nevertheless make sense here. Artworking makes this meaning available for later conceptual elaboration.[49]

I find in Ettinger's novel phrasing a means to articulate what in Maiolino's art defies available critical vocabulary. The idea of a *cross-inscription* endows the made forms, material things, elements of the world, that never become mere objects of contemplation or recognition, with a subjective/affective dimension while the subjective, human consciousness is impregnated (a loaded term) with aspects of the otherness from the objective world. This is not pure phenomenology of being one with the flesh of the world, although it pays some debt to Merleau-Ponty, and it is also filiated with the machinic anti-Oedipal thought of Deleuze/Guattari human/nonhuman interconnectivities. Ettinger also makes clear how art can generate thought by its own artworking processes that are not about representing anything, but rather about making something happen that solicits our elaboration as thought. Thus while not being a cognitive, symbolic language, artworking is sufficiently attuned to meaning-making to pass across the passage art can open between being and language.

What is looking at sculptural objects in a non-phallic mode? The phallic gaze alleges that something was there and is now lost. The matrixial gaze indicates that something happened and the event has passed, and also that someones were there and that these someones have already changed.[50]

Notes

1 Catherine de Zegher (ed.), *Anna Maria Maiolino: Vida Afora/Life Line* (New York: The Drawing Centre, 2002), 353. The image shows the original installation at the Kanaal Art Foundation in Kortrijk in 1994 from which the 1996 exhibition developed.

2 Catherine de Zegher, *Inside the Visible: An Elliptical Traverse of Twentieth Century Art in, of and from the Feminine* (Cambridge, MA: MIT Press, 1996).

3 Exhibition: *Anna Mario Maiolino*, Fundació Antoni Tàpies, Barcelona (15 October 2010–16 January 2011), travelling to Centro Galego de Arte Contemporánea, Santiago de Compostela (4 February–1 May 2011) and Malmö Konsthall, Malmö (20 May–21 August 2011). Catalogue: Helena Tatay (ed.), *Anna Maria Maiolino* (with essays by Marcio Doctors, Jacob Fabricius, Anna Maria Maiolino, Ivone Margulies, Griselda Pollock, Laurence Rassel, Helena Tatay), trans. Discobole, Maite Lorés (Spanish: Barcelona: Fundació Antoni Tàpies, 2010; Santiago de Compostela:

Centro Galego Arte Contemporánea, 2010) (English: Malmö: Malmö Konsthall, 2010; London: Koenig, 2010).

4 De Zegher (ed.), *Anna Maria Maiolino*, 103.

5 Paulo Venancio Filho, 'The Doing Hand', in de Zegher (ed.), *Anna Maria Maiolino*, 284–5.

6 de Zegher, *Anna Maria Maiolino*, 353.

7 De Zegher, *Inside the Visible*. See my 'Parallel Lives' in de Zegher (ed.), *Anna Maria Maiolino*, 188–9.

8 The phrase is the opening line of the Duke of Mantua's cynical canzone from Giuseppe Verdi's opera *Rigoletto* (1851). Woman is flighty/ Like a feather in the wind,/ She changes her voice – and her mind./ Always sweet,/ Pretty face,/ In tears or in laughter, – it is always lying.

9 Tatay (ed.), *Anna Maria Maiolino*, 38.

10 Despite almost universal misunderstanding of his arguments, Freud's theory of sexuality asserts that sexuality is not the remains of some pre-psychical animal elements of humanity, but that it is the psychological product of our complex processes of humanization. See Griselda Pollock, 'The Visual Poetics of Shame', in Claire Pajaczkowska and Ivan Ward (eds), *Shame and Sexuality* (London: Routledge, 2008).

11 Sexual difference does not mean the difference between the sexes. It is a term used in largely psychoanalytically inflected cultural theory to suggest that the significance attached to differences between male and female is culturally produced, and articulated for and to us by language. Difference is produced across a mark, a slash that distinguishes yet places in relational, asymmetrical hierarchy its two component terms. Thus the phallic mark creates a plus and a minus, attaching plus and positive to the masculine and the negative and lacking to the feminine. Feminist deconstruction works to suggest that under this phallocentric cultural system, nothing can be said about the feminine or from that position since it is already colonized to declare only its lack. Julia Kristeva identifies the feminine as the very principle of creative negativity in a dialectical sense and identifies the feminine with the avant-garde itself, irrespective of the gender of the writer/artist/musician. Julia Kristeva, 'La femme n'est jamais ça', *Tel Quel*, autumn 1974. Hélène Cixous seeks a poetics she names 'écriture féminine', beautifully explored in her most polemic essay 'Le rire de la Méduse' (Laugh of the Medusa), *L'Arc* (1975), 39–54.

12 On art as encounter see 'Encountering Encounter' in Griselda Pollock and Vanessa Corby, *Encountering Eva Hesse* (London and Munich: Prestel, 2007).

13 'At this level of interiorization with its social as well as individual stakes, what I have called "aesthetic practices" are undoubtedly nothing other than the modern reply to the eternal question of morality.' in Julia Kristeva, 'Women's Time' ['Le Temps des Femmes', *Cahiers de recherché de sciences des textes et documents*, 5 (Winter, 1979), 5–19] in Toril Moi (ed.), *The Kristeva Reader* (Oxford: Basil Blackwell, 1986), 210–11.

14 Kristeva, 'Women's Time', 211.

15 Had I the space, I would want to expand on this aspect of Anna Maria Maiolino's work plotting the unexpected affinity it displays to the writings of Clarice Lispector and the reading of Lispector by Hélène Cixous: 'This woman, our contemporary,

1 Bracha L. Ettinger (b. 1948). *Ophelia and Eurydice no.1*, 2002-2009, oil on paper mounted on canvas, 51.5x20 cm. Courtesy of the Artist.

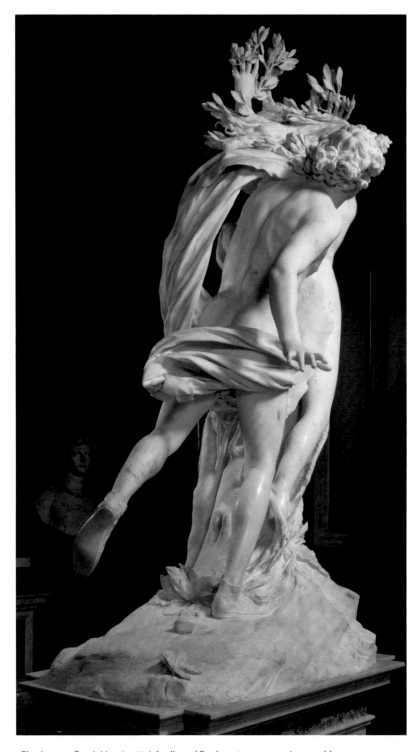

2 Gian Lorenza Bernini (1598–1680) *Apollo and Daphne* 1622–25, rear view, marble, 243cm.

3 Gian Lorenza Bernini (1598–1680) *Apollo and Daphne* 1622–25, front view, marble, 243cm.

4 Ana Mendieta (1948–85) *Tree of Life*, 1976, 35 mm colour slide.

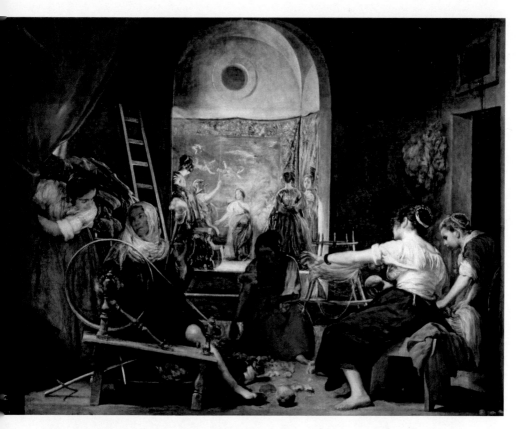

5 Diego Rodríguez de Silva y Velasquez (1599–1660) *The Fable of Arachne,* or *Los Hilanderas/The Spinners* (c.1657–58), oil on canvas, 220×289 cm.

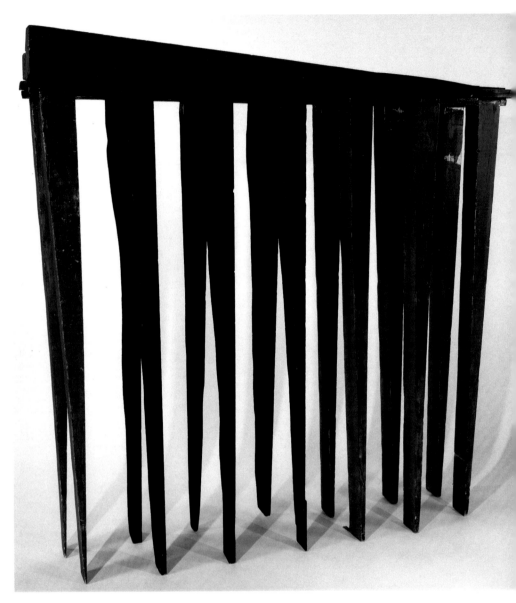

6 Louise Bourgeois (1911–2010) *The Blind Leading the Blind*, 1947–49, wood, painted red and black, 170.4×163.5×41.2 cm.

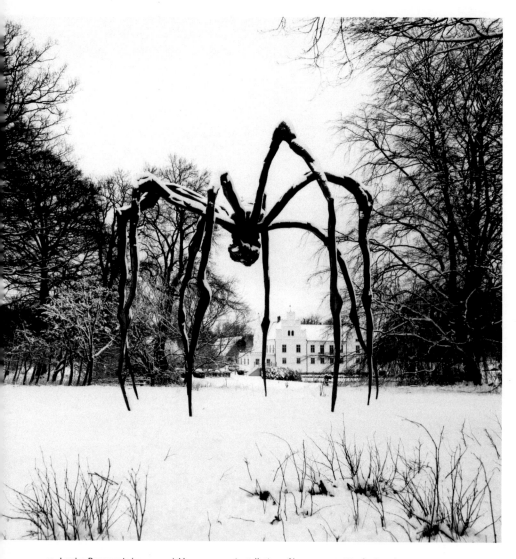

7 Louise Bourgeois (1911–2010) *Maman*, 1999. Installation of bronze cast, Wanås, Sweden.

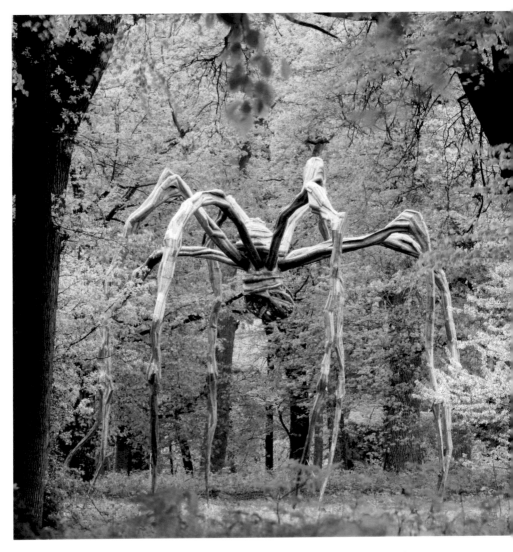

8 Louise Bourgeois (1911–2010) *Maman* 1999, installation of bronze cast, Wanås, Sweden.

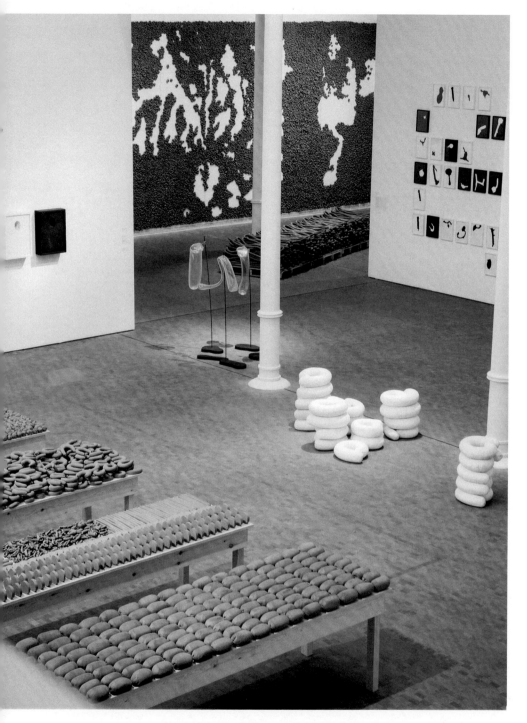

9 Anna Maria Maiolino (b. 1942), *Modelled Earth*, installation, Fundació Tàpies, Barcelona, October 2010. In addition to *Modelled Earth* can be seen *They Are*, 1994, *Emanated* (blown glass), 2007 and *Drip Marks X*, 2000 (on wall).

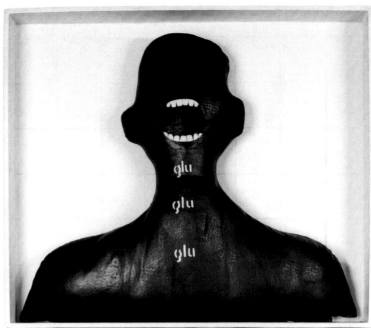

10 Anna Maria Maiolino (b. 1942) *Glu Glu Glu*, 1967, acrylic, cloth on wood, 110×59×12.5 cm. Museu de Arte Moderna Rio de Janeiro.

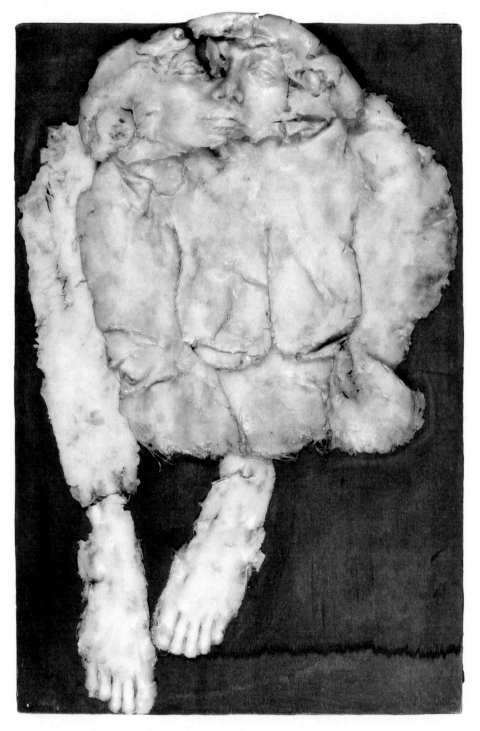

11 Alina Szapocznikow (1926–73) *Self Portrait: Herbarium*, 1971, polyester and polychrome wood, 81×52×5 cm.

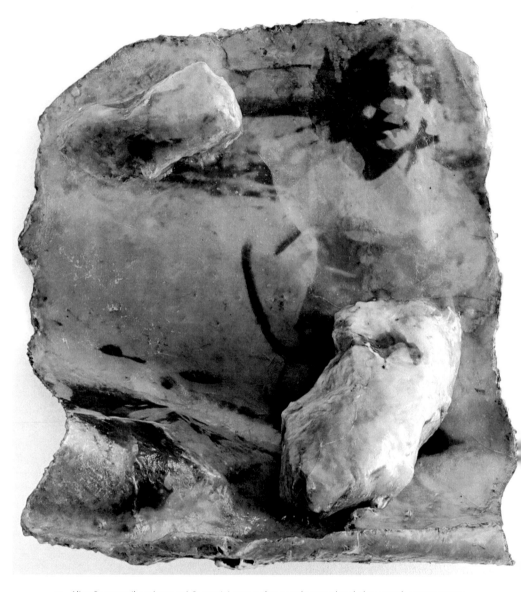

12 Alina Szapocznikow (1926–73) *Souvenir I*, 1971, polyester, glass wool and photograph, 75×70×30 cm.

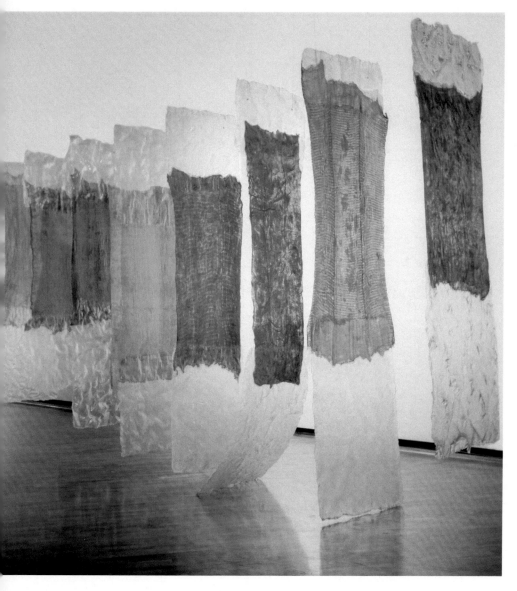

13 Eva Hesse (1936–70) *Contingent*, 1969, Cheesecloth, latex, fibreglass, installation, 350×630×190 cm.

14 Vera Frenkel (b. 1938) '*… from the Transit Bar*', 1992, Installation at The Power Plant, Toronto, 1994.

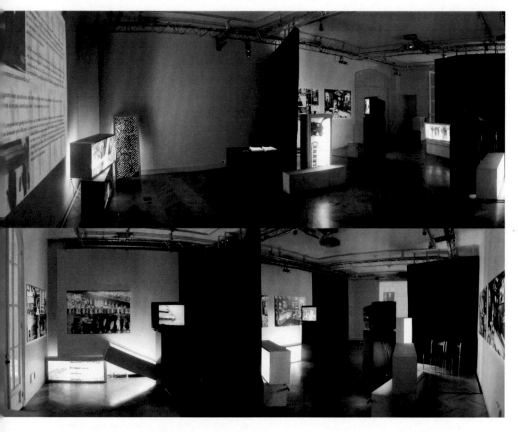

15 Vera Frenkel (b. 1938) *Body Missing*, 1994. Installation, video monitors, lightboxes and mural. Three-channel version, Centre culturel canadien, Paris, 2001–02.

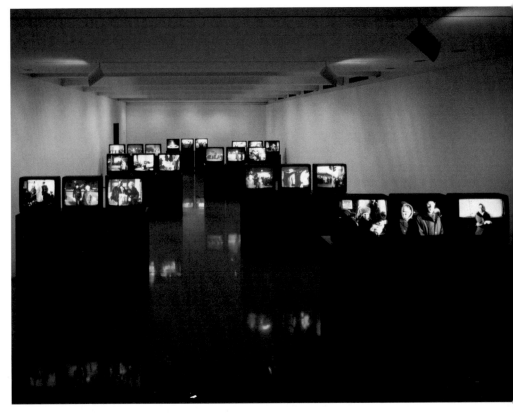

16 Chantal Akerman (b. 1950) *Bordering on Fiction: D'Est*, 1995, mixed media, 25-channel video, 16 mm film, Walker Art Center, Minneapolis.

Brazilian (born in the Ukraine of Jewish origin), gives us not books but living saved from books, narratives, repressive constructions. And through her writing-window, we enter the awesome beauty of learning to read; going, by way of the body, to the other side of the self. Loving the true of the living, what seems ungrateful to narcissus eyes, the nonprestigious, the nonimmediate, loving the origin, interesting oneself personally with the impersonal, with the animal, with the thing.' 'Clarice Lispector: The Approach …', trans. Sarah Cornell and Susan Sellars, in Deborah Jenson (ed.), *Coming to Writing and other Essays* (Cambridge MA and London: Harvard University Press, 1991), 59. French original: 'L'Approche de Clarice Lispector', *Poétique*, 40 (November 1979), collected in *Entre l'Ecriture* (Paris: des Femmes, 1986).

16 Tatay (ed.), *Anna Maria Maiolino*, 40.
17 De Zegher, *Anna Maria Maiolino*, 199.
18 Anna Maria Maiolino cited in de Zegher, *Anna Maria Maiolino*, 199.
19 Walter Benjamin's concept of *Bloße Leben*, elaborated by Giorgio Agamben, *Rermnants of Auschwitz* (New York: Zone Books, 1999), inspired Roger Buerger and Ruth Noack in *documenta 12*, Kassel, 2007.
20 Anna Maria Maiolino cited in de Zegher, *Anna Maria Maiolino*, 260.
21 Anna Maria Maiolino, *1990 Sculpture (in-process, casts and moulds) Clay Installations Drawings 1995–1999*, writings provided by the artist, p. 2, paragraph 5.
22 Anna Maria Maiolino, *Vir a 'Ser', Coming to 'Be'*, reprinted in de Zegher, *Anna Maria Maiolino* (2002), 281.
23 De Zegher, *Anna Maria Maiolino*, 281.
24 Simone de Beauvoir, 'Introduction', *The Second Sex* (1949), trans. H.M. Parshley (London: Vintage Books, 1997), 13–29.
25 De Zegher, *Anna Maria Maiolino*, 281.
26 See Bracha L. Ettinger, *Matrixial Borderspace*, ed. Brian Massumi (Minneapolis, MN: University of Minnesota Press, 2006).
27 Maurice Merleau-Ponty, 'Eye and Mind' (Paris: Gallimard, 1964), reprinted in Galen A. Johnson (ed.), *The Merleau-Ponty Aesthetics Reader: Philosophy and Painting* (Evanston, IL: Northwestern University Press, 1993), 121.
28 Merleau-Ponty, 'Eye and Mind', 122.
29 Merleau-Ponty, 'Eye and Mind', 122–3.
30 Merleau-Ponty, 'Eye and Mind', 123.
31 Merleau-Ponty, 'Eye and Mind', 123.
32 Merleau-Ponty, 'Eye and Mind', 217.
33 Merleau-Ponty, 'Eye and Mind', 217.
34 Henri Bergson, *The Creative Mind: An Introduction to Metaphysics*, trans. Mabelle Anderson (New York: Citadel Press, 1992).
35 Anna Maria Maiolino, *1990 Sculpture (in-process, casts and molds) CLAY INSTALLATIONS DRAWINGS 1995–1999*, p. 1 paragraph 2.
36 Anna Maria Maiolino, *1990 Sculpture*, paragraph 6.
37 Brian Massumi, *Parables for the Virtual: Movement, Affect, Sensation* (Durham, NC and London: Duke University Press, 2002), 3.
38 Simon O'Sullivan, *Art Encounters: Deleuze and Guattari: Thought Beyond Representation* (Basingstoke: Palgrave Macmillan, 2006).

39 Gilles Deleuze, *Difference and Repetition* (1968), trans. Paul Patton (New York: Columbia University Press, 1994), 139.

40 Deleuze, *Difference and Repetition*, 280.

41 Sigmund Freud, 'Beyond the Pleasure Principle' [1920] *Standard Edition of the Psychological Works of Sigmund Freud*, Vol. 18 (London: Hogarth Press, 1955), 1–64. See also Esther Sanchez-Pardo. *Cultures of the Death Drive: Melanie Klein and Modernist Melancholia* (Durham, NC: Duke University Press, 2003).

42 Elizabeth Grosz, 'Deleuze's Bergson: Duration, the Virtual and a Politics of the Future', in Ian Buchanan and Claire Colebrook (eds), *Deleuze and Feminist Theory* (Edinburgh: Edinburgh University Press, 2001), 230.

43 De Zegher quoted Joan Rivière, Julia Kristeva and Bracha Ettinger.

44 For the argument about the join of life and meaning, see Catherine Clément and Julia Kristeva, *Le Féminin et le sacré* (Paris: Editions Stock, 1998).

45 De Zegher, *Anna Maria Maiolino*, 352.

46 De Zegher, *Inside the Visible*.

47 André Breton named the gallery in Paris, *Gradiva*, Salvador Dali, Anne and Patrick Poirier, 2000, William Cobbing, 2007, Alain Robbe-Grillet's novel and film, 1984.

48 De Zegher, *Anna Maria Maiolino*, 2002, 186.

49 Bracha L. Ettinger, 'Wit(h)nessing Trauma and the Matrixial Gaze', in *Matrixial Borderspace*, 143.

50 Bracha L. Ettinger,'Wit(h)nessing Trauma and the Matrixial Gaze', 143.

Part **II**
Memorial bodies

Traumatic encryption: the sculptural dissolutions of Alina Szapocznikow

4

Captions to chapter 4

36 Alina Szapocznikow (1926–73), photograph of the Artist with *Ça Coule en Rouge* in her Malakoff Studio, Paris, 1967.

37 Alina Szapocznikow (1926–73) *Self-Portrait 1*, 1966, marble and polyester resin, 41×30×20 cm.

38 *Alina Szapocznikow: Sculpture Undone*, 1955–72, Wiels Art Centre 2011. Installation shot: work 1950s.

39 *Alina Szapocznikow: Sculpture Undone*, 1955–72, Wiels Art Centre 2011. Installation shot: work 1960s–70s.

40 Photograph of Alina Szapocznikow, New York, 1970.

41 Alina Szapocznikow (1926–73) *Rolls Royce II*, 1971, pink Portuguese marble, 20×64×21 cm.

42 Alina Szapocznikow (1926–73) *Stele*, 1968, polyester resin and polyurethane foam, 79×46×69 cm.

43 Alina Szapocznikow (1926–73) *Illuminated Breast*, 1966, coloured polyester resin and electrical wiring, 56×17.5×16 cm.

44 Alina Szapocznikow (1926–1973) *Photosculptures*, 1978. Photo: Alina Szapocznikow Archives.

45 Hannah Wilke (1940–93) *S.O.S. – Starification Object Series*, 1974–82, gelatin silver prints with chewing gum sculptures, 40×58½×2¼ inches (101.6×148.6×5.7 cm).

46 Alina Szapocznikow (1926–73) Photograph of the artist with *Invasion of the Tumours*, 1970, outside her studio at Malakoff.

47 Alina Szapocznikow (1926–73) *Tumors Personified*, 1971, polyester resin, fibreglass, paper, gauze, ranging from 33×56×34 cm to 15×23×16 cm.

48 Alina Szapocznikow (1926–73) *Herbarium XIII*, 1972, polyester resin and polychrome wood, 110×80 cm.

49 Michelangelo (Buonarroti, Michelangelo, 1475–1564) *Last Judgment – detail (Saint Bartholomew)* [before restoration].

50 Hans Holbein (1497/98–1543) *The Body of Christ in the Tomb*, 1521–22, oil on wood, 30.5×200 cm, Basel, Kunstmuseum.

51 Mathis Grünewald, Mathis (1455–c.1528) *Isenheim Altar: Crucifixion and Entombment*.

52 Zoran Music (1909–2005) *Dachau*, 1945, pen and ink on paper, 21×30 cm. Private Collection/The Bridgeman Art Library.

53 Bedrich Fritta (1906–44) *Temporary Living Quarters for the Elderly in One of the Barracks Terezin (Theresienstadt) ghetto*, c.1943, wash.

54 Alina Szapocznikow (1926–73) *Exhumed*, 1957, bronze, 64×42×30 cm.

55 Alain Resnais (b. 1922) *Nuit et brouillard (Night and Fog)*, 1955, Argos Films: shot.

56 Alina Szapocznikow (1926–73) *Untitled*, 1971–72, pencil on paper, 29.5×21 cm.

57 Alina Szapocznikow (1926–73) *Alina's Funeral*, 1970, polyester resins, glass wool, photographs, gauze, artist's clothing, 135×210×50 cm.

58 Alina Szapocznikow (1926–73) *Souvenir of the Wedding Table for a Happy Woman*, 1971, polyester, glass wool and photograph, shown at the Galerie Florian, 1971. Photo: Jacques Verroust.

59 Photographic Source (The Artist and Her Father) for *Souvenir I*, 1971, polyester, glass wool and photograph, 75×70×30 cm, photographic source.

60 Photographic Source (Unknown Newsreel or Photograph) for *Souvenir I*, 1971, polyester, glass wool and photograph, 75×70×30 cm, photographic source.

61 Montage using two sources for *Souvenir I*.

62 Judith Tucker (b. 1960) *Ahlbeck 1932*, 2006, charcoal, 152×121 cm.

63 Bracha L. Ettinger (b. 1948) *Eurydice*, no. 37, 2001, oil and photocopic dust on paper mounted on canvas, 21.4×28.3 cm.

64 Uziel Lichtenberg, Bluma Fried and friend, Łodz, 1938: the parents of Bracha L. Ettinger.

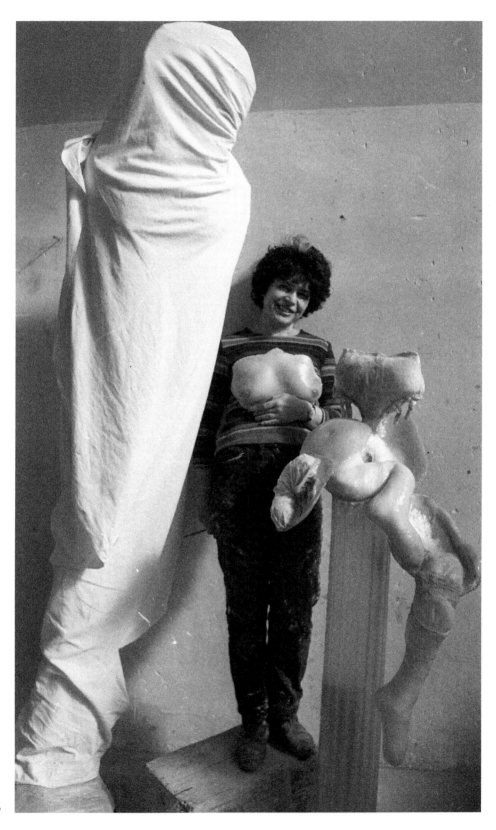

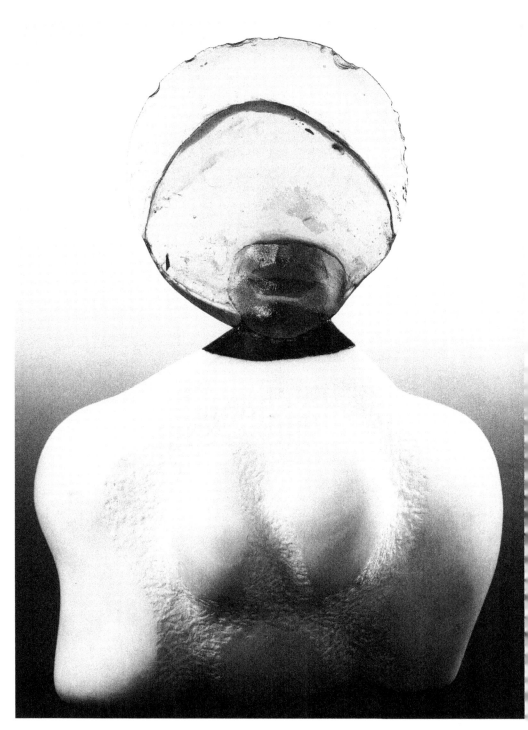

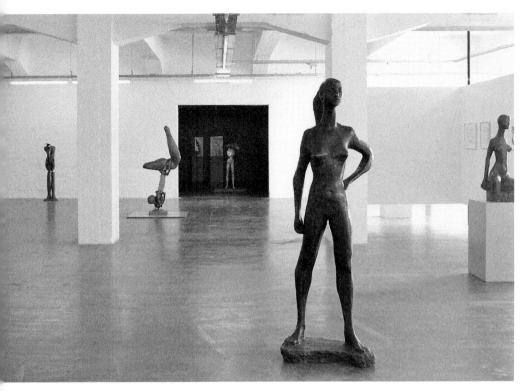

38

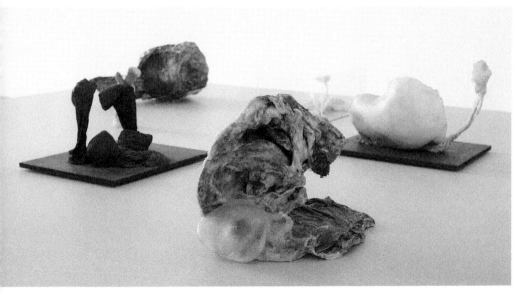

39

40

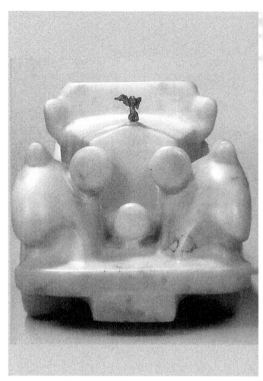

41

42

43

L'AUTRE SAMEDI, EN PLEIN SOLEIL, FATIGUEE D'AVOIR POLI
PENDANT DES HEURES MA ROLLS-ROYCE EN MARBRE ROSE DU PORTUGAL,
JE ME SUIS ASSISE ET ME SUIS MISE A REVER EN MACHANT MACHINALEMENT
M ON CHEWING-GUM.
TIRANT DE MA BOUCHE DES FORMES INSOLITES ET BIZARRES J'AI SOUDAIN
REALISE QUELLE EXTRAORDINAIRE COLLECTION DE SCULPTURES ABSTRAITES
ME PASSAIT PAR LES DENTS.
IL SUFFIT DE PHOTOGRAPHIER ET D'AGRANDIR MES DECOUVERTES MASTICATOIRES
POUR CREER L'EVENEMENT DE LA PRESENCE SCULPTURALE.
MACHEZ BIEN, REGARDEZ AUTOUR DE VOUS.
LA CREATION SE SITUE ENTRE LE REVE ET LE TRAVAIL DE TOUS LES JOURS.

 92 MALAKOFF, LE 22 JUIN 1971
 ALINA SZAPOCZNIKOW

44b

44a

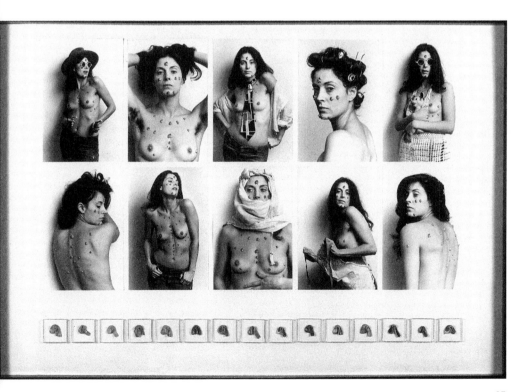

46

47

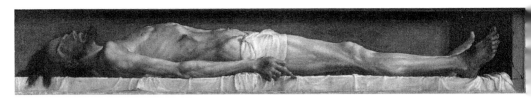

50

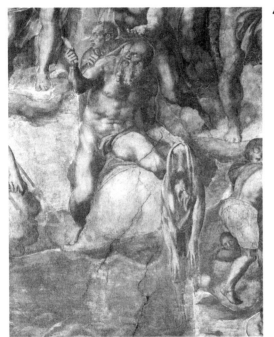

49

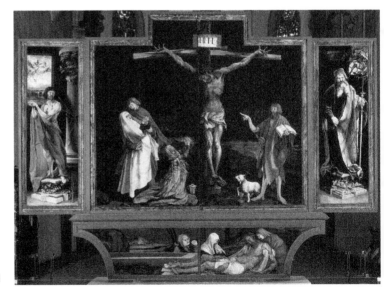

51

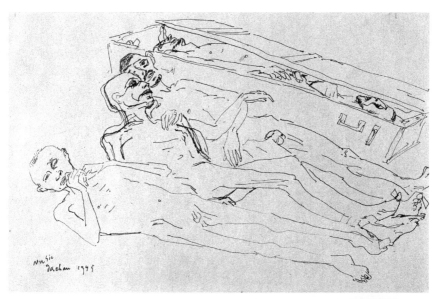

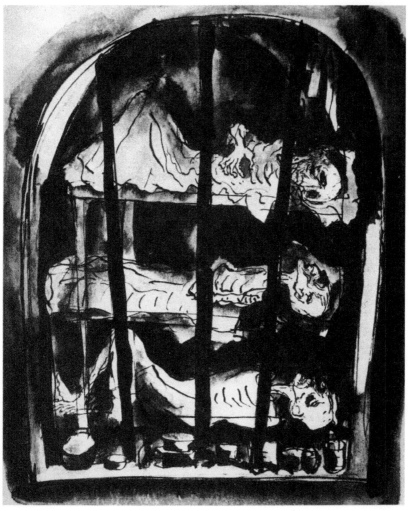

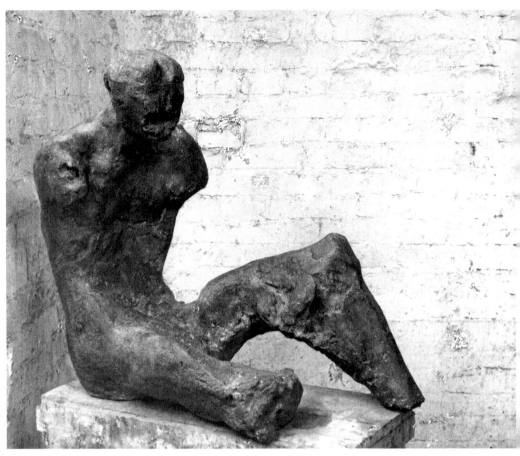

54

55

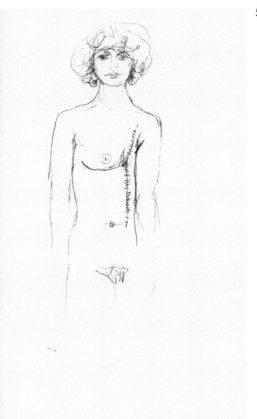

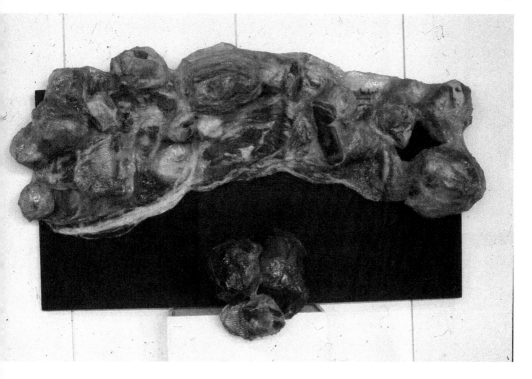

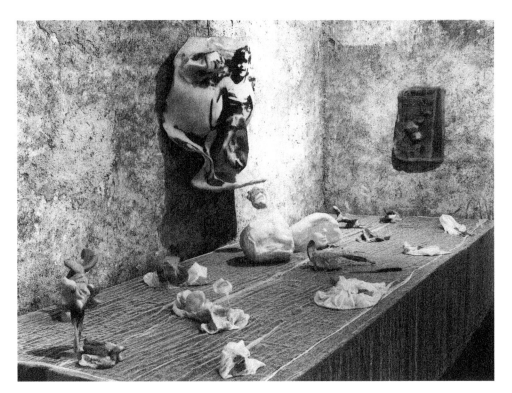

58

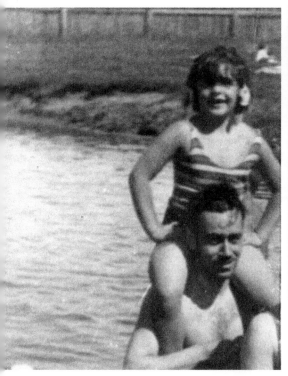

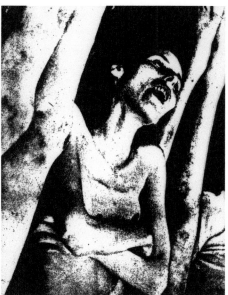

60

59

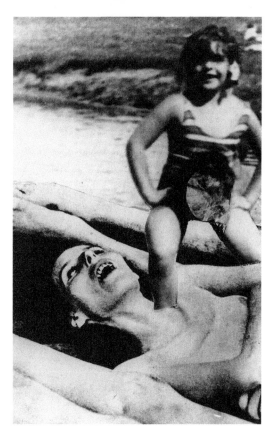

61

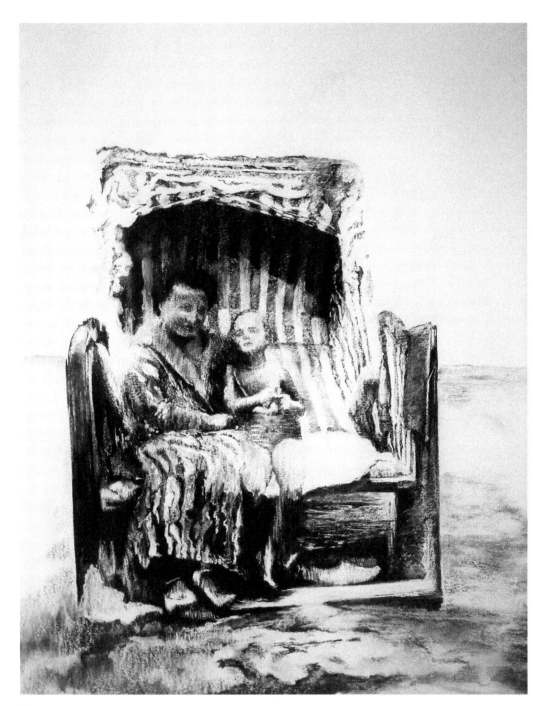

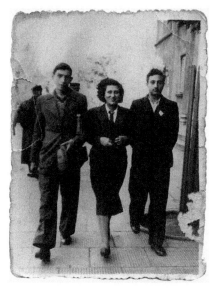

64

63

I have been defeated by the main protagonist, the wonder of our times, the machine. Today all beauty, the discoveries and testimonies of our times, the recording of history, all belong to the machine. True dreams belong to it; it is applauded by the public. I only produce clumsy [or awkward] objects. (*Objets maladroits*) …

Despite everything, I persist in attempting to fix in resin the imprints of our body: I am convinced that among all the manifestations of perishability, the human body is the most sensitive, the only source of all joy, all pain, all truth … On the level of consciousness because of its ontological misery which is as inevitable as it is unacceptable.

Alina Szapocznikow, April 1972[1]

In these statements, Alina Szapocznikow (1926–73), an artist born in Poland who died in France, places the adulation of modern technological and mechanical beauty, associated with various moments of Pop Art in North America and *Nouveau Réalisme* in France in direct opposition to the fragile human body (Figure 36). Displaced and yet still potent, the body is for her alone sensitive to questions of perishability. The choice facing the artist is, therefore, to produce objects that lack the formal beauty and technological order of the machine age, emblematic of an inhuman modernity, and instead exhibit their own *deformation* as testimony to the ontological misery of human corporality and an acute sense of mutability and mortality.

What are the conditions for this aesthetic and philosophical manifesto? Are they personal? Are they historical? Are they evidence of an aesthetic practice formed by the encryption of a traumatic burden at once intensely experienced in the artist's own body and yet of a truly historical order of catastrophe?

I was introduced to Alina Szapocznikow's work by two outstanding queer feminist Polish scholars, Tomas Kitlinski and Pawel Leszkowicz, during a visit to Poland on the occasion of the first retrospective of Louise Bourgeois in Warsaw's prestige Zachęta Gallery, in 2003, already referenced in Chapter 2. They gave me the catalogue of Anda Rottenberg's exhibition of Szapocznikov at

Zachęta in 1998 to confront me as a Western European feminist scholar with an artist celebrated internationally during her life, canonical in Eastern European art history, and utterly unknown to me in 2003.[2] Rottenberg commented on the weak response to the first retrospective exhibition of Szapocznikow, held in Paris shortly after the artist's death in 1973:

> The exhibition fell on stony ground. The autotelic and linguistic references within the sphere of seventies artists [she is referring to conceptualism] did not accord with the carnality and drama of the artist's work … a new generation grew up before art started dealing with the human body. Louise Bourgeois gained recognition only a few years ago. Eva Hesse who had been active more or less at the same time, did not leave her imprint on American art until the 1990s. Alina Szapocznikow is still waiting for the place which is her due.[3]

Thus despite Szapocznikow's fascination with 'personal fate and the functioning of our bodies, biological, cultural, existential and social', Rottenberg felt that Szapocznikow was awaiting her time even ten years after the realignment of Eastern and Western Europe had expanded our understanding of art in the later twentieth century across all of the continent.

From the moment I saw the mixed media *Self-portrait* on the cover of the 1998 catalogue, I was completely fascinated (Figure 37). Why had I never seen her work before? How did she come to make this kind of work? It was like things I knew and yet radically, troublingly different, disturbing, perplexing. Yet the work also opened a window into the disappeared modernisms of post-war Eastern Europe for Szapocznikow's work had its own relations to influential but still little known Czech sculptors such as Eva Kmentová (1928–80) and Vera Janousková (1922–2010) who shared her material experimentations and engagements with both the female figure and contemporary representations of femininity. How many other women have been hidden behind the Iron Curtain that severed East from West in European modernism for forty years?

Like Bourgeois, Szapocznikow was a thoughtful modernist, moving, however, from figuration into abstraction, while deeply engaged also with questions of equilibrium. In the late 1950s she began to work with malleable cement; in the 1960s she began carving in the most classic sculptural material, Italian marble from the quarries at Carrara, where her residency did not quite coincide with that of Bourgeois, who also came to Italy in the later 1960s to carve marble. She was also experimenting with dangerous industrial materials including latex, polyester and polyurethane.[4] When she died in 1973, she had been on the verge of radically moving beyond sculpture while dealing with embodiment, corporality, sexuality and mutability in installations of an early kind.

Across Alina Szapocznikow's extraordinary sculptural project, amplified by an equally extraordinary body of drawings, I am tracing contrary directions.[5]

Initially there was an attempted reconsolidation of the body through traditional sculptural figuration in modernist and then social realist modes, the latter culturally as well as economically supported in post-war Communist Poland. But a dissolution of materials and melting of forms begin by the early 1960s, some hilarious and joyfully erotic, others unbearably burdened by both ontological misery and historical trauma, as the once upright sculptures slip to the horizontal axis, spill, flow, crumple and corrupt. Compare the effect of two installations of the early sculptures of the 1950s and of the work of the 1960s (Figures 38 and 39). I suggest that the 'body' of work registers the gradual surfacing of a traumatic charge, embedded in the body, that does not achieve aesthetic transformation. Forms at first erect and grounded in the classical manner of sculpture, shift to a horizontal axis and succumb to a progressive dissolution of form. *Encrypted trauma* ultimately surfaces in forms and materials finally shockingly imprinted via photographic traces embedded into the dried resin with memories of the body through the fabrication of an artificial, damaged skin (Plate 12).

Finding a place

A photograph taken in New York in 1970 (Figure 40) places Alina Szapocznikow in a city and an artistic community that might have recognized an affinity with what she was doing in working with polyurethane and resin, combining a daring engagement with the sexed and sexual body but also with dereliction.[6] Alina Szapocznikow was only in New York briefly, exhibiting at the Bonino Gallery with a group of conceptual artists brought from Europe to show in New York by the critical advocate of *Nouveau Réalisme*, Pierre Restany. In New York, there was no artwork on show. Artists merely attached to the wall proposals for a project. Szapocznikow outlined her plan to make a double-scaled model of a Rolls Royce carved in pink Portuguese marble (Figure 41). She rendered useless the most luxurious and expensive of cars by using age-old sculptural skills to carve it in weighty, impenetrable stone. Deposing the usually semi-naked women who draped desirable cars in advertising, and the frank equation of status symbol automobile and phallic machismo, the manufacturers' elegant female insignia was replaced, wickedly, by a winged, erect phallus. Szapocznikow had hoped that Harald Szeeman, Director of *Documenta '72* would help her realize the full-scale version, but, at the time of an oil crisis, neither he nor she could find sponsors to raise the huge funding necessary to carve and transport such a work.[7] The artist also created another conceptual work for a Pierre Restany project: a skating rink to be suspended over the chasm of the volcano on Mount Vesuvius that might aggravate an eruption to petrify, like a modern Pompeii, modern pleasure-seekers.

Witty conceptual works, already in tune with new directions in contemporary art, were, however, hardly representative of Szapocznikow's originality during the later 1960s and early 1970s. Had the show at Bonino Gallery presented her most recent 'sculptural projects' such as the steles made of black polyester foam with imbedded female torsos and legs made from fragmentary body casts (Figure 42), or mounds of transparent but cherry-coloured breasts or lips on stems illuminated with electric light (Figure 43), who knows if American art critic Lucy Lippard, who had curated an influential exhibition in 1966 on what she named *Eccentric Abstraction* (including work by Louise Bourgeois and Eva Hesse), might not have written Alina Szapocznikow into the emerging feminist history of women artists of the 1960s?

But, we might also have then to ask: What would have been rendered invisible by such a purely feminist, and perhaps body art focus at that date? Would it have prematurely foreclosed the darker and traumatic histories, as was the case of Jewish child survivor of the Holocaust Eva Hesse until the work of Vanessa Corby in the 1990s re-examined Hesse's work in relation to survivorship, Jewish subjectivity and maternal loss?[8]

Long adulated 'at home' as a key figure in Polish post-war art, and widely exhibited and regarded in her own lifetime across Europe, Alina Szapocznikow is in the process of being 'discovered' internationally. In 2011/12, the first major retrospective exhibition staged outside Poland, *Alina Szapocznikow: Sculpture Undone 1955–1972*, opened at the Wiels Art Centre, Brussels, before travelling to the Hammer Museum in Los Angeles, The Wexner Center, Columbus, Ohio and the Museum of Modern Art, New York. Accompanying the exhibition a catalogue contains essays by Elena Filipovic, Joanna Mytkowska, Allegra Pesanti and Connie Butler. In 2011, under the title *Awkward Objects*, referring to the epigraph above in which the artist avows her own work as *objets maladroits*, Polish art historian Agata Jacubowska edited papers by international scholars delivered at a symposium that accompanied Joanna Mytkowska and Agata Jacubowska's new, contextualizing exhibition of the works of Szapocznikow in Warsaw in 2009, Jacubowska being in addition the author of the first monographic study of the artist.[9] Since 2007, dealers and curators have promoted Szapocznikow's work in Europe and New York leading to new conversations, for instance, in *Lynda Benglis, Louise Bourgeois, Alina Szapocznikow: After Awkward Objects* (London: Hauser & Wirth, 2009).[10] In 2010–11, Szapocznikow's works have appeared in a survey of women in pop art, *Seductive Subversions 1958–1968*, organized by Sid Sachs for the Rosenwald-Wolf Gallery of The University of the Arts, Philadelphia and been shown at The Brooklyn Museum by Catherine Morris, Curator of the Elizabeth A. Sackler Center for Feminist Art, Brooklyn Museum and in *Mind and Matter: Alternative Abstractions: 1940–Now* at the Museum of Modern Art, New York, curated by Alexandra Schwartz in conjunction with

the publication of that museum's volume *Modern Women: Women Artists at the Museum of Modern Art* (2010). Photoworks were exhibited at *documenta 12* (2007) and included in *Elles@Pompidou* (2009–11). Dedicated research in Poland produced catalogues raisonnés of her drawings and of her sculptures in 2000 and 2004 and her work is now accessible to researchers through her archive, which is on line at the Museum of Modern Art, Warsaw (http://www.artmuseum.pl/archiwa.php?l=1&a=1).

Will Alina Szapocznikow now find her place in the art history of post-war sculpture? Aligned with contradictory tendencies from Pop Art to Abstraction while also being appreciated for her postminimalist use of new industrial materials, Szapocznikow is gaining belated critical visibility as an innovative post-war sculptor. Is this at the cost of erasing specificities of art under Communism, post-Auschwitz Jewishness and gender-specific morbidity and mortality?

In 2007, Alina Szapocznikow was brought to international attention by her inclusion in *documenta 12*. Featured with a few sculptures, Szapocznikow was noted, however, for her series of *Photosculptures* (1971) (Figure 44), a series of micro-sculptures created with softened masticated chewing gum, suspended into unpredictable and temporary forms on wooden or stone edges that were then photographed and enlarged in scale by Szapocznikow's husband Roman Cieslewicz. When exhibited in a special format devised in 1978, they appear as flat, serial, refined photographic prints. The uncanny quality of chewing gum softened by the teeth and spit, then allowed to take on its own forms once exposed to air when suspended is contained by a formal beauty of framed prints that has made these dematerialized images immediately 'digestible' in contrast to the many challenging works by Szapocznikow that frankly confront the viewer with abject, horizontal forms made of rubbish and despair (Figure 39).

In the Virtual Feminist Museum, however, Szapocznikow's gum pieces enter into conversation through that medium with the work of Hannah Wilke (1940–93) who, in 1974, the year after Szapocznikow's death, independently began using masticated but coloured chewing gum. Wilke shaped the softened gum into suggestive vulval forms and attached them to her own partly nude body in a photographic series called *S.O.S Starification Series* or invited audiences to create them during performances to attach to wall texts. She also peppered found images with this signature form (Figure 45).[11] Marking of her own body with insignia of her sex that also touched on both the abject and the scarifying resonated for Hannah Wilke with the racialized marking and wounding of Jewish bodies during the Holocaust. In an interview Wilke stated: 'My consciousness came from being a Jew in World War II' and in her performance '*Intercourse with …*' she affirms, 'To also remember that as a Jew, during the war, I would have been branded and buried had I not been born in America.'[12]

Remembered, and critiqued, for her beauty, daring and intensely corporeal sculptures and performance, Wilke's sense of Jewish identification and historical trauma was overlooked until scholars such as Amelia Jones and Nancy Princenthal paid close attention to her affirmations.[13] It is a further terrible irony that Hannah Wilke would also die too young from cancer, making some of her most powerful work about the body she had so insistently mobilized as a sculptural material throughout her career in the face of her own mortality. Her final series, *Intra-Venus* (1994) is in fact a posthumously printed and assembled photographic series of staged photographs plotting out her chemotherapy and bone marrow transplants during her fight against lymphoma from which she died in 1993. She had earlier produced a series of works with her own mother, Selma Butter, whom she had nursed during her battle with breast cancer. Like Szapocznikow, Wilke has had to wait until the first decade of the twenty-first century for the first monographic study.[14] But placed in conversation now, both artists open up this intricate field of Jewishness, femininity, and creative innovations in media and practice around the body stemming from a sculptural imagination that occurred simultaneously in so many different sites in the 1960s and 1970s, and which hinged trauma, sexuality, corporality and mortality in ways that then defied critical comprehension. Yet, it must be stressed that there is a world of difference between Wilke, experiencing her Jewishness at a safe distance of projective identification, and Szapocznikow's direct subjection to the horrors of ghettoes and concentration camps, and to the life-long horror of being a survivor from that universe.

Out of time: too early and too late: the exhibition of 1973

Alina Szaopcznikow died on 2 March 1973, aged forty-six, from secondary bone cancer following her long fight against breast cancer (first diagnosed in 1969). ARC Director Suzanne Pagé and art critic Pierre Restany organized a posthumous exhibition at the Musée Moderne de la Ville de Paris of Alina Szapocznikow's recent works: two series called *Tumours* (Figures 46 and 47) and *Herbarium* (1971) (Plate 11 and Figure 48).

The first series directly referenced the deadly growths of spreading cancer that would take the life of a woman who had already fought off virtually untreatable peritoneal tuberculosis in 1949/50 – only surviving by means of an experimental dosage of Streptomycin. She had also 'survived' the German invasion of Poland in 1939 when she was thirteen and, as a result of being Jewish, incarceration in two ghettoes – Pabianice (1940–42) and Łodz (1942) – being sent via Auschwitz to Bergen-Belsen (1942/43) for ten months and then possibly to the Czech ghetto of Terezin (autumn 1943–May 45, also unconfirmed), from which she was finally liberated, aged nineteen, on 7 May 1945, imagining herself as the sole survivor of her immediate family. She was

separated from her mother in late 1944 and her brother is known to have died on 15 January 1945 in Terezin.

The terrible irony of imminent and excruciating premature death from an already mutilating disease after twice defying extinction charges the *Tumours* with almost unbearable pathos – these lumpen confrontations with biology run amok made from rubbish, newspapers, imprinted photographs and cloth bunched into clumps by polyester resin (Figure 46). Are they exorcisms, externalizing the invisible, autogenetic killer within? What happens when, as in some cases, these tumour forms are personalized with human features (Figure 47)? Are they being claimed back by the subject whose body and hence whose locus of subjectivity they were destroying? How do these clumsy objects register or dispel the repeated battle with mortality or register and dispel accumulating, and repeating, trauma in the face of death?

The second series *Herbarium* is a group of works in low relief made from flattening polyester positive imprints from negative body casts of the artist (Plate 11, Figure 48) and her adult son, Piotr Stanisławski. These crushed body forms were hung pathetically on black wooden boards, functioning as both objects and relief sculptures. Colourless, the sculptures at once remind me of a flayed skin, like St Bartholomew in Michelangelo's *Last Judgement* in the Vatican (Figure 49), onto which the artist projected his own distorted features; as such, they might tip into the abject. Yet, their waxy whiteness also invokes the distancing and eternal peacefulness of carved marble. Sleep rather than death is suggested. Tender and pathetic, the meditative *Herbarium* works counter the awkward litter of the 'clumsy forms' of the *Tumours*, which lie scattered, on a horizontal axis on beds of naked earth or pebbled stone, suggesting both burial and disinterral.

Both series insist on the organic physicality of the body, its own generative distortions, its fragility and its eventual disappearance leaving, however, imprinted traces. Both the body represented and its imprint have suffered. The procedure of body casting and then making an imprint in a malleable form, however, undoes the bonding of death and resurrection that marble once offered, in the Western tradition of sculpture, as a means of maintaining the body beautiful in petrified eternity beginning with pagan antiquity and appropriated by the Christian imaginary for European culture.

Of the works in the 1973 exhibition, Pierre Restany, long-time supporter of Szapocznikow's work in France, stated:

The *Tumours* and *Herbarium* are Alina's (*sic*) last works. Apart from their value as a human testimony they illustrate in a gripping way the naked truth of the creative process, conditioned directly by the imperious drives of organic sensuality. Alina had no need to conceptualize her love of life. She lived that love most intensely, with all her biology, that sensitive energy which became

naturally crystallized in the act of creation. She had that rare gift, typical of great sculptors, the innate gift of integrating mental motivation into the flesh of forms, the idea into matter.[15]

Perspicacious and generous, Restany's comments also betray gendered and gendering tropes about 'Alina' (note the use of only her first name) as a spontaneous, sensual, carnal artist, while at the same time recognizing something profound that he cannot quite articulate in the intensity of what he calls 'her love of life'. He is struggling to reconcile a quality that defies conceptualization and calculation and yet invests matter with sense: the term holding both sensuousness and some elusive suggestion of symbolic meaning. I want here to catch the difficulty of understanding a 'mental motivation' that is translated into the 'flesh of forms' when what we see are a resin skin entombing rubbish and the empty, fragmented trace of an invisible body.

Listing the events of Alina Szapocznikow's life between 1939 and 1945, as I have done, risks overwhelming the encounter with the artist's work with an outrageous biography. Her posthumous reception has indeed suffered from such overemphasis. Any study of this artist's career, however, that did not pay due respect to the enormity of her encounters with one of the most traumatic events of the catastrophic twentieth century, the Shoah/Holocaust, or to the nature of her own struggle with one almost untreatable illness that robbed her of her fertility aged twenty-three and then with fatal cancer would be guilty of an egregious ethical failure. How can we calculate the meaning of experience for the artist as a person, and for his or her artistic practice, especially when those experiences are so extreme? We swing between outlawing biographical reference for fear of reductive sentimentalization of women as artists – the cases of Frida Kahlo, Eva Hesse and Louise Bourgeois would be examples of biographical reductiveness – and modes of feminist cultural analysis that attempt theoretical finesse. The significance of lived experience itself is read with a range of psychoanalytical and phenomenological resources, while the mode of translation into aesthetic formulation is also given its full due.

Szapocznikow was never as loquacious as Louise Bourgeois about the significance of her past or the range of associations engendered by her work. Indeed, the years of what Szapocznikow poignantly named her 'baptism of despair' were clearly so horrific that she was intensely reticent, refusing to speak in public about her past. Some survivors, we know, lived for and felt compelled to bear witness; others buried their dreadful experiences in disavowing silence. Survivor Primo Levi wrote honestly and with a hint of anguish, moreover, about the shame that afflicts survivors for having survived, and a sense of being impossibly compromised by contact with the 'gray zone' that was often necessary for survival.[16] Szapocznikow once wrote to her first husband of the gulf that lay between them because of what she had experienced

and witnessed in the various camps that indelibly altered her being in the world.

Thus, without abjuring the significance of Szapocznikow's histories, I want to dispel the aura of pathos or tragedy by following her own lead: what matters is that she chose to become a *sculptor*. We should not read her work for testimony to any of her life's events; but we can, I suggest, decipher beyond the energetic engagement with life and a successful career in conditions of financial, political and cultural difficulty – post-war Europe, Communist Poland, foreignness in France, and so forth – the traces of the *encryption* of trauma (some of it known but unbearable, some unassimilably horrific) that nonetheless leaked from its psychic entombment and 'surfaced' over the twenty-eight years of her practice as a sculptor in ways that radically altered the sculptural form to which the artist had dedicated her life's work.

Szapocznikow's choices were, I suggest, historically and traumatically overdetermined precisely by the absence of the words she would not speak, for experiences indelibly engraved upon her own flesh. These refused to remain ultimately invisible. Between 1939 and 1945 her young body was tortured by starvation, brutality, exhaustion and worse. She witnessed the unspeakable atrocities committed against other bodies around the dark core of mass industrial killing and the struggle for survival in 'the concentrationary universe'.[17] She hung onto life but then had to live that life imprinted by what she had endured and seen, smelt and touched. Hence we need to approach her work through the deeper understanding of the concept of the survivor, and I shall discuss her work in relation to Terence des Pres's study and Charlotte Delbo's writings on the nature of survivorship and traumatically imprinted deep memory.

Secondly, Szapocznikow endured the experience of infertility, an anguish that has only recently been fully acknowledged in public discourse to deepen our understanding of its grief. Studies of Holocaust survivors remark on the urgency of having children that overtook many still fractured men and women, as if procreation, the sheer will to create life, was the last act of defiance in the face of attempted genocide. To be unable to renew life from within one's own body – when the desire or the compulsion is there – is not a wound to be superficially dismissed by mere mention. It is perhaps one of most profound and unfathomably painful afflictions to be endured by a healthy woman and far too little recognition is given to the ramifications of this experience in terms of an understanding of oneself as a body at war with one's will and desire. Alina Szapocznikow and her first husband adopted a baby in July 1952, revealing to no one, not even her son during her life-time, his adopted status.

Thankfully, I have not yet faced a mortal disease prematurely claiming my life; my mother and some of my closest friends have. Even that vicarious experience of the imminent and unwilled death was terrifying enough for me

to insist, alongside both of the above extremities of human suffering, upon the terror Szapocznikow confronted through cancer and to admire the courage of those who have to face the coming of their deaths out of time.

Thus instead of the bathos of a *tragic* life (given that tragedy involves the subject participating in her own tragic destiny), I wish to encounter the work of Alina Szapocznikow under the sign of *trauma* which will, nonetheless, impress itself into the changing forms of her innovative aesthetic experimentations that traverse recovered memories of interrupted modernisms, brutal post-war abstractions that themselves register cultural trauma, and onto Pop, *Nouveau Réalisme* and postminimal hybridizations and new materials.

Alina Szapocznikow did not live to see her life's work through. Imminent death seems to have speeded up certain tendencies and engagements with anti-forms while detouring her from other longer considered questions about equilibrium and volume that had preoccupied her initial involvement with sculpture. Given the abrupt foreclosure of a longer career by premature death, how could we now, as we belatedly reinstate her place in the history of twentieth century art, perform what Ettinger in a feminist and Matrixial move calls *transcryptum*, lending our perspective of the afterwardness of feminism and Holocaust awareness to this work that seemed brilliant, but indecipherable, in its own moment?

Thus we need the information about Alina Szpaocznikow's life in order for us to tune into the unsaid, as well as to that which surfaced in her artworking. Szapocznikow's sculptural work shifts from solid, carved and moulded forms into progressive dissolutions, distintegrations and disruptions of inside and outside that testify to the belated 'surfacing' of the latent trauma of the unspeakable violations of the human body that she had witnessed during her teenage years, assisting her doctor-mother as a nurse in ghettoes and camps before she became an artist 'after Auschwitz'. I speculate that the unconscious propulsion of Alina Szapocznikow towards sculpture was initially an escape from what she had seen 'in the Real'.

At her liberation in 1945, Alina Szapocznikow did not go 'home' to Poland. She went to Prague. It seems she was at that point not aware that her mother had also survived. She thus felt that she was entirely alone: the last of her own world, her own family in a post-Jewish Europe. (She would later encounter cousins in Paris.) Penniless, without much education, she trained to become an artist by producing sculpted bodies that are modelled and constructed as relatively whole entities. Traditional sculptural practice and materials, carving stone, casting bronze, moulding plaster, construct and secure imaginary integrity. Sculpture is by definition form-creating, sometimes monumental, producing a volume that takes its place in real space, repopulates the world. Her work exhibits a restorative will to create whole forms, reparatively to carve and model whole bodies, remade into solid figures in hard or permanent materials

like plaster and stone. This desire was paradoxically legitimated precisely by the emergence of a public culture of monumental figurative sculpture in post-war Stalinist Poland. But then, as part of an equally lively Polish avant-garde, the nature of her forms and materials gave way to more abstract forms, rendered in materials like malleable cement that explored more formless, dissolving and abjecting effects, but which nevertheless turned permanent and remained upright. By the early 1970s, however, we are confronted in her oeuvre with works that no longer have volume or form, but feel like crushed casts. Made experimentally with industrial materials such as the new polymer, polyester, works are poured, viscous, transparent and sometimes invaded by ready-made, photographic images. Some appear now as hardened relics or, worse, suggesting dried, even detached fragments of skin (Plate 12). Such a transformation from the solid and the contained to the fragmentary, trans-parent and detached cannot be explained as a progressive teleology shaped alone by shifts by the artist's maturing engagements with the artistic cultures of Prague, Warsaw and Paris. Nor are they symptoms of what Krauss and Bois would, in 1996, finally name as the counter-trend of twentieth-century modernism: the formless – Bataille's *informe* and touching on what Georges Didi-Huberman would concurrently explore as the archaeology of the imprint in modern art, *L'Empreinte*.[18]

The mutability of her own body forced the artist to negotiate or even, shall we say, accede to the return of the repressed in a secondary encounter with trauma that released the encrypted source of the emerging dance of death that characterized her work, the play of eroticism and mortality that so radically distinguishes her work even from those with whom she is now being art-historically connected. I wonder if this is the source of the after-affect that so confused even her admiring critics?

Encryption

In studying melancholia occasioned by profound loss, psychoanalysts Nicholas Abraham and Maria Torok argued that the loss, sometimes not even one's own but inherited from other generations or from surroundings, can induce a psychic entombment of unspeakable secrets deposited in the specific life-histories of individual subjects which bypass signification. The crypt forms a kind of hyperlinked network between sounds or between syllables or between visuals through which the encrypted trauma, however, continuously leaks. Abraham and Torok identified a 'poetics of hiding' that has implications for understanding the relays between trauma and aesthetics. My suggestion is that we might well consider the 'movement' in Szapocznikow's work from solid to molten, from formed to disintegrating, as indications of both the psychic entombment of trauma and the paradoxically affecting aesthesis of

dissolution by which its encrypted traces 'surface', not as a known story that can be consciously 'expressed', but as that which operates its poetics of hiding and forced disclosure through displacement into de-signified materiality and (de)form(ation). Yet the work is saved from abjection by the artworking of aesthetic transformation borrowed from, but never completely liberated by, consciously deployed artistic resources offered in contemporary developments in the surrounding art worlds.

Alina Szapocznikow was, of course, not alone in daring to mingle sexuality and death. Their intersection was one of the central problematics of much that was significant in culture in the twentieth century, certainly after Surrealism and after the writings of Georges Bataille. But, I suggest, the sources of her initiative are not phantastic, or phantasmatic, but traumatic. We can also understand the conjunction of eroticism and death as the result of what Freudian psychoanalysis disclosed about the dialectical operations of human subjectivity and desire oscillating between the pleasure principle and the death drive.[19] Furthermore, in a broader cultural perspective, such contradictory psychic forces intersected with the destructiveness of the novel, industrialized World Wars while at the heart of the Third Reich's regime of terror, Jean Améry placed a sexual perversion: sadism. Such socio-cultural attentions to the modernity of *Eros* and *Thanatos* need also to be juxtaposed to the ravages of our special modern diseases, primary among which is cancer that attacks many organs, but frightens us most when it takes over those associated most with our sexual identities and erotic pleasures.[20]

As the epigraphs insist, Szapocznikow chose the *body* as her central problematic as an artist while 'Auschwitz' was as much the terminus for the European artistic tradition based on the *pathos formula* of the emotionally expressive body as it was for real bodies, precisely because of what happened in that real event to millions of human bodies, destroyed in industrial genocide or forced to endure and die from the concentrationary regime of dirt, disease, starvation, exhaustion, cold, heat, and a systematic assault on the moral, psychological and social structures of human subjectivity and personality. To have survived by not being gassed or shot as a Jewish European is not to have escaped. The witness-survivor, *pace* Primo Levi who disclaimed being the real witness because he did not endure either mass murder or become the abject walking corpse – named in Auschwitz slang a *Muselmann* – is indeed the bearer of continuing hell of being split between what one has seen and known and endured and the world to which one has returned without being ever able to communicate any of it to those who never saw it and could never imagine what has once been real 'beyond imagining'.[21] What does making sculpture based on the body mean not only in the epoch 'after Auschwitz' but as the bearer of its imprint? To answer this question, we need to return to an earlier moment of epistemic rupture in Western culture's imaginary of death and the body.

Confronting Death in 1521

In 1521 but dated 1522, Hans Holbein the Younger (1497–1543) painted a chilling rendering of the Christian theme of Christ's entombment, titled *The Body of the Dead Christ in the Tomb* (Figure 50). Relentless in its horizontality, the compressed space allocated to the corpse is oppressive. The painting's extended rectangle increases the sense of enclosure, entombing the cold, yellowing and tortured body with its distorted features and contorted hands still registering the prolonged agony endured prior to and during an excruciating death.

According to Hegel, Christian thought and theology and hence iconography circle around the paradox of the natural death – the death of the body – and its overcoming through one death – a sacrifice made out of such divine love that death itself is overcome once and for all. The Christian narrative moves swiftly through a redemptive sequence of suffering, death, entombment and resurrection over three days. In artistic representations, bystanders registering gesturally or facially the appropriate grief and astonishment, doubt and joy, typically attend to focalize the moment of suffering, deposition from the cross and then resurrection. The body that is the subject of and subjected to this passage through death back to life is more often than not represented as the figure of pure and heroic pathos in which suffering becomes the transient physical ordeal that will lead to resurrected and eternal beauty as a result of the divinely appointed victory over human mortality. Michelangelo's drawings of the Crucifixion would be the apotheosis of this tendency. Holbein's painting, however, arrests the Christian narrative at a moment that is hardly ever pictured – after the crucifixion and before the resurrection. Mathis Grünewald envisions the tender entombment as a predella to his Gothically brutal *Crucifixion* (1506–15; Figure 51). Grünewald's and Holbein's afflicted bodies form a counter-imaginary.

In her study of melancholia, *Black Sun* (1982), Julia Kristeva devotes a chapter to Holbein's dismal painting exploring his aberrant figuration of the dark and unattended, unwitnessed, rarely represented stage between entombment and resurrection. She places the work in its cultural-historical moment of early sixteenth-century European humanism and iconoclasm which marked the emergence of Protestantism and its novel theology. Hans Holbein the Younger is *the* subject of this moment; his intellectual, theological and artistic significance is stretched between the desolate, ascetic and lonely image of the derelict, dead Jesus and his other famous work, the *danse macabre*: the dance of death, a parallel commentary on human mortality, its defiance and disavowal.[22]

At the junction of Catholicism with its spiritual understanding of the death of Christ and novel Protestant insistence on the reality of suffering,

this painting, according to Kristeva, offers us 'an unadorned representation of death' which conveys to the viewer 'an unbearable anguish before the death of God, here blended with our own, since there is no hint of transcendence': everything save a tiny touch of light on the toe produces a feeling of permanent death. Christ's dereliction is seen here at its worst.

Kristeva senses that, in Holbein's confrontation with the entombed body, 'Humanization has reached its highest point'. Thus she concludes that Holbein's vision is the Renaissance vision of 'man subject to death, embracing death, absorbing it into his own being, and enjoying a desacralized destiny that is the foundation of a new dignity'.[23] Holbein was not melancholic, but rather the painting is the register of the melancholic moment of its creation that witnessed a 'loss of meaning, a loss of hope, a loss of symbolic values, including the value of life'. The structure of the painting proposes itself to a 'solitary meditation of the viewer in disenchanted sadness'. Despite the novelty of oil painting and its potential, this act of painting the entombed Christ poses a question: 'is it still possible to paint at that point where the body and meaning are severed, where desire disintegrates?'

> Holbein's chromatic and compositional asceticism renders such a competition between form and a death that is neither dodged nor embellished, but set forth in its minimal visibility, in its extreme manifestations constituted by pain and melancholia.[24]

I am using Kristeva's reading of Holbein's image and its moment to make visible an even more radical rupture in representability associated with the chronotope 'Auschwitz'. For the truly thoughtful, 'Auschwitz' rendered it impossible to maintain the relations between Western aesthetic conventions for representing the human body in its mutable and mortal condition and what had actually happened in the real. Aesthetic models were exploded by the dreadful transformation if not obliteration of *human* death brought about by a novel crime: racially targeted, industrialized genocide coupled with totalitarian experiment to extinguish the human in bodies subjected to a lingering dehumanizing dying in the concentration camps.

In his second reflection, in 1962, on the question of the barbarism of aesthetics 'after Auschwitz', Theodor Adorno, quoting Sartre from his play *Morts sans sépulture* (*The Unburied Dead*) (1946), argued that something had happened in the real 'when men beat people until their bones break in their bodies' (Sartre) which act of inhuman brutality seems to stand in for that to which Adorno had given the generic name of a time and a place: 'Auschwitz'. The real, having happened, was so atrocious that metaphysical speculation, imagining, was henceforth knocked out completely.[25] In his third and final return to the question of art's situation 'after Auschwitz', in *Negative Dialectics* of 1966, Adorno elaborated on his argument that what had happened in

'Auschwitz' had changed the conditions of all human dying.[26] Reversing the one sacrificial death that according to Christian thought might save all humanity, mass murder went beyond the merely cruel and sudden ending of a life. The death camps did not 'murder'. They manufactured corpses from which were extracted a range of resources desecrating the very body whose dignified and respectful disposal after death defines human culture.

Artist-bystanders, however, who felt compelled to comment upon the rise of Nazism or its aftermath, continued to draw upon the iconographic and stylistic resources of Western Christian imagery of death, despite being Jewish or communist: Picasso in his painting *The Charnel House* (1945, New York, Museum of Modern Art), responding to liberator photographs of the tangled bodies found in concentration camps, or Chagall in his pre-Holocaust series using the image of a Judaized Christ to denounce the new wave of persecutions of European Jewry, beginning with his *White Crucifixion* (1938, Chicago Art Institute). The novelty of the event, however, evades the pre-troped conventions, exposing the inadequacy even of Gothic expressionism or the desolate melancholy of Holbein because they belong to a moment *before* the radical alteration 'in the real' of the nature of all human death because of the nature of administered annihilation of some within the human community.

We find a similar problem in the work of artist survivors of the concentration camps. The Slovenian artist Zoran Music (1909–2005) (Figure 52) was a prisoner in Dachau in 1944/45. Music recast the Holbeinian confrontation with the skeletal body and anguished features of the imaginary Dead Christ to represent the figure of the *Muselmann*. His witness drawings and later paintings from memory are not, however, of corpses but of the terrifying novelty of the concentrationary universe: human beings who cannot be securely defined as living or dead. Degraded, starved, diseased, the inmates of a concentrationary universe hover in a state of non-human life that is not-yet-death. Czech artist Bedrich Fritta (1906–1944) (Figure 53) one of the famous group of artists in the Terezin camp/ghetto – in which Szapocznikow endured eighteen months – draws with vivid Expressionst extremity the unclothed bodies of starved men lying in the three-layered bunks as if they already lie in Holbein's tomb but in triplicate, destabilizing our encounter with what we cannot establish as corpse or still living man.

Trained modernists, Fritta and Music still draw on the Gothic-modernist paroxysm of pain translated into twentieth-century modernist Expressionism. As such, they can only repeat existing ways of imagining suffering through aesthetic distortion, rather than seeking to create utterly new forms through which to meet the novelty of the circumstances Adorno would explore in his final reflections on 'after Auschwitz'. Holbein's extraordinary gesture in painting the desolation of the entombed and dead Christ invites a reading of

a painting that opens on to a shift in cultural history of the Western Christian imaginary at the beginning of humanism and Protestantism. Yet Holbein's model proves inadequate to the enormity of the event 'Auschwitz' precisely because after what was done and seen, the human body could no longer be retrieved to signify the deeper horror of the destruction of the human perpe-trated by the Nazi state, even in such frank abjection as Holbein's vision of the battered incarnated divinity who would, none the less, promise to defeat death. What happened in 'Auschwitz' was at once a trauma for Western culture, henceforward without means of knowing it through available significations or images – hence an event beyond thought or imagination – and for those individuals who lived through and witnessed the exterminatory or concentra-tionary universe, carrying it with and in their own bodies.

What does it mean to live after Auschwitz?[27] What does it mean to have survived? Is it living on, after but always oriented towards those who did not? Is it living with unbearable knowledge but also with the imprint of the real upon the entire sensorium of the survivor's body?

Surviving: debates

In 1976, American scholar Terence des Pres published his study *The Survivor: An Anatomy of Life in the Death Camps*. His text draws on both fiction and testimonies to build a detailed picture of the unspeakable conditions suffered in both Hitler's and Stalin's camps. His purpose, however, was to trace a will for life that produced the unimaginable: the survivor. Des Pres' argument troubles me, but the evidence he assembles is overwhelming. The book honours the extraordinary courage and endurance of men and women who fought actively against the systematic destruction of their humanity through self-mainte-nance, care for others, solidarity and even revolt, holding onto language and memory, willing themselves to survive to testify. From this particular material Des Pres derives a general lesson for humanity and the world: that there is something resilient in humanity capable of withstanding everything in the name of life. This argument echoes Robert Antelme's profound testimony to the unbreakable bond uniting '*L'espèce humaine*'.[28]

Paradoxically, in tracing this comforting thread through the memoirs and novels, Des Pres has to assemble a terrifying picture of what was endured. His most telling chapter is entitled 'Excremental Assault' which ends with the scene of the survivors of the Warsaw Ghetto uprising who had hidden for days in the foul sewers beneath the city and emerged 'strange beings, hardly recognizable as humans'.[29] Yet even here Des Pres finds the comfort: 'life and will, as if these shit-smeared bodies were the accurate image of how much mutilation the human spirit can bear, despite shame, loathing, the trauma of violent recoil and still keep the sense of something inwardly inviolate'.[30]

Why do we seek comfort in such beliefs of the indomitability of the human spirit? Not all survivors attribute survival to will or the power of life; not all preserved a sense of something inwardly inviolate. We do not have any comments from Szapocznikow nor other evidence about Szapocznikow's experiences between 1939 and 1945. But that of which she could or would not speak publicly was nonetheless utterly significant for she was a survivor – sustained, we know, by being able to remain for some period with her mother, thus to be recognized by an other and protected in ways that subsequent studies, particularly of women's experiences and survival, have shown to be often decisive.[31] Her project for the monument at Auschwitz-Birkenau is significantly the pairing of a protective mother and a small child. But her work, despite her evident capacity to reclaim life as a survivor, refuses to allow the past to be cleansed.

Before becoming Alina Szapocznikow

In most accounts of Alina Szapocznikow's artistic career the briefest mention is made of her youth which involved the death of her father when she was twelve in 1938, the loss of her brother in 1939 (he died in Terezin in 1945) and the process of surviving two ghettoes, a brief possible but undocumented stay in Auschwitz, a longer incarceration in Bergen-Belsen and finally, we think, eighteen months in Terezin. During these desperate years between 14 and nearly 19, she worked beside her mother, a doctor, as a nurse, witnessing not only her mother's and her own suffering and constant danger, but the diseases and afflictions of those subjected to starvation, brutality and untreated infection. The anguish of these years and the violent destruction of the world into which she had been born must constitute a locus of massive trauma. There is little record. So let me revisit the chronology and life-story, not to mine it for explanations of the artworks, but to establish the generational and geopolitical landscape against which it was created, that haunts the work that did not ever represent it, that indeed was made to assert life in defiance of it.

Alina Szapocznikow was born to a middle-class professional Polish-Jewish family in Kalisz, Poland on 16 May 1926. The family lived thereafter in Pabianice, just outside Łodz. Her father, a dentist, died of tuberculosis in 1938. Losing sight of her brother at the very outbreak of the war in 1939, Alina Szapcznikow and her mother Ryfka (Regina), moved through a series of ghettoes and camps surviving liquidations and death transports.

Thus, like Janina Bauman, author of the telling memoir of her adolescence surviving the Holocaust in and outside the Warsaw Ghetto, *Winter in the Morning* (1986), Alina Szapocznikow was thirteen, on the cusp of womanhood (also like Anna Frank who was 13 in 1942 when forced in to hiding) when Germany invaded Poland and began its campaign to subordinate the Polish

nation as a slave state and to eradicate Poland's large Jewish population. She effectively lost her teenage years, secondary education, coming of age socially and sexually; her adolescence comprised memories or amnesiac obliteration of life in two ghettoes, then possibly Auschwitz and definitely Bergen-Belsen, and finally Terezin, each location more ghastly than the last. Auschwitz-Birkenau was a factory of death but the Auschwitz system as a whole was also a slave-labour complex and a concentration camp; Bergen-Belsen, founded in 1943, was a German concentration camp not manufacturing instant death but producing a slow and agonizing dying through starvation, overwork, lack of sanitation and rampant disease. 50,000 prisoners died there. It was there that Anna Frank would perish, aged fifteen, in April 1945 from typhus, malnutrition and despair.

Terezin was a ghetto. Using a barracks town built in 1780 to house 5,000 soldiers and supply the fortress that protected Prague from the North, Terezin was made into a ghetto for the Czech and then for other European Jewish populations, housing up to 55,000 people. Regular deportations were made to Treblinka and Auschwitz-Birkenau, and in conjunction with the extreme conditions in Terezin itself it is calculated that 97,297 people died there from disease, malnutrition and violence. 15,000 children died in Terezin; only 93 children survived this ghetto. In addition, distinguished figures like German Liberal Rabbi Leo Baeck, too prominent to destroy, were sent there, and these prominent persons included known artists, musicians and writers for whom people might inquire. Hence, the inmates generated a remarkable cultural life of theatre and opera. The Austrian modernist, Frederika 'Friedl' Dicker-Brandeis (30 July 1898–9 October 1944), student of Johannes Itten and Bauhaus teacher, was sent to Terezin in December 1942. There she taught art especially to assist the children: much of their work survives, over 4,500 drawings. She was deported to Auschwitz and was killed on 9 October 1944. Several other artists were employed in a technical drawing office and they secretly documented the horrors of life in the crowded ghetto. When they were betrayed to the SS, the artists were tortured to discover the whereabouts of the incriminating drawings. Some had their hands broken so as never to be able to draw again. Bedrich Fritta (1906–1944), Leo Haas (1901–1983), Malva Schalek (1882–1944), Charlotte Buresova (1904–1983) and Otto Ungar (1901–1945) are just some of the names of artists whose testimonies in art survived, though as these dates reveal the artists often did not.

Artists were also used by the SS to create the great hoax that presented Terezin as a model town created to protect the Jews from the war. This came about because a transport of 456 Jews from Denmark (those who had not managed to be taken to safety in Sweden) was sent to Terezin and the King of Denmark, Christian X, demanded that the Red Cross be allowed to visit his compatriots. The camp was prepared for the inspection by delegates –

one from the Danish and two from the International Red Cross – on 23 June 1944 by false shop fronts being painted like a movie set to suggest ordinary consumption and trade. Gardens were planted. Children were given unheard of food and required to call their guards 'Uncle' and complain of receiving so much. The visitors were shown special accommodation allocated to the 'prominent', which were bearable compared to the overcrowded barracks, and performances were staged. So successful was the deception – that the Jews of Europe were being well cared for – that Hitler commissioned a propaganda film along the same lines to be made between August and September 1944 titled *Terezin: A Documentary Film of the Jewish Resettlement*, directed by a Jewish prisoner who with the crew and cast was later deported to their deaths in Auschwitz-Birkenau.

Narratives of dates and figures, even references to some of the artistic representations that dared to document the horrifying truth of this ghetto cannot bring us to understand what the experience was for Alina Szapocznikow. Yet we must hold onto whatever indications we can glean of six years of terror, defying daily death and dealing as part of a medical team with the horror, as we approach the emergence from this history of the young woman who chose to leave Poland and become a sculptor, to work with her own body, forming mirrors, however idealized or deformed, for the body as the imperative figure of post-'Auschwitz' human *being*.

Following liberation in May 1945, Szapocznikow opted to remain in Czechoslovakia, changing the spelling of her name, claiming a Czech birthplace and moving to Prague as a citizen. In Prague, she initially worked with several artists on a project to restore Baroque sculptures. In 1946 she enrolled in the arts and crafts school in Prague to study sculpture under Joseph Wagner (1901–57). I read this as a fascinating gesture of defiance and reclamation: sculpture involves carving or moulding or otherwise making figures – whether figuratively or abstractly. It is perhaps the art form most physically involved with the body: the body of the maker and the body that is made figuratively or abstractly. To restore eroded sculptural forms and eagerly to learn every skill in creating the solid and the monumental face and body of the human being carries an excess freight for a survivor who had been witness to the atrocities and sufferings she did not want to remember.

The rediscovery of the broken link with the European avant-garde centred in Paris was intense in Prague art circles, enhanced by the memory of Czech surrealism from the 1930s. In 1948 Szapocznikow moved to Paris, enrolling in the Ecole Nationale Supérieure des Beaux-Arts, attending classes in the studio of art deco sculptor Paul Niclausse (1879–1958). Working to support herself in masonry while also studying, Szapocznikow lived largely in the extensive Polish expatriate cultural community. She was overcome with a potentially deadly illness in 1949 from which she almost died in early 1950;

peritoneal tuberculosis left her unable to have a child. In 1951, she moved to a now-Communist Poland offering greater opportunities for work to artists in the new state. She returned to Paris finally in autumn 1963, having stayed in Poland to be with the mother she had refound who died in 1961.

During these Warsaw years Szapocznikow won many prizes and commissions within Poland and was internationally recognized in biennial exhibitions at Venice (1962, where she represented Poland), France and USA, as well as having a monograph show at Zachęta in Warsaw in 1957. The sphere of art in post-war Poland was both public and intensely political, even prescriptive. The scale was monumental and memorial. The sculptor entered and sometimes won competitions that were frankly socialist realist, even Stalinist, while also submitting projects for the International Auschwitz Memorial Competition in 1959 and for memorials for the Warsaw Ghetto Uprising. Jewish-Polish identity vied with participating in the making of a culture for a new communist nation.

Janina Bauman's second memoir, *A Dream of Belonging* (1988) provides relevant context here. It is a frank and revelatory account of being a Jewish survivor and a Communist in post-war Warsaw. In 1945, Janina Bauman and her husband, sociologist Zygmunt Bauman, who had survived the war in the Soviet Union whither his working-class family had fled before the German invasion, chose not to emigrate but to remain and build the new socialist dream of Poland, a 'dream of belonging' that slowly turned sour. Bauman's memoir opens a window into the intense cultural life of the still materially devastated country, the energy of their social and intellectual worlds despite poverty and real material limitations, the place of cultural institutions and their 'administered' hence framing controls. She is very frank about working with this emerging regime – she read film scripts for the State Film Production, even blocking a project by Andrzej Wajda. Then she tracks the ultimate disintegration of her youthful hope for a better society as the screws of Stalinist bureaucracy crushed all genuine socialist hopes. She also documents the persistent anti-Semitism that would eventually be politically resurrected in the mid-1960s, depriving Zygmunt Bauman of his professorship and driving his family secretly to escape in the night in 1968. In Warsaw at that date, Szapocznikow was witness to this terrifying return of the past in March 1968.

One work that indexes something of this changing political climate and at the same time marks a confluence of encrypted past and political present is Szapocznikow's sculpture *Exhumed* 1957 (Figure 54). It is at once a political condemnation of Stalinism and a tribute to László Rajk, the Hungarian politician murdered in 1949 and rehabilitated during the Hungarian 'thaw' in 1955. The forced confession and show trial of Rajk in the Hungarian Stalinist regime of Mátyás Rákosi's anti-Titoist purges had been used as the justification for the crack-down that followed. Once Rákosi had to admit Rajk's innocence, his legitimacy began to weaken, leading ultimately to the fated Hungarian

uprising in 1956. Originally exhibited as *Rehabilitation*, the title *Exhumed* replaces rehabilitating a reputation with the drastic realism of representing an exhumed and hence decomposing body. This is not resurrection in the Christian sense. A buried past whose actual physical form must come somewhat horrifically to light is uncovered. The torso is shown upright as if the figure is rising but without arms or complete legs; the body is at once an amputated fragment and a figure of defiance, yet the damaged skull-like face voids the site of identity and humanity. Critic Urzula Czartoryska places this work in conversation with other post-war sculptors, pushing the form of the body to its formal limits, such as Germaine Richier, Henry Moore, Alberto Giacometti, Kenneth Armitage, Lynn Chadwick: all of whom Czartoryska suggests were 'facing the twin obligations to forms and materials of modernism and the politics and history of a failed modernity'.[32] She also suggests that this combination produced a more viable compromise in painting daring to rely on brutal materiality such as we find in works by Jean Fautrier, Wols and Dubuffet. As an association generated by the form of *Exhumed*, Czartoryska brings in the charred and petrified bodies of Pompeii as well as broken bronze sculptures recovered from the Mediterranean around that time. She also suggests that *Exhumed* is not only 'private memento of [Szapocznikow's] own experience of dealing with the dead, but also an unparalleled accusation'. Referencing directly the tortured and executed of Stalinist terror, Szapocznikow may also be invoking the victims of the Warsaw Ghetto and the Warsaw Uprising whose remains were discovered in the rubble of the city as it was being reconstructed:

> If *Exhumed* is rightly perceived as an innovative work, one must take into account that it was made by a mature artist who was familiar with the decaying body, dug out of the mud and devoid of limbs. For Alina Szapocznikow the history of figurative sculpture and its inspiration, the knowledge of the transitory nature of the human body, is found not only in museums but also in junkyards of stones and discarded sculptural fragments, and terrible as it may sound, in the camp cattle trucks with layers of dead bodies. Perhaps this last above all.[33]

Exhumed evokes the searing images from Soviet newsreels, soon to be circulated after 1955 in Alain Resnais's *Nuit et brouillard*, of charred bodies found in the open pyres of Auschwitz (Figure 55). It seems, that along with the recently buried past now rising to the surface both materially in Warsaw and in the political thaw after Stalin's death, Szapocnikow's own knowledge of death and dying was surfacing. *Exhumed* is a turning point as it begins a process, linked with her use of malleable cement that allows for an initial working with a pliant material that will ultimately set as hard as stone while retaining the bodily imprint of the sculptor's handling even as the sculptures formally evoke decay and distintegration.

In 1963 Szapocznikow's move to Paris brought her into contact with the circle of *Nouveau Réalisme* around the critic Pierre Restany. These artists were playfully interested in the machine age and into the signs and materials of contemporary urban life and its visual culture. Szapocznikow began to make combines, breaching the discrete space of sculpture with objects, embedding Soviet and German military relics of the Second World War, one of which *Spiky* was shown in the exhibition *Auschwitz* (25 January–10 February, National Theatre in Warsaw). She began making body and face casts in 1965. In 1966 she worked in marble quarries at Carrara in Italy reclaiming marble for her sculptural practice – as did Louise Bourgeois in these years – but she also began to make works using polyester, making casts from parts of her own body and those of her friends in this new material, some of which she illuminated with electrical wiring: her breasts and lips series date from this time (Figure 43). Pierre Restany writes:

> Plastic casts, until now the last stage of the artist's opening her eyes to the real world, bring a new element of transparency and light effects to Alina Szapocznikow's technical repertoire and means of expression. Forests of bright red mouths, extensive dunes of torsos with nipples glistening like pearls, luminous spheres of breasts heavy with electric glow – are among the wonders of a new *Jugendstil* … These all too beautiful bodies dispose of their primitive sensuality for the benefit of some kind of transcendent magic of objects.[34]

In 1966/67 Szapocznikow embedded photographs into polyurethane. In 1967 she had a one-woman show in Paris curated by Pierre Restany that travelled to Warsaw, Stockholm and Copenhagen. Witness to rabid anti-Semitic attacks in Warsaw, she was also in Paris for the May 1968 events. In that summer she returned to carving to make monumental repeating stomachs from a cast of a friend in Italian marble. But she also began using polyurethane foam to make works called *Expansions* and *Pollution*.

By 1969 she was exhibiting all over Europe and listed among the figures in European post-war art. Pierre Cabanne would also write of the very bodily art works being made at this time:

> Yet experimenting with the body, to which she has become attached as to a 'totally erogenous zone', was not devoid of a feeling of repulsion, because all flesh carries within it its own decease. The flesh is vulnerable to the same extent that it is glorious, joyful and desired. In Alina's fetishist catalogue eroticism blends with exorcism. One never knows if breasts and thighs emerge from a bed destroyed by lovers' embrace or from the mud of Hiroshima, if they belong to the realm of love or death.[35]

In 1971 she wrote her own manifesto about art and the everyday, and did her sculptures in chewing gum which were rephotographed by her husband

and presented as *Photosculptures*. She had a solo show in Geneva in which she realized a spatial arrangement called *Disintegration of Personality*. Critics puzzled over the dramatic juxtapositions of body casts and masses of black polyurethane foam (Figure 42):

> Is Alina's a pessimistic vision of the world, in which man is absorbed by matter? Does Alina want to immortalize living matter in a casket made of dead matter, or does she in a fit of self-adoration want to immortalise Alina? And yet in her last works the artist seems to raise the question of narcissism to a general theme. The form of her body increasingly loses individuality and becomes an object. Her abdomen becomes a cushion, a serial object of general use and module whose composition is changeable. Narcissism moves from irony to sarcasm.[36]

In 1972, she was offered the Chair of Sculpture at the Academy of Fine Arts in Nice but declined on grounds of her health. Later in that year she returned to hospital for her second operation. In 1973 she was moved to a sanatorium in southern France where her secondary bone cancer caused increasing paralysis and agonizing pain and left in her a state of extreme agony. She died on 2 March 1973 aged 46, and is buried in Paris at Montparnasse Cemetery. Another of the post-war generation of Polish intellectuals, film-maker Andrzej Wajda, perceptively wrote a kind of epitaph:

> That she had long been seriously ill I found out only a couple of days before her death. But that none of us knew about it, that you couldn't tell when looking at her, I see as normal. When you go through the kind of things she went through as a child, life is neither good nor bad. It appears in cruel brightness and leaves no room for sentimentalism. This means not suffering but expressing suffering, and not returning to the past, unless in order to answer the question of what one is today …[37]

Carnality and sexual difference

How will we read this artistic project, dealing with life and death, sex and destruction, while overshadowed by a specifically feminine encounter with mass annihilation? What of the trauma of fatal disease attacking a locus of her sexuality and symbol of her femininity?

As we have already seen, the French critic Pierre Restany is typical – and both very French and very masculine – in affirming, from his personal encounter with Alina Szapocznikow that

> Alina loved life completely, without mental reservations. She loved it with her mind and with her heart, with the sensual fullness of her body, a woman's body.[38]

Was this love of life identified by Restany the spontaneous and mindless outpouring of the woman's body, of woman as body? To accept such a proposition would be to fall prey to the essentialism in Restany's concept of the artist as a woman. Was the constantly smiling face of the survivor of atrocity that we see in many beautiful photographs of Alina Szapocznikow not a sign of 'natural feminine' *joie de vivre* so much as a reaction to, if not a defence against, the traumatically real encounters with death that the artist had endured at different points in her all too brief life?

Writing in 1966, Frankfurt School philosopher Theodor Adorno declared that 'Auschwitz' introduced 'physical death into culture'.[39] Do we yet fully grasp what he meant? Writing on the adolescent experiences endured by Alina Szapocznikow and the secondary trauma of her own mortal illness to which she succumbed in 1973 when she was 46, Pierre Restany avers:

> During the Second World War at 16 (*sic*), she was deported and that early experience of suffering and death marked her for life, but she emerged from it alive and beautiful, yet with no illusions. Her work was to be but one long scream of revolt against the *genocide of the flesh* and ineluctable calamity of evil; it was to be testimony and a premonition. The memory of the camp was to be replaced by a baleful premonition of cancer which would claim her at the age of 47 (*sic*) … (my italics).[40]

In Restany's dramatic text, we have three vital clues to a reading of Alina Szapocznikow's artistic project. Restany interprets her work as at once mute (she does not speak of her past) and deafening (the work is itself a perpetual scream). It is, therefore, a silent scream (wordless, inarticulate yet viscerally intense at the level of its aesthetic affectivity) and a different kind of testimony (bearing witness through its particular forms and materialities) to an ethico-political revolt against what fascism had done, and she had seen, that was a *genocide of the flesh*.

If Adorno, the survivor removed from the actual experience of ghetto, camp and endurance, knows intellectually and politically that new forms of physical death disabled philosophical transcendence, Alina Szapocznikow knew that this was a genocide of the flesh. But she does not know it: for its traumatic reality is not accessible to knowing. Thus Restany is identifying, even before the language of trauma analysis emerged to name it in this way, the singularity of the manner in which body and the new plane of existence post-Auschwitz are inscribed; or rather, as I am suggesting, encrypted into sculptural deformation by Alina Szapocznikow. Restany evokes the horror and pain burned into the flesh of those who were also frozen, starved and abjected by filth and disease. But this 'bare life' of the human body suspended between living and dying has been formulated, in the case of Alina Szapocznikow, not by attempting to make art represent this genocide of the flesh, expressionisti-

cally or cubistically remartyring the body. Hers is a sculptural practice that succumbed, creatively, to the process of its own undoing/impossibility, its entanglement with contradictions that could not be kept apart.

Sculpture is the least propitious but the most necessary site for this battle against representation that is nonetheless to become grotesquely eloquent and tenderly violent. Encountering, enduring, surviving the horror of attempted racist genocide are given a kind of *aesthetic anti-inscription* in Szapocznikow's work because the attempt to remake the body through sculpture unravels from within itself, not representing the damaged body but performing the impossibility of restitution in the face of that history.

Thus Restany presents Szapocznikow's work as a repetition that invokes trauma. Trauma is not merely horror; it is rather the always unthinkable, the endlessly unrepresentable, and the eternally immemorial that does not go away but haunts those other events or objects that we do make. Yet, it seems that the aesthetically evoked corporality of an artistic practice could or did, by means of its (de)forms and novel manipulations of non-aesthetic materials from the world of machines and industry, bear witness, *if mutely*, to the past of horror and its current residues in modern machinic society that needed to be silently *mouthed* yet also insistently *enfleshed* even in mutilated, bound, emaciated, diseased forms. Indeed, modern horror since industrially manufactured killing began with the First World War, atrociously exposes human bodily vulnerability to technological and chemical violence. Hence the silent scream registers the will to expunge the pain from the body, while the body fails to provide the sound for the discharge of its pain and becomes the site of its encryption. It breaks even as it longs to be desirable and desired. Restany recognizes a potent force in the *plastic* work of Alina Szapocznikow's sculpture that finds a visual form for both the screaming body and the traumatically arrested silence in face of the unspeakable.

The life and work of Alina Szapocznikow stages the collision of different kinds of encounter with death that is not at all abstracted from sensuous, embodied subjectivity. That is why *aesthesis*, a form of knowing and an economy of affects that holds the sensuous, sentient and reflective together without the Christianocentric division of reason versus flesh, does not become a site of consoling beautification. It is instead a means to encounter the traumatic residues of real, and sometimes awful, actualities.

At the other end of the string of her ultimately shortened life, Alina Szapocznikow endured the premature claiming of her body's vitality by breast cancer waging its secret and internal war against its subject's own desire to live on. She became the patient in a hospital, subject to intrusive and deforming surgical procedures, drawing a series of her terrible agony and her own surgically scarred body (Figure 56). Before she underwent mastectomy, she made casts of scrumptious breasts that float free and replicate, sometimes accumulating

like piles of candy, offering a non-maternal and non-eroticized appeal to the oral. Restany continues:

> All humanist discourse, all the cosmic vision of the artist, is written in the *carnal memory of the body*. In the same way that her woman's body was, so each human body is the receptacle of life's experience. All Alina's work is dominated by this biological sense of history … Anatomy … is the organic foundation of her language. With the same organic gestures, the flesh of her sculptures registers the passage of time and the determinism of its destiny.[41]

Transcending the normalized sexism of Restany's good but benighted intentions towards an artist because she is a woman to whom he attributes some biological destiny because of her sex, we can nevertheless glean a profound insight from his writings. *Feminist* readings of sexual difference and of the body that is in fact psychically shaped by phantasies (rather than by spontaneous knowledge of anatomy) help us to understand the dramatic collision of history, the carnal and the aesthetic without recourse to ideas of biology and anatomy. In the light of the later twentieth-century theorizations of the centrality of the body, from phenomenology to psychoanalysis and feminism, Restany's thoughts about the art of Alina Szapocznikow sets off a fascinating rewriting of Freud's misunderstood statement that 'anatomy is destiny'.

Freud did not argue that physiological anatomy predestines gender absolutely. In the famous essay in which he declared 'anatomy is destiny' he was explaining the phantasmatic structure of the Oedipus Complex.[42] The phantasizing child attributes the psychological meaning of difference (presence/absence/having/not having/ wholeness/mutilation) to a minor detail of bodily difference, thus *investing* anatomy as a support for a purely logical dilemma of acquiring a sexed identity in relation to a binary logic of presence/absence. Anatomy is not the cause of sex differences: it becomes its imagined site and as subjects we are trapped within that imaginary order signified by the phallus as arbiter of sexual difference. What Freud does offer us, therefore, is the important insight that corporeality is charged with psychological significance, and is shaped in phantasy by which the imagined and also the pleasured body is integrated into psychic life. Thus anatomy is not destiny on its own accord; but historical destinies can be written into anatomy, as the whole anti-Semitic trope of the Jewish body reveals.[43] Race thinking inflicts its hatreds into the skin, nose, ears, hair, sex of those it racially others.

I want to take Restany's phrase – *the carnal memory of the body* – into yet another direction that touches on Jewishness and the body in a different register. In his book *Carnal Israel*, cultural theorist Daniel Boyarin has identified the different concepts of the flesh in Judaism and Christianity.[44] Christianity fell under the profound ascetic influence of Pauline doctrine and encouraged the mortification of the flesh as the only road to the transcendence of the spirit

symbolized by the risen, death-defeating Christ-God. As a result Christianity has tended to condemn its 'father' religion – Judaism – and hence the Jews themselves for being too carnal, and for too comfortably inhabiting the living, desiring, reproductive and working body, instead of disowning the physical body in favour of spiritual transcendence of the soul. It would be tempting, therefore, to hear in Restany's fervent affirmation of carnality in the work of Szapocznikow an unconscious trace of this old divergence between Jewish and Christian sensibilities towards the body. But there are problems in such an assertion.

Restany's idea of a carnal memory, however, runs the risk on the one hand of affirming an anti-Semitic stereotype about the fleshliness of the Jewish people, and notably about the sexuality of *la belle Juive*, and on the other of imposing a typically patriarchal, gendered stereotype: woman as flesh.[45] Hence the combination of being Jewish and woman, above all, creates for Szapocznikow an image of pure flesh, mortified and mortal. This phantasy of the Jewish woman's carnality can only operate imaginatively in a very different manner from Christian theology of the incarnation of the Word associated with the canonically sacrificial masculine body in Christian culture represented by the masculine image of the pathos of the crucified Christ to which I have already pointed in the discussion of Holbein's *Dead Christ*.

So how can I work through this tangle of carnality and mortality, flesh and death, gender and Jewishness, overdetermined by an abhorrent historical deformation of death associated with Nazi racialized genocide, but equally haunted by deeper cultural tropes: Christian thought about Jewish bodiliness and phallocentric phantasies about woman as mindless, material flesh?

Skin

Alina Szapocznikow was never tattooed with a prisoner number. Nevertheless, the question of skin, rather than flesh, emerges in her later works finally to deter the desire expressed by Restany and others for the living woman they palpably saw in the person of the artist herself.

In 1971 Alina Szapocznikow created a trio of works all titled *Pamiatka I, II, III*. The French title is *Souvenir*. The Polish word always refers to an object, not to remembrance. Souvenir II and III share the forms of the *Tumours* and lie on surfaces. But *Souvenir I* is different (Plate 12). Like *Herbarium* (Plate 11) and *Alina's Funeral* (Figure 57), *Souvenir I*, shown here in an installation titled *Souvenir for a Wedding Table for a Happy Woman*, hangs on a wall (Figure 58). Made of polyester, glass wool and photography, measuring 75×70×30 cm, *Souvenir I* is attached to a wall like a relief. Yet it has three-dimensional qualities. Like a sheet of dessicated newspaper, it curls into space. Unlike newsprint, it is not fragile, but hard and fixed in its form. Two protruberances bulge

outward from its surface. Into the polyester have been embedded traces of two photographs already conjoined into a photomontage (Figures 59 and 60). The archive shows us two photographs from the 1930s which the artist marked up for reprinting. She chose only one for this work (Figure 59).

Dominating the right-hand side of the work is part of a family holiday snap showing a young girl, in a bathing costume, sitting on a man's shoulders, apparently smiling at the photographer. The ambiguity derives from the heavy shadowing of the original black and white photograph taken in sunshine which makes the child's the eye sockets become skull-like deep hollows. In the transposition of the photograph to the photomontage and then to this embedding, they now appear as smears of blackness in the flattened enlargement into its crude component masses of dark and light. The photographic image has been suspended in and this is melded with the polyester. The resulting effects of blurred transposition introduces the uncanny suggestion of a death's head. The happy image of *before* also becomes overshadowed with *after*. Derived from a family photograph from the early around 1932, the relic of this past is a freighted artefact, a haunting trace of a disappeared world of integrated, modernizing European-Jewish civilization in pre-war Poland. It appears to be one of only two images in the surviving photographic archive that shows the artist's pre-war childhood and the only one that portrays her father who died of tuberculosis in 1938.

The British artist Judith Tucker (b. 1960), herself a child of a German-Jewish refugee mother, growing up displaced in Britain, also works from a rescued photograph that shows her mother, Eva, as a young child on a seaside holiday in Ahlbeck, Germany in 1932 (Figure 62). Taken the year before the very beach on which the child was playing was forbidden to her because racializing persecution of Germany's Jewish citizens forbade public space to its Jewish citizens, the photograph of her mother's lost childhood resonates with the legacies of traumatic loss and forced migration that still shapes those who belong to what is named as 'the second generation'. Marianne Hirsch identifies in a whole generation of artists and writers a condition of post-memory that links past and present through the mediation of the indexically potent, analogue photograph that carries the past into the present through the uncanniness of the indexical image.[46]

In her early inclusion of the photograph as a ready-made of history, an image that bears a historical meaning of catastrophe even as it commemorates happier times, Szapocznikow's *Souvenir I* also anticipates these later artists' use of photographs as transports of memory. But she also connects with a very different use of the photograph that we find in the work of the Israeli-French painter artist Bracha Ettinger (b. 1948; Figure 63) who, as I have already suggested, has posited the possibility of art functioning as 'the transport station of *trauma*'.[47] In her painting practice Ettinger takes a found

image from the family album representing the time before she existed, passes it through a photocopier that is interrupted before the ashen grains forming the replication can be heat-sealed. Ettinger uses the emerging/disappearing spectral trace of the past in order to intensify the affect of the borderspace between two moments. She has worked repeatedly from a photographically arrested moment in 1938 in Łodz, Poland when a smart young couple and their friend walked freely down the public streets in confident anticipation of their modern future, smiling into the street photographer's camera (Figure 64). They also stand on the edge of an abyss which severs that modern street scene from the artist's own beginnings as the child whom this young couple bore after they had survived the annihilating terror in which their place in Europe was brutally eradicated and their companion destroyed. In this work on deep purple paper their ghostly trace shares its space with another archival image, one of the few direct visual documents of Nazi mass murder, from which Ettinger rescues a group of faces, one turning in mute appeal before her imminent destruction to the photographer 'shooting' the procession of naked women and to the viewers coming after the death that followed this 'shot'. Before and after moments also reach out to new times of retrospective encounter with these traced pasts.

Alina Szapocznikow's *Souvenir 1* (Plate 12) differs from the postmemory work of Tucker and the trans-temporal compassion of Ettinger. The photograph is not just a record of another time, place and generation from which the artist is severed. Captured in the freeze-frame and frozen time of the artist's own self 'before the event', a moment is now sealed into a chemically created simulacrum of skin, like an image tattooed by this process (Figure 58). It is hard not to evoke one of the atrocious remnants of National Socialist sadism in which human skin was harvested from corpses, especially when that skin bore a tattoo.

In the new surface Szapocznikow has made of photographically imprinted resin, her photograph has in fact been superimposed in an intermediary stage onto a found image that represents what was to come for this smiling child still so confidently perched on invisible shoulders. In order to make the montage of the two images, the father, who once supported his child has been cut out (Figure 61). Death suspends her over a void. The archive has a copy of the original photograph already incised for the extracting of the child from the father's shoulders. Like Ettinger's work which removes the companion striding with her parents-to-be from the reworking because he did not survive, Szapocznikow marks the loss of her father in isolating the child from the original photograph. Her legs now dangle into the space of the second source photograph, which operates, however, on the horizontal axis.

This image carries a heavier freight. It is the image of a dead woman (Figures 60 and 61). Between a tangle of emaciated limb lies a woman with her arms crossed over her breasts in a more formal presentation of a dead

body. Her head lolls back and the slackness of death has made her mouth fall open. Her eyes may not be closed. We do not know the source of the image.[48]

Szapocznikow scholar Agata Jacubowska argues that what we are witnessing in 1971 is a visual connection being made between herself as a child 'before' and an image from the event itself, as seen and recorded by outsiders entering the space of the camps from which Szapocznikow was finally liberated in 1945. Szapoznikow had repeatedly touched on the Shoah through engagement with public monuments for Auschwitz and the Warsaw Ghetto during the 1950s. But then Polish national memory had claimed Auschwitz I, with considerable justification, as the site of a Polish suffering because many Polish intellectuals and resisters were sent to the concentration camp of Auschwitz I. The death camp of Auschwitz II: Auschwitz-Birkenau was different. Instituted as an overflow camp in spring 1942, it was rapidly expanded and became the site of mass industrial extermination by Zyklon B, eventually having five crematoria to dispose of the 900,000 Jewish and Roma victims killed on this site. But images of unburied corpses are *not* icons of Auschwitz; they are the evidence of the concentration camps in Germany where in the last weeks starvation and disease produced daily deaths in the thousands. But what is significant is Szapocznikow's choice of an image of a dead *woman*, inserting her own childish leg so that it first overlays (see Szapocznikow Archive no. sz XIII.152) and then (sz XVII.73) touches the shoulder of this feminine corpse.

This ghastly visage of abandoned and desolate death is repeated three times in *Souvenir I*. As we can see in the photograph showing the original condition of the work in 1971 (Figure 58) the face of this dead woman is also embedded in the excrescence or protruberances bulked by glass wool that bulge phallically from the abdomen of the child. To the left the face has been flipped and 'looks' towards the smiling child. Emerging out of her belly is a close-up of the face now inverted in the vertical axis. Jacubowska suggests that the presence of this image indexing the horrors of exterminatory genocide and the concentrationary terror has moved from the public and monumental, typical of the 1950s work, to the personal and intimate, possibly as a result of catastrophe then facing the sculptor not from an external threat that killed the camp victims, but from an internal menace that was killing her. The protruberances that bulge from this skin-like sheath evoke the cancerous tumours growing another kind of deadliness out of life-forces gone crazy. Alina Szapocznikow had been living with the menace of cancer since 1969.[49]

The little child's own womb has been replaced on the photomontage with an image of a 'tumour' and now this skin, identified with the concentrationary past is bulging with a disease that is killing her. The smile of the hopeful, happy child is countered by the repeating image of the open-mouthed woman whose deathly grimace takes on new power as a screech of pain: the silent scream Restany imagined.

Thus the woman's face becomes its foreclosed other, the counterpoint of the smiling child who makes us see behind the glamour of the modern consumer image an echo of the horrific face of modernity. Once placed on the horizontal axis in this work, and juxtaposed with the only image of the pre-'Auschwitz' era, when the child still had a father and the world still functioned without death, disappearance and genocide, and placed in this yellowing polyester resin encasement, apparently curling with age, yet generating horrendous growths to disfigure its surface, *Souvenir I* – here connoting 'memento' – enters into a different register of affect. The after-affect seeps through the play with history, memory and the image to produce an after-image that is, in effect, the one that her art was made to blot out, but which, in its curious echo of Holbein's ghastly dead Christ, performs a powerful iconological gesture.

Szapocznikow's chemical skins of melting sculptural form turns her engagement with *Nouveau Réalisme*, so engaged with ordinariness and popular culture, back to the intersection of the machine, media and modernity. That *image* of death was itself created in and by the media, and served to fix it in cultural memory as an image, even for those who, like Szapocznikow, had themselves witnessed such processes traumatically as prisoners in the concentrationary and exterminatory universe. This close-up of a dead woman offers a post-Christian encounter with the kind of (in)human death created by fascist deadliness from which we can derive no narrative of resurrection or redemption. Instead it poses only the endless question of fidelity to a new aesthetic encounter with suffering, the ethics of perpetual witnessing and the life politics of determined resistance to the terror that created it.

I want to introduce one final association between self and skin through the writings of the French resistance fighter and concentration camp survivor Charlotte Delbo (1913–85) whose tattooed skin indelibly carried the marking of her dehumanizing in Auschwitz and Ravensbrück. In her attempt to explain something of the paradoxes of trauma that resists common memory, and is indelible, constant, inescapable, Delbo's writing invoked two different dimensions of skin.

> Explaining the inexplicable. There comes to mind the image of a snake shedding its old skin, emerging from beneath it in a fresh glistening one. In Auschwitz I took leave of my skin – it had a bad smell, that skin – worn from all the blows it had received, and I found myself in another, beautiful and clean, although with me the molting was not as rapid as the snake's. Along with the old skin went the visible traces of Auschwitz; the leaden stare out of sunken eyes, the tottering gait, the frightened gestures.[50]

In this first metaphorical evocation of skin, Delbo writes of the liberated survivor shedding her dirtied, abjected and tortured camp non-self like a snake shedding its skin for renewal. The new Charlotte Delbo emerged, clean,

boundaried, warm, fed, apparently returned and normalized; she learned to use knife and fork, a toilet, was able to bathe, say hello when walking into a room, even eventually to smile with both eyes and lips. She even learned to be able to smell again after being steeped in a fetid odour of diarrhoea and the soot and smell of burning flesh from the crematoria at Auschwitz and Ravensbrück. In a counter-image, however, Delbo suggests that the traumatic real of the camp cannot ever be shed; it is merely buried or blocked off by a toughened membrane that attempts to cover over the abyss of endlessly vivid traumatic sensations.

> Rid of its old skin, it's still the same snake. I am the same too, apparently. However …
>
> How does one rid oneself of something buried far within; memory and the skin of memory? It clings to me yet. *Memory's skin has hardened*, it allows nothing to filter out of what it retains, and I have no control over it. I don't feel it anymore.[51] (my emphasis)

This skin over this abyss is, however, sometimes breached; the membrane that divides that the present from other time and place, whose sensations defy words and their power to structure a journey away from unbearable experiences, disintegrates.

> Auschwitz is so deeply etched on my memory that I cannot forget one moment of it.
>
> So you are living with Auschwitz?
>
> No I live next to it.
>
> Auschwitz is there unalterable, precise but enveloped in the skin of memory, an impermeable skin that isolates it from my present self.[52]

Delbo affirms that at any moment she can feel suddenly and completely plunged into the total sensorium of an arrested and ever-powerful time and place that interpenetrates with her current moment and refuses the very concept of a past separated from the present.

> Unlike the snake's skin the skin of memory does not renew itself. Oh, it may harden further … Alas, I fear lest it grow thin and crack, and the camp get hold of me again. Thinking about that makes me tremble with apprehension.[53]

No longer a linear subject, then and now, Delbo attests to feeling that she is a vertical composite, a layered being who may collapse unexpectedly into the encrypted place which may emerge unbidden to engulf her and make time dissolve. The memory is in the skin (or the muscles of the concentrationees, as David Rousset writes); it is both reality and metaphor.

In this underlying memory sensations remain intact. No doubt, I am very fortunate in not recognizing myself in the self that was in Auschwitz. To return from there was so improbable that it seems to me that I was never there at all … No, it is all too incredible. And everything that happened to that other, the Auschwitz one, now has no bearing upon me, does not concern me, so separate from one another are this deep-lying memory and ordinary memory. I live within a twofold being. The Auschwitz double does not bother me, does not interfere with my life. As thought it weren't I at all. Without this split I would not have been able to revive.[54]

Delbo shifts again: 'The skin enfolding the memory of Auschwitz is tough. Even so it gives ways at times, revealing all it contains.' Her concept of deep memory is crucial here. 'Deep memory preserves sensations, physical imprints. It is the memory of the senses. For it isn't words that are swollen with emotional charge.' She compares the word thirst shared between those who have known Auschwitz thirst and the everyday feeling that makes one feel like having a cup of tea. In dreams, she says 'I physically feel that real thirst and it is an atrocious nightmare.'[55]

Freudian psychoanalyst Didier Anzieu proposed the skin as a primary form of the ego. For Anzieu, the skin is the carnal ground for the formation of an ego that imagines itself initially as an integrated whole precisely through the phantasy of the clean surface and the impenetrability of skin as a boundary between self and world. Skin psychically defines the ego's space and its outer limit, its join with the world. Skin allows the ego to imagine itself as intact, contained and discrete.[56] Thus skin emerges as a psychically powerful element of subjectivity and hence a site of psychic and physical vulnerability.

Enveloped in its own skin, memory for Delbo lives beneath a hard layer that isolates the ever-intense, traumatizing event, but maintains it so that the self is experienced as living beside this other, yet ever-present event that happened to a self that has been alienated by means of this internal boundary, a boundary that is in fact the scar tissue of traumatic events written sometimes literally but always psychically etched on the sensing body. Yet this membrane cannot be trusted to maintain the boundary between the encrypted sensorially imprinted trauma and the living subject. It is significant that the book from which I have been quoting was the last collection of poems and sketches Delbo assembled, as she lay dying from a fatal cancer.

Charlotte Delbo wrote of the book she felt compelled to write, *None of Us Will Return*:

It's a book that belongs to me intimately. I had the will to write it, the need to write it. A need that everyone had over there: to tell, to tell the world what it was. I wrote, wrote in one stretch. Carried. And the book came out of me from a deep inspiration.[57]

Delbo wrote in French: *C'est un livre qui me tient à la peau du ventre*. This is a French idiom that invokes an intense attachment through the image of skin of the belly; it cannot be literally translated. It reminds us that to have something deeply inseparable from the self is understood to relate to the skin of one's belly, a phrasing that is very suggestive given Alina Szapocznikow's later work on bellies: *la peau du ventre* is the very site of the self in this French idiom. Delbo's first book written immediately about her Auschwitz-Ravensbrück experiences, *None of Us Will Return* was published in French in 1965. Perhaps Alina Szapocznikow might have known it. As Delbo finally allowed a book she had written in the immediate aftermath of liberation to see the light of day, did Szapocznikow sense a new climate in which her own unspoken 'deep memory' might find a world to meet it?

At the other end of the spectrum, the use of a new polymer, polyester, in *Souvenir 1* links Alina Szapocznikow with a moment in sculpture inter-nationally when melting, flowing and congealing industrial substances were explored by many artists. These industrial materials offered fluid materials that solidified in ways that provided sculpture with temporality and even its own mortality through decay in place of monumentality. In these processes sculpture could shift from one state to another, soft becoming hard, translu-cent becoming opaque, flowing becoming arrested, the rigid seeming to melt, the melted becoming fixed. Eva Hesse specifically delighted in the intima-tions of human skin produced by molten latex in its initial and light-reflecting state that would, however, eventually dry, becoming brittle and increasingly opaque.[58] We could argue that the inherent alterations typical of this indus-trial material introduced into art a means of conveying a sense of human ageing, of time that metaphorically makes the viewer of such self-altering works confront irresistible human finitude: the physical qualities of the work's material would ensure that the work could not but undergo decay and would, as in the case of Hesse's latex pieces, eventually 'die'. For Hesse's miraculous but now brittle work *Contingent* (Plate 13) one test piece in latex survived in its unchanged, original state to remind us of that elastic evocation of skin that ends its life brittle and unforgiving.[59] Szapocznikow created the hard and brittle from beginning; time has faded the image of death encroaching on the ambivalent child.

In trying to track the trajectory from Szapocznikow's carved forms to such works as *Souvenir I*, and beyond to *Tumours* and *Herbarium*, possible resonances with other key shifts in sculpture that can be discerned in the 1960s which provide the necessary artistic framework for its very possibility, I am fundamentally posing the question: what would it mean to become a sculptor, working on the human figure 'after Auschwitz'?

I wonder if making sculpture – that is, creating form and even remaking virtual bodies – was an initially necessary and reparative response to the

outrageous assaults upon the body and the destruction of the human that the artist had not only witnessed but lived in her body: the creation of something worse than death, the organically living but no longer human being: the *living corpse*. Carving and fashioning almost classic forms of sculptured human faces and bodies was an impulse to disown that novelty, to recreate a lost phantasy of bodily integrity that had underpinned Western art since the Renaissance reclaimed a classical figuration of the body by making stony and bronze skins modelled from solid clay, plaster or carved from ancient stone. Ultimately it was unable to hold. Post-traumatically, Szapocznikow's work yielded to a deeper recognition of the real rupture in history and hence in art's refractions of history that focused on both the really brutalized body and the suspension of the idealization of the virtual body that is art. I am suggesting deeper *new realism* in the traumatic encryption of the agonizingly bodily event and physical assault of the industrialized genocides of Jewish and Roma/Sinti peoples of Europe, that personally affected Alina Szapocznikow as a child and teenager.

I have tried to plot a trajectory in Szapocznikow's work from unprocessed entombment within, towards a radically different kind of aesthetic resurfacing, of the residue of encrypted trauma. In her forties, Alina Szapocznikow created sculpture that evoked the senses of pain, disgust and impossibly erotic physicality in a troubling collision. It is as if her escape from the comforts initially offered by sculpting itself disintegrated, but brilliantly, under her own hands.

To call attention to the specificities of Alina Szapocznikow's work as the creation of a Jewish woman survivor of the Shoah must not enclose her or her work in any limiting identity. Szapocznikow's work was at once too late – the belated emergence of its deep traumatic kernel – and too early for this surfacing to be culturally legible in a culture that was itself still traumatically disavowing the meaning of the Shoah and had no means of reading its deeper implications for and already in art itself. Perhaps only at the conjunction of elaborated trauma studies, philosophical reflections of the meaning of Auschwitz for humanity and aesthetics, and feminist theories of sexual difference, can the potency of Alina Szapocznikow's work come into view as Ettinger's *transcryptum*:

> The transcryptum provides the occasion for sharing and affectively-emotively recognizing an uncognized Thing or Event. Art as transcryptum gives *body to a memory of the Real* consisting in virtual strings and memory traces of the oblivion of the Other and of the world … Our post-traumatic era becomes, by virtue of this art trans-traumatic.[60] (My emphasis)

If the current international museal and commercial interest in Alina Szapocznikow finds only delight in her sexiness, or surprise at her formless abstraction, and does not or cannot find the means to sense the radical nature

of the work that 'gives *body* to a *memory* of the Real' in the face of mortality, politically encompassed as well as internally corrosive, this artist will not have found her time and place, once again. In the Virtual Feminist Museum, I hope, the dissolution of solid forms into curling skins of imprinted trauma may acquire the space for their after-affects and after-images to become legible in their pathetic, tragic and terrifying splendour.

Notes

1 Typescript in French by Alina Szapocznikow, dated April 1972, document id: sz/VII/7/17j in the Alina Szapocznikow Archives held at the Museum of Modern Art, Warsaw, Poland. First published in *Alina Szapocznikow 1926–197: Tumeurs, Herbier* (Paris: Musée Moderne de la ville de Paris, 1973). Translation from Anda Rottenberg (ed.), *Alina Szapocznikow 1926–1973* (Warsaw: Institute for the Promotion and Art Foundation and Zachęta Gallery, 1998), 148–9.

2 Rottenberg, *Alina Szapocznikow 1926–1973*.

3 Rottenberg, *Alina Szapocznikow 1926–1973*, 9.

4 As Amelia Jones pointed out to me, it is troubling that like other artists working in the 1960s with these materials, such as Eva Hesse and Hannah Wilke, Szapocznikow also succumbed prematurely to cancer.

5 Anna Zakiewicz, 'On Alina Szapocznikow's Drawings', in Jósef Grabski (ed.), *Capturing Life: Alina Szapocznikow Drawings and Sculptures* (Warsaw: IRSA, 2004), 35–50 and 174–282.

6 To highlight this missed encounter, see *Circa 1970*, an exhibition of works by Louise Bourgeois and Lynda Benglis at Cheim and Reid, New York, July/August 2007.

7 The show *Alina Szapocznikow: My American Dream*, at Broadway 1602, New York, September to December 2010 assembled and exhibited all the documents relating to this project.

8 Vanessa Corby, 'Don't Look Back: Reading for the Ellipses in the Discourse of Eva Hess[e]', *Third Text*, 57 (winter 2001/02), 31–42. Corby examines the ways in which issues of Jewishness and Holocaust trauma were unacknowledged in initial feminist studies of Eva Hesse during the 1970s–90s. See her book *Eva Hesse: Longing, Belonging and Displacement* (London: I.B. Tauris, 2010).

9 Elena Filipovic and Joanna Mythowska, *Alina Szapocznikow: Sculpture Undone 1955–1972* (New York: Museum of Modern Art in conjunction with Mercatorfonds, Brussels, 2011). Agata Jacubowksa (ed.), *Alina Szapocznikow: Awkward Objects* (Warsaw: Museum of Modern Art, Books No. 5, 2011). Agata Jacubowksa, *Portret wielokrotny dzieła Aliny Szapocznikow* (Poznan: Wydawnictwo Naukowe UAM, 2007).

10 For instance Anke Kempkes (ed.), *Flesh at War with Enigma* (Basel: Kunsthalle, 2004) and exhibitions in 2008 and 2010 dedicated to Alina Szapocznikow at Broadway 1602, New York.

11 For a detailed feminist reading of Hannah Wilke's gendered and ethnically loaded associations in her use of chewing gum as branding and marking, see Amelia

Jones, 'The Rhetoric of the Pose: Hannah Wilke and the Radical Narcissism of Feminist Body Art', *Body Art: Performing the Subject* (Minneapolis, MN: University of Minnesota Press, 1998), 151–97.

12 Hannah Wilke to Ruth Margolin in Gary Noland, 'Art's Impact Depends on Feminist Content', *Forum*, 14:5 (November–December, 1989), 9; Wilke, 'Intercourse with…' text reprinted in Thomas K. Kochheiser (ed.), *Hannah Wilke: A Retrospective* (Columbia, MO: University of Missouri Press, 1989), 138. My thanks to Marsie Scharlatt for further information on this matter.

13 Jones: 'Rhetoric of the Pose', 182–3; Nancy Princenthal, *Hannah Wilke* (London and Munich: Prestel, 2010).

14 The first monograph is Princenthal, *Hannah Wilke* and it was preceded by the important catalogue and exhibition: Tracy Fitzpatrick, *Gestures* (Neuberger Museum of Art, 2009). See also the catalogue *Hannah Wilke: Selected Work, 1963–1992*, Hannah Wilke Collection & Archive, Los Angeles, and Solway Jones, Los Angeles, 2004.

15 Pierre Restany, 'The Eternal Language of the Body', *Alina Szapocznikow 1926–1973: Tumeurs, Herbier* (Paris: Musée Moderne de la ville de Paris, 1973), reprinted in Rottenberg, *Alina Szapocznikow 1926–1973*, 27–8 and Jósef Grabski (ed.), *Alina Szapocznikow: Capturing Life – Drawings and Sculptures* (Cracow: IRSA, 2004), 122–3, trans Maja Laverne.

16 Primo Levi, *The Drowned and the Saved*, trans. Raymond Rosenthal (New York: Vintage Books, 1989), 36–87.

17 The phrase, 'l'univers concentrationnaire' was created in 1945 by David Rousset, a French political deportee to German concentration camps. See Griselda Pollock and Max Silverman (eds), *Concentrationary Cinema* (London: Berghahn, 2011).

18 Rosalind Krauss and Yves-Alain Bois, *Formless: A User's Guide* (New York: Zone Books, 1997); Georges Bataille: 'Informe', *Documents*, 7 (December 1929), 382; Georges Didi-Huberman, *L'Empreinte* (Paris: Centre Pompidou, 1997).

19 Sigmund Freud, 'Beyond the Pleasure Principle' [1920], in *On Metapsychology: The Theory of Psychoanalysis,* Penguin Freud Library, Vol. 11 (Harmondsworth: Penguin, 1984), 69–338.

20 Susan Sontag, *Illness as Metaphor* [1978] (Harmondsworth: Penguin, 1983).

21 On the figure of the *Muselmann* as the true horror of the camps see Giorgio Agamben, *The Remnants of Auschwitz: The Witness and the Archive*, trans. Daniel Heller-Roazen (New York: Zone Books, 1999).

22 Julia Kristeva, 'Holbein's Dead Christ', in *Black Sun: Depression and Melancholia*, trans. Leon S. Roudiez (New York: Columbia University Press, 1989), 105–39 [*Soleil noir: dépression et mélancolie* (Paris: Editions Gallimard, 1987)].

23 Julia Kristeva, 'Holbein's Dead Christ', 119.

24 Julia Kristeva, 'Holbein's Dead Christ', 122–3.

25 Theodor Adorno, 'Commitment' [1962], in Andrew Arato and Eike Gebhardt (eds), *The Essential Frankfurt School Reader* (Oxford: Basil Blackwell and New York: Urizone Books, 1978), pp. 300–18.

26 Theodor Adorno, *Negative Dialectics* (1966), trans. E.B. Ashton (New York: Seabury Press, 1973).

27 Theodor W. Adorno, *Can One Live after Auschwitz? A Philosophical Reader*, ed. Rolf Tiedemann, trans. Rodney Livingstone et al. (Stanford, CA: Stanford University Press, 2003).

28 Robert Antelme, *The Human Race* (*L'espèce humaine*, 1947), trans. Jeffrey Haight and Annie Mahler (New York: Marlboro Press, 1993).

29 See *In Darkness* (Agnieska Holland, 2012), a film about Lvov Ghetto survivors living in the city's sewers.

30 Terence Des Pres, *The Survivor: Anatomy of Life in the Death Camps* (Oxford: Oxford University Press, 1976), 71, citing Philip Friedman, *Martyrs and Fighters* (1954), 290.

31 Joan Ringelheim, 'Women and the Holocaust: A Reconsideration of Research', *Signs*, 10:4 (Summer, 1985), 741–61.

32 Urzula Czartoryska, 'The Cruel Clarity', in Anda Rottenberg (ed.), *Alina Szapocznikow 1926–1973* (Warsaw: Zachęta Gallery, 1998), 14.

33 Czartoryska, 'The Cruel Clarity', 16.

34 Pierre Restany, 'Forma miedzy, cialem a gra', *Alina Szapocznikow: Rzezba* (Warsaw: Zachęta Gallery, 1967); trans. *Alina Szapocznikow 1926–1973*, ed. Anda Rottenberg (Warsaw: Zachęta Gallery, 1998), 128–9.

35 Pierre Cabanne, 'Aline à corps perdu', *Le Combat*, no. 8986 (1973), my translation; reprinted in Jósef Grabski (ed.), *Alina Szapocznikow: Capturing Life – Drawings and Sculptures* (Cracow: IRSA, 2004), 126, trans Poitr Mizia.

36 G.Q.H., 'A la recherche d'Alina', *Journal de Genève*, no. 252 (1971), cited in translation in Anda Rottenberg (ed.), *Alina Szapocznikow 1926–1973* (Warsaw: Zachęta Gallery, 1998) 135.

37 Andrzej Wajda, 'Szapocznikow', *Projekt*, no. 5 (1973), 22–7.

38 Restany, 'Eternal Language of the Body', 26.

39 Adorno, *Negative Dialectics*, 366.

40 Restany, 'Eternal Language of the Body', 26.

41 Pierre Restany, 'Eternal Language of the Body', 26.

42 Sigmund Freud, 'Some Psychical Consequences of the Anatomical Distinction between the Sexes' [1925], *Standard Edition of the Collected Works of Sigmund Freud*, Vol. 19 (London: Hogarth, 1950), 241–58.

43 Sander Gilman, *The Jew's Body* (New York: Routledge, 1991).

44 Daniel Boyarin, *Carnal Israel: Reading Sex in Talmudic Culture* (Berkeley, CA: University of California Press, 1995).

45 On the French ideology and stereotype of *la belle Juive*, see Janis Bergman-Carton, 'Sarah Bernhardt and the Possibilities of Jewishness', *Art Journal*, 55:2 (Summer, 1996), 54–64.

46 Marianne Hirsch, *Family Frames: Photography, Narrative and Postmemory* (Cambridge, MA: Harvard University Press, 1997).

47 Bracha L. Ettinger, 'Art as the Transport Station of Trauma', in *Bracha Lichtenberg Ettinger: Artworking 1985–1999* (Gent: Ludion and Brussels: Palais des Beaux Arts, 2000).

48 Jola Gola has suggested that the image is from Soviet newsreels and reports of unburied dead bodies from Madjanek or Auschwitz, camps the Red Army liberated in 1944 and 1945 respectively.

49 The artist was diagnosed with cancer on 17 January 1969.

50 Charlotte Delbo, *Days and Memories*, trans. Rosette Lamont (Marlboro: Marlboro Press, 1990) (first published in France in 1985), 1.

51 Charlotte Delbo, *Days and Memories*, 1.

52 Charlotte Delbo, *Days and Memories*, 2.

53 Charlotte Delbo, *Days and Memories*, 2.

54 Charlotte Delbo, *Days and Memories*, 3.

55 Charlotte Delbo, *Days and Memories*, –4.

56 Didier Anzieu, *Le Peau-Moi et la psychanalyse des limites* (Paris: Editions Dunod, 1995). Nicholas Chare, *Auschwitz and Afterimages: Abjection, Witnessing and Representation* (London: I.B. Tauris, 2010).

57 'C'est un livre qui me tient à la peau du ventre. J'avais la volonté de le faire et surtout le besoin de le faire. Un besoin que tous ont eu là-bas: dire, dire au monde ce que c'était. J'ai écrit, écrit d'un jet. Portée. Et le livre est sorti de moi dans une inspiration profonde.' Claude Prévost, 'La déportation dans la littérature et l'art: entretien avec Charlotte Delbo', *La Nouvelle Critique*, 167 (1965), 41.

58 Benglis managed to find ways to stop this disintegration.

59 For a discussion of the meaning of Hesse's transient materials and the impossibility of redemption 'after Auschwitz', see Griselda Pollock and Vanessa Corby (eds), *Encountering Eva Hesse* (London: Prestel, 2006).

60 Bracha L. Ettinger, 'Transcryptum: Memory Tracing in/for/with the Other', in Ettinger, *The Matrixial Borderspace*, ed. Brian Massumi (Minneapolis, MN: University of Minnesota Press, 2006), 166.

Fictions of fact: **5**
memory in transit in Vera Frenkel's
video installation works
Transit Bar (1992) and *Body Missing* (1994)

Captions to chapter 5

65 Vera Frenkel (b. 1938) *Body Missing*, 1994, installation in Offenes Kulturhaus, Linz, six panels in window and one video station.

66 Vera Frenkel (b. 1938) *Body Missing*, 1994: Murals representing elements of video channel 1. Photo: Courtesy of the Artist.

67 Vera Frenkel (b. 1938) *Body Missing*, 1994: Murals representing elements of video channel 2. Photo: Courtesy of the Artist.

68 Vera Frenkel (b. 1938) *Body Missing*, 1994: Murals representing elements of video channel 3. Photo: Courtesy of the Artist.

69 Vera Frenkel (b. 1938) *Body Missing*, 1994: Murals representing elements of video channel 4. Photo: Courtesy of the Artist.

70 Vera Frenkel (b. 1938) *Body Missing*, 1994: Murals representing elements of video channel 5. Photo: Courtesy of the Artist.

71 Vera Frenkel (b. 1938) *Body Missing*, 1994: Murals representing elements of video channel 6. Photo: Courtesy of the Artist.

72 Vera Frenkel (b. 1938) '… *from the Transit Bar*', 1992, documenta IX, Fridricianum, Kassel.

73 Aby Warburg (1866–1929) *Mnemosyne Atlas*, 1929: Plate 79.

74a Auction of *Modern Masters from Germany*, 30 June 1939, Fischer Gallery, Luzerne.

74b *Hitler and Mussolini at the Borghese Gallery before Pauline Bonaparte*, 1938, photograph.

75 'Rick's Piano Bar', still from *Casablanca* (1942, Michael Curtiz). Warner Brothers 2012.

76 Vera Frenkel (b. 1938) '… *from the Transit Bar*', 1992, editing composite the six participants from video monitors.

77 Vera Frenkel (b. 1938) in the installation '… *from the Transit Bar*', 1992.

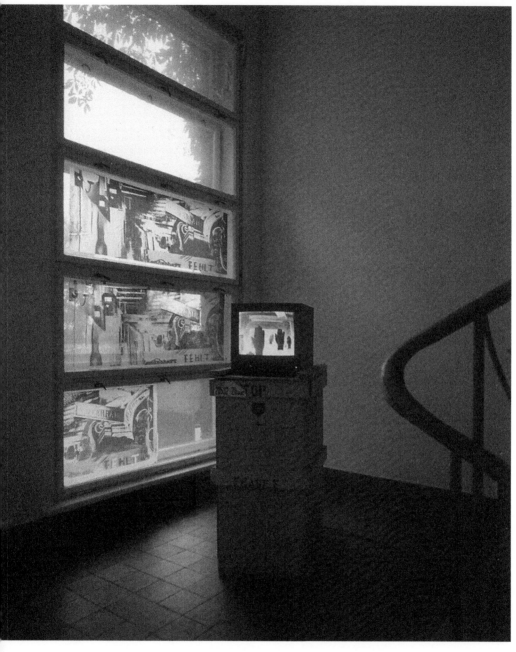

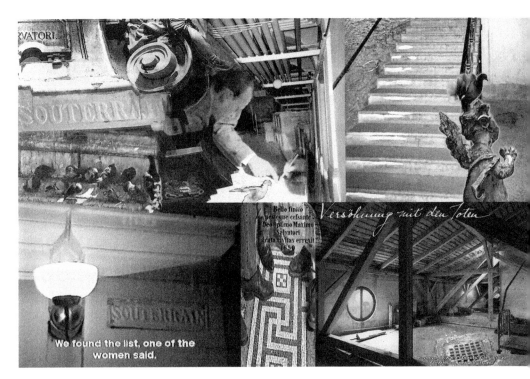

Versöhnung mit den Toten

We found the list, one of the women said.

66

Maikäfer flieg!
der Vater ist im Krieg,
die Mutter ist im Pommerland
Pommerland ist abgebrannt.
Maikäfer flieg!

Fly-fly, mayfly,
fly away,
Your father is in the war,
Your mother is in Pomerania
Pomerania is burnt down.
Fly-fly, fly!

Ladybird, ladybird, fly away home
Your house is on fire
Your children are gone!

67

70

71

74a

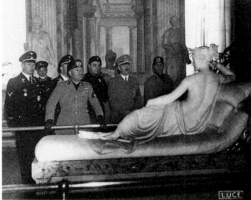

74b

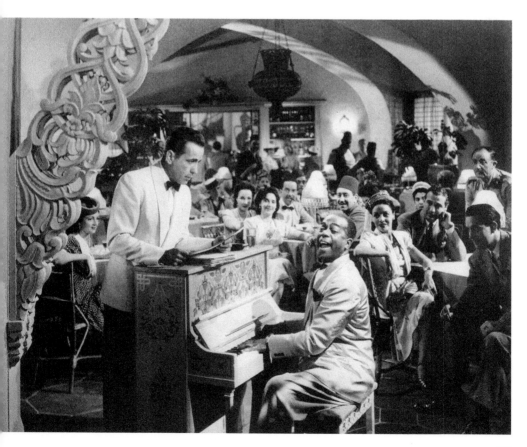

75

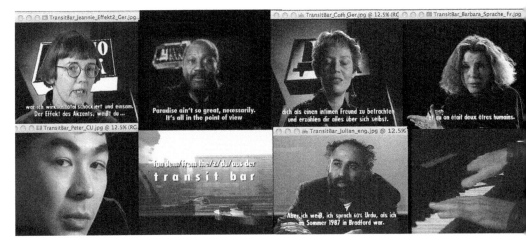

The only relation to art that can be sanctioned in a reality that stands under the constant threat of catastrophe is one that treats works of art with the same deadly seriousness that characterizes the world today.

Theodor Adorno[1]

The aporia of Auschwitz is, indeed, the very aporia of historical knowledge; a non-coincidence between fact and truth, between verification and comprehension.

Giorgio Agamben[2]

And this is why it seems to me that the kinds of antinarrative nonstories produced by literary modernism offer the only prospect for adequate representation of the kind of 'unnatural' events – including the Holocaust – that mark our era and distinguish it absolutely from all the history that has come before.

Hayden White[3]

Preface

In his study of transgression in art, Antony Julius argues that the paradigm of avant-garde transgression as the motor for modern artistic gestures is exhausted. As an example of its loss of conviction and reduction to theatrical parody, Julius vehemently criticizes the installation *Hell* by Jake and Dinos Chapman (1999–2000) that appeared in an exhibition *Apocalypse: Beauty and Horror in Contemporary Art* (London, Royal Academy, 2000). With its interconnecting vitrines forming a swastika, and evoking the Third Reich and its horrors, *Hell* lures the unsuspecting viewer into a close examination of 5,000 toy figures. The figures have been mutilated and dismembered in an ambiguous environment that mixes violations enacted by and on German army and SS uniformed figures with oblique references to concentration and extermination camps whose particular victims are sidelined.[4] Condemning those critics who claim that *Hell* is a work of 'imaginative empathy', Julius declares that extreme events such as the 'Holocaust [do] not mandate transgressive art'.

To the contrary, art-making responsive to the Holocaust demands a break with the transgressive aesthetic ... The best of these works contend with these dilemmas: how can the Holocaust be represented, when representation seems to entail the making of art objects that invite purely aesthetic contemplation? ... Only a non-transgressive art practice, one that acknowledges the certainty of defeat and is willing to efface itself before its subject, while knowing that this subject is an impossible one, can negotiate such complexities. It must be allusive, modest, fragile, provisional. It must give witness to the inadequacy of images, and therefore, its own inadequacy, to retrieve meaning of the lives that were extinguished ... It is an art that meets its subject at the mind's limits.[5]

Linz: other bodies

In 1994 an exhibition curated by feminist art historian Sigrid Schade, titled *Andere Körper/Different Bodies*, opened at the Offenes Kulturhaus, an art production space in Linz.

Linz? A beautiful town in upper Austria.

By chance, it was the adopted home town of Adolf Hitler. (He was actually born in Braunau-am-Inn.) As part of a grandiose cultural design, Hitler had plans for Linz. Its centre was to be redesigned – a project overseen by Albert Speer – as the new Empire's cultural capital with an Opera House, a library and a world-class art museum, designed by architects Hermann Giesler (1898–1987) and Roderich Fick (1886–1955). To fill this museum, Europe's great collections and museums would be acquired or looted in a project titled *Sonderauftrag Linz/Special Assignment Linz* established on 1 June 1939. Forcibly taken from collections in Occupied countries, 'bought' under duress for later useless Reichsmarks from private owners, or appropriated from the possessions of persecuted and later murdered minorities, much of the hoard was discovered and some elements were repatriated after 1945. But to this day many works have disappeared and remain missing.

As the starting point for her contribution to *Andere Körper*, *Body Missing*, Czech-born Canadian multidisciplinary artist Vera Frenkel (b. November 1938) focused on this missing body from the stolen artworks, that is *missing* after liberation or during the acquisition from the vast hoard accumulated by the *Sonderauftrag Linz* to create the Führermuseum. I wish to read her installation *Body Missing* originally made for the show in Linz in conjunction with Frenkel's earlier work first exhibited in Germany in 1992 '... *from the Transit Bar*' (Plates 14 and 15). Both works will be viewed in relation to the three epigraphs above and Anthony Julius's judgement about what art might do in the face of all of this history in which art, bodies and loss are grievously intertwined.[6]

At the Offenes Kulturhaus, *Body Missing* was composed of six monitors, placed strategically throughout the cultural production space of the Kulturhaus,

itself a former Wehrmacht prison. The monitors played six videotapes, each six minutes long: *Reconciliation with the Dead, Recalling the Benign Things of the World, Trail of the Fragments, The Apparatus of Marking Absence, Athena's Polished Shield, The Process of Redemptive Naming Begins* (Figures 66–70).[7]

Into the pillar of rectangular windows that formed part of the building's modernist façade addressing the outside of the building, the artist placed images that appeared on the videotapes and historical images (Figure 65). Photomural no. 6 was installed in the building's kitchen. When the exhibition moved to other venues these murals became transparent photomontages and were placed in light boxes that looked like packing crates, adding a more material association with storing and transport. (Plate 15) Thus there were still images, themselves layered and fragmented, complementing the moving images, which were also layered by the varied technologies available in video-editing and montage. The soundtrack included songs – notably as leitmotif the surprisingly sinister children's song full of references to war, absence and fire: *Maierkiefer flieg*, the German version of *Ladybird, Ladybird, Fly Away* – ambient sound, dialogue spoken by unseen mouths, numbers listed in German, lists read in English, secret conversations held among people whose feet alone are seen. The predominant language of the tapes was German with English subtitles.

The images on the videotapes included filmed material from the town of Linz itself. Material from the present-day was filmed in colour. It included a visual meditation on the monuments in Linz, erected in 1650 to commemorate victims of seventeenth-century mass death from the plague and to celebrate freedom from plague. Birds perch on a Baroque monument reminding us of both that deadly past and the indifference that befalls memory in relation to that which a lonely monument haphazardly commemorates. Using a moving camera, the artist is filmed descending into the basement of the Vienna Academy of Art, an institution which twice refused Adolf Hitler's application to study there as an art student. Had he been admitted, his fellow students would have been Egon Schiele and Oskar Kokoschka. This 'souterrain' – the cast-iron sign naming this below stairs domain – recurs as both emblem of the underground storage typical of any art school and as metaphor for the lumber-room of neglected cultural memory (Figure 66).

The videos and murals also contain archive images in black and white, photographs from 1945 or before, of the stacked stolen artworks stored in the salt mines at Altaussee, near Linz. Pointing out this alternation between colour and black and white, new footage and archive images, we can recall Alain Resnais's benchmark film *Night and Fog* (1955) which used precisely the contrasting rhythm of colour/black and white: present/past to create an anxious sense of the penetration of the present by the haunting past, as well as of the everyday by horror.[8] With the images on the canvases hidden, the world

of art into which the viewer is imaginatively solicited remains firmly closed. Instead the photographs make visible the compulsive amassing of merely promised bliss, not experienced but fetishistically invested in having things in one's possession. Storage becomes, therefore, an allegory not so much of memory as neurotic compulsion that cannot actually enjoy its objects, but which lives always in the hope of its excess through consumption or mere possession. Frenkel had long studied cargo-cults, and she daringly defines the Third Reich itself as a kind of cargo cult, delusionally promising one thousand years of bliss.

Finally, there are filmed scenarios punctuating the carefully choreographed and recurring interplay of these elements all now translated into video's idiomatic grain and greyness. These involved shots of feet and legs, walking up stairs or forming circles for the secret and conspiratorial meetings of artists and art historians who have, we discover, found the lists of the lost works and are scheming to remake some of the missing works, not as restitutions, but as homage. 'I remember you' is their gesture.

In her study of Frenkel's *Body Missing*, art historian Dora Apel places *Body Missing* under the sign of memory and its politics: 'The *Body Missing* project addresses both the relationship between art and politics and the role of memory as a moral force and foundation for a civilizing opposition to tyranny, that is, a site of moral resistance.'[9]

Body Missing became also a website, http://www.yorku.ca/BodyMissing/intro.html. Its point of entry is the *Transit Bar* from the 1992 installation (Plate 14), now moved to virtual space. There is a bartender who overhears the artists meeting to plan their reconstruction works and hence who have discovered the double crime (the looting and the thefts from the looted hoard) in the first place. There are the piano-players and their stories. There are the artists and their art works. The six videos from the '...*from the Transit Bar*' source materials are also there, all linked on a beautiful hand-written site map that leads to bibliographies, including Hitler's idiotic will and lists. One list, discovered by the bartender pasted into a notebook, found by 'Anna' is a list of lists. It is also spoken repeatedly in the video work and uses the dry form of a list in order to draw an elaborate picture of the nature of Hitler's *Kunstraub* (art-theft).

- what was collected
- what was stolen
- what was safeguarded
- what was transported by train
- what was shipped by truck
- what was hidden
- what was sold in Switzerland

- what arrived at the saltmine and on what date
- what left the saltmine and when
- what was given as gifts
- what was insured
- what came from private collections
- what was once another country's treasure
- what the Allies found
- what the Russians took
- what now begins to appear at auction
- what was burned
- what crossed the ocean in strange ways
- what was saved
- what was brought back after the war
- what never existed but was longed for
- what can be shown only privately
- what sits in the museums of Europe under new names
- items known to be in North and South America
- (list of vendors and sources)
- (list of postwar collections, no questions asked)
- inventories of castles
- handwritten orginal lists
- typewritten collection point lists
- what has been returned and reinstated
- what is 'heirless'
- what is still in dispute in the courts
- what was unsuccessfully claimed
- what is still missing[10]

Apel comments:

> The master list may be read as a kind of shadow list for a much larger moral horror, the other body missing that endows the Nazi *Kunstraub* policy with an intensified resonance of historical enormity. Kyo Maclear testifies to the palpable tension created between the given subject of Frenkel's project, with its lists, logs and registers, and the unspeakable dominating master text, the bureaucratic efficiency of Hitler's genocidal program.[11]

Although the connection between lists of objects and lists of people is suggestive, nothing in Frenkel's work directly refers to lists of people such as we have come to know through Thomas Keneally's docufiction *Schindler's Ark* (1982) that was made into a movie by Spielberg as *Schindler's List* (1993), where names on a list become the sole means of deliverance from annihilation. It is the viewers/readers who make the connection, assembling the fragments

and providing their own terrorized memory as the ground for reading a work that is itself foregrounding another aspect of the Third Reich: the interface of criminality and desire in the Hitlerian project, a conjunction that is far more discomforting in its proximity to the everyday than the extremity of atrocities perpetrated by the same regime. The question posed by the work may then be: what is the relation between the two, then, and now? Frenkel's work is a prompt to remember the *Kunstraub*, excavating archives and assembling documents from trials, from witnesses, from photodocuments. But it is also a supplementary comment on another, hidden theft, and hence a disappearance from the body of art, what the Monuments Men (the Allied specialists charged with tracing and relocating the looted works) named 'internal looting', on which this artwork performs its own analytical work, probing the archive theoretically by means of the capacity of video to assemble fragments, layer histories, intimate connections.[12]

Apel also stresses the multi-vocal quality of *Body Missing* as a web project with its many contributing artists. It becomes an open text, co-inhabited by their diverse relations to the missing artworks, and their own histories. It creates out of *Transit Bar* a form of hypertextual and cybernetic hospitality that already anticipates what Michael Rothberg has theorized, from readings of post-war critiques of colonialism by key concentrationary writers such as Charlotte Delbo and others, as *multi-directional memory*. Confronting competition in American society over the commemoration of different communities' traumas, Rothberg boldly defines the problem of competitive memory in which various constituencies vie for space for their identity-securing memory in a zero-sum-game of public commemoration:

> The understanding of collective remembrance that I put forward in *Multidirectional Memory* challenges the basic tenets and assumptions of much current thinking on collective memory and group identity. Fundamental to the conception of competitive memory is the notion of the public sphere as a pregiven, limited space in which already established groups engage in a life and death struggle. In contrast, pursuing memory's multidirectionality encourages us to think of the public sphere as malleable discursive space in which groups do not simply articulate established positions, but actually come into being through dialogical interactions with others.[13]

Frenkel's work of the early 1990s is precisely dialogical and hospitable, creating through video and the web such a public space for multi-directional memory. Apel, therefore, stresses a passage from past to future, a mechanism created through this brilliant early use of video and web technologies as aesthetic practice for the interpersonal, intercultural trans-temporal transport and continual disturbance of memory:

Body Missing, then, constitutes the production of a new archive, a new body, that incorporates the memory of the body missing. It reads both back into the past and opens onto the future … *Body Missing* is not, therefore, a work of mourning; rather, Frenkel posits the question: 'What is to be the fate of all the missing artworks?' in order to project the possibility of a future for the absences of the past. In *Body Missing*, memory is not a passive repository of longing but a catalyst to action.[14]

Frenkel's attention to the missing artworks within the vast body of looted artworks becomes a specific but also metaphorical focus not only for mourning loss, but for engendering in the present engagements with the nature of the absence, that cannot be fetishistically restored, but must be actively encountered and confronted in terms of the action in the present. Frenkel's aesthetic procedures and the effects of the works in their capacity to open both to the past and the future offers us an economy of passage: a transport station.

During the Third Reich (1933–45), the building now housing the Offenes Kulturhaus in Linz, where *Body Missing* was first installed, was used as a Wehrmacht (German Army) prison. It was the site of incarcerated and probably tortured bodies, the kind of bodies (and their inhabiting subjects) who haunt so many places in Austria and Germany, their once horrible usages overwritten by new façades and democratizing purposes. A former prison is replaced by a cultural venue, a public space for cultural production, and in *Andere Körper*, it housed a feminist-inflected exhibition exploring the question of the body that had become such a fruitful topic in art engaged with gender since 1970. But what were the relations riddled (recall Hartman's periphrasis) into view between militarism, power, racism, cultural policy, art and the body, raced, gendered and otherwise under the Third Reich, an era haunting this show, knowingly, in its very location?

To invoke other bodies or indeed the bodies of others in such a context already agitates intense historical anxiety. It suggests a critically considered and political challenge to the corporeal order associated with the name of Hitler and the Third Reich that both racially and homophobically othered bodies, some eventually reduced to no-bodies in ways so catastrophic and horrific that we can hardly bear to look again at the image traces. In the case of millions gassed and cremated, there is neither trace nor marker. Gay bodies, Romany bodies, Jewish bodies, politically defiant and resisting bodies, bodies of minority faiths, naked bodies, tortured bodies, dead bodies: these were all part of the Nazis' universe of terror inflicted with intense purpose on the body as locus of the subject. I must ask again here: what is the body *after* the event in history that was the Third Reich – that is, after what the *real* and the *cultural* trauma such a historical event inflicted: what is otherness and corporality in its wake as an institutionalized process rupturing the conditions of being

human, living and dying and of representation itself? Posing such a question harks back to Theodor Adorno's insistence on both the impossibility and the necessity of art 'after Auschwitz' that requires from the artist a paradoxical obligation to engage endlessly with what cannot be represented but must not be forgotten: Lyotard's differend.[15] In exploring the work of aesthetic inscription as a transport station of trauma – rather than mourning or healing – I want to delineate the aesthetic strategies of the multi-media, audio-visual and installation practice of Vera Frenkel, who arrived at this 'station' through a series of meditations and interventions operating between innovative expansion of new audio-visual media, notably pre-digital video and a kind of anthropological inquiry into the compulsive search for the messianic and bliss. At this intersection both the contingently historical and the everyday on the one hand, and the mythic or structural on the other, are disclosed in works that involve us in their passage. As counter to the missing bodies of genocidal extermination, and to the prohibition of repetition by representation of horrific images of deadly remains of the concentrationary universe such as surfaced in Szapocznikow's enfleshed post-traumatic work, Frenkel's Levinasian gesture is to work with the face and the voice. Her aesthetic practice elaborates itself through video with its complex plays of intimacy and technological communication. She explores the potential of its wipes and dissolves, its animation of photographic montage and modernist collage as a language with which to confront what must be encountered and yet can only be so in riddling, periphrastic, allusive, modest, antinarrative nonstories.

We shall need, however, in the context of this study of trauma and aesthetic inscription, to ponder how the surfacing of a specific and personally inscribed trauma of forced migration and family loss in the life-story of Vera Frenkel intersected with the belated surfacing of a cultural responsiveness to the Holocaust, c.1990, that belatedness of public representations often read as itself a symptom of the latency inherent in *cultural* trauma.[16] Popularly known as the 'Holocaust' as much because of the use of that term as the title of an American NBC TV series widely broadcast in 1978, during the 1980s and 1990s the atrocious history of the Final Solution became much more widely circulated as a cultural memory and a theoretical challenge. In the context of resurgent racisms after the fall of the Berlin Wall in 1989 and ethnic cleansings in the former Yugoslavia and Rwanda during the early 1990s, the understanding of the significance of Holocaust became subject to the cross-inscription of parallel situations for which legacies of the study of the Holocaust and its traumatic effects could provide a vocabulary, notably around the traumas of asylum seeking, escape from torture and dictatorship, exile and migration.[17]

Never forgotten or ignored by those who sought to bear witness and agitate the conscience of the world to this egregious assault on humanity itself, the Holocaust took off as a dense focus of multidisciplinary academic analysis

and cultural memorialization during the later 1980s and early 1990s.[18] One of the most influential of these new engagements occurred when sociologist Zygmunt Bauman broke what had been a virtual silence in sociological thinking with his benchmark study *Modernity and the Holocaust*, published in 1989.

Janina Bauman had written her memoir *Winter in the Morning*, discussed in Chapter 4, and in the preface she had posed the probing question: 'in inhuman conditions why do some people continue to behave in a human way while others do not?' As he read this line, Zygmunt Bauman acknowledged that, as a sociologist, he had never considered the Holocaust as a significant event in human social relations that presented substantial challenges to sociological thought. As a result he realized the depth of questioning now required: what is ethics, what is morality, what is the nature of submission to immoral authority, or, as he himself posed it in a series of lectures at the University of Leeds in 2010: 'What makes good people do evil?'[19] Granted there were people of extreme sadistic wickedness, psychopathic and criminal, who perpetuated the crimes of Nazism against humanity. But displacing the crime onto others whom we disown through exceptional extremity, deeming them to be essentially unlike us in their demonic evil or national character or any other device for creating a distance from ourselves, relieves all of us of a deeper horror: we could also perpetrate these crimes.[20]

Zygmunt Bauman ties the Holocaust into Modernity, not to regressive barbarity. While not directly a product of Modernity – sociologically defined as instrumental rationality that severed means from ends, fostered bureaucratic reason, and a conviction in a rationalized, scientifically evidenced notion of perfectability – the Holocaust was a potential in Modernity produced by what Bauman calls the social gardening metaphor of all modernizers (social engineers foster the healthy plants and weed out the weak and diseased). It was, therefore, entirely modern and hence inconceivable without many of Modernity's defining features. Far from being a throwback to ancient barbarism or a deviation from the enlightened path of modern progress, the Holocaust was par excellence a modern programme and a possibility of Modernity, indebted to its industrialization, social engineering, scientific racism, administrative and bureaucratic reason.

Bauman's subsequent books on *Modernity and Ambivalence* (1993) and *Postmodern Ethics* (1993), as well as his ever more coruscating analysis of the replacement of citizenship by the cultures of consumption and consumer society take up the logic exposed in his reading of the Holocaust not as an exceptional other to the norm of Modernity, but as its darkly mirroring face and hence a continuing possibility present in many banal forms of contemporary society. He writes:

The anxiety can hardly abate in view of the fact that none of the societal conditions that made Auschwitz possible has truly disappeared, and no effective measures have been undertaken to prevent such possibilities and principles from generating Auschwitz-like catastrophes.[21]

Vera Frenkel's works *Body Missing* and *'...from the Transit Bar'* were not a response to the work of Zygmunt Bauman, although she subsequently became aware of his writings. Rather her work is a parallel investigation through an artistic practice that constantly takes the anthropological temperature of contemporary Western culture. *Body Missing* and *'...from the Transit Bar'* of 1992, made first to be installed at *documenta IX* in Kassel, Germany (Figure 72) have their own genealogy in Frenkel's distinctive investigations of storytelling, cultural genres of romance and mystery, institutional power and the messianic cults, typical of traditional and modern consumer cultures, of imaginary investment in things as a means of access to bliss. But the conjuncture of sociological thought and new modes of art (conceptual, video, installation for example) serves to highlight the cultural moment, c.1990, when the long delay of traumatic aporia around the meaning of the Holocaust in general produced a belated explosion of cultural inscription, and Vera Frenkel's artworking was at its cutting edge, directing us not towards the past, but to its residues and ghosts in the present.

To arrive at the moment and the reading of *Body Missing* in 1994, I need to undertake a series of backtrackings into history, art and fascism and into the career of Vera Frenkel.

Digression I: screen and body

Illustrated here is the last plate, numbered 79 (Figure 73), of the *Mnemosyne Bilder Atlas* assembled by Aby Warburg in 1929. The Atlas – composed of canvas screens hung with photographs constantly in process of re-organization and new juxtapositions – was Warburg's grand scheme for producing a historical psychology of the image, in which various configurations of bodies were tracked as what Warburg called the *pathos formula*: the gestural and representational mnemonic formulations of intense emotional and affective states. These formulae could be symptomatically tracked as they persisted and returned (the very terms of trauma)

in the culture of the image both Western and beyond. Two elements need to be signposted. The first is the *screen* created in a moment of early expository use of photography and montage. I think it will give us some insight into what can happen in the pursuit of knowledge like this when video editing, dissolving, overlaying and moving through the image becomes an artistic tool. Secondly, Warburg's work might make us ask what becomes the *pathos formula* for our era, of othered or disappeared bodies, or the paradox of the immense engagement with feminist-inflected artists with the gendered and sexual body in the context of a potential *Bilderverbot* (prohibition on the image) in the post-Auschwitz condition?

In this final plate, beside a photograph (left centre) of the fresco of the *Mass of Bolsena* (1512–14) by Italian artist Raphael, in the Vatican, Warburg placed contemporary Italian and German newspaper cuttings from 1929. These primarily document the historic, if troubling event of the reconciliation of the Papacy with the newly established dictatorship of Europe's first Fascist leader, Benito Mussolini. On 7 June 1929 the Lateran Concordat was signed between them recognizing the Pope's autonomy within the enclave of the Vatican City, but yielding its formerly autonomous military and political power to the State of Italy. The distinguished Warburg scholar Charlotte Schoell-Glass has provided a complex reading of the juxtapositions made by Warburg on this most contemporaneous and political of plates in the *Mnemosyne Atlas*. Schoell-Glass reveals how Warburg is 'seeing' then current historical events taking place in the new imperialist projects of Italy, Germany and Japan that presage the menacing rise of fascist imperialism with its inherent racist violence. Warburg is 'showing' by this montage or conversation between times and genres, the deeper imaginary structures resurfacing in these contemporary images where a brawny swimmer, showing off his built body overlaps with an image of a Catholic monstrance – the procession of sanctified communion host involving both the idea of the Christ's sacrificed body and the Catholic dogma of transubstantiation wherein spiritually the host is a real body. These are then linked with Japanese sacrificial punishments like *harikiri,* and the ceding of earthly power by the Vatican to a militaristic fascist dictatorship in return for State protection of Catholicism.[22] Underlying all this are Warburg's political counter-hope for an end to shedding blood for religious causes, his fear of a re-emerging form of sacrificial culture and his reminder, swinging back to the *Mass at Bolsena* by Raphael, a painting in the Vatican, of the relation between the emergence of the Catholic dogma of transubstantiation – the belief that the host does indeed become the 'body' of the Saviour – and the events following the Lateran Council in 1215 declaring this doctrine. A blood libel spread across Europe accusing Jews of desecrations of the Host at which the wafer was claimed to have bled. In retaliation for these supposed offences, real Jewish bodies bled real human blood. Warburg's analysis of the

pattern registering in these images and events disclosed the immanence of racist violence persisting in and reignited by imaginary forms.

Warburg's early twentieth-century use of a 'screen' to allow photographic reproductions of images from different orders, time periods and topics to converse and interpenetrate, drawing mythic substrates into play across everyday photojournalism and art, astutely exposing the often sinister movement of power and its dissembling across the ordinary, is a necessary reference point for what Vera Frenkel was herself doing in her multi-screened video installation *Body Missing* for the exhibition in Linz, *Andere Körper* in 1994. Independently, Frenkel and Warburg share a way of reading their own cultures, sensing its intertextualities, and making 'visible' for interpretation what remains unrepresented while being present 'across' the relays between words and images, times and spaces, media and practices. Both have influenced the conception of the virtual feminist museum as a form of cultural analysis.

Digression II: Kunstraub and the cultural politics of the Third Reich: art in exile

The Virtual Feminist Museum extends Warburg's *Mnemosyne Atlas* with another montage of news photographs (Figures 74a and b). One photograph would show us the infamous sale of *Paintings and Sculptures by Modern Masters from German Museums* that took place at the Fischer Galleries, Luzerne in 1939. On the block is Van Gogh's *Self Portrait as a Bonze* (1888, Fogg Art Museum, Cambridge), sold as lot no. 45 on 30 June 1939 to an American, Frankfurter, for $40,000 on behalf of Maurice Wertheim of New York. This photograph of an art sale stands for the denuding of German national and provincial museums of works by 'modernist' artists following the assumption of power by the National Socialists in January 1933. Museum directors sympathetic to modern art were sacked. Works were first taken from the walls and then de-accessioned and this sale in Luzerne was the most notable. This points to two important issues. One is the identification of modernism itself with both of the mythic enemies of Nazism: bolshevism and Jewry. In the same terms as the latter were redefined as non-citizens and non-humans, namely degeneracy, modern art was named *entartete/degenerate*. Before being sold or destroyed (or privately appropriated) a vast exhibition of *Entartete Kunst: Degenerate Art* was organized, opening in Munich on 19 July 1937, one day after the opening of the Haus der Deutschen Kunst, a fascist monument to the art forms and tendencies authorized by the Nazi state as authentically German. Thus international modernism, notably its most German face, Expressionism, was held up to contempt in a perversely didactic exhibition that was paradoxically perhaps one of the first comprehensive surveys of early twentieth-century modernism, while it was also the last chance to see/celebrate modernism in Germany until 1955, when the founding by Arnold Bode of

the *documenta* initiated in Kassel resumed the broken thread of Germany's relation to international modernism and made *documenta* one of the most important quinquennial reviews of contemporary art.[23] It was at *documenta IX* that Vera Frenkel installed '*...from the Transit Bar*'.

The photograph (Figure 74b) shows the Fascist leader of Italy, Benito Mussolini; with his late-coming fascist ally from Germany, Adolf Hitler, on an official visit to Rome in May 1938, two years after the formation of the Rome-Berlin alliance, the year Mussolini, under pressure of his new ally, imposed racist anti-Semitic laws in Italy. Mussolini was showing off the splendours of his new Roman Empire to the German dictator, who would, in jealous emulation, imagine that his own imperial ambitions should be realized by relocating *all* of Europe's major art treasures to a single museum, that he would build, in his favoured town, Linz in Austria.

It may come as a surprise that Hitler's primary concerns were aesthetic. In the opening to *Hitler and the Aesthetics of Power*, Frederick Spotts reproduces a photograph taken on 13 February 1945.[24] The scene is a room in a bunker under the Reichskancellerei in Berlin. The Russians are closing in. They are at the Oder. The Allies are closing in. They have crossed the Rhine. The war is more or less lost. 'Yet', writes Spotts, 'Hitler spends hours absorbed in his model of his home town (*sic*) of Linz transformed by his favored architect Albert Speer into the cultural capital of his delusionary vision of the Thousand Year Reich. Complex lighting systems have been rigged up so that Hitler can study the overall effect at all times of the day of the entire urban project. Its several buildings must not detract from the spire of the cathedral of Ulm nearby but it must catch the first rays of the daily sun.'[25] Spotts uses this bizarre image of the near-destroyed leader in his bunker still contemplating his great aesthetic scheme to introduce us to the unexpectedly significant place of culture in Hitler's grand design. Frenkel will also repeatedly screen these images of both model and Hitler's fascinated gazing at his dreamworld.

Spotts advances the argument that Hitler's primary aims and indeed means were aesthetic: 'his conviction that the ultimate objective of political effort should be artistic achievement', although, as of 13 February 1945, the architectural reconstruction of Linz was still but a model.[26] The contents for one of its key buildings had already long been assembled. Confiscated from museums and collections, from all the countries of occupied Europe, some bought, some stolen, some liberated, some borrowed, the treasures of great European private and public collections had been systematically transferred to the Reich and many were being stored in the dry conditions of the salt mines of Altaussee not far from Linz. At its core was, however, the criminal theft of Jewish collections whose owners had been driven into exile or murdered.

Art History, museum- or university-based, thinking art to be autonomous or immune from the dirty work of politics, has been slow to see what was

always before our eyes, namely, a compromised and difficult relation between aesthetics, culture and fascism in the long twentieth century. Vera Frenkel was one of the first, as an artist, to draw attention to this topic when she created for an exhibition in 1994 at the Offenes Kulturhaus, Linz, the video-based installation work titled *Body Missing*. That same year, as the fruit of ten years' research, Lynn Nicholas published *The Rape of Europa: The Fate of Europe's Treasures in the Third Reich and the Second World War*, followed by Hector Feliciano's study titled *The Lost Museum: The Nazi Conspiracy to Steal the World's Greatest Works of Art* in 1997.[27] This book documents the systematic 'pillage' of Jewish-owned artworks in Occupied France, because, according to Lynn Nicholas, art was a matter of the highest priority in the Reich from the moment Hitler came to power. She names Hitler and Goebbels as 'ravenous collectors' with 'insatiable appetites'. Perhaps the most outstanding example of this theft, rape, pillage, looting – note the loaded vocabulary associated with the ravages of the Roman Empire or the Viking invasions of Northern Europe – was the project to assemble a new museum to dwarf the Louvre or the Uffizi, centralizing all of European-based world culture's art treasures in Hitler's chosen town.

It is this assemblage, *Sonderauftrag Linz*, and the mechanisms and traces of this mass looting that Vera Frenkel used as the point of departure for a subtle reflection on the implication of art in the criminality of the Third Reich, then but also now. At the same time, we know that a great deal of work from these stored lootings never resurfaced – some taken by Soviet troops, some by untraced others.[28] Frenkel's work is not a documentary, such as has been made from Lynn Nicholas's book by Bonnie Cohen in 2008, although it also calls on archival material. *Body Missing* is a video meditation on memory and amnesia, loss and mania, restoration and recreation, bureaucracy and crime, and Hitlerian looting and his cultic adulation as a symptom of the delusional search for bliss by means of the acquisition of things and a faith in a false messiah.[29]

When the Allies first opened the Altaussee saltmines near Linz, where for reasons of their dry conditions, many of the stolen/looted works were stored during the war, a large amount of the scrupulously inventoried and listed artworks were or went missing. Although many works were speedily restored to their original museum homes, much has never been found. The estimated value of what was looted in art and other artefacts amounts in current terms to $90–140 billion. Although hundreds of thousands of artworks and objects were repatriated to public collections, in many cases private owners were never found. Some were missing. National Museums across Europe failed in their obligations to create inventories of returned works and then to trace owners or their descendants.

As a result of Feliciano's work, the scandal of indifference of the official art institutions in France to this historical legacy led to major exhibitions of

unclaimed works during the 1990s. A series of further scandals rocked the museums worldwide when works that had been looted now appeared in exhibitions and were reclaimed by heirs of the depropriated and murdered owners. Moreover, museum collections that had been beneficiaries, knowingly or unknowingly, of either the looted art work or that which was stolen and illegally sold by the Nazi cultural apparatus found themselves the object of disgracing lawsuits. All work in museums and coming as part of temporary exhibitions now are required to have their provenance examined and affirmed to ensure they were not part of this criminal and often genocidal appropriation.

Thus do Nazism and the Holocaust reach into the heart of the art world. Paintings wandering through strange hands now become symbols of the events of the fascist era, casting over this most discrete and elite of fields, art history and the art museum, with the shadow or criminality and genocide. The recovered or resurfacing objects become both signifiers of their own looted fate and the uncanny, chilling index of their murdered or exiled former owners.

Cultural looting is not unknown in history.[30] Indeed it has been part of the process of motivating and paying the vast hordes that conquerors mobilized in their adventures abroad. Napoleon's appropriations from many parts of Europe during his conquests in the early nineteenth century are the most famous example in recent Western history before the mid-twentieth century. Dora Apel writes:

> What distinguishes Nazi looting, like the Holocaust itself, is its breathtaking scale, ruthlessness and planning. Even the term 'looting' with its implications of spontaneous ransacking, does not begin to describe the massive, systematic, and highly organized bureaucratic machine by which the Nazis thoroughly dispossessed the culture of the Jews, as well as state property, not only in France, but all over Europe.[31]

'Like the Holocaust itself' – this phrase might tempt us back into the equation between murdered millions and missing stolen treasures, substituting what people once collected while living for those who were expropriated of their very lives. I think we must forestall any false metaphorical translation. With its specific artistic and signifying modes, the artworking in and through *Body Missing* uses video, voice, staging, documents, contemporary filming and installation to focus on the phantasmatic structure of this orderly greed, this bureaucratized theft, which was rational to the point of irrationally inventorying its own criminality. Utilizing documents that index the event in its administrative specificity – a bureaucratization that has been seen as the hallmark of the Modernity of the Holocaust, the Third Reich and its perpetrator – Frenkel lodges her operation in the present, figured by her use of an earlier artwork, '...*From the Transit Bar*', which I shall shortly discuss.[32] Frenkel re-invokes, virtually, the meeting space of a transit bar where fictitious

and actual researchers assemble to contemplate lists and losses. This becomes the unlocatable intersection between a past full of holes and gaps and a historical investigation in the present into absences that shape that very present and its subjectivities.

In the originary installation of *Body Missing* and its many subsequent exhibitions in Japan, Scandinavia, Poland, France and the Freud Museums in both Vienna and London, the transit bar returns via installation, projections, looped video sequences and computer workstations that make us, the viewers, party to this utterly symptomatic dimension of the criminal history of the Third Reich that stretches beyond the barbed wires and sites of atrocity to inhabit, sometimes too closely for comfort, the discipline of art history and the museum of art.

Vera Frenkel: the backstory

Vera Frenkel is above all a storyteller who at once uncovers the stories that are told and that we tell ourselves. In her work *The Last Valentine* (1985) she presents us with an imprisoned storyteller in a country or a time when storytelling has become a crime. The story of her work I am going to tell here will run against the flow of narrative, working back from 1994 to draw out the themes of absence and amnesia and the role of the indexical trace that binds the invisible past to remnants and objects solidly in the present. Underlying and linking the different works I shall discuss is also a question of spatial displacement, linguistic dislocation, and dissembling as well as what to do in the face of irretrievable loss.

Vera Frenkel – one of Canada's most respected and celebrated contemporary mulitdisciplinary artists – was, however, born in Bratislava into a Jewish family in the then newly formed nation of Czechoslovakia (1918–92) that would become the first sacrificial lamb offered to Hitler's imperial designs on his easterly neighbours in the mistaken policy of Appeasement.[33] When it was created in 1918, out of the ruins of the Austro-Hapsburg Empire, Czechoslovakia was a liberal, multi-ethnic democratic state that gave national identity to its many constituents: Hungarians, Germans, Slovaks, Czechs and Jews. The latter had their own schools in Czech and modern Hebrew and the Jewish people (a minority of less than 2 per cent) was recognized as a national entity (not a racial or a religious definition) in modern cultural terms. Rapidly modernizing and committed to all that Modernity could bring after generations of stagnation at the edges of a decaying empire, inspired by the democratic and egalitarian thinking of nation's founder Tomas Mazaryk, Czechoslovakia was disgracefully dismembered when the Sudetenland (home province of Oscar Schindler) was ceded to the Third Reich at the Munich Conference in 1938. In 1939, Hitler invaded the remaining sections and made them the Protectorates

of Moravia and Bohemia while setting up a puppet fascist Slovak state and ceding other parts to the fascist-dominated state of Hungary led by his ally, Admiral Horthy. Vera Frenkel's father was able to escape to Britain before the borders were closed in the summer of 1939. She, a toddler, and her mother could not immediately do so. A tiny blue-eyed, blonde-haired Vera and her desperate, equally blonde mother spent many months negotiating their escape across seven or eight European borders, finally crossing into Italy, only to find their train compartment filling up with SS officers. Racist propaganda against the Jewish body preserved them: the officers did not for one instance imagine the blue-eyed blonde mother and daughter were Jewish. The journey passed, however, with her mother wracked with terror. Mother and daughter managed eventually to get to Britain to reconnect with her father in London. The Blitz bombing of that city drove the family to Leeds, the city where the artist lived until she was eleven. The meteorological as well as economic climate was too mild for her father, a furrier, to make a living, and her mother, an accomplished *corsetière*, could only create her specialized products with hard-to-get doctors' prescriptions for her clients, so the family emigrated to a chillier Montreal in 1950 on HMS *Scythia*. At McGill University Vera Frenkel studied art and anthropology, traversing that space between unconscious motivations – the domain of anthropology – and thoughtful aesthetic practice; she also studied at the Montreal Museum School of Fine Arts. Moving to Toronto, Frenkel began as a sculptor and printmaker, but soon created 'installations' by showing prints hinged with mirrors and empty frames so that real and formal space were put into play and spectators had to participate. Performance work was also explored when she was an artist in residence at the Art Institute of Chicago and housed in the former Playboy mansion, where *Trust Me, It's Bliss: The Hugh Hefner-Richard Wagner Connection* was created in 1987, and this thematic of 'bliss' was developed in *Mad for Bliss* at the Music Gallery in Toronto, in 1989, where the text for a work that was later transformed into a Spectacolour Board amidst the advertising billboards in Picadilly Circus, *This is Your Messiah Speaking*, was first presented. This linked in with exploration of cargo cults and other contemporary symptoms of messianism in mass consumption. Her analysis of contemporary consumption picked up on the expansion of the vast cathedrals of consumption now ubiquitous as shopping malls. During a residency at Newcastle in Britain in 1990, Frenkel further observed the effects of what was new to Britain at the time, an out-of-town shopping centre named the Metro, where shopping based on ersatz Little Greece and Little Italy mixed with an amusement park, a Salvation Army band playing beneath a First World War aircraft, led her to comment: 'The convergence of war, religion, and profiteering and deliberately programmed delusion was the way they were leeching the energies of a previously thriving city.'[34] *This Your Messiah Speaking* opens:

> This is Your Messiah speaking instructing you to shop/Don't worry. No one
> will force you to do anything you don't want to do.

The tone becomes a little more menacing when it concludes: 'Shop, I tell you. Shop, he said. Or someone will shop for you.' Frenkel wanted to pose to us the question: what makes us believe in things to deliver us over to bliss? Of this work Vera Frenkel herself writes, making the link to *Body Missing*:

> Looking back, I see that this work, rooted in the interrogation of the abuses of power and its impact, formed the basis of my subsequent work on the forms of identity shifts and fear-induced collusion that characterize the immigrant experience, concerns that are of course central to feminist practice. This led in turn to *Body Missing*, a work on the collecting fever of the Third Reich as a cargo-cult phenomenon, and to the *Institute*, my current project on the travails of a large cultural institution as a symptom of cultural suicide.[35]

From 1979 to 1986, video, performance and installation were used in a cycle of works about a 'lost' Canadian author, named Cornelia Lumsden, which took the form of staged scenarios that problematized fiction and fact, and the use of multiple personae to reflect back to the viewer both deep cultural assumptions about art and gender, and marginality and national identity, as well as the contemporary modes of mediated information and representation through which they are recycled. As curator Louise Dompierre wrote in 1982, Vera Frenkel's method of enquiry 'relies on the use of daily myths and clichés to discover the underlying structure and, like structuralist methodology, attempts to analyse … surface events and phenomena … by structures, data and phenomena below the surface.'[36] From early on Vera Frenkel was always interested in institutions and power, making a hilarious work, to contest conservative moves to censor artistic expression, about the desperate attempt of a natural history film-maker making a documentary about fleas to cover the tiny insects' sexual organs: *The Business of Frightened Desires: Or the Making of a Pornographer* (1985).

'… *from the Transit Bar*' was an installation in the Fridericianum at the core of *documenta IX*, 1992, curated somewhat chaotically, it was felt, by the Belgian Jan Hoet.[37] (Figure 72) The context for Frenkel's work included Louise Bourgeois's cell *Precious Liquids* (1992, Centre Pompidou, Paris), and works by Marina Abramovic, Marlene Dumas, Iza Genzken, Jimmie Durham, Rebecca Horn, Eugenio Dittborn, to name but a very few who formed Frenkel's peers at this date.

Both *documenta* in Kassel and *Andere Körper* in Linz evoke the very phases of German history that shaped the life of the Czech-born Jewish artist who is now a Canadian, but within that space an immigrant. Already attuned to what would become by the mid-1990s a massive cultural tide of renewed awareness

of the significance of the Holocaust for European cultural memory, Vera Frenkel's two works introduced innovative and radical aesthetic modes for troubling these emergent modes of memorialization that suffered from what Eric Santner, a specialist in post-war German culture, identifying contrary modes of opposing dealing with the difficult past, first named 'narrative fetishism':

> By narrative fetishism I mean the construction and deployment of a narrative consciously or unconsciously designed to expunge the traces of the trauma or loss that called that narrative into being in the first place. Narrative fetishism … is the way an inability or refusal to mourn emplots traumatic events; it is a strategy of undoing, in fantasy, the need for mourning by simulating a condition of intactness, typically by situating the site and origin of loss elsewhere. Narrative fetishism releases one from the burden of having to reconstitute one's self-identity under 'posttraumatic' conditions; in narrative fetishism, the 'post' in indefinitely postponed.[38]

Santner elaborates on the counter-process:

> The work of mourning is a process of elaborating and integrating the reality of loss or traumatic shock by remembering and repeating it in symbolically and dialogically mediated doses; it is a process of translating, troping, and figuring loss and, as Dominick LaCapra has noted in his chapter, may encompass 'a relation between language and silence that is in some sense ritualized'.[39]

Certainly, countering narrative fetishism by means of her strategies of fluidity, metaphor and suggestion, Vera Frenkel's work is not quite mourning either. I want to explore it under the sign of trauma, as a deeper loss haunting critically conceived aesthetic inscriptions that call upon the sounds of subjectivity and the memories of the body in social and communication spaces of transit and exchange, momentary intimacies and perpetual foreignness to be the home to an affective charge that arrives only when this station has been built.

'… from the Transit Bar', finally

Let me describe the '… *from the Transit Bar*' as the original installation created for *documenta IX* (Figure 72). As time-space work, using video and a constructed environment, '… *from the Transit Bar*' is difficult to describe in its full complexity and effect. There are three key elements I want to focus upon. There is the *event-performative* aspect of the bar that involved creating a fabricated space in a major quinquennial art exhibition around which thousands of tourists and art visitors drag themselves over 100 days. There is documentary footage of actual art visitors in 1992 resting in a working bar, buying drinks,

listening to a piano player, reading newspapers, and chatting or sleeping while TV screens display talking heads speaking languages that are subtitled in German, English and French. In the centre there is a real bar and a bartender who is sometimes a woman with a soft, melodious voice, ready to pour a drink and listen to whatever story that is offered. There is also a Yamaha Disklavier that plays recorded music and will record as you play.

The *documenta* visitors animate this space with their own displacement. Drawn from all over the world and from the locality and Germany itself, they are all momentarily in transit, some genuinely foreign, some merely not local. They are passing through this temporary space, resting, meeting, relaxing, chatting, sitting alone and pondering what they have just seen in the more conventional exhibition spaces. They may not even register that they are players in this artwork. The bar they make into a bar with their behaviour is a crossing point in many lives, a fragmentary moment in those lives. Will it make them think?

'... *from the Transit Bar*' is a structure that has been artistically fashioned and carefully built within the Fridericianum, a monumental piece of eighteenth-century Enlightenment architecture and one of Germany's oldest public museums. Built in 1779 in Hesse, the princely state of pre-unification Germany, as a library and show case for the Landgraf of Hesse's art collection, it inscribes into the city the prince's cultivation and plans to educate his subjects. So how can something that is about marginality and migration, temporariness and transit, take its place inside the very opposite architectural statement: the museum, that quintessential modernist and enlightenment project?

It does so by being a false construction built within the shell of the classical architecture of the work's allocated exhibition space. The bar itself shifts the axis of the original space. So while there was internal coherence, the space was displaced in relation to the architecture while also subtly disorienting the body by slight dissonances of angle and tilt. At certain points there are holes in the walls, which allow the visitor to peer through to realize that this is a setting, a staged space built at oblique angles to the neo-classical building. The visitor has to ask: what does this mean? Is this a real bar built with, now we look closely, a slighted dated, almost 1960s modernist style, or is it a set? Or is it a work of art?

The work claims its riddling relation to the museum building's grand classicism that it has masked with what art historian Elizabeth Legge astutely describes as a space that 'combines the structure of an airport bar with the crudeness of a school play production of *Casablanca*'.[40] Legge has hit on another level of Frenkel's artworking (Figure 75). *Casablanca* (1942, Michael Curtiz) is not only a beloved icon of cinematic history; it tells the story of two displaced people, escapees from Nazism, who last met in a Paris bar in 1940 and by chance refind themselves in another seedy bar infested with occupying

German officers and French police in a city on the edge of Moroccan coast. Wrapped up in the great love story enacted by Humphrey Bogart and Ingrid Bergman is the more terrifying political history of the fight against fascism and flight from persecution. How subtle to evoke the romantic cultural scenarios in which real terrors have been sentimentalized while placing the current consumers of culture in both a Hollywood-like set and a real space similar to that which desperate migrants and asylum seekers populate, those spaces that French anthropologist Marc Augé, admirer of Frenkel's work, named *non-lieux* – non-places of supermodernity.[41]

But into this structure within a structure, a novel historical form of social space and social and psychological experience set against the older historical form of aristocratically ritualized cultural space, Vera Frenkel obliquely places the evidence of deeply experienced lives of dislocation, forced migration, exile and perennial strangeness. For one thing, the newspapers lying around to be read were those of local refugee and immigrant communities. The profits from the bar were passed on to the hostel for asylum seekers in Kassel itself. These publications function as ports, forms of connection and communication, affirmations of temporary homes in language or custom. In each subsequent venue of the installation – Sweden or Poland or Japan or Canada – the marginal communities connecting through this now almost archaic mode of communication, the local paper, were included to colour this impersonal space with their urgent need for human and social contact and with reference to local tensions. In an interview that accompanies the DVD collection of her work *Of Memory and Displacement* (V-Tapes, 2005), Frenkel remembers that each time the installation was created with these elements, the local anxieties featured strongly in the debates it aroused around immigration and the resurfacing of treacherous racism. Past and present collide.

But the main index of and aesthetically reconfigured counterpoint to the supermodern space of late capitalism mediated through its typical non-place is the ubiquitous TV monitor that is part and parcel of the furniture of a bar, its screens never, as in the cinema, being the focus of attention and the binding centre of a communal experience. On these TV monitors, Frenkel placed faces, filmed in intimate, conversational close-up, as if we were on the other side of the bar table at which they sat to be filmed. (Figure 76) Thus the passing anomie of the supermodern bar is punctured by the face of the other presented in portrait format, as it were, a face that calls to the passing customer at the bar and offers a singular story. The stories were filmed in close-up. They are stories of people known to the artist who have for many reasons experienced displacement, forced migration, exile and hence perennial strangeness. They speak of their experiences of such situations. Hers is also one of these stories. Her temporary presence in the bar as the bartender also invested this transient space with her own memories, soon to be elaborated in a new work,

The Blue Train (2012), recovering the story her mother told her of their escape and prolonged and dangerous transit in 1939 (Figure 77).

Frenkel has plaited their narratives into a new tapestry in video montage by fracturing the stories in broken elements that layer each other, forming new patterns by coincidence despite radically different histories. Some have experiences from the Holocaust in Europe; others are political refugees. Yet others are economic migrants. Without losing specific identities, their words are woven by the video montage into a multi-threaded cloth that is at once a displaced self-portrait by an artist who so often performs and speaks in her works but is not present this time and a multiple portrait of the experience of strangeness she shares with many others.

Placing this Levinasian 'face' of the other into the Fridericianum in Kassel, in Germany in 1992 was a courageous and bold gesture. The words of these faces of otherness add to the outrage. For the spoken words of the fourteen people who appear have been dubbed into two languages the artist longed to hear, languages associated with the grandparents she never knew: Yiddish and Polish. These two languages represented for the Third Reich the barbarous deformities of lesser Slav 'races' and the non-human Jewish 'race'. For Frenkel, they are lost linguistic homes. The voices speaking languages abhorred in German, and in Germany, was, we must now admit, a kind of mourning.

The speaking heads' words were subtitled in the dominant languages of the European Union: German, French and English. But they were not subtitled consistently. For even these texts were fractured again across the many monitors because sometimes the subtitling was French but soon shifting to German and interrupted by English. Only those who travel in languages, or were forced to acquire several dominant languages because of many migrations could find their way through a single monitor. Or else the visitor to the bar would have to become the participant in the artwork, spending time with these other virtual visitors, tracking their fractured stories, building up the fragments into a picture of many colours, voices and histories. These intimate portraits defamilarized by unfamiliar tongues become the site of affect in the work, largely through the aesthetic manipulations of video technologies editing, lighting, dissolves and its most affecting feature, duration.

'*… from the Transit Bar*' now exists beyond its installation and performative history in actual exhibition spaces. Frenkel made a specially edited version on video (now available on DVD). This new piece opens with footage filmed from a moving train of railway tracks, sidings, goods wagons. The train journey became the iconic image for the transports that characterized the Holocaust through cinematic inscription. There is one infamous piece of footage of moving trains, filmed at Westerbork Transit Camp, commissioned by its Commandant Gemmeker and made by Rudolf Breslauer, in 1944 which was included and thus widely disseminated commemoratively in Alain Resnais's

benchmark film *Night and Fog* made in 1955. The movement of contemporary Polish and German trains on the actual tracks used in the 1940s became a recurring feature of Claude Lanzmann's nine-hour film *Shoah* (1985), in which the relentless movement of the trains became both a punctuating space offered to the viewer periodically during the film for reflection after a particularly harrowing testimony, and an interval recurrently reminding the viewer of the actuality of the transports that moved millions of people to their deaths along the ordinary railway lines, travel that had to be paid for like any excursion, ticketed, funded and scrupulously planned and timetabled. The train is the emblem of the modern machinery, bureaucracy, and industrial infrastructure of mass transportation to death factories and a figure of movement, displacement, exile from home and place. It is the ultimate non-space of that catastrophe and the everyday sign of people on the move.

Frenkel shares Lanzmann's desire to keep visible the modern reality and to keep us in present time rather than fetishistically distanced by archival imagery that has become iconic. Thus her trains are Canadian railways, Canadian sidings. They play as a moving back curtain to the inserted visitors to the Piano Bar who now seem to be in the club car on the train itself, put on the move. Here the moving image, video, underlines the image of mobility that is its topic. Dot Tuer, an astute reader of Frenkel's work, writes:

> Her use of video as an installation, in which the physical environment framing the video monitor is a foil for images on the video screen, entangles the viewer in an intricate skein of fictional space. Through the use of props, ordinary, almost mundane and the telling of stories, complex, almost fractured, themes of exile and memory, of false messiahs and primordial longings, emerge.[42]

A trauma reading, 1994

In an essay for the re-installation of '... *from the Transit Bar*' at The Power Plant, Toronto and the National Gallery of Canada, Ottawa in 1995, Irit Rogoff remembers the moment in the summer of 1992 in Kassel when she saw ' ... *from the Transit Bar*'. Of the 'polyglot speech' coming from the TV monitors in Yiddish and Polish, she writes that they

> echoed the babel of languages from my childhood in Israel as well as that of other migrant languages around me in present life in California. Such echoes reverberated in the urgent harried speech of Yugoslav refugees on the move that summer in train stations all over western Germany and in the news covering the rage and grief expressed by communities of foreigners living in Germany, singled out for vicious attacks that same summer.[43]

With the fall of the Berlin Wall in 1989 and the reunification of the two Germanies in November that year, fierce debates about citizenship and national

identity spilt over in a terrifying resurrection of Neo-Nazi groups and racist attitudes intensely hostile to the new 'strangers': migrant workers notably from Turkey. In Germany in 1989 there were 1,500 cases of xenophobic violence reported and 2,200 cases in 1990. There were even calls for *Ausländer-freie* – Foreigner-free – zones with clear overtones of Nazi policies of making Germany *Judenfrei*: free from Jews. Two particular instances of Neo-Nazi attacks on Turkish families long resident in Germany occurred in fact after *documenta IX* had closed, namely 25 November 1992 at Möln and 29 May 1993 in Solingen, although the press were reporting less fatal assaults throughout the summer of 1992. The *Los Angeles Times* reported on 3 August 1992 a weekend of Neo-Nazi skinhead rampages in six German cities or towns including Nuremberg. The links with the past were all too apparent but this time massive protest marches were held in solidarity with the victimized. Migrancy, foreignness and the resonances with the past led Rogoff to her key interpretation of the work of Frenkel. As a viewer and then a writer, Rogoff performed some of the effects solicited by Frenkel's project theoretically and practically.

> In '*… from the Transit Bar*' that summer, we viewers all became aware of the complex associative layering of displacement within our own unconscious, and some of us became more acutely aware of the task we had set ourselves as cultural critics; to read the embeddedness of one cultural history in another, one displacement in another, our own embeddedness in an *intertextuality of trauma*.[44] (My emphasis)

Prompted by Vera Frenkel's early acquaintance in 1992 with Cathy Caruth's then very new work on trauma after Caruth had lectured in Toronto, Irit Rogoff became one of the first writers on art and visual culture to engage with trauma, extending it into intertextuality of trauma as a frame for analysing Frenkel's own work. For Rogoff trauma is not a 'shocking occurrence' but a 'deeply affecting event that has gone unremarked by consciousness and is nevertheless constantly revisited through associations'. Following Caruth, Rogoff lays out the double scene of trauma in the typical psychoanalytical scenario. The primary scene of infantile 'seduction' lies dormant until puberty when a revived 'memory' of the first scene 'occasions an influx of sexual stimuli that overwhelms the ego's defences. Only as a memory does the first scene become pathogenic by deferred action'.[45] To make a move from the traumatic origins of sexuality in the individual to the scene of history, Rogoff suggests that we replace the 'event' with a narrative of symptoms rather than the simple sequence of facts. The symptoms reveal themselves and that which is returning through them by means of narratives, repressed histories in the process of finding articulation. For instance by paying attention to the historical and cultural conditions of the post-colonial world that is so marked by exile, migration, transition, displacement, it becomes possible to return

to foreclosed or abbreviated narratives of flight, exile, forced migration of an early period such as the era of Nazi persecution in which, as Rogoff points out, the notion of 'flight to safety' can now reveal deeper trauma and prolonged affects resulting from the unending sense of loss, absence and uncertainty. To be a child-survivor like Vera Frenkel is not merely to have escaped to safety.[46] She has to live 'displaced' between worlds with affects that may only become apparent decades later, or when certain kinds of work, generated within the intellectually conceived project, create the space for an encounter with them, not so much surfacing but finding the aesthetic *differend*, and the means to be phrased – the Lyotardian term for what cannot be fully articulated but finds gestures that incline towards it, frame it, draw a space for its momentary flash of recognition.[47]

But by the same token, Rogoff wishes to insist that the belated Western narratives of Nazism and Stalinism run the risk of their own displacement of other narratives of genocides of Armenians, Biafrans, Bosnian Muslims.[48] It is with this in mind that Rogoff appreciates the ways in which Frenkel makes the juxtapositions and flows across the video screens refuse hierarchy and make 'equal claims on the viewer's imagination'. Furthermore, she points to the manner in which fragments of narratives of forced migration occasioned by political persecution or poverty not only create a web of traumatic instances but 'Circulating as the cultural representations of the traumas of rupture and leave-taking [they] can serve to link the symptoms of historical trauma in which we are all steeped. A hybrid historical weave emerges from these encounters' and we the viewers can become, because of their lack of specificity, 'cultural co-inhabitants of the narratives'.[49]

As a psychic space, Rogoff sees the space of transit in which history operates within it as trauma. 'What is realized is not the place of departure and not the place of arrival but the space in which trauma comes into being, into language and representation through articulated memory.'[50] I have been arguing that trauma remains inarticulatable as the Real; but its residues and traces, its affects and anxieties, can surcharge a later event. That event becomes the formal and aesthetic creation of a space hospitable to the encountering of traumatic traces, and to the ordering that a 'writing' allows us, in its mediated symbolic doses, to phrase it and in so doing create for the traumatic residue a narrative base for memory – memory, agitated however, by its ever elusive traumatic excess which in Frenkel's work is used to open up laterally and historically to the many sites and many subjects of trauma.

Trauma, as Rogoff points out, was for Freud akin to a foreign body. We use the language of colonization to explain how trauma inhabits and alienates the subject. We are, therefore, playing between the psychic register of trauma's invasive foreignness and the real experience of being made foreign. By overlaying the actual histories of mid-twentieth-century traumas of

genocide and flight with the accumulating and present-day narratives of other forced displacements and their attendant process of becoming and remaining 'foreign' as an immigrant who is always an outsider, multidirectional trauma and memory work comes into view. Caruth, cited by Rogoff, argues that it is 'in the bewildering encounter with trauma … that we can begin to recognize the possibility of a history which is no longer straightforwardly referential. Through the notion of trauma … we can understand that a rethinking of reference is not aimed at eliminating history, but at resituating it in our understanding, that is, precisely *allowing history to arise* where immediate understanding may not'[51] (my emphasis). This formulation beautifully captures the key proposition in this set of studies, in which the artwork becomes an occasion for *encounter* and hence a transport station of trauma.

The reception of Vera Frenkel's daring work took place strategically in a German context at a highly volatile moment of both resurgent anti-immigrant racism in reunited Germany and of anxiety in the post-colonial moment about widespread racism. Might the very allusion to both simply allow a comforting viewing position secure in its proper anti-racism? Rogoff reminds us of the delusion involved in any such position.

> One is never outside race, outside strangeness, outside difference. To be anti-racist is not only to assume a position against the evils of racism but also to extract oneself, to some degree, from the positionality of race. It is for these reasons that I need to read these theoretical texts across the surface of '… *from the Transit Bar*', for they allow it to be read as a process without closure. Slipping and sliding between the familiar and the strange, layering transparencies of association on top of one another, we are deprived of a clear-cut position that allows us to exit and stand outside the work to reframe it for the convenience of having a comfortable more ground beneath our feet, recapturing the reference that will allow us to clearly assert 'immediate understanding'. In the circular motion and layered density of '… *from the Transit Bar*', we may reflect on how we have been produced out of the vilifications and elisions of numerous racisms, the ruptures they have visited on all of us and the unexpected cultural formations that have emerged in their wake.[52]

Indirectly acknowledging the conflicts shattering the peoples Israel/Palestine as part of a much longer history of nations and racisms still playing out across Europe and the post-colonial nexus, Rogoff acknowledges the powerful force of Frenkel's aesthetic formulation as a means of generating such necessary unsettlement of victims and perpetrators before the implicated trauma of historical violation: racism in all its forms. Her commentary brings out the dialectic of what is seen and shown, what I see, *video* in Latin, and what is being incited as the reciprocating thought before the screen. We shall need, therefore, to go more deeply into Frenkel's process and medium.

Video …

This encounter with Vera Frenkel's work takes place, therefore, in the vidéothèque of the Virtual Feminist Museum. From the sculpted body hollowed, monumentalized and rendered arachnid, reduced to abjected resin skin impregnated with an atrocity image, or put into ontologically repetitious action – discussed in the preceding chapters – we are now going to examine a 'body missing' by means of a virtual screen, situated, nevertheless, in a real and uncanny space in Europe's modern historical geography of terror. This work operates at the intersection of two different strands of analysis.

One is the pairing of memory and amnesia. The other is opposition between indexicality and virtuality. The question of what is remembered, forgotten and selectively written into the narratives we call history is still deeply contested; but we have some purchase on these terms. The other axis – that which existentially indexes a real and that which enables us to think, imagine and project – puts into relation the question of why we might wish to remember and establish historical knowledge that is both verifiable by evidence but also by understanding at a deep level that it was once real but in a way that matters to us affectively in the present.

The index is one of the categories of signification, according to the American semiotician C.S. Peirce, who created a trichotomy of signs:

> I had observed that the most frequently useful division of signs is by trichotomy into firstly Likenesses, or, as I prefer to say, *Icons*, which serve to represent their objects only in so far as they resemble them in themselves; secondly, *Indices*, which represent their objects independently of any resemblance to them, only by virtue of real connections with them, and thirdly *Symbols*, which represent their objects, independently alike of any resemblance or any real connection, because dispositions or factitious habits of their interpreters insure their being so understood.[53]

The index produces meaning by being in a real or existential relation to that which it signifies for an interpretant.

Virtuality, however, has different meanings in different contexts. It can mean the real thing: 'this is virtually the same as that'. It is used of cybernetic operations and representations. Thus we speak of virtual reality as a simulacrum with which we interface 'as if' it were real. Finally, in philosophical terms, virtuality constitutes a perpetual resource for difference and change that is not bound by the logic of given reality. Thus the Virtual Feminist Museum is not an 'on line' cybernetic museum; it is a work of differentiation that may create that which does not yet exist: a feminist future and it can be actualized in a variety of ways, not limited by what existing models of reality or sense consider 'possible'.

Vera Frenkel's work of the early 1990s operated in the expanding field of aesthetic engagements with 'new media' – not yet digital – such as video and with the potentialities of the internet, the network of networks, whose origins lie in the 1960s when military and government needs required a robust system of distributed computer networks. Only in the 1990s was the internet commercialized to become the world-wide communication forum it is today. In 1989 Tim Berners-Lee, a British computer scientist, developed earlier systems of hypertext connections to create the world wide web accessed through the internet. Frenkel's work was thus at the critical edge of experimentation with the potentialities for critical work and aesthetic inscription by means of an electronic technology for capturing, storing, processing and transmitting motion images. The first Video Tape Recorder was invented in 1951 using magnetic tape; in 1971 Sony was the first to sell VCR tapes to the public and it was not until 1997 that digital video recording was initiated. The Portapac, a portable video camera and recorder, was produced by Sony in 1965, thus enabling the video camera to move out of the studio. Artists were swift to explore its new potentials.

These dates indicate the recentness of what we now consider to be the indispensable and normal technological landscape we inhabit. They also allow us to situate the temporality of Vera Frenkel's aesthetic use of a medium that by the early 1990s was also institutionalized as television, entertainment, news and relays of other cinematic and film material.

Video=I see – what is not there

As for television, we think of video technology as that which brings images into our homes and offices. Yet video shares with photography and film its own intrinsic relation to absence. As film theorist Christian Metz argued, the cinema is the imaginary signifier operating on a fetishistic register of absence disavowed.[54] What we see is an event or process (the making of the work/film) from which we, as spectator now, were excluded. This structural problematic incites a recurrence of a primal scene of phantasy in which the desire to see and the trauma of seeing too much or seeing nothing is played out in a form of oscillating ambivalence to which Freud gave the name fetishism. As a scopic regime of representation the visual in its photographic, cinematic and extended codes is always about absence and our modes of knowing and not knowing this: this is called disavowal. Fetishism means holding together contradictory knowledge: I know but I don't know.

Video shares its medium with television. Tele-vision, meaning seeing at a distance, also implies this dislocation in time and in place. Television is a vernacular, commercialized medium associated with the popular culture working its dialectics of technological merchandising, the TV set itself and the production of information and semiotic materials transmitted into a largely

domestic and increasingly personalized scene of consumption.

As an art medium, however, video operates, according to Martha Rosler's influential genealogy, on three levels.[55] Video can be used to evoke the contexts and practices of a non-fine-art domain of popular cultural production and consumption, entertainment and information, with its own borrowed as well as indigenously developed tools. Artists may use video to produce, however, a meta-critical perspective on the practices and experiences of video, ethnographically, as it were, analysing 'us', its consumers and 'them' the producers and their codes. In the manner of conceptual art, one practice critically works on and interferes with another cultural practice, usually charged with a form of ideological critique of the role of television in cultural hegemony.

Finally, Rosler argues that artists using video enter into the use of this medium with a training in medium-determined formalism – the modernist creed was that the central objective of all modernist art of value was the ever-deepening exploration of the potential of its specific medium. Some artists used video as a means of reacting against medium-specificity and its formal agenda. While others foreground of video as a medium rather than an instance of media culture in order to establish their artistic or aesthetic credentials. Hence a video fine-art practice explores and extends the defining features of video as medium: duration, montage of a new kind through video editing procedures, extended and playful modes of dissolve and transition, the box-like space of the object-like monitor, the potential for manipulating speed, delays, repetition, the potentialities of integrated audio-visual-spatial processes, its insertability. By means of this approach, the material and aesthetic dimensions predominate over the semiotic structures and conventions, exposed in the second mode discussed above. Under this rubric of radically rewriting the possibilities of the technology, image and sound can de dislocated, layered, troubled, thickened, opening up new space, while sequencing can dispense with narrative and thus attempt to solicit a different kind of spectatorship, more critical precisely as the familiar habits of the televisual become the aesthetics of video art.

An interview

In writing this analysis of Vera Frenkel's two key works of the early 1990s, I have been at pains to situate the project in its subtle responsiveness to precise historical configurations in the memory politics of that decade in which other times and other scenes replay through contemporary tensions. I have equally emphasized Frenkel's innovative aesthetic plays with video as medium for her significantly multi-vocal and intertextual memory work. But we have touched, through Rogoff's insightful reading, on trauma as a possible thematic of Frenkel's work.

Whose trauma, however? The question I posed in the preface returns. It would seem that Frenkel's work is so imaginatively in tune with its moment – indeed is one of the symptomatic sites of that complex interfacing of the primal scene of twentieth-century horror in Europe with a recognition of Europe's implication in economic, racist and colonial legacies of trauma – that it would seem limiting to re-introduce a more personal level. But throughout my arguments in this book, I have been seeking to enact the deep feminist intertwining of the lived, personally experienced, and the thought, reflected and socially or politically engaged.

My contribution to the reading of Vera Frenkel's works does not intend to collapse the anthropological and historical grandeur of her imagination into the biographical. It is rather to weave the latter back into the formal analysis and the cultural reading. Something beyond both is the affective pulse for both these works, infusing their intelligent commentary on memory politics, racism and delusion with a different tenor. Not mourning but *yearning*. Mourning works with a phallic economy of loss – Freud wrote of mourning the loss of country, identity as much as a loved object. These are relevant. But yearning – *nichsapha* in Hebrew – is a term from Ettinger's concept of a supplementary Matrixial psychic economy which elaborates a concurrent trauma that longs for a lost connectedness, and is prepared to fragilize the self, and importantly, in compassion, cannot abandon the other.

In a long and probing interview for the installation of '...*from the Transit Bar*' in Toronto in 1993, Dot Tuer asks Frenkel about the level of pain in the immigrant experience that leads to silence. She acknowledges how this works with a loss of memory and a kind of amnesia in Frenkel's work. The artist replies:

> The silence of trauma, when parents try to protect the next generation from internalizing the unspeakable, is very familiar in Canadian immigrant experience, though I am not sure the silence works. The fact that something is unspeakable is internalized through the silence itself.[56]

This silence evokes the notion of an entombed trauma composed of fear, shame and unmourned losses. Such a silence is necessary for the survivor, she argues, simply in order to carry on. But there is a second silence.

> The silence of the next generation, of deracination, also familiar, is something else. There are ways of being homeless that are not physical. Both silences were entered into and broken during the *Transit Bar* shoot.[57]

The shooting was a process of entering into silences shared with other immigrants, hence a joint occasion for the lifting of long-maintained silences. But then she avows something much more particular about Canadian experience and 'passing'.

When people discover that I'm an immigrant, they're sometimes surprised. In some instances, I see them make their internal recalculation. Have they unwittingly shown their chauvinist card? Perhaps they have, and are angry or ashamed at having been witnessed. Or sometimes our stories are similar.[58]

Language, notably English, assists in the assimilation process. 'But it's also a mark of what my parents had to give up, and of a lost continuity.' This leads Frenkel into a discussion about Yiddish, the former lingua franca of Eastern European Jewry that traversed the national entities of Poland, Russia, Czechoslovakia and more. It appears that only recently had the artist discovered that her mother understands Yiddish although it was never spoken in her home, and that her father spoke it fluently, as he did Hungarian, Czech, Hebrew, German and English. She then tells us of an act of compassionate imagination she performed that underlines the infinitely deep resonances of language and loss of home. When her father was dying, the artist brought one of the caregivers to her father to share some words in Yiddish with him. She hoped that the simple exchanges might bring him some comfort.

> I wanted to give him the feeling of going home, of the safety of his childhood in Czechoslovakia before all the upheaval. I wanted to provide, in his moment of dying, the kind of innocence, and the bliss of the deeply familiar, of the oneness, of the openness that all my adult work warns against as an illusion. And because I had begun to learn German, which was his other mother tongue, I tried to speak to him in German, again to wash away what was alien in the hospital and to appeal to the embedded structures of his mind, to give him some kind of place to be that was not clinical, filled with machines and strangers.[59]

I am utterly pierced by the poignancy of this gesture and this scene. The voice-over languages of '...*from the Transit Bar*' were Polish and Yiddish, languages of an old, destroyed European-Jewish civilization that will never return that were also personalized as the languages of unknown grandparents. Their bodies, voices and culture had once been home to her father. In the alienated and indeed foreign medical environment of modern dying of old age, the artist's father is bathed again by voices from that lost home of childhood. But his loss, intensely felt and compassionately comforted by his daughter, is irreparable. It is, in fact, hers not as a memory but as the lining of her present, as an inheritance whose affective charge fuels her affectionate gesture of fragile and fractured linguistic restoration. She has no home to mourn. Foreignness as she later says is a natural state. The fracture that severed her father from his parents does not sever her. His dying before her does. She rebinds his lost connections with her voice. But the fracture is historical. After the event, there is no innocence, no bliss of the deeply familiar, no oneness. There can only be scepticism before all illusions of such. As trauma, the rupture that is beyond

any naming as Holocaust, Final Solution, racism, genocide, xenophonia, informs or rather forms the artworking of Vera Frenkel with that inescapable condition of the loss of the possibility of safety. Romance and mystery have been Frenkel's favoured genres and playful targets, the one delusional with its promises of bliss and union, the other compelling a perpetual detection of the secrets that are never the real ones. Here is history as symptom. Storytelling and document play games with the normal distinctions between fact and fiction, truth and lies.

Never testimonial, the oeuvre of Vera Frenkel is at once the most profoundly indexical register of the traumatic imprint of the catastrophe enacted by the Third Reich and its most imaginatively virtual translation into a form that offers something to see – *video* – and a translation by video as a theoretically expanded aesthetic medium of layering, resonating, connecting. While at one level it performs the admirable, post-colonial gesture of refusing closure and particularization of suffering, offering inventive modes of aesthetic openness and transitivity, its energizing force arises from what it never directly speaks. This is not silence any more but, I suggest, becomes *after-affect*. The anthropological perspective and the formal-structural use of her media acquire their pertinence and significance from the affective-compassionate and intergenerational dimensions glimpsed here in the scene by her father's hospital bedside.

Opening this chapter I quoted from Anthony Julius calling for non-transgressive yet creatively novel forms that might address the unprecedented legacies of the Holocaust. The final sentence of the passage reads: 'It knows that there are limits to representation that cannot be removed, in the critic Geoffrey Hartman's phrase, "without psychic danger".'[60] If, as I am proposing, Vera Frenkel's work in video installation created both culturally and personally a transport station of trauma, it also, therefore, performed aesthetic transformation of its underlying traumatic foundations that deflected psychic dangers of retraumatization into a co-inhabitable and multidirectional space. But it did so in a periphrastic, oblique, often playful way, becoming 'a site for the interpenetration of fact and fiction, the undoing and reaffirming of each by each, the acceptance of the lie in the truth, and the truth in the lie.'[61] It put memory in transit. The challenge of reading her work is to sense, to trace and also gently to allow into recognition the shadow of the trauma – that of her parents and her grandparents, and her own – that forms an affective truth playing through the stories she collects and tells. The truth lines but never directly appears in the art forms she has brilliantly shaped. What is critical is that trauma was not encrypted, entombed. Not spoken, however, formal procedures created a home for its discovery and a space to move and to be transformed at the intersection with the world. For that multiply traumatized world, Frenkel created a form of agitating but also reflective and compassionate memory that formed a passage to an ever-sensitized future.

Notes

1 Theodor Adorno, 'Valéry Proust Museum', *Prisms*, trans. Samuel Weber and Sherry Weber (Cambridge, MA: MIT Press, 1983), 186.

2 Giorgio Agamben, *Remnants of Auschwitz: The Witness and the Archive*, trans. Daniel Heller-Roazen (New York: Zone Books, 1999), 12.

3 Hayden White, 'The Modernist Event' [1999], in Neil Levi and Michael Rothberg, (eds), *The Holocaust Reader* (Edinburgh: Edinburgh University Press, 2003), 344.

4 The work was installed in the exhibition *Apocalypse* curated by Norman Rosenthal at the Royal Academy of Arts in 2000. It was destroyed in a fire in 2004 but rebuilt and massively expanded in 2008.

5 Anthony Julius, *Transgression: The Offences of Art* (London: Thames & Hudson, 2002), 221.

6 *Body Missing* was also installed at the Gallery Georg Kargl, Vienna, 2001/02, and in the Freud Museum, London, 2003.

7 The title 'Process of Redemptive Naming' is derived from Siegfried Kracauer as interpreted by Gertrude Koch and Jeremy Gaines in '"Not Yet Accepted Anywhere": Exile, Memory, and Image in Kracauer's Conception of History', *New German Critique*, 54 (1991), 95–109. The fourth title is drawn from Lynn Nicholas, *Rape of Europa: The Fate of Europe's Treasures in the Third Reich and the Second World War* (London: Macmillan, 1994). Information kindly supplied by the artist.

8 Griselda Pollock and Max Silverman (eds), *Concentrationary Cinema: The Aesthetics of Resistance in Alain Resnais's* Night and Fog (London and New York: Berghahn, 2011).

9 Dora Apel, 'The Reinvention of Memory', *Memory Effects: The Holocaust and the Art of Secondary Witnessing* (New Brunswick, NJ: Rutgers University Press, 2002), 87.

10 http://www.yorku.ca/bmissing/news/lists.html.

11 Apel, 'The Reinvention of Memory', 89. Kyo MacLear is a visual artist and novelist based in Toronto.

12 Robert M. Edsel and Brett Witte, *The Monuments Men: Allied Heroes, Nazi Thieves and the Greatest Treasure Hunt in History* (London: Preface, 2009). See also www.monumentsmenfoundation.org.

13 Michael Rothberg, *Multi-directional Memory: Remembering the Holocaust in the Age of Decolonization* (Stanford: Stanford University Press, 2009), 5.

14 Apel, 'The Reinvention of Memory', 90.

15 Theodor Adorno, 'Commitment' [1962], in Andrew Arato and Eike Gebhardt (eds), *The Essential Frankfurt School Reader* (Oxford: Basil Blackwell, 1978), 312–13.

16 See David Cesarani and Eric J. Sundquist, *After the Holocaust: Challenging the Myth of Silence* (London: Routledge, 2011) for a major revision of this dominant thesis through historical research.

17 With the fall of dictatorships in Spain and Portugal in the 1970s, as well as the 'dirty wars' in Latin America, psychoanalysts and health workers with experience of working with Holocaust survivors were able to offer resources for assisting the tortured and those released from long-term imprisonment.

18 I cannot go into detail here but the timeline of *public* and *cultural* engagement with

the Holocaust as a matter of cultural memory unfolds very slowly, punctuated by key events such as the film *Night and Fog* (1955), the Eichmann Trial (1961), the translations of Primo Levi and Elie Wiesel's writings in the later 1950s and 1960s, The Auschwitz Trial (1964), the TV series *Holocaust* (1978), Claude Lanzmann's *Shoah* (1985) and the opening of the US Holocaust Memorial Museum (1992). See Griselda Pollock, *From Trauma to Cultural Memory: the Unfinished Business of Representation and the Holocaust* (forthcoming 2013).

19 Janina Bauman, *Winter in the Morning* (London: Virago Books, 1986).

20 *Concentrationary Memories Project*, University of Leeds, April 28 and October 12 2010, online www.CentreCATH.leeds.ac.uk.

21 Zygmunt Bauman, *Modernity and the Holocaust* (Cambridge: Polity Press, 1989), 11.

22 Charlotte Schoell-Glass, '"Serious Issues": The Last Plates of Warburg's Picture Atlas', in Richard Woodfield (ed.), *Art History as Cultural History: Warburg's Projects* (New York: GB Arts and London: Routledge, 2001), 183–208. See also Griselda Pollock, 'Aby Warburg and Mnemosyne: Photography as *Aide Mémoire*, Optical Unconscious and Philosophy', in Costanza Caraffa, *Photo Archives and the Photographic Memory of Art History* (Munich: Deutscher Kunstverlag, 2011), 73–100.

23 See Jürgen Klaus (ed.), *Entartete Kunst: Bildersturm vor 25 Jahren* (Haust der Kunst, Munich, 25 October–16 December, 1962); *Degenerate Art* (Forbidden Art in Nazi Germany), 4 April–20 May 1972, New York: La Boetie Gallery; and Stephanie Barron (ed.), *'Degenerate Art': the Fate of the Avant-garde in Nazi Germany* (Los Angeles County Museum of Art, 1991), 17 February–12 May 1991.

24 Frederic Spotts, *Hitler and the Power of Aesthetics* (London: Overlook TP, 2004). See also Jonathan Petropoulos, *Art as Politics in the Third Reich* (Chapel Hill, NC and London: University of North Carolina Press, 1996).

25 Spotts, *Hitler and the Power of Aesthetics*, xi.

26 Spotts, *Hitler and the Power of Aesthetics*, xi.

27 Nicholas, *Rape of Europa*; Hector Feliciano, *The Lost Museum: The Nazi Conspiracy to Steal the World's Greatest Works of Art* (New York: Basic Books, 1997).

28 Robert Edsel, *The Monuments Men: Allied Heroes, Nazi Thieves and the Greatest Treasure Hunt in History* (New York: Center Street, 2010); Elizabeth Simpson (ed.), *The Spoils of of War: World War II and its Aftermath: The Loss, Reappearance and Recovery of Cultural Property* (New York: Harry N. Abrams, 1997).

29 Elizabeth Legge, 'Analogs of Loss: Vera Frenkel's *Body Missing*', in Barbie Zelizer (ed.), *Visual Culture and the Holocaust* (New Brunswick, NJ: Rutgers University Press, 2001), 340–50, 341.

30 Sigrid Schade et al. (eds), *Kunstraub: Zur symbolischen Zirkulation von Kulturobjecten* (Vienna: Verlag Turia +Kant, 2000); Jeannette Greenfield, 'The Spoils of War', in Simpson (ed.), *Spoils of War*, 34–9.

31 Apel, *Memory Effects*, 77.

32 Zygmunt Bauman, *Modernity and the Holocaust* (Cambridge: Polity Press, 1989), 83–116; I am also thinking of Hannah Arendt, *Eichmann in Jerusalem: A Report on the Banality of Evil* [1963] (London: Penguin, 1994); See also David Cesarani *Becoming Eichmann: Rethinking the Life, Crimes and Trial of a 'Desk Murderer'* (Cambridge, MA: Da Capo Press, 2006).

33 For a memoir of a fellow Jewish resident of Bratislava witnessing these events see Thomas O. Hecht, *Czech Mate: A Life in Progress as told to Joe King* (Jerusalem: Yad Vashem, 2007).

34 Vera Frenkel, Dot Tuer and Clive Robertson, 'The Story is Always Partial: A Conversation with Vera Frenkel', *Art Journal*, 57:4 (1998), 9.

35 Vera Frenkel, Dot Tuer and Cliver Robertson, 'The Story is Always Partial', 9.

36 Louise Dompierre, 'Introduction', *Likely Stories: Text/Image/Sound Works for Video and Installation – Works by Vera Frenkel* (Queen's University at Kingston: Agnes Etherington Art Centre, 1982), 3.

37 Steven Henry Madoff, 'Documenta IX: More is a Mess', *Art News* (September 1992), 129–31. Giancarlo Politi, 'A Documenta to Reflect Upon', *Flash Art* (October 1992), 86–9; Dan Cameron, 'Documenta IX: The Hassle in Kassel', *Art Forum* (September 1992), 86–92.

38 Eric Santner, 'History Beyond the Pleasure Principle: Some Thoughts on Representation and Trauma', in Saul Friedländer, *Probing the Limits of Representation: Nazism and the 'Final Solution'* (Cambridge, MA: Harvard University Press, 1992), 144.

39 Santner, 'History Beyond the Pleasure Principle', 144.

40 Elizabeth Legge, 'Of Loss and Leaving', *Canadian Art* (Winter 1996), 60–4, 61.

41 Marc Augé, *Non-places: Introduction to the Anthropology of Supermodernity*, trans. Jon Howe (London: Verso Books, 1995). For Augé, place has its aura of history and memory; but in the age of airports, shopping malls, hotels, motorway cafés, computer screens, radically different forms of non-place emerge in which no organic social life takes place between individuals interacting in routinized and often depersonalized forms.

42 Dot Tuer, 'Worlds Between: An Examination of Themes of Exile and Memory in the Work of Vera Frenkel', in *Vera Frenkel: Raincoats, Suitcases, Palms* (Toronto: Art Gallery of York University, 1993), 21.

43 Irit Rogoff, 'Moving On: Migration and the Intertextuality of Trauma', *Vera Frenkel:...from the Transit Bar/...du transitbar* (Toronto: The Power Plant and Ottawa: National Gallery of Canada, 1994), 27–43, 26.

44 Rogoff, 'Moving On ...', 29.

45 Rogoff, 'Moving On ...', 30.

46 While researching, I contacted the artist to clarify my own memory of the stories of her escape from Czechoslovakia, only to find at that very moment she was planning a work about that journey, *The Blue Trains* (2012), trying to refind the tape she made with her mother, because however many times she had heard the tale, its details never stuck – a feature found in other child survivors or children of survivors.

47 Jean-François Lyotard, *The Differend: Phrases in Dispute*, trans. Georges Van Den Abeele (Minneapolis: University of Minnesota Press, 1988).

48 Rogoff: 'Moving On', 32.

49 Rogoff: 'Moving On', 3–4.

50 Rogoff: 'Moving On', 34.

51 Cathy Caruth, 'Unclaimed Experience: Trauma and the Possibility of History', *Yale French Studies*, 79 (1991), 181–92, 182.

52 Rogoff: 'Moving On', 43.

53 C.S. Peirce, 'A Sketch of Logical Critics' [1911], *The Essential Peirce: Selected Philosophical Writings*, Volume 2 (1893–1913) (Bloomington, IN: Indiana University Press, 1998), 460–1.

54 Christian Metz, *The Imaginary Signifier: Psychoanalysis and Cinema* (Basingstoke: Macmillan, 1986).

55 Martha Rosler, 'Video: Shedding the Utopian Moment' [*Block* 11 (1985–6)], reprinted in *Decoys and Disruptions: Selected Writings 1975–2001* (Cambridge, MA: MIT Press, 2004), 53–88.

56 Dot Tuer, 'Interview with Vera Frenkel', in *Vera Frenkel: Raincoats, Suitcases and Palms*, 48.

57 Tuer, 'Interview with Vera Frenkel', 48.

58 Tuer, 'Interview with Vera Frenkel', 48.

59 Tuer, 'Interview with Vera Frenkel', 49.

60 Julius, *Transgression*, 221.

61 Tuer, 'Interview with Vera Frenkel', 55.

Part **III**
Passage through the object

Deadly objects and dangerous confessions: the tale of Sarah Kofman's father's pen **6**

Captions to chapter 6

78 Edmund Engelman *Freud's Desk*, Berggasse 19, Vienna, 1938.

79 Leonardo da Vinci (1452–1519) *The Virgin and Child with Saint Anne and the Infant Saint John the Baptist ('The Burlington House Cartoon')*, 1499–1500, charcoal (and wash?) heightened with white chalk on paper, mounted on canvas, 141.5×104.6 cm.

80 Sarah Kofman (1934–94) *Self Portrait*, 1991, pencil on paper.

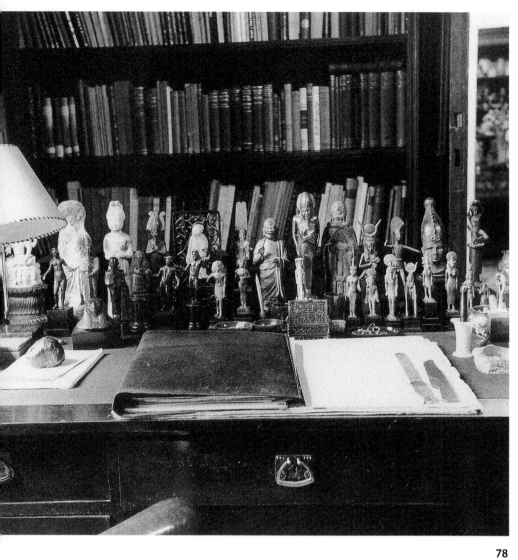

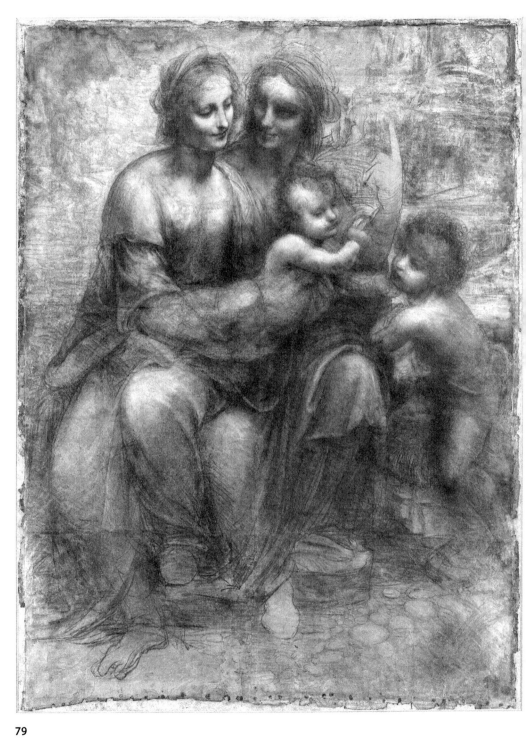

Sarah 1991

Can writing kill you? Can the coming of memory be deadly? These are the questions I want to pose in my reflections on a slim memoir by French philosopher Sarah Kofman that became the last book of the voluble and prolific writer's life. Titled *Rue Ordener, Rue Labat*, it is an account of the author's childhood between the ages of eight and eighteen. This childhood was passed as a Polish-Jewish immigrant child in France who was forced into hiding by the German occupation of France in 1940, after which her life was constantly under threat as a result of the enactment after January 1942 of the Final Solution.

The main elements of the story that *Rue Ordener, Rue Labat* will replot are these: foreign-born Jewish citizens of France were initially targeted by the Occupying German forces with the collaboration of the French authorities. On 16–17 July 1942 a mass arrest of 28,000 Jews was planned. In fact, they seized 13,152 men, women and children who were taken to a bicycle-racing stadium known as the Vélodrome D'Hiver, the *Vél d'Hiv* for short, or to a holding camp in an apartment block in Drancy before being deported to Auschwitz-Birkenau, which had just started operating as a death factory a few months earlier. Under French law there could be no census on religious affiliation. But a German ordinance of 21 September 1940 required all Jewish people in Occupied France to register with the police. These files were handed to the Gestapo where they were colour-coded and classified by nationality, region, profession and street. It revealed a population of 150,000 Jewish residents in the Paris area. By 1944, 76,000 Jewish people had been deported from France under the Nazi Occupation. Only 811 returned.

Sarah Kofman's father was the Rabbi of a small Polish-Jewish community in Paris. He spent the days preceding the leaked round-up warning his congregation to flee or go into hiding. He could not himself do so for fear that they or his family would bear the retribution for his escape. He was therefore arrested, leaving his wife and their six children without visible support and at risk themselves of future round-ups. Madame Kofman renamed her children and hid them out of Paris. But Sarah would not be separated and in her noisy

grief and refusal to eat non-Kosher food risked exposure. Finally her mother brought her back to Paris. One night in February 1943, Madame Kofman was warned that their names were on the list for arrest that night. Leaving their meagre meal on the table, mother and vomiting daughter fled to the home of a Christian woman who had helped them before. Hidden in her house until June 1944, Madame Kofman was powerless to prevent the Christian woman, known as *mémé*, from taking over her child: renamed Suzanne, Sarah was made to eat horsemeat in broth and steak *sanglant* while being told that the family's Orthodox Judaism was archaic, unhealthy and backward. Progessively detached from her family, culture and religion, Sarah-Suzanne was enthralled by this luminous woman who also introduced her to philosophy, her later profession.[1] The bond with her anxious mother was broken forever. When the war ended Madame Kofman reclaimed her children including Sarah while the Christian lady sued in court to adopt the child. She lost but Sarah's life had been altered irrevocably. Fighting her mother with her recurring anorexia and relentless secular and academic study in lieu of earning money, Sarah remained attached to the Christian lady during her student years. An unexplained break then occurred. The memoir ends with *mémé*'s funeral which, however, Sarah Kofman writes she could not attend.

So the key historical facts concern the rescue and preservation of a hidden Jewish child during the German Occupation and genocidal persecution of Jewish Europeans. But it also tells of the destruction of a family in the wake of the arrest and disappearance of the author's father, a Rabbi. Written in retrospect, the book adds the post-war discovery of the nature of his death.

Rue Ordener, Rue Labat, composed between April and September 1993, was published in Paris by Gallilée on 24 March 1994. On 15 October 1994, one month after she turned sixty, Sarah Kofman committed suicide on the 150th anniversary of the death of one of her intellectual objects: Friedrich Nietzsche. No one can know why a person takes his or her own life. But the sequence of dates has made many scholars speculate that something about writing, completing and publishing the book – that is to say, completing a journey into the trauma of the past and writing it into memory – contributed to the devastating depression that overtook the author. Gleaning information from those who knew her state in 1994, Penelope Deutscher has written: 'At the end of her life, and after *Rue Ordener*, she felt herself disastrously unable to read or write', and to enjoy music, art and cinema, the mainstays of her life and work.[2] Depression drains life of emotional colour. Above all, as Julia Kristeva argues in her study of the 'black sun' that is depression, it severs the link between the psyche and language, between the subject and the signifier. Words become depleted, empty things.[3] For an intellectual, a writer, a thinker, a reader, this is already a living death. We can only feel a depth of compassion for the disaster this must have been for Kofman.

The opening line of her memoir has haunted many of its readers and indeed it points towards the source of the danger:

> De lui il me reste seulement le stylo. (Of him all that remains to me is the pen.)

What could be more poignant? All that remains of a man's entire life is a single object. Can this be true of a man who is a father? What is then the relation of this paternal object to his surviving daughter? As object, a pen is highly symbolic, the instrument of writing, the emblem of the writer, a prized tool in a pre-digital, pre-word-processor age and one that marks masculinity in an era when men wrote and, if at all, women typed up their writings. But this writer to whom the pen belonged was culturally specific in his relation to this object and all it implied about access to the word and the world created through words: he was a Rabbi, a learnèd man, a teacher, a scholar in a culture which had for centuries engendered writing. In pre-modern times all Jewish men were literate, schooled to read and write from the age of three.

Thus this fountain pen represents a time-specific memory. That generation of handwritten texts that bear the physical but also psychological imprint of the writer in drafting, revising and finalizing a text is now a relic of the past, a thing of memory.

> Of him all that remains to me is the stylo, the fountain pen.

De lui (*Of him*) as if a possession, *de lui* (*from him*) as if a bequest, *de lui*, a remnant as if part of him, the pen remains, but it remains *alone* and *to me*. This claiming of this lonely writing implement forges linguistically a link between *lui*, him and me. The usual French grammatical formulation would be *De lui il ne me reste que le stylo*. Kofman has refused the normal. She has wanted to avoid the use of the negative in order to stress the solitary condition of the pen and the desolation of the *me* who only has this one remnant of/from him. Now we see that it was not the only relic but one which remains only to me. The text continues:

> I took it one day from my mother's handbag where she had kept it with other souvenirs of my father. It is the kind of pen that is no longer made, the kind one has to fill with ink. I used it through my school days and studies. It 'failed' me before I was ready to let it go. Yet I have it with me still, patched up with scotch tape, it lies before me on my desk and it constrains me to write, to write.[4]

Stolen from his wife, the writer's mother, the pen is already seen as an anachronism, hence a carrier of the past, not the present. Moreover, it is in effect a dead pen, for it has failed this writer before she was ready to 'let it go'. It had been a companion throughout her own entry into education and scholarship. Vicariously, its use reforged a link with the missing owner. It had indeed been her instrument, allowing her to enter into his place and space by

this rather obviously Freudian association between pen and masculinity. Yet this wounded, defunct, patched-up pen that is so closely identified with *him*, the father, cannot be abandoned. It is preserved. Where? Not in a handbag, the maternal space, but on the desk, the space of writing and of men who write. This invokes Freud's emblematic desk where the great psychoanalyst, whose writings on aesthetics and femininity Kofman rigorously analysed, sat confronted not by writing instruments, but by sculptures, images from other times and other cultures, icons of their negotiated fears of love, life, death and even thought (Figure 78).

Kofman's passage creates a scenario. The writer begins to write a book. Before her is the wounded but bandaged pen of her father. It is endowed with power. It constrains her to write. It does not inspire her. It does not quite command. It is experienced as an obligation and a restricting force. The Latin root *constringere* means to bind together, tie tightly, fetter, shackle, chain but also to draw together. There is pain in this word. Then comes an even more powerful sentence:

> Mes nombreuses livres ont peut-être été des voies de traverse obligés pour parvenir à raconter 'ça'. (9)
> My numerous books have perhaps been the necessary detours to bring me to write about 'that'. (3)

In the end, therefore, this book, this writing is different from the others she had profusely undertaken – thirty books published in her philosophical career. This writing arrives only after many detours of other writings at a destination: telling 'ça' it, this, that. Did telling 'ça', however, lead to dying? What catastrophe could writing it engender?

It seems clear that a change had occurred in Kofman's professional writing already in 1987, when the philosopher first interjected reference to her father's deportation and death in Auschwitz into a much more personally scripted text, *Paroles Suffoquées/Smothered Words*, an intended homage to Maurice Blanchot.[5] The book also acknowledged Robert Antelme, who was author of one of the most searing, but humanity-affirming of accounts of life as a political deportee in a concentration and slave-labour camp, *L'Espèce humaine*.[6] Did that shift – from playing so brilliantly in the texts of other writers to inscribing herself in her own – render writing deadly?

Bringing memory into the space of writing became dangerous because of what was to be confronted as a result of its having been given literary form. Or was Kofman's a long journey *away from* an encrypted trauma that, once encountered through the prism of a 'writing', ceased to be a negative force driving her towards writing and instead arrested her before what could not yield 'the relief of signification'? Some outcomes of this dangerous undertaking find a passage through Ettinger's *transport-station of trauma* through their aesthetic inscription as transformation. Others, it seems, long encrypted

and finally inscribed in the narrative field where memory claims them, may not find a way back from the meeting that emerges in the writing trauma. I want to explore this proposition in the case of the writing by Sarah Kofman about an object and what it marks.

I first encountered Kofman's book while preparing an interdisciplinary module in 1996 ranging across literature, cinema, art, museology, commemoration debates, philosophy and psychoanalysis that confronted the cultural memory of the Holocaust. Wanting to pose the question of gender in relation to the overall annihilating terror of that event, my section on witness and testimony aimed to convey to students the extensive range of experiences by Jewish and non-Jewish survivors. Beyond the famous works of concentration-camp literature by Primo Levi and Eli Wiesel, Charlotte Delbo and Robert Antelme were testimonies to ghetto life and living in hiding. I placed Sarah Kofman's newly published and recently translated text *Rue Ordener, Rue Labat* on my reading list in a weekly schedule that addressed gender and stolen childhoods. This included the newly complete edition of *The Diary of Anna Frank*, read in conjunction with Janina Bauman's *Winter in the Morning* (1986), the story of her experiences in the Warsaw Ghetto and in hiding (discussed in Chapter 4). Bauman's book is presented as the diary she wrote as a teenager; the text, in fact, had to be reconstructed from a moment in the 1980s because the original, which had survived the destruction of Warsaw during the uprising in the summer of 1944, had been lost when Janina Bauman and family were forced to escape from Poland in 1968 under the regime's anti-Semitic persecution. Bauman sought to write from the perspective of her teenage self, and in her preface speaks of having to go away from the present and relive an almost eidetically imprinted other world of which she had never spoken to husband or children.[7] I added *When Memory Comes* by Saul Friedländer, the distinguished historian and specialist on Nazism and the Persecution of the Jews.[8] Friedländer was the child of assimilated Czech-Jewish refugees, stranded in France, whose safety was only ensured by his parents' handing him over to a Catholicism in which he grew up. Planning to become a priest, he was reminded by an older priest of a past that had faded; he was encouraged to reconnect with it, in order to make his choice more honestly founded. Friedländer did not become a priest and ultimately moved to Israel from where, in 1977, under the shadow of the Yom Kippur War, he wrote his memoir. Published in French in 1978, the text is structured as a diary, with a running commentary on the present interspersed with shards of memory that take him back to the ten-year-old he was when he was separated from his parents. All these texts thus involve a form of retrospect while also seeking to conjure up the subjectivities and positions of the authors' child-selves. The forms and aesthetics of such writing offer diverse strategies that seek to hold affective reconnection to create vivid literary texts while also being safely ensconced in the present of writing.

In reading Sarah Kofman's cryptic memoir of her years as a hidden Jewish child in Occupied Paris, *Rue Ordener, Rue Labat*, there is the temptation to undertake a psychoanalytical interpretation of the author, using the text as if it were the speech of the analysand. Kofman was, however, a philosopher of writing, dwelling in language, its play and possibility as the ground not only of thought of but of how living and writing cannot be disentangled. In 1978, Kofman wrote:

> It is not a question of my attempting here to reduce philosophy to pathology or system to biography. It is rather a certain relationship of system to life which interests me: to see, not what the work owes to life but what the work *brings* to life; to grasp how a philosophical system can take the place of *délire*.[9]

The writing in *Rue Ordener, Rue Labat* feels lapidary, precise and polished, acutely self-aware as any deep student of Freud and notably of his books on dreams and jokes must be, of the treacherous power of language to say more than we mean or even know. 'It' speaks; we are spoken. The other scene, the unconscious, shapes and impresses itself upon the surface of our conscious utterances, leaving us exposed to the analytically inclined reader's detection, but also to our own self-discovery.

Verena Andermatt Conley wisely reminds us that one of the powerful effects of reading Kofman's 'récit autobiographique' – as Kofman named *Rue Ordener, Rue Labat* in a dedication of a copy to Conley – in the light of the death of its author so soon after its completion is the force of the book's *refusal* to provide any possible way to understand the death with which the writing career of Kofman concluded so soon after its publication.[10] Despite the depressive drag muting her voluble identity, Kofman had written several texts around this period 1993/94. In her thesis, Ashlee Mae Cummings plots a web of connections between the four final projects of Kofman that include an essay on Wilde's *The Portrait of Dorian Gray*, on Nietzsche's anti-Semitism and an essay, posthumously published from the notes, on Rembrandt's painting *The Anatomy Lesson*. Cummings places these texts within the space between *Paroles Suffoquées* (1987) and *Rue Ordener, Rue Labat* (1993/94). Cummings, however, contests the views of Deutscher and Oliver on the meaning of the opening paragraph of *Rue Ordener, Rue Labat*. They consider that all her work was leading to the writing of 'ça'. Cummings argues the opposite. Kofman wrote philosophy to evade 'ça':

> Her previous writings and *ça* are not at all one and the same and they are certainly not interchangeable. One could even go so far as to say that every work that Kofman wrote before *Rue Ordener, rue Labat* served the purpose of evading her own personal traumatic story and I would argue that *not* writing about *ça* in those earlier works was the only way that she could arrive at the moment of writing about *it* later.[11]

Any invocation of belatedness speaks to me of trauma. But it also gives rise to this proposition: the writer or the artist does not journey away from trauma as if it were lodged in a chronological past. Timeless, trauma knows no past. But the artist or the writer may, in fact, circuitously be creating, over a lifetime of writing, a journey away that becomes one obliged ultimately to turn towards the encounter with trauma. An edifice may have been built to contain its de-encryption, or it might fail.

The traumatic past had set out her destiny, to write, and the pen is its symbol. Yet some kind of settlement of accounts with the past the pen holds before her had *now* to be written, demanded by the dead pen. Because the past was a trauma that had not yet become a memory, it happened in writing, and only in the present, after all the books. In finally ceasing to evade it, the unprocessed past of which she was the voluble effect flashed into the present as her own becoming. Still, something could not be said: *ça* remains an enigmatic signifier.

Ça is the enigma Kofman bequeathed to her readers. Thus my question is what remains encrypted in that word? What does this line mean?

> Mes nombreux livres ont peut-être été des *voies de traverse* obligées pour parvenir à raconter 'çà'. (9)
> Maybe all my numerous books have been *the pathways* required for me to reach the point of telling 'that'. (3)

This is my inelegant retranslation: detours become pathways. *Voies de traverse* have Lacanian psychoanalytical overtones that echo but differ from Ettinger's transport station of trauma. *Voies de traverse* are the difficult and complex routes of our psychological movement from the frozen, repressed, disavowed, repetitions of our arrested neurotic or traumatized condition into a certain kind of fluid or fluent self-knowledge. It is the movement, not the destination, that psychoanalysis attempts to facilitate as a transformation from petrified blockage locked into symptoms into the possibility of a mobile economy of *life*, engagements with the world and others. Thus there is the notion of a *voie*: the railway track in French and the notion of a passage, a transfer and a journey. Kofman had undertaken an academic journey, but precisely not to arrive where her father's began in 1942 and where a *voie*, a train track, took him. Yet, she senses that she must now tell: 'raconter', which contains within it the notion of a *conte*: a tale. This is not writing per se as a physical act, but relating a story, giving the past a narrative form. So what is it to tell the *story*, to make a narrative without analysis, of *çà*? *Çà* is the least descriptive, least referential indicator of something. Perhaps it is akin to *Das Ding*, *La Chose*, the Thing in Freudian-Lacanian psychoanalytical vocabulary, where it stands for a substance-less void before and beyond representation, the latter, in the form of the object, invisibly determined by this shaping presence

of the unsignified Real.[12] It is also, of course, the French term for Freud's *id*, the repressed remnant of the most intractable and infantile of psychic organizations and impulses.

Kofman dared herself to tell '*ça*'. So the text raises a critical and destructive relation between trauma and writing *it*. This means we have to follow Kofman's own methods and do a careful reading of the structure of this writing in order perhaps to glimpse the movement – the *voie de passage* – of the always unsaid and unsayable trauma somehow agitating or shaping a text that touches upon it but never contains it in the safety of a narrated representation. This is where my reading departs from the many brilliant analyses that read the text under the sign of autobiography or memoir and hence find a relatively coherent narrative of the past. I read the writing as an aesthetic operation marked by the attempt to give shape to trauma, without the writer fully knowing what 'it' was that was being shaped; whatever it was, could not be and was not said or written. Something had happened. Something that might be tracked across a telling of past events. The text, however, reveals *it*, by something that is not inside the text, not said. The pen constrained her to write what she did not (want to) know. Alone without the texts and lives and thoughts of others, Kofman was now abandoned to her own birth as a writer in the womb of historical catastrophe. It is bound, above all, to the dead object that links her to her dead father.

I discern an encrypted trauma of shame related to a scene of seduction whose recognition through writing what appeared to be a memory emerged in writing but not as language. To elaborate this reading, I shall plot out three structures in Kofman's text: Rhyme, Topography and Object.

Rhyme

In her reading, Verena Andermatt Conley identifies a core rhyme in Kofman's book between the beginning and the end that involves two deaths, two departures through dying. Conley calls it *Vanishment*.[13] The confrontation with the death of a loved one is traumatic; culturally, we have created rituals through which we deal with immediate necessities, to take a leave, however painful, through burial or cremation, through wakes and, in Jewish tradition, a carefully calibrated calendar for the first week of immediate mourning with daily services at the home, a month of less intense but still noted mourning, a year of saying Kaddish every day for the departed and a setting of the gravestone at the end of that year, followed by an annual remembrance by lighting a 24-hour candle: *Yahrzeit*. Without such formal procedures to lead us through the tearing of the cloth of shared life, and to facilitate the integration of loss as cherished memory, it is difficult to undertake full mourning as Freud analysed its stages in his text, 'Mourning and Melancholia'.[14] In my

own work on childhood maternal bereavement, however, I have found myself questioning Freud's optimistic sense that mourning is ever completed.[15] The bereaved live beside a gap. Those left-behind are, in effect, the subjects of death, the locus of where the ending of life is registered as a subjective event by the perpetual fact of 'the absence of presence, nothing more … the endless time of never coming back …'[16]

Vanishment captures the deeper sense of the mystery of a continuous and unrelieved condition of someone 'not being there', as an absence that redirects the trajectory of a life now marked by it. In both cases of the two deaths that frame Kofman's text, however, there is no participation in the rituals of farewell with which we, the survivors as subjects of death, accommodate the shock of loss. Kofman's father died out of sight, *là-bas*/over there, in Auschwitz, leaving no remains. The pen is the only relic. In the second case, Kofman is not witness to the farewell because she cryptically states she 'was not able to attend' the funeral, an ambiguous phrase leaving open both logistical impediment and psychological inability or emotional uwillingness.

The first *vanishment* is that of the author's father, Rabbi Berek Kofman, arrested during the infamous *rafle* or round-up by the French police of 16–17 July 1942, and deported through Drancy to Auschwitz where he was selected for labour, not immediate gassing. He was killed in Auschwitz, but not by the SS. We shall return to this later. The second departure is that of an elderly woman who had entered Sarah Kofman's life as the Christian-French woman who sheltered her and her mother in 1943/44, the decisive year of the author's life to whose lineaments this slim volume returns to trace them into language and also into a form of knowledge that Kofman decided to share publicly through publishing a text that would appear to diverge radically from her philosophical studies and her readings of texts, films and paintings by being so unadornedly autobiographical, but in a manner oblique, anxious and enigmatic.

If indeed this book has a shape determined by two deaths which somehow invited Kofman to join the departed and to vanish, it must be because something in the story in between, *le conte*, the fairy tale as Conley daringly names it, was traumatic at the point at which retrospect and language converged to touch it. Rather than an autobiography, written backwards from a secure point in the account's future, Kofman's text becomes an allothanatography: *allos* meaning other, and *thanatos* meaning death. It is a writing of the death of others between which what had been ten year's of the life of Sarah Kofman was now apparently restrung.

Topography I

By titling, *Rue Ordener, Rue Labat*, moves between the two streets of Paris, very close to one another, divided by a long street, Rue Marcadet, along the length

of which Kofman describes herself vomiting in anxiety as she and her mother fled for their lives from Rue Ordener to throw themselves on the mercy of 'la dame' at Rue Labat in 1943. Street names become, however, allegorical of two worlds between which the child was then stretched by racist persecution that propels mother and child away from the one towards the other. Rue Ordener is a Jewish world; Rue Labat a Christian space. In Occupied and collaborationist as well as resistant Paris, how and why might the passage from the one to the other be traumatizing?

Kofman's representation of the two worlds as two homes, two kitchens, two regimes of intergenerational social and emotional interaction makes acutely visible that both Judaism and Christianity are regimes, if radically different, of the body, installing their differentiated subjectivities by means of a writing on and of the body. Kofman's hysteria – in classic psychoanalysis, a sign of a subject in trouble with the kinds of sexual identity and identifications proposed by heteronormative phallocentric cultural law, and in more recent elaborations a subject primordially traumatized by mortality – is recoloured by the starkness with which *as a child* she was obliged to make sense of the shocking encounter not with sexual difference but with cultural difference. Her hysteria, which takes the very physical form of vomiting, retching to expel what is within, refusing to ingest what is inserted into her body, is supremely eloquent of what Julia Kristeva revealed in her psycho-anthropological study of abjection.[17]

The textual architecture of Kristeva's analysis of abjection involves three elements that traverse comparative religion, anthropology and psychoanalysis to trace the issue of the body, its imaginary frontiers and the passage into symbolic thought. Starting with the Biblical text of *Leviticus*, Kristeva daringly concludes with a reading of the vicious anti-Semitic writer of modern literary abjection whose writing deflects abjection and violence into literature. Kristeva initially plots out the issue of the sacred (the issue of a boundary between life and meaning that marks a symbolic division: sacred or holy means simply set apart) and its counter-face the abject through a history of Abrahamic religious forms. In ancient Judaic religious practice based on taboo and transgression righted by sacrifice, setting apart and the ritual acts which perform it, give rise, however, to a powerful code of morality and ethics. Kristeva then plots the radical shift effected by Christianity's psychologization of sin, and onto modern literature that inherits and displaces religion itself by dealing with the issue of the now subjectivized abjection not as extraneous taboo or as internalized sin, but as the psychic lining of the sublimating subject. Literature becomes the symbolic space to manage and contain the fear of abjection, of the unboundaried eruption of the messy unsymbolized body, the collapse of boundaries within the psyche, projected often outside onto a scapegoat figure representing all that must be abjected for the subject

to imagine itself as clean, distinct, contained: hence, for the heteronormative white man, the image of woman, the Jew, the homosexual as leaky, viscous, disordering and grotesque.

The Judaic, originating in and intellectually transforming the ancient sacrificial understanding of the sacred as distinction/separation, defines what can and cannot be taken in either to the body or to the Temple. The Judaic body is thus defined by what it does not ingest and how it deals with emissions and eruptions from within. Kashrut, its food rules, are thus integral and symbolic, defining a particular order of sublimating abjection and subjectivity based on boundaries in which the individual body and the sacred space of the Temple mirror each other. Christianity utterly altered this logic of bodies and separations with its concept of original sin. If human subject is born in sin, s/he is by nature sinful. The flesh and the psyche are contaminated from within by sin. To be purified, body and soul must paradoxically take in that which in the Judaic sacrificial system had to be released ritually but never ingested: blood, symbolic of life itself. Thus the Christian sacrament of communion makes the body of the sinner participate by symbolic ingestion of the divinely sinless body that is willingly sacrificed and of life-blood of the incarnated divinity, thus performing a symbolic pollution in order to purify a primordial sinfulness. For Kristeva, this Christian logic fostered the elaboration of a concept of interiority that in turn engendered a different sense of moral and psychological self-reflective subjectivity, hastened by the development of the confessional. In the secular modern form, this interiorization became the basis for the evolution of literature as a subjective space and the novel as its displaced site of ritual: form. Both take over, transform and sublimate the formerly religiously defined operations, creating an allegorical space for interiority, communion and elaboration of subjectivity.

Kristeva's is a structural analysis that identifies different symbolic systems. The danger, however, is that different systems will be placed in succession, justifying the necessary supersession of the older by the newer. Christianity is then presented as leaving behind and transcending the representative of an archaic, sacrificial mode: Judaism. Yet, as evolving historical bodies of thought and practice responding internally to many changes over centuries, Jewish and Christian regimes coexist in present time, each with its own evolution through historical time while maintaining different configurations of being and body, inside and outside. Despite the confusing and impossible adjective, Judeo-Christian, Judaism and Christianity are radically different ways of conceiving the relation between bodies and meaning. For the religiously observant within either Judaism or Christianity, the nature of the each other's psychic world and corporeal imagination remains a blind spot, unknown and unrecognized.

Thus the collision of an Orthodox Jewish child, from a family from the Eastern European home of Polish Judaism, with an actively Christian-French

woman under the alienating and terrifying conditions of a political abjection of 'the Jew' by Nazism's radical genocidal racism and under the seductive and fascinating conditions of an increasingly intimate relationship between child and the older Christian woman takes on historic proportions with potentially massive psychological ramifications.

As a child inducted into the only socio-cultural religious world she knows in an observant Orthodox Jewish household, Sarah Kofman would experience her being, her identity, her genealogical relation to both family and world by means of actions: rituals, festivals, performances and above all the highly differentiating procedures for preparing food and avoiding certain foods or mixtures, and above all blood. Patterned into the order of days, months, yearly cycles, observed as rituals performed by a mother who soaked meat to extract the blood and a father who ritually slaughtered chickens to ensure immediate exsanguination, the physicality of food, notably meat, would have been vivid and magical. To transgress Judaic food rules and ingest the forbidden is to cross a boundary that can never be re-established, for the body has been both physically changed and symbolically altered, defiled by ritual uncleanness. To eat what is forbidden is also physically to become something else even if at a later date rules are resumed. For in modern times there is no sacrifice that can be performed to right the transgression, as there was in Temple times when the rules of Kashrut were generated.

There are, however, conditions under which it is permitted to break the rules. The saving of life takes precedence over everything. Thus in a text written in 1983 titled untranslatably as *Sacrée Nourriture* (*sacrée* meaning both sacred, holy, *Kadosh*, and damned), Kofman tells both a very Jewish and a classically Oedipal story. The Jewish story: First, mother says: 'you must eat'. This is the oldest Jewish tale about the Jewish mother who stuffs her children with food as a violent and misdirected form of love created out of historic poverty. Then the father, representing the law, says 'you must not eat everything'. In the Freudian tale, it goes like this: the mother is the breast, the nourishment and nurturer, fostering desire. The father is the law, interrupting this dyadic bliss with the *nom/non du père* and says you cannot have everything you want. There is a sacrifice of desire to be made in order to access culture under my sign/ name. Sarah Kofman hysterically refused this deal. Anorexia and vomiting were forms of childhood resistance born of both the fear of being stuffed and the fear of transgressing a taboo.

Now comes history. The war made all food scarce. As the Germans invaded, the population of Paris fled to the west. The Kofmans take the train to Brittany. The Red Cross provides wholesome nourishment for the refugees: ham sandwiches on buttered bread. Imagine anything more contrary to the rules of Kashrut when pork is utterly forbidden and meat and milk products cannot be mixed! The Rabbi-father, following the law, places life above food

rules, as he can and must. Despite the mother's attempt to uphold their cultural practice, the father allows the children to eat what the Red Cross has provided. It tastes good. But the text in which this recollection is recorded becomes severe immediately. Two brief sentences follow:

> A few years later my father was deported.
> We could no longer find anything to eat.[18]

Formally, the text proposes and yet hesitates to make the link between the moment of savouring the forbidden food under the benign eye of the father and the stark introduction of his disappearance and the forced advent of hunger. Was what followed experienced somehow as retribution, or is the author just stating historical fact? Kofman then gives a brief account of being 'saved' by a woman who taught her what it was to have a Jewish nose and who put her on an entirely anti-Jewish diet of raw horsemeat in bouillon. This brief *récit* ends with:

> Put in a real double bind, I could no longer swallow anything and vomited after each meal.[19]

Brevity underscores the pain of what is being recalled. Language puts its hysteria in place. The text registers the tormented body of a child without the linguistic skills the later adult will deploy in order to evoke the body as her psychic space. She has only her body to speak with. She can only be hystericized by the encounter with this third adult, who cannot easily be positioned within the structure of child/Other, self/culture that the Oedipal scenario exists to negotiate on our behalf.

The high-priestess mother who administers too much food but also polices the law the father upholds but is also empowered by it to suspend, represents one big Other. This can be dealt with. Does Kofman, however, imply that her childish thought was that the father was in some way deported for his transgression that initially corrupted the pure body of his Jewish child, seducing her with forbidden flavours, only then to abandon her, vanishing, leaving her vulnerable not to momentary, authorized transgression but a rewriting of her whole being by means of what is now repeatedly inserted into her body by someone who is between and both mother and father, and who, in the absence of the father, takes the place of the law? Yet this woman-Father stands for new law, in fact an anti-law, 'liberating' the child from the Jewish law that Christianity, as a historical-theological force, disdains as archaic and considers to have been overthrown by its new, lawless, covenant.

Many scholars read the story of Kofman's childhood recounted in *Rue Ordener, Rue Labat* as a painful struggle between the two mothers, the hated Jewish Rebbitzen, Madame Kofman, and the lovely Christian saviour. There is no doubt that Kofman's relation with her own mother did not survive

her childhood. We cannot tell whether it would have otherwise. Part of the unspoken trauma embedded in this text may lie in the terrible, irretrievable destruction of that bond. I am, however, more troubled by the way in which this episode of two women fighting for the affection of a child has been represented by many commentators. Inadvertently, they repeat Christianocentric culture's negative stereotyping of Judaism as loveless ritualism, superstition-based rule-bound archaicism, which these readers make their account of the anxious Madame Kofman embody while she is contrasted to the lumimous desirability of *la dame*.[20]

In an article on Kofman's complex relation to philosophical fathers, Freud and Nietzsche, philosopher Diane Morgan interprets the opposition in *Rue Ordener, Rue Labat* as

> …a disarmingly blatant account of the rejection of a mother, the *bios*, in search for a freer cultural identification with another. The Jewish mother in Rue Ordener is bad, restrictive, suffocating. The French mother in Rue Labat provides access to a higher, less backward looking cultural realm. That which is 'made in France' is modern, European; by contrast, the Jewish *bios* is archaic, hampered by strange and frightening customs that belong to some dark and unenlightened world. Her separation from her family and her adoption by her French Mémé, which the war permitted, allowed the young Sarah to liberate herself from this biological drag on her development.[21]

Reading this text as a kind of allegory of Kofman's philosophical orientation, Morgan's reading of the opposition which Kofman appears to offer between two maternal figures in the text runs the danger of passively reinforcing the anti-Semitic and Christian point of view of the woman named *mémé* in which Judaism is seen as archaic, strange and unenlightened.[22] Morgan is, however, not alone in tending to read Kofman's little book in terms of a struggle between her mother and the adoptive rescuer, straddling Jewish and French Christian worlds, the old and the new, and in seeing it as a story of liberation.

The conflict was not, in my opinion, a tug-of-war between two maternal subjects for one child. The historical conflict in which Sarah Kofman found herself was hugely overdetermined by long-standing religious contestations between Judaism and Christianity, aggravated by the conditions under which a Christian woman 'saved' a Jewish child in the presence of another woman, her own mother, bereaved horribly by the terrifying arrest and deportation of her husband, without any money, powerlessly responsible for the survival of her scattered hidden children, herself living in daily fear of being discovered and deported to her death. She was then forced helplessly to witness a systematic attempt to appropriate the child and alienate its affections from its own mother and cultural identity and to remake the child's subjectivity within an alien system.

I want to offer a Freudian reading. The Christian woman who 'saved' the child effectively took over the place of the father who had been deported. It was she who now determined what was eaten and how, disempowering/ castrating the Jewish mother and abjecting Judaism itself. She controlled the input and output of the little girl's guts, already twisted with anxiety, hysterically closing against forced ingestion, already symptomatically responding to oral seduction. Red meat – that is, with blood – is mentioned for more than factual reasons. The bloodiness is deeply symbolic of the depth and resonance of what was being perpetrated by the new food regime.

I am suggesting that the topographical distance between the two apartments signalled by the two addresses in the title dramatize the overlay between the structural formation of subjectivity in the Freudian Oedipal triangulation by the historical and ethnically specific conditions by which it was exploded. That traumatic reconfiguration, like the Oedipus Complex itself, was written symbolically and literally on the child's body. The f(n)ormative structure was shattered by the departure/deportation of her father. It was rewritten by the insertion, into his space of authority over the child's body and being, of a woman. This *Christian* woman, was not empowered by the phallus, but by her Christianity and Frenchness. That was the passport to survival. Yet acceding to survival on these grounds, enacted upon the child a trauma of deracination that humbled all things Jewish, turning what was innermost in her identity and its intergenerational connections to both mother and father into what was most to be abjected. If Jewish legal identity passes through the mother, Kofman was being severed from her own lineage by adoption; severance from her father was being performed by substitution.

The Christian woman could do what neither the actual mother nor the vanished father could: save the child, keep her alive, literally by feeding her up with radically different foods, and, metaphorically, by protecting her through passing her off as her own daughter. The 'lady' – *la dame* – has no name in the text. She is called *mémé*, a French term of endearment for grandmother. The repeated syllables of the 'm' can also be associated with *ima*, the Hebrew word for 'mummy', or *maman* of the French. Both involve opening the mouth and touching the lips together: it is a very oral or labial consonant that also has the quality of infantile echolalias, primary vocalizations, calls. We discover that the lady was in fact called Claire. But she is only invoked as *la dame* or *mémé*, and by place-namings.

Much of Sarah Kofman's critical work was written *with* and *against* Freud. *With* signals Kofman's acknowledgement of the psychoanalytical discovery of how unconscious structures and fantasies shape what we think and write; *against* indicates some resistance to the manner in which what Freud thought and wrote continuously foreclosed the space of the feminine. As theorized by classic psychoanalysis, femininity is unlivable. Freud could explain the

formation of a heterosexual feminine subject, initially, like the boy child, totally enamoured of the mother, only by positing a violent rejection on the girl's part of the mother because she failed to give her a phallus. Turning away from the mother in hurt and rage, Freud supposed that the feminine subject unconsciously imagines indirect access to the phallus by passively offering herself to the father or his substitute in the delusive hope of becoming thereby a passage for the phallus to enact its own phantasy of generation through her, by her becoming a mother.

Kofman did not become a mother. Not only did she reject Freud's definition of femininity but also she resisted the culturally defined feminine position her Jewish mother had lived and tried to foster upon her. In the typical Jewish sexual division of labour, a woman lived a life of work and procreation, but not thought. The Jewish woman works and maintains the family, often supporting them, while the husband is a scholar or a teacher. This is not the Christian bourgeois disposition of the working breadwinning man and the leisured woman.[23] But both in different ways exclude the girl and woman from scholarship and the life of the intellect, symbolic creativity.

Philosophy is thus the sphere of the masculine in both cultures. It is culture, language and otherness. After the war, Kofman's mother pressures Sarah into work, to make her perform her proper function, namely to go to work to maintain the family. Sarah Kofman wants access to the masculine position made possible for her through the secular French education system. She wants to generate language and ideas in a curiously filial and disobedient relationship with surrogate fathers: Freud and Nietzsche. This is typical of intellectual women of the twentieth-century moment of emancipation through education. But it is also ethnically slanted because of the Jewish order of gender difference. Not based on the opposition masculinity=activity versus femininity=passivity, it works in the reverse: men are quietist but creative thinkers, women the active procreative doers. *Mémé*'s domestic agency is consistent with women's work. Structurally, however, she had taken the place of the Oedipal father of desire because she momentarily possessed the symbolic phallus, displacing the Jewish father of identification who, in disappearing and dying, evacuated his place-holding of the phallus.

The psychic economy plays itself out across the two spaces: the economy of sexual difference in which desire is forged is reconfigured by traumatic events within history. Sarah Kofman lived on after the rupture of her Orthodox family, and lived out its contradictions in terms of cultural identities created through gaining access to a secular education that enabled her to become a distinguished modern philosopher, while being forced to confront Christian notions of transcending Jewish archaicism. She had to make her own psychic negotiation of what happened to her when a child, vulnerable, menaced and in need of everything racist persecution made her own parents unable to provide.

Topography II: the text

We must now approach the topography text itself. Why does it end where it does? Why does it end as it does, abruptly?

Chapter XXIII is titled in the French edition by place names: *Hendaye – Moissac – impasse Langlois*. Most of *Rue Ordener, Rue Labat* recounts the events of one day – 16 July 1942 – and eighteen months between February 1943 and August 1944. But it is also a testament to the effects of this brief but formative moment: the traumatic core of a life that had to be lived when those two 'events' rerouted the child's life.

A traumatic event ends childhood prematurely and abruptly. From almost one moment to another, the child moves from the world of childhood, an evolving and protected series of spaces and relationships which absorb life's events into an order that will continuously be integrated as real memories or retold narratives and provide the cushion on which the child can grow up. Extreme events disrupt this fragile process with terrifying suddenness inducing a traumatic rupture in itself. They precipitate the child into a new world where she must prematurely study adults, follow new leads, make sense of the enigmatic world outside in order merely to survive. Kofman's story of the destruction of her family and the abrupt cessation of her childhood is not unique. It is there, in that space, that she fashioned a text for those who can read what it is trying to say about the child's encounter with the specific locale and aftermath of that moment within a terrible history when being a Jewish child exposed her not only to total loss but also to the risk of her own possible death precisely for 'being' Jewish, a hitherto unknown 'identity' since it was identical with being, but has now become an indelible 'sin' that merits death.

With its geographical namings, *Hendaye–Moissac–impasse Langlois*, Chapter XXIII tells of the attempted distanciations from Rue Labat enforced by Madame Kofman after liberation. After moving in and out of Paris, trying to see *la dame* openly or secretly, Sarah Kofman is eventually sent with her sister to a Jewish institution in Hendaye, on the borders with Spain, and then to Moissac in the south of France near the Pyrenees, in order to re-introduce her to Judaism. There she remains for five years. Not technically oriented, Sarah is, however, allowed to go to the local French schools to follow the classical, mathematical and scholarly curriculum. This sets her apart from the other Jewish children in the ORT establishment that aimed to prepare Jewish children for a working life in technology and industry. For her final years of schooling she returns to Paris to live again with her mother who cuts off the electricity at night to prevent her 'improper' studies – she defiantly reads by flashlight – while once again attempting to feed her. Hunger strike is the teenager's resistance once again. Losing seven kilos over two years, Sarah Kofman also loses all faith and ceases religious observance completely.

Kofman finally moves away from life with her mother in the *impasse Langlois* thanks to a scholarship. Nothing is said in *Rue Ordener, Rue Labat* of the agonizingly dysfunctional mother-daughter relation: her mother's death is only mentioned in passing. But *mémé* has also moved away, retiring to Sables D'Olonne on the Atlantic Coast just north of La Rochelle. In a beautifully crafted sentence, Kofman writes of visits during her student years:

> L'été, je passais *là-bas* un mois de vacances avec elle. Nous promenions au bord de la mer. (98)
> During the summer, I spent my holiday month with her down there. We would go for walks beside the sea. (84)[24]

Sarah Kofman is punning on *Labat* and *là-bas*, the latter meaning 'over there' or 'down there' – i.e, on the Atlantic Coast; both the street name and the phrase sound the same in French.[25] Like an enthusiastic student come home for the vacation, Sarah Kofman shares with *mémé* all the joys of her liberated student life, cinema, friends, acting, discussions about the existence of God, eating sandwiches in the gardens of the Luxembourg.

But from this seemingly easy-going and familiar scenario of happy summer days by the sea, the final two paragraphs of the last chapter of *Rue Ordener, Rue Labat* radically swerve away. As a university student, another life begins. This represents an act of *déchirement*. She who was repeatedly severed from *mémé* against her will, now performs her own severance and dons a new identity: *étudiante* cutting off all contact with *mémé*. A colon explains:

> …je ne supporte plus de l'entendre me parler sans cesse du passé, ni qu'elle puisse continuer de m'appeler son 'petit lapin' ou sa 'petite cocotte'. (99)
> … I can no longer tolerate hearing her talk about the past all the time or letting her keep calling me her 'little bunny' or her 'little darling'. (85)

Something made unbearable the affectionate encoding within the world of *mémé* that she had struggled so hard against her mother and the odds to maintain up to that point. No explanation is offered. The tense changes from the past of *récit* to the present. The inability to tolerate the evocation of the past is continuous. Later, when visiting, Kofman tells us that she makes sure she is accompanied by a man friend: *un ami*. The text then reports the recent death of *mémé* in a hospice. Did she die of cancer? Handicapped, almost blind, she could no longer listen to music but still whistled tunes on the telephone. So there was contact at the end.

The final paragraph starts with a puzzling sentence: '*Je n'ai pu me rendre à ses obsèques*. I was not able to go to her funeral.'(99/85) It is not in the conditional but the past perfect: a fact that does not permit of psychological speculation. But she knows something of what was recalled at *mémé*'s graveside: the priest reported that she had saved a Jewish girl during the war. This is so

ambiguous. *Sauver* is the Christian word for salvation as well as a term for rescue. Had she rescued her from destruction, or saved her from her Judaism? The final sentence returns us to a little Jewish girl 'pendant la guerre', the time and place of a saving of a girl affirmed by the priest forever as 'Jewish'.

What is the relation of the death of *mémé* and the unattended funeral? It would have been a Christian funeral. Perhaps that made it impossible to attend. Is Verena Andermatt Conley correct in relating it back to the death with which the book opens: a death that is unmournable for its lack of a grave and *obsèques* proper to it? That death, all commentators agree, is the significant traumatic void for Kofman. It is the death of Bereck Kofman at Auschwitz. I will have to return to it.

Topography III: scenes

As I suggested above, the twinned topographies *Rue Ordener, Rue Labat* became sites of a gender-variant restructuring of a normative Oedipal triangulation determined by a historically imposed traumatic rupture of the Kofmans' lives. Sarah Kofman's writing of this is also shaped by a knowingly Freudian imaginary. The book works not so much as a narrative of events as the evocation of a series of scenes that recall Freud's trope of the scene, the scene of sexual difference, above all the primal scene.

The first scenario in the present sets us before the desk of the writer. Unlike Freud's Vienna and London working spaces (Figure 78), Kofman's has no visual record. But her opening paragraph sets up the scene of writing, at a desk with only – it seems – the broken pen before her to incite her to write.

Chapter II has a date as a title: *16 Juillet 1942*. This also sets a scene. It was on 16 July 1942 that the police arrested Sarah Kofman's father. It is the last time she saw him. It was the day her childhood ended. Kofman tells us that he knew he would be 'ramassé': she has it in quotation marks, marking the deformation of language typical of the Third Reich: 'collected', rather than arrested, picked up like rubbish.

A premeditated act of racist historical violence is registered in Kofman's barest prose that sets a scene, just one scene of what the word 'picked up' translates. It is known that French police had leaked the proposed Gestapo-led *Operation Spring Breeze*. Jewish people were warned of an approaching *Aktion* against them. Indeed Rabbi Kofman did his fair share of warning his co-religionists, encouraging them to flee. Then he came home, waited and prayed. He feared that if he attempted to hide, his wife and children would be taken in his stead, or more of his congregation might be taken in his stead. Many other commentators on the perfidious logic in which the Jews were trapped have spoken of these impossible, doomed choices people were forced into once the trap was set by the Nazis.

A new scene. The rabbi remains in his study, a wonderful cabinet of curiosities and site of many Jewish rituals. Sarah watches and recalls the strangest of Biblical legends, the story of Abraham's attempted sacrifice of Isaac. The Jewish formulation is *Akedat Itzak, the Binding of Isaac*. The *sacrifice* of Isaac is the Christian reformulation of the story in Genesis, which functions to turn the momentous Judaic displacement of actual child sacrifice into a topological and symbolic act of substitution that serves as a precedent for the return of human sacrifice that the Son of God will undergo to save the world. Like many children I have taught in Jewish religion schools, Sarah Kofman was disturbed by this horrifying story of a father who conscientiously obeyed his God's injunction to kill his own son, even to binding him and laying him on the altar before an angel stopped the knife in his hand and offered a ram in the boy's place. The Binding of Isaac may be understood as the Hebrew version of the Laius element in the Greek story of Oedipus; both evidence the father's infanticidal wish. Watching the Rabbi-shochet ritually slaughter chickens and circumcise baby boys under an image of Abraham raising his knife to his son's neck bound a series of violent images to the man who now sat passively awaiting his fate.

When the police come, the mother tells them her husband is not there. Afraid that they will take her and the children instead, the father comes forward. Madame Kofman tries every ruse to protect her husband, lying about her infant son's – significantly named Isaac – age, and pushing out her belly to suggest a new pregnancy. The Rabbi waits ready for the sacrifice. Observant and obedient, he allows himself to be 'picked up'. The writer, a watching, witnessing child, is shamed at her mother's mendacity, worries about the news of a forthcoming child, and tries to make sense of her father's sacrifice.

The wife must go to the police in her last ditch attempt to convince the police of the two conditions (being pregnant and having a child under two) that might save him. The text gives us the first primal scene of the traumatic past: six orphaned children standing in the Parisian street weeping like a Greek chorus: *o fate* which comes out in French as *o papa*, rather than *o popoi* (14/7). The invocation of the Greeks Kofman knew well in her philosophical capacity here allows a truly frightful moment of violent fear, grief, confusion, total abandonment and loss of all safety to be secured into a ritualized evocation of 'fate'. Deflection is at work, but for the reader tuning in to the condition of six children under ten, alone in a foreign land – they speak Yiddish and Polish and only learn French at school – watching those who are meant to guard them being taken brutally by the French police, this is a truly traumatizing scene. Nothing can be the same again when parents are thus officially 'castrated' by alien authorities.

In her pitiless and astute double autobiography of her classed and gendered history of her mother and herself, cultural historian Caroline Steedman writes

tellingly of two primal scenes in her white, working-class London childhood when class became the instrument of parental 'castration': her mother is berated in front of her children by a middle-class health visitor who condemns her house as unfit for children, and her father is humiliated by a park warden when he picks some bluebells for his daughter. Steedman wants to show how the classic Freudian model is painfully inflected by class, and how Freud's own compensatory phantasy of paternal authority can be destroyed within the social axes of power.[26] In Kofman's case fascism and racism perform this destruction of parents before the eyes of baffled children.

The blank in the page pauses the narrative but Chapter III begins: 'As it turned out, never again did we see my father (15/8).' Removed forever, the story must now be told again – it was first averred in the text in 1987, *Paroles Suffoquées* – what Kofman came to know later about how her father died at Auschwitz. But before that is told, the text records the receipt of a postcard written in French in another's hand requesting that the Rabbi-father be sent cigarettes in the 2 kilogram package that was permitted. This postcard becomes a treasured relic into which the young child invested the voice and desire of the missing father. She tells us that the later discovery of its loss was experienced as a second loss of her father. This resonates. The first loss, the traumatic wrenching away into the unknown void of separation, is fetishistically disavowed by attachment to that which recreated a momentary line of communication, a thread of contact from the transit camp at Drancy: the postcard full of its own paradoxes, not written by her father, in French, bearing the collaborationist Maréchal Pétain's image. Given the horror of the paper that later turns up confirming definitively his death and the later oral report of how he died, this attachment to a postcard, bearing Pétain's hateful face becomes a means of holding on to the man whose attachment to cigarettes is lovingly reported in the following chapter where the smoker's weekly torture of the well-observed non-smoking rule of the Sabbath is described. But did we notice in this chapter, as an aside about the later loss of the paternal postcard, that we are given the only passing reference to the death of the author's mother here? It holds no emotion. It is only the occasion to discover the mother's lack of care in keeping a postcard that we can then understand imaginatively rather than actively was so cherished by the daughter. If she lost her father a second time, it seems it was through the death of her mother which led to the discovery of the postcard's being missing. The supposed guardian of the other souvenirs kept in a handbag failed even in this and is thus blamed for a second severance from the father as memory. Yet in the writing, her death –as it were – occurs at the same time as the father's double dying.

We shall soon come to the other souvenir still kept by the daughter, taken from the mother's purse, the pen – when and why? Does it, a writing

implement relate to the missing written postcard retrospectively? Is it another layering of identification performed and preserved through writing?

This section and the next opening backwards into the world before 16 July also serves as a description of a Jewish childhood in an Orthodox Polish family that plots out the annual cycle of Jewish festivals in irregular order and fractured memories. Chapter VI returns us from this idyllic retrospect back to 16 July: setting into writing the defining dates of Kofman's world – before 16 July and after 16 July. Happy memories of school find a place out of time because Chapter VII starts with the account of how between July 1942 and February 1943 her mother has to undertake the task of hiding her renamed children; Isaac becomes Jacquot, Rachel becomes Jacqueline, Aaron Henri: so why was Sarah's name not changed too? The children are hidden in the countryside. Chapter VIII tells of 'the real danger' now experienced: 'separation from my mother' (33/27). This reconnects with an earlier experience of toddler anxiety when Sarah Kofman, aged 2 or 3 years, had once lost her mother in a public place. This is a portrait of a child submerged in separation anxiety. She has also just experienced the arrival of another brother, the annihilating sibling.

Juliet Mitchell has recently drawn psychoanalytical attention to the relations that Freud ignored: sibling relations and the impact on any child of the arrival of a sibling.[27] The experience Mitchell describes as akin to death. From being the one, the baby, the displaced infant experiences its dispossession when another arrives and takes its place 'at the breast' as a profound assault on being, a sensation akin to dying which can become the ground for hysteria: hysteria according to Mitchell is thus without gendered particularity. It arises in this nexus of being with and being utterly without, of desire and a feeling of dying, becoming nothing.

The round-ups increase in intensity and, clinging to her mother, Sarah and Madame Kofman must find refuge here and there. But they have one refuge of habit 'la dame de la rue Labat'. So comes the second primal scene that has the quality of arrested memory of the night of 9 February 1943 when mother and daughter are warned that they are on the list for this evening's round-up. Mother and daughter flee along the length of Rue Marcadet (the geographical reference is hallucinatory) to be welcomed by the beautiful lady in her *peignoir*. That image too is held as an angelic but erotic vision.

Along that long journey, Sarah Kofman reports that little Sarah vomits all the way. Anxiety has taken over the site of the other brain: the digestive system, that most delicately calibrated sensitive and loquacious site of psychic anxiety converted into the body's language of symptoms.[28] Mother and daughter dare to make one last visit next day to the desecrated site of origin – the family home mutilated by the Gestapo with its seals and punitive destruction for their not being there; never again would Sarah have a family home. The only

refuge for the 'recherchées' was the apartment on Rue Labat. Thus at once we have a welcome and hospitality on the one hand, and a sense of this place being the only site of possible escape from fleeing endlessly from a now utterly destroyed 'home'.

Up to this point in her life, however, little Sarah refused to be separated from her mother. Despite many attempts to hide her somewhere safe, the child refused food and forced a reunion. In the telling, this fact is repeated often. It is insisted upon. The repetition in writing provides it with a significance that the text does not spell out; the intensity of the attachment becomes all the more remarkable because of the violence of that mother's emotional disappearance effectively from Sarah Kofman's life after arrival at Rue Labat.

The following chapters document what is titled by Chapter XII: *Metamorphosis*, the hinge of the text. Evoking Ovid, once again, metamorphosis is the title in French and English of Kafka's infamous allegory, *Der Verwandlung* (1915), implying the total transformation of species being. Metamorphosis is also the link across Kofman's memoir with creative but devastating transformation. Like Daphne or Arachne, Sarah Kofman is being faced with a forcible alteration that in some way involves a kind of dying. Noticing this term alerts us to its profound rupture. Contemplating a formal conversion to Christianity from which, in fact, little Sarah/Suzanne actually flees the church in which baptism is to take place, Sarah is informally renamed Suzanne and step by step, *la dame* transforms the child inside and out. This is not a matter of superficial makeover: a few new clothes, a new feminine hairstyle to replace her lice-infested cropping by her mother, entrancing as they may be.

Two different verbal constructions occur that confuse us as to who was the agent in this metamorphosis. Chapter XII concludes:

> Je ressens vaguement ce jour-là que je me détache de ma mère et m'attache de plus en plus à l'autre femme. (53)
> On that day I feel vaguely that I am detaching myself from my mother and becoming more and more attached to the other woman. (44)

Then in Chapter XIV we read:

> A son insu or non, *mémé* avait réussi ce tour de force: en présence de ma mère, me détacher d'elle. (57)
> Knowingly or not, *Mémé* had brought off a tour de force: right under my mother's nose, she'd managed to detach me from her. (47)

So there was a change of *attachment* brought about by an act of *detachment*. The text continues that the detachment was 'Et aussi du judaisme/And also from Judaism'.

> She had saved us, but she was not without anti-Semitic prejudices. She taught
> me that I had a Jewish nose and made me feel the little bump that was the sign
> of it. She also said, 'Jewish food is bad for the health; the Jews crucified our
> savior, Jesus Christ; they are all stingy and love only money; they are very intel-
> ligent, no other people has so many geniuses in music and philosophy.' Then
> she'd cite Spinoza, Bergson, Einstein and Marx. It is from her lips and in that
> context that I first heard those names, which are so familiar to me today. (47)

Kofman thus records a babble of anti-Semitic tropes confusing the child with
negation of her own parental family and its traditions while offering one
positive lifeline that could win *la dame*'s approval and maintain a link with her
past: intellectual achievement. Yet this is troubling. Naming this list of great
thinkers as Jewish can itself be anti-Semitic when coming from 'her lips'; they
are being named, othered, by a non-Jew as Jewish. They are being marked out
for that fact, and not existing merely as great thinkers. Significantly, Freud is
not part of this list.

A series of transformations of habits, eating, clothes, and language –
Kofman soon no longer speaks but still understands Yiddish – culminate in
two further scenes. Kofman is taken to visit the lady's large extended family in
the countryside on Sundays. There she discovers 'family and the family spirit'
based on gathering several generations together (52). The almost Impressionist
image of the bourgeois family gathering in gaiety and peaceful interaction
evokes a negative memory of the lack of such relations in the Kofman house-
hold. The Rabbi and his wife had emigrated from Poland to France in 1929.
Just over ten years later his entire family had died in the Warsaw ghetto. Of
ten brothers and sisters, only one escaped, living in Yugoslavia and married
to a non-Jewish wife. The Rabbi did not throw him off but sent letters to this
brother signed with drawings of the hands of his children. Compressed into
one paragraph, the two worlds are being juxtaposed: the flower-filled garden at
L'Haÿ-les-Roses and the burnt-out remnants of a ghetto, the site of mass dying.
This recollection leads to mention of a recovered object: a photograph of the
Rabbi from his youth when 'he doesn't know what lies in store for him' (53).

The book is moving in to what I identify as its climactic scene: the final
scene of seduction. Whatever it is that the text is telling at this point, it
wants the readers to catch its sexual overtones. In his reading of Kofman's
book, Michael Stanislawski's interpretation is unequivocal in describing the
homosexual seduction of the child by 'the lady'.[29] One night they return from
L'Haÿ-les-Roses too late for the last *métro* and *mémé* books them into a hotel.
Kofman calls this chapter *Paravent*, after the screen behind which she remem-
bers the mature woman undressing.

> I have no memory of that night in the hotel save of the undressing scene
> behind the mahogany screen.

The next day we took the first *métro*. My mother was waiting, sick with worry, certain we'd been arrested and obviously unable to enquire at the police station.

I had completely forgotten her. I was quite simply happy. (54–5)

I do not think anything happened here. But this does give us a clue to the core of what constitutes the anxious knot at the centre of this *conte*: a double process of seduction. First comes an emotional and oral seduction away from the mother, away from Judaism, and into the complex and alluringly different life-world of the French-Christian woman. Part of this, however, involves the precocious exposure to adult sexuality in the form of *la dame's* weekly tryst with a boyfriend at which Sarah-Suzanne is allowed to participate. The book intimates a knowing courtship of the child, but not simply into a replacement maternal relationship, even if that was *la dame's* conscious purpose. Survival, love and desirability are plaited into a bond with disturbing transgressions that produce momentary happiness in a child's world trimmed at every turn with terror. Kofman tells us that she buried 'her entire past' and, worst of all, feared the end of the war, the ending of her time so close to *mémé*.

But liberation comes in August 1944. Kofman's mother is free at last to reclaim her scattered children, find a home, and take back the daughter the lady has tried to 'steal' from her. Another sudden and absolute severance is imposed on the child, forced now to return to another hotel, to share a bed, this time with her mother. I detect an unconscious rhyme between the two scenes; one of blissful happiness and another of penniless misery marked by a bad meal cooked on a butane gas cooker that Sarah, of course, refused to eat. Negotiations for a slower severance are begun, but physical violence from the mother – beating with a strap – attends any breach of the terms. In a French court, *mémé* sues for custody of Suzanne-Sarah and is awarded her care on the grounds of violent abuse by Madame Kofman. The lady phones her boyfriend triumphantly reporting the legal win of 'my little girl'. Sarah Kofman records feeling uneasiness, neither happy nor secure until her mother, fearsome in her defence of maternal and Jewish rights, 'violently' reclaims her. 'I struggled, I cried, I sobbed. Deep down I was relieved.' (61)

At this point the *conte* stops, and it seems, veers off into two detours which are, in fact, other scenes that evoke the indecipherable complexity of feelings before these two contesting figures. Kofman tells us that for the cover of her book on Freudian aesthetics, *The Childhood of Art* (1970), she wanted a detail from Leonardo da Vinci's *Madonna and Child with St Anne* (Figure 79). The chapter is composed of a lengthy quotation from Freud's essay on Leonardo, the topic of Freud's first attempts at theorizing the aesthetic psychoanalyti-cally. The drawing shows St Anne, her daughter Mary on her knee, the child Jesus with John the Baptist leaning on his grandmother's knee. It is about two generations of women, and two children. The unfinished drawing repeats a

relatively rare Christian iconography that occurs in the painting in the Louvre by Leonardo, but with a more complex relationship between the figures of Anne and Mary and the child. Freud interpreted this doubling of the maternal figure as Leonardo's imaginary projection onto the screen of art as a double scene. At once it reflects his own experience of his adoptive mother Donna Albiera, his father's wife, and his father's mother, Mona Lucia. Behind this historical explanation of mother and grandmother tenderly gazing at one child, lies another memory that involves the two women who mothered him in infancy and childhood: the peasant Caterina to whom he was born, and the adoptive higher-class mother, wife of his minor aristocrat father who acknowledged him, thus alienating him from the nourishing mother of infancy and the social space into which he was born. Freud suggests that the grandmother figure of St Anne corresponds to Caterina, the peasant mother. The blissful smile screens the envy the latter may have felt in giving up the child to an aristocratic rival. Freud's doubled reading holds before us both the generational pairing mother/grandmother (*maman* and *mémé*), while reversing that hierarchy to use the older woman as screen for registering the displaced mother's rage and envy. Does this chapter allow for both little Sarah's shifted affections and the anguish of the displaced mother, now recalled as doubling the maternal gaze within which the child is held?

Contradictory emotions are also registered by the second detour, into Alfred Hitchcock's film *The Lady Vanishes* (1938), a film about the substitution of a good old lady (a secretly brilliant spy disguised as a nanny) for a harsh and ugly one. Kofman's description concludes with a reference to Melanie Klein's good and bad breast, which these swopped mother figures represent, 'utterly separate from one another, but changing into each other' (66). Only with these two allegories in between can the story continue to tell of one blissful reunion with *mémé* which reads more like the reunion of lovers. Yet, I stress, it is being told from the point of view of the unconsciously 'seduced' child's ignorance of what is happening emotionally, and sexually, within her at this point. Thus truth or phantasy matter little compared to the affective after-affect. Sleeping in the same bed with *mémé*, Kofman candidly confesses:

> I remember especially the first night, when my emotion and excitement were very great. Just to feel close to her put me in an 'odd' state. I was hot, I was thirsty, I was blushing. I kept mum, and really would have been hard put to say anything about it, since I had no idea what was happening to me. (67)

I do not think that this is a frank avowal of homosexuality. For that self-discovery of the capacity to feel love or desire for another woman is not the meaning of what Kofman is reporting. The writing clearly evokes a highly eroticized scene, but one in which the child-participant is not yet a sexual being, even while her bodily signs are initiating it. She is experiencing an

intensity of emotion and its attendant physical excitement in relation to being close to an older woman, who has been inscribed in the text as a woman of desire and a desired one through the regular visits of the boyfriend. In one sense she dangerously evokes the unconsciously desired Oedipal father who can open up the space for the daughter to separate from the mother.

I want, however, to suggest that on the *Matrixial* string, this woman offered access, through what Bracha Ettinger calls *fascinance*, to the girl's emerging own femininity. For Freud, femininity as a difference is forged only in desperate discovery of feminine lack vis-à-vis the masculine phallus, in which the girl becomes a feminine subject through penis-envy and her hateful rejection of her castrated mother. Ettinger radically shifts Freud's solely phallocentric and hence negative explanation of feminine sexual difference.

> If Oedipal difference is the key to feminine sexual difference, the question '*what does a woman want?*' quickly turned into the question *what does a woman want from a man?* It is not sustained long enough at the level of *what does a woman want from a woman?*[30]

Returning to the text of Freud's case-study of 'Dora', a troubled eighteen-year-old, fascinated by her father's 'mistress', Frau K., and who gazed for hours at the *Sistine Madonna* by Raphael in the art gallery at Dresden, Ettinger argues that the girl who will become a woman learns what femininity might be through a prolonged gazing – *fascinance* – at another woman, what Ettinger names the *ffam*, the *femme-fatale-autre-Mère*, namely a mature, sexual woman, who is not the actual mother (for we find it hard to contemplate our own conception in our mother's active sexuality).

This quest for knowledge of femininity takes the form of *fascinance*:

> Dora's fascination with Frau K., like Dora's admiration of the Madonna were not expressions of homosexual desire. Dora did not desire Frau K. sexually. She desired to be caught in a move of fascination that belongs to femininity, a move composed of a girl towards a woman-figure, who is fascinated too by the daughter-girl and who allows her sufficient proximity to sustain the *illusion of inclusion in her mature and elusive maturity – a femininity which is not directed at the girl but outside and away from her.* Yet the girl desires to be included inside it for instants of eternity whereby she participates in advance, and by proxy, in a world not yet fit for her own immature sexuality.[31]

In her elaboration of the concept of *fascinance*, Ettinger focuses on Marguérite Duras's novel *The Ravishment of Lol V. Stein* (1964) in which a violent disruption of this prolonged gazing at and exposure to another woman leads the heroine Lol compulsively to seek to repeat the scene that she still needs time to complete. Finally, when that fails, Lol succumbs to psychosis, unable to make the transition into her own sexuality and femininity.

I am arguing that Sarah Kofman's *récit* is not a confession as such. Her writing registers, in a kind of faux-naive but true-naive manner, a process instanciating this concept *fascinance*. The girl-becoming-a-woman-Sarah needed to watch and be near *mémé* to find a way to access a preferred femininity that the older woman hospitably represented. Her need was to be included in something, *in the feminine*, in the desirable, represented by the mature, sexual woman, through which she can pass from a traumatically arrested and hystericized childhood into joyfulness in life. Having reparatively read for *fascinance*, we cannot ignore Kofman's creation of this scene of reunion that tilts towards eroticism.

Rue Orderner, Rue Labat registers an undecipherable form of seduction that loops back, in a very different way to the scene of seduction discussed in Chapter 2 on Louise Bourgeois. But, unlike Bourgeois's scene under the table, the trauma of seduction it indexes is ultimately not concerned with sexuality. The eroticism is a distraction. Here, instead of a pure hystericization of anxiety when confronted with the enigma of adult sexuality, as was the case in Bourgeois's story of the children hiding under the table, the scenes Kofman has chosen to highlight within the structuring of her text by place and scene have the opposite, dehystericizing, eroticizing effect, allowing the body to become hot, excitable and pleasured but in a pre-pubertal, non-genital sense of participating in advance in a moment of space of female sexuality on the verge of which she still hovers. What makes us burn, however, is shame.[32]

Narratively or textually, the process of separation from this need to remain in permitted fascinance/proximity to what is not yet finished with her own real sexual awakening is thus traumatizing, even though it happens slowly over the next few chapters with furtive visits and secret letters and a long stay in hospital. But finally sent to the South, educated and then back to war with her mother, Sarah Kofman becomes a *student*. She takes up the life of the intellect. She has her own friends, including *un ami*. She has made her own sexual choice. She continues to have some contact, but revolts against being held in that overwarm childish relation of now uncomfortably eroticized childhood that she no longer needs. She does not attend the lady's funeral.

The object

We can now return to the opening lines:

> De lui, il me reste seulement le stylo.
> Of him, all that remains [for/to me] is the pen.

I have already discussed elements of this paragraph, and spent much of this chapter placing it in the context of the ending and the climax of the book, its topographies and primal scenes. I have suggested a trauma of seduction

and veered away into another, matrixial account for what the lady might have represented for the child Sarah Kofman. I have also suggested a distortion, via religious and cultural alienation of the Oedipal configuration and the appropriation of the place of the father. For the passage into her own womanhood, modern, educated, secular but still Jewish in identity if never in practice, Kofman returns to the disappeared father. Only now can we go back to the desk, and back to 16 July 1942 and ask what is the role of the surviving object: *le stylo de lui?*

Chapter II opens with a date in italics: 'On *16 July 1942*, my father knew he was going to be picked up.' Was it that *ça*/'that' that the pen incited its final, vicarious owner to travel back and yet always, towards – remembering Adorno's German phrasing *Nach Auschwitz*, meaning towards as well as after? Remember Chapter III, written in retrospect: 'As it turned out, we never did see my father again.' With the postcard she had 'that last sign of life we had for him'. It was lost: 'It was as if I had lost my father a second time. From then on nothing was left, not even that lone card that he had not even written' (9). His death was, however, certified in writing. It took place in Auschwitz. So we confront two pieces of writing – the last sign of life and the official inscription in a register that confirmed two things: At the age of forty-two, Rabbi Kofman had been selected for slave labour, probably in Auschwitz-Monowitz, and was not sent for immediate gassing. Yet he was killed. This is the bookend writing of his death. After the bleak death certificate, an Auschwitz survivor who apparently witnessed that death gives the family a report. Refusing to work one day, and wanting to pray on a Sabbath, Rabbi Berek Kofman was beaten with a pickaxe by a French-Jewish butcher-turned-Kapo and then buried alive.

The full and horrific import of the title of the first book to dare to speak of her father's death, *Paroles Suffoquées: Smothered Words*, now hits us. That text transferred the horrible dying onto the very words that had been written to speak of the entire trauma that culminated in something worse that ordinary death, in Auschwitz. Chapter II *Smothered Words* text begins:

> Since Auschwitz all men, Jews and non-Jews die differently: they do not really die; they survive death because what took place – back there – without taking place, death in Auschwitz was worse than death: 'Humanity as a whole had to die through the trial of some of its members (those who incarnate life itself, almost an entire people, a people that had been promised an eternal presence). This death still endures. And from this comes the obligation never again to die only once, without however allowing repetition to injure us to the always essential ending.'[33]

Framed philosophically with a paraphrase of Theodor Adorno's final meditations on metaphysics 'after Auschwitz' (1966), the passage also cites Maurice Blanchot's afterword to *Vicious Circles* before returning to the brutal statement:

> Because he was a Jew, my father died in Auschwitz: How can it not be said?
> And how can it be said? How can one speak of that before which all possibility
> of speech ceases? Of this event, my absolute, which communicates with the
> absolute of history, and which is of interest only for this reason. To speak: it
> is necessary – *without (the) power*: without allowing language, too powerful,
> sovereign to master the most aporetic situation, absolute powerlessness and
> very distress, to enclose it in clarity and happiness of daylight. And how can
> one not speak of it, when the wish of all who returned – and he did not return
> – has been to tell, to tell endlessly, as if only an infinite conversation could
> match the infinite privation.[34]

To tell endlessly, because such endless telling alone matches the infinite priva-
tion, recalls the *telling* to which the author was eventually constrained by the
pen itself, all that remained because he did not return, and he did not return
because he died '*because* he was a Jew'. Not *as* a Jew under Nazism racial laws.
But he died being a Jew, speaking to his God 'beseeching God for all of them,
victims and murderers alike' (10). *This* has to be spoken, voiced, enunciated by
a language that threatens to betray those 'smothered words' by its own illumi-
nating power to master every experience, to cover over the void, the traumatic
aporia, that it must remain.

Calling upon Lyotard, Adorno, Blanchot and Antelme, honouring them for
writing and speaking, *Smothered Words* is a wilfully painful journey through
other writers' words to the impossible place where the father, the Rabbi, the
Jew, died a death worse than death, as part of a historical catastrophe that
afflicts all humanity (according to Blanchot) through what happened to two
peoples, the Jewish people in particular, *back there, là-bas*, in the event collec-
tively remembered after Adorno as 'Auschwitz' which, however, for many like
Rabbi Kofman was the actual site. Berek Kofman born 10 October 1910, in
Sobin, Poland, did not die in the specially industrially manufactured killing
machinery of that place, Auschwitz-Birkenau, where as a Jewish man he would
have been starved, overworked and eventually gassed or worse, left to die the
death of internal disintegration they called becoming a *Muselmann*. He was
buried alive after suffering a brutal beating by a fellow Jew for daring to carry
on an act of religious fidelity in a place where all such human aspiration and
ambition for grace or hope had been systemically abolished.

It is of this man, suffocated to death to smother his words, that all that
remains, as the writer of these texts writes, is a patched-up, unusable fountain
pen. So that object is a material index, an affective icon and an intellectual
symbol: but of what? It is also a link in an affective chain between child and
father, a chain severed by what Blanchot named an absolute, both personal
and historical, while being maintained precisely by the power of the object to
'speak' a command: write, write. Yet, all the books the author did write were to
avoid coming to tell *that*. *That* cannot be simply what she had already written

in *Smothered Words* about his terrible dying that she embedded in a textual study of writings by Blanchot and Antelme. The *that* cannot just be the story of the contestation over her identity and affections that forms the narrative of *Rue Ordener, Rue Labat*. But the what of *ça* lies between them.

The *that* that must be finally written is the act from which her father died and its relation to the acts that occurred with his vanishment. The act of saying words, words that got him smothered, signify a relation to a non-relational, radical alterity which sustains the humanity of the utterer.

> In this unnameable 'place', he continued to observe Jewish monotheism, if by this, with Blanchot, we understand the revelation of the word as the place in which men maintain a relation to that which excludes all relation: the infinitely Distant, the absolutely Foreign. A relation with the infinite, which no form of power, including that of the executioners of the camps, had been able to master, other than by denying it, burying it in a pit with a shovel, without ever having encountered it.[35]

This is not about his religious faith per se. It is about its philosophical potency to imagine a humanity in relation to an otherness in opposition to the total destruction of humanity represented by the camp in totalitarian usurpation that rendered all men superfluous.

Smothered Words was the first address to either autobiography or the Shoah. That writing showed how intensely intertwined were her life and his death. What followed were texts in which Kofman engaged with Judaism, anti-Semitism and the Shoah and culminated in *Rue Ordener, Rue Labat*, the story of what happened to Sarah Kofman herself after the deportation of her father and the break-up of the family forced into disguise and hiding. Thus the pen also constrains her to write of what happened in the chain of events following the round-up on 16 July 1942. All that remains from before is a pen. The Rabbi's pen is the sign of all the writing, speaking and practices in faithful observance of which he was murdered in the most ghastly way imaginable. The terrible truth is that his actual death did not occur as part of the process of impersonal annihilation of the Jewish population under racial laws. *It happened in a confrontation over the very religious identity and its philosophical possibility that Sarah Kofman was **seduced** into abjuring as a vulnerable child in an extreme historical situation.*

For me, the deep unsaid of Kofman's text lies smothered, buried, here. The father's pen links writing to daring to confess what I can only overdramatically name a forced and unknowing apostasy – a radical alienation – while plotting out its psychological/ emotional/historical conditions which forced it. About Auschwitz, and after Auschwitz no story – *récit* – is possible, Kofman says, if by a story one means: to tell a story of events which makes sense. So the pen incites a memoir that is not a story that makes sense. It is the writing of its

senselessness that is contained in the presence of the pen, instead of the father, and in the life of writing of the daughter who now has to write her way back through unbearable grief and unspeakable shame. She cannot hide behind other men-writers-thinkers to deflect this journey into the traumatic fissure in the historical formation of her self.

Becoming scholar and writer in the French secular education system involved breaking the conventions of her Orthodox Jewish home in more ways than no longer eating Kosher meat. It involved a transgendering identification with the masculine, the scholar, the Rabbi, the philosopher by means of the pen. Of this Sarah Kofman made a creative and productive life writing over thirty books. But there is something else in that pen: *ça*.

The trauma remains in senselessness – the unnegotiable, irrecoverable trauma of the daughter, who having broken the covenant in fidelity to which her father outrageously suffered an exceptional and unthinkable living death, and in her having loved and been loved for it, touches the unspeakable shame at the process of her survival – *seduction* into apostasy – and her compensatory but transgressive identification with the masculine scholar that was made possible indirectly by it. Now the pen is both transport station to the missing father and the means of prying open the encrypted secret: the pain of the encounter with what was not imagined – shame.

On 15 October 1994, a year after completing the book that begins, *Of him all that remains is the pen*, six months after its publication, Sarah Kofman took her own life. I am asking, therefore, if the final utterance of words that never directly spoke of *ça* but tracked their way to a realization of what had been the encrypted secret, functioned, therefore, catastrophically. Rather than being a transport station of trauma, the pen of the father called forth an encounter with the hitherto uncognized affect at the core of her trauma and its knowledge gave no relief. Her writing's revelations smothered her as if the surrogate identification with the writing man-pen fractured to leave a gap and breach between father and daughter that could not find a link or a string to transport the trauma to anywhere but nothing: death was where no more writing would come.

Postface

In the publication of *Sacrée Nourriture: Damned Food* in *Les Cahiers du Grif* in 1997, a drawing by Sarah Kofman precedes the text (Figure 80) From childhood, Kofman drew incessantly, later as a daily ritual. There are hundreds of drawings by Kofman, mostly faces and figures, some landscapes.

Drawn in pencil, a cage of lines that might suggest hair encircle a face created by smudged pencil punctuated by darker intensities that signal two

eyes, a cocked eyebrow, and an opened mouth. The effect is one of intense anxiety. There is no volume, just a skin of colour pierced by an intense gaze created by the dark marks that give the eyes a strange but distracted intensity. What is striking in all Kofman's drawings of herself, her husband and others, is that there is no substance to the bodies. Her lines, washes and smudging create a force-field of intensity, a map of charged tension across forms that freely float in space or are sometimes caged.[36]

In *Rue Ordener, Rue Labat*, there is one other object mentioned that links back to her father. It is a letter he had written to his brother in Yugoslavia, signed with drawings of his children's hands. It is recovered by Kofman's sister from the brother's surviving wife. It reminds Sarah Kofman that she drew hands constantly throughout the war years. The pen – writing – meets the hand drawing hands. Indeed it seems Kofman drew and painted all her life. There was one exhibition of her work in Paris at a bookshop. I have failed to track down its traces. It is time perhaps to see her drawings again.

Notes

1 In the original French Sarah Kofman calls this woman *mémé*. In the English translation the translator capitalizes the name. I follow the French original but in references using the English translation the name will appear as *Mémé*. Sarah Kofman, *Rue Ordener, Rue Labat* (Paris; Galilée, 1994), trans. Ann Smock (Lincoln, NE and London: University of Nebraska Press, 1996).

2 Penelope Deutscher and Kelly Oliver, 'Sarah Kofman's Skirts', *Enigmas: Essays on Sarah Kofman* (Ithaca, NY: Cornell University Press, 1999), 7. I also want to thank Penelope Deutscher for helpful correspondence during my research.

3 For a superb analysis of the affective zone of depression see Julia Kristeva, *Black Sun: Depression and Melancholia*, trans. Leon S. Roudiez (New York: Columbia University Press, 1989).

4 Sarah Kofman, *Rue Ordener, Rue Labat* (Paris; Galilée, 1994), 9; trans. Ann Smock (Lincoln and London: University of Nebraska Press, 1996), 3. Hereafter I will give the page references in the text to the French/English editions.

5 Sarah Kofman, *Paroles Suffoquées* (Paris: Galilée, 1986); *Smothered Words*, trans. Madeleine Dobie (Evanston, IL: Northwestern University Press, 1998). Brief, almost autobiographical texts had appeared in *Première Livraison*, no. 4 (1986) and no. 5 (1987). Translations: Sarah Kofman, 'Autobiographical Writings', trans. Frances Bartkowski, *SubStance*, 15:1 (1986), 6–13. For a review of these texts see Michael Stanislawski, *Autbiographical Jews: Essays in Jewish Self-fashioning* (Seattle: University of Washington Press, 2004), 139–74.

6 Robert Antelme, *L'Espèce humaine* (Paris: Gallimard, 1947); *The Human Race* trans. Jeffrey Haight and Annie Mahler (Evanston, IL: Northwestern University Press, 1999). Antelme argued that he encountered certain instances of human solidarity within the camp and even with bystanding Germans.

7 Janina Bauman, *Winter in the Morning* (London: Virago Books, 1986) reprinted recently with her second volume of memoirs, *A Dream of Belonging*, in one volume

as *Beyond These Walls: Escaping the Warsaw Ghetto – A Young Girl's Story* (London: Virago Modern Classics, 2006). 'Why? And Why?', ii.

8 Saul Friedländer, *Quand vient le souvenir* (Paris: Editions du Seuil, 1978); *When Memory Comes* [1978], trans. Helen R. Lane (New York: Farrar, Straus & Giroux, 1979).

9 Sarah Kofman, *Aberrations: le devenir-femme d'Auguste Comte* (Paris: Aubier-Flammarion, 1978), 41; trans. Paul Patton.

10 Verena Andermatt Conley, 'For Sarah Kofman: On *Rue Ordener, Rue Labat*', *SubStance*, 25:3 (1996), 153–9.

11 Ashlee M. Cummings, *The Shelter of Philosophy: Repression and Confrontation of the Traumatic Experience in the Work of Sarah Kofman*, MA Thesis, University of Miami, 2009, 13, http://etd.ohiolink.edu/view.cgi?acc_num=miami1248976254.

12 For an elaboration of Freud's concept of the Thing, see Jacques Lacan, *The Ethics of Psychoanalysis Book VII 1959–60*, trans. Dennis Potter (London: Routledge, 1992).

13 Conley, 'For Sarah Kofman: On *Rue Ordener, Rue Labat*', 154.

14 Sigmund Freud, 'Mourning and Melancholia' [1917], Penguin Freud Library, Vol. 11: *On Metapsychology* (London: Penguin, 1984), 245–68.

15 Griselda Pollock, 'Deadly Tales', *Looking Back to the Future: Essays on Art, Life and Death* (London: Routledge, 2001), 371–90.

16 Tom Stoppard, *Rosenkrantz and Guildenstern are Dead* (London: Faber & Faber, 1967), 90–1.

17 Julia Kristeva, *The Powers of Horror: An Essay on Abjection*, trans. Leon S. Roudiez (New York: Columbia University Press, 1982).

18 Sarah Kofman, 'Sacrée nourriture', in Christiane Besson and Catherine Weinzaep-flen (eds), *Manger* (Liège: Yellow Now, 1980); trans. Frances Bartkowski as 'Damned Food', in Thomas Albrecht, Georgia Albert and Elizabeth Rottenberg (eds), *Sarah Kofman: Selected Writings* (Stanford, CA: Stanford University Press, 2007), 248.

19 Kofman, 'Sacrée Nourriture', translated as 'Damned Food', 248.

20 For a subtle study of the manner in which European culture since Shakespeare has represented Judaism as a dried up, exhausted, rule-bound and loveless religion contrasted with the youthful beauty and emotional freedom of Christianity, see Hyam Maccoby, *Antisemitism and Modernity: Innovation and Continuity* (London: Routledge, 2006), particularly 97–108.

21 Diane Morgan, 'Made in Germany: Judging National Identities Negatively', in Penelope Deutscher and Kelly Oliver (eds), *Enigmas: Essays on Sarah Kofman* (Ithaca, NY and London: Cornell University Press, 1999), 233.

22 Kofman, *Rue Ordener, Rue Labat*, 1996: 41–2 and Chapter XIV, 47–80.

23 For a fascinating study of Berthe Pappenheim, exemplifying the difficulties modernizing Jewish women experienced as they moved from traditional Jewish forms of sexual division of labour into Christian bourgeois mores that imposed limited education and restricted activity upon women, see Daniel Boyarin, *Unheroic Conduct: The Rise of Heterosexuality and the Invention of the Jewish Man* (Berkeley and Los Angeles; University of California Press, 1997), 313–60.

24 My literal translation. Ann Smock translates: 'Mémé had moved to Sables D'Olonne where I spent a month's vacation with her in the summer. We went for walks on the beach.', 84.

25 In *Paroles Suffoquées*, the text that marks a break from philosophy into some form of memory work and personal disclosure, Kofman opens its second chapter about the nature of death after Auschwitz with another chance invocation of this freighted word: '*Parce que ce qui a eu lieu – là-bas – sans avoir lieu, la mort à Auschwitz, a été pire que la mort.*' 'Because what took place – over there – without taking place, death in Auschwitz, was worse than death.' Kofman, *Paroles Suffoquées*, 15; trans. *Smothered Words*, 9.

26 Carolyn Steedman, *Landscape for a Good Woman* (London: Virago, 1986).

27 Juliet Mitchell, *Mad Men and Medusas: Reclaiming Hysteria* (London: Basic Books, 2001) and *Siblings, Sex and Violence* (Cambridge: Polity Press, 2003).

28 Elizabeth A. Wilson, *Psychosomatic: Feminism and the Neurological Body* (Durham, NC: Duke University Press, 2004); Janine Chasseguet-Smirgel, *The Body as Mirror of the World*, trans. Sophie Leighton (London: Free Association Books, 2005).

29 Stanislawski, 'Autobiography as Farewell II: Sarah Kofman', in *Autobiographical Jews*, 166–7.

30 Bracha L. Ettinger, '*Fascinance* and the Girl-to m/Other Matrixial Feminine Difference', in Griselda Pollock (ed.), *Psychoanalysis and the Image* (Boston and Oxford: Blackwell, 2006), 61–2.

31 Ettinger, '*Fascinance* and the Girl-to m/Other Matrixial Feminine Difference', 61–2.

32 See Griselda Pollock, 'The Visual Poetics of Shame', in Claire Pajaczkowska and Ivan Ward (eds), *Shame and Sexuality: Psychoanalysis and Culture* (London: Routledge, 2008), 109–28.

33 Kofman, *Paroles Suffoquées*, 15; trans. *Smothered Words*, 9.

34 Kofman, *Paroles Suffoquées*, 15–16; trans. *Smothered Words*, 9–10.

35 Kofman, *Paroles Suffoquées*, 42; *Smothered Words*, 34–5.

36 For an appreciation and description of Kofman's drawings see Philippe Boutibonnes, 'En ce commun effroi …', *Fusées*, no. 17 (2010), 9–17.

'… that, again!': *pathos formula* as transport station of trauma in the cinematic journey of Chantal Akerman

Captions to chapter 7

81 Chantal Akerman (b. 1950) *Walking Next to One's Shoelaces Inside an Empty Fridge*, 2004. Installation in two rooms, tulle sculptures, double-screen video projection and tulle screen with video projections and soundtrack. Variable dimensions. Detail: Second part of Installation, Video: the Kiss.

82 Chantal Akerman (b. 1950) *Woman Sitting after Killing*, 2000. Video installation.

83 Chantal Akerman (b. 1950) 'A Russian Night' still from *D'Est*, 1993, Lieurac Productions.

84 Alain Resnais (b. 1922) *Night and Fog*, 1955, still, archive footage, Argos Films, Paris.

85 Chantal Akerman (b. 1950) *Bordering on Fiction: D'Est: Twenty-fifth Screen*, installation.

86 Chantal Akerman (b.1950) *Tomorrow we Move*, 2004, detail. Paradise Films, Brussels.

87 Chantal Akerman (b. 1950) *Walking Next to One's Shoelaces Inside an Empty Fridge*, 2004, spiral sculpture in tulle netting fabric, metal structure, video projection, entrance. First part of the installation: spiral sculpture in tulle netting fabric, metal structure.

88 Chantal Akerman (b. 1950) *Walking Next to One's Shoelaces Inside an Empty Fridge*, 2004, video projection with scrim, moving projection of image and notebook. Second part of the installation.

89 Chantal Akerman (b.1950) *Walking Next to One's Shoelaces Inside an Empty Fridge*, 2004, video projection with scrim, moving projection of image and notebook. Detail: Notebook.

90 Chantal Akerman (b.1950) *Walking Next to One's Shoelaces Inside an Empty Fridge*, 2004, video projection with scrim, moving projection of image and notebook.

91 *Arrival of Jewish Prisoners in the Inner Court of the SS Collection Camp Malines/Mechelen*. Photo: Maurice Pioro, 1943.

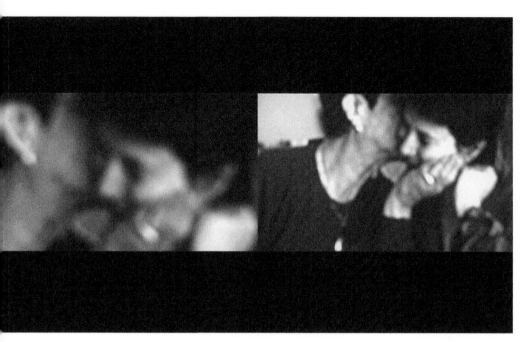

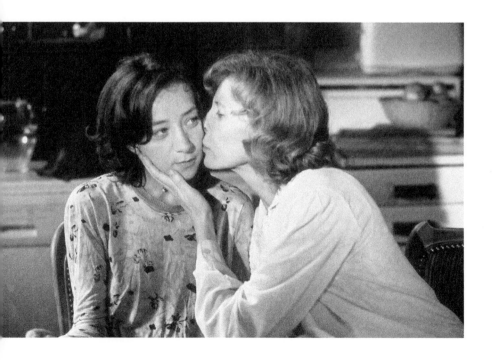

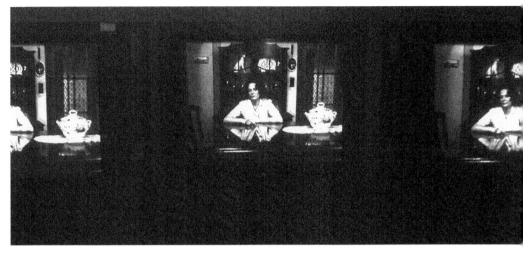

82

83

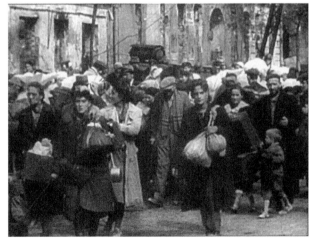

84

85

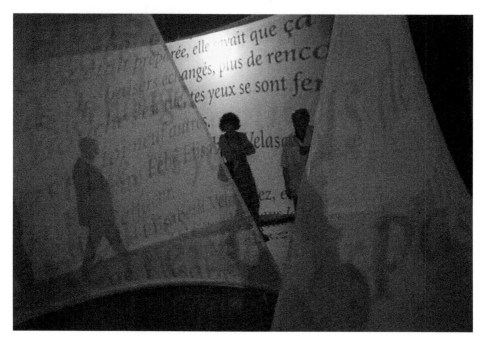

87

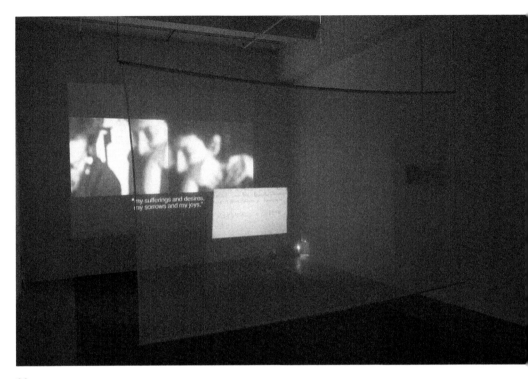

88

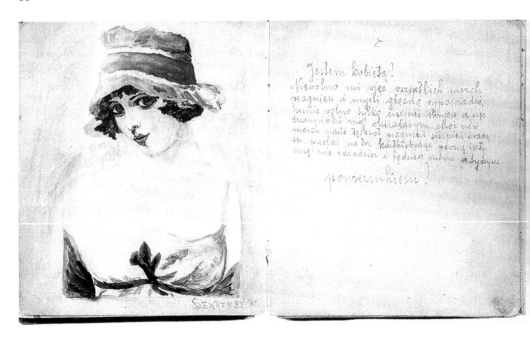

89

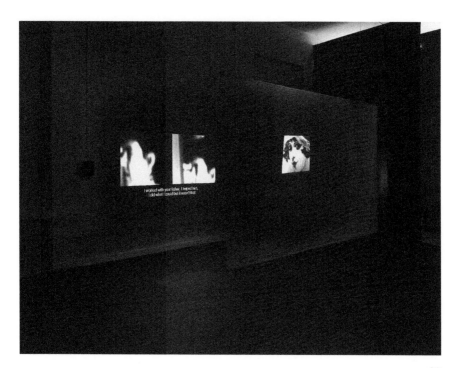

90

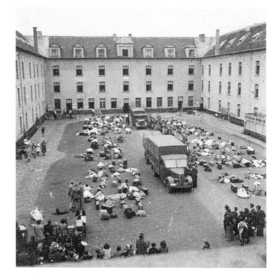

91

I've talked so much about my mother in these films. Have I really worked so many years on her, around her, about her? (Or, as I have just read in a review, against her. Not her personally, especially not that. It's more complex than in the review).

<div align="right">Chantal Akerman</div>

Memory is always reinvented but with a story full of holes it's as if there is no story left. What to do then? Try to fill the holes – and I would say even this hole – with an imagination fed on everything one can find, the left and the right and in the middle of the hole. One attempts to create one's own imaginary truth.

<div align="right">Chantal Akerman[1]</div>

I encountered this maternal kiss in an installation at the Jewish Museum Berlin in 2006. (Figure 81) The title of the installation was, in translation, *Walking Next to One's Shoelaces Inside an Empty Fridge* (referenced hereafter as *Walking*). The installation was paired with the first showing in Berlin of a comprehensive exhibition of Berlin-born painter Charlotte Salomon's (1917–43) painting cycle *Life? Or Theatre?* (1941/42) on which I was writing a monograph. Salomon was murdered in Auschwitz at the age of 26. Along with scattered portraits and landscapes, she left one major work, a compendious work composed of 769 paintings selected from a total of 1325 made in a period of under one year. *Life? or Theatre?* performs through paintings, text and musical cues a 'theatre of memory' in order to the examine the lives, and the tragic deaths, of the artist's mother and grandmother, both of whom committed suicide. This panorama of Jewish life and death is, however, all set in the context of the historical events assaulting German-Jewish subjects in the period up to 1940, hence 'before Auschwitz'.

The woman in the double-screened projection *Walking* who kisses her daughter is Nathalia (Nelly) Akerman who returned from Auschwitz via concentration camps in Germany, receiving on her return to Belgium the only surviving relic of her own mother, murdered like Charlotte Salomon, in Auschwitz-Birkenau in 1942. Nelly Akerman is younger than Charlotte

Salomon (1917–43) by less than ten years and her mother was younger than
Salomon's mother by about a decade; yet their worlds had much in common.
Seeing Akerman's installation, in which the film-maker and her mother
eventually talk about Nelly Akerman's experiences during the Shoah, in the
context of the exhibition in Berlin of an artist of the city, Charlottte Salomon,
destroyed by the Nazi genocide, clearly overdetermined my deeply affected
response to Akerman's installation. But it was also my history of maternal
bereavement and bereaved motherhood that overlaid my sensitivity to its
moments of transformative intimacy between mother and daughter shadowed
by the hitherto unspoken events of the Shoah.

I was emotionally undone by this kiss in Akerman's installation. The flood
of emotion it released was, however, restorative. Its single moment of intense
pathos relieved me from a temporary depression that had deprived me totally
of the ability to write. My writer's block was occasioned by the unanticipated
intensity of missing my own daughter who had just left for New York to study
– leaving me in a situation not unlike Chantal Akerman's own mother so
tenderly commemorated in her earlier film, *News from Home* (1976). There,
long takes of the streets and subways of Manhattan filmed on Akerman's
second sojourn in the city in 1975 are punctuated by the film-maker-daughter's
voice reading, in her accented English translations, letters from home, written
in halting French, during her first stay in New York in 1971. These letters give
voice to the brave but clearly sorrowing mother, at once wishing wholeheart-
edly for her daughter's artistic self-realization and, as unbearably, missing her
and worrying over her well-being. Something in the conjugation of the actual
installation with my knowledge of Akerman's long career in film-making
made it urgent to write this work. For in that moment I realized that the
whole of Chantal Akerman's work could be re-read, retrospectively, as a long
journey home, namely as a journey *towards* the trauma that is finally claimed
and transformed in this work – trans-formed by a process of film-making that
hovers undecidably between fiction and history through the creative devices
that Janet Bergstrom named 'invented memories' and Alisa Lebow identified
as 'transitive autobiography'.[2]

I first encountered Akerman's cinema at the Edinburgh Film Festival in
1975. I was a rookie in emerging radical cultural politics, utterly naive about
the cinematic avant-garde. As part of the *Psychoanalysis and Cinema* event at
the Festival that engaged with nascent feminist cinematics, Akerman's three-
and-a-half-hour film *Jeanne Dielman, 23 Quai du Commerce, 1080 Bruxelles*
was screened. I had no means of immediately appreciating this film. I felt
aggressed by the film's duration, its slow deliberate attentiveness to 'nothing'
but the silently performed ritual of a woman's emotionally immiserated
daily life as widow and prostitute. Domesticity, motherhood and prostitu-
tion were certainly 'feminist' issues. It would not, however, take much time

for my theoretical and cultural education to improve sufficiently by means of viewings of more Godard and Snow movies, joining a *Screen* magazine reading group and attending SEFT film education weekends, to realize what a profoundly radical film Akerman had made about all of these issues. Laura Mulvey's infamous essay that ignited feminist film theory appeared in *Screen* that same year. My close association with key artists in the development of feminist avant-garde art and film practices during the 1970s further extended the resources with which I could return to Akerman's extraordinary film and recognize its beautiful ambivalence towards the mother-figure, its 'feminist' refusal of classic cinematic language of shot and reverse shot, of cutting and fast editing, its radical production of duration and a novel mode of gazing. Akerman's fixed, low camera position and the long takes were welcomed as signs of a new feminist grammar that avoided objectifying woman within cinema while allowing, by such radical disobedience from Hollywood conventions, a representational space for inscribing woman as a subject, for creating a narrative, however ambivalent, of feminine subjectivity in its subjection to the domestic. The film witnessed the loving attention of the daughter film-maker to the typically overlooked and unconsidered gestures of daily, housewifely life. Yet much remained inexplicable and remote. I wrote that off as the enigma of its avant-gardeness.

Feminists argued, of course, over what the murder in the final hour of the film signified. Was it revulsion at 'Jeanne's' emptied life or a troubling eruption of sexual pleasure? The extraordinary final scene of seven minutes during which the central character simply sits in silence while blood trickles off her hand (Figure 82) was read cinematically as creation of a time-space for reflection in lieu of the usual tidying up, the ideological packing away of the problem that is the norm in classic Hollywood entertainment cinema.

It was in New York in 1997 that I saw Akerman's first 'art' installation. Her field of independent cinema as a major art form lost its institutional base in alternative cinemas just as the visual arts embraced new media as their privileged form. Unexpectedly, the museum was now going to be the primary site of encounter with Akerman's work as she began to bridge the spheres of independent cinema and new visual art forms with an installation art work based on a recently made film: *D'Est/From the East*.

In the early 1990s, Chantal Akerman, known up to that point as an avant-garde film-maker, was invited by the curators Kathy Halbreich and Bruce Jenkins of the Walker Art Center in Minneapolis, one of the prestigious venues for showing modern and contemporary art in the US, in collaboration with two other US art institutions, to create a new work using the emerging form of contemporary practice: installation. The already distinguished and respected cinéaste – formed in the tradition of Jean-Luc Godard, Margué-rite Duras, Agnès Varda and Alain Resnais – created an 'art work' called

Bordering on Fiction. In the early 1990s Akerman was seeking to make a film about the Russian poet Anna Akhmatova. Initially unable to get funding, Akerman independently made a film about a journey from Berlin through Eastern Europe to Moscow that she called, not to the East, but *From the East*. *D'Est* then became part of and source material for a three-part installation that opened at the San Francisco Museum of Modern Art on 21 January 1995, before travelling to the Walker Art Center, and concluding with its exhibition at the Galerie nationale du Jeu de Paume, in Paris in the autumn of that year. In 1996 it was shown in Brussels and Valencia and in Wolfsburg, Germany before concluding its tour in New York at the Jewish Museum in the spring of 1997.

Made possible by the break-up of the Soviet Union and its extended empire, in 1992/93 Akerman made several journeys with her crew travelling east from Berlin to Moscow across the newly democratized countries of Eastern Europe. The result was a full-length 107-minute film in which her signature cinematic features – fixed camera, long travelling shots, slow drive-by filming – were now applied to the newly traversable landscapes of a formerly unknown Eastern Europe. The camera's agnostic attention to landscapes, roadsides, bus stations, people walking in the street, disclosed to the viewer, without voice-over or commentary, a terrible truth: it created the accumulating sense of absence of the disappeared Jewish populations of these spaces, combined with a haunting sense of the menace in these ordinary daily rituals. The fields and cities of Eastern Europe were, after 1985, cinematically inscribed as *the* landscape of loss: 'this is the place', as Chelmno survivor Simon Srebnick declares in the first spoken words of Claude Lanzmann's *Shoah* (1985) when he is taken back to the emptied and desolate site of the first death camp in Chelmno in rural Poland. Unlike, yet after Lanzmann, Akerman was not looking for witness(es) to the destruction of European Jewry. She was not expecting anything. She simply filmed the place, as it was, fifty years after. The filming found this history.

When I first entered the space of the cinematic projection of *D'Est* and seated myself in expectation of a work of typical Akermanian duration, I came to realize that I was experiencing once again the key cinematic effect of Akerman's temporality: disclosure. Her fixed camera watched a landscape where women worked. Trucks trundled by. The camera stayed put. As I in turn watched these scenes in Poland in which, to use Ivone Margulies's term, 'nothing happens', I realized that I was witnessing agriculture and daily life more or less unchanged since before 1945.[3] Suspended in historical deep freeze by economic stagnation under Communism, the landscapes of Poland or the Ukraine in the mid-1990s looked unchanged from those of 1939, with little technological advancement. Poland and Eastern Europe had remained in the same time-space as before Communism – except for the absences of those who had, just fifty years before, also worked, walked and lived here. It was

this tangible quality of absenting of once-ubiquitous Jewish communities that was revealed by what the film's attention disclosed. Visibility of this same yet different life-world made absence poignant, and injected terrible pathos into the cinematic encounter with this denuded present.

The filming unostentatiously made the viewer sense history by virtue of its attention to these places that Belgian-born Akerman was herself seeing for the first time but which she was also, personally, finding vicariously familiar. This was another disclosure. This other scene had been the one-time home of her own displaced Jewish family. She would recognize here familiar foods from her own home found nowhere else in Brussels. But there were other resonances.

Scenes of Russians in wintry nights walking the streets or waiting at a bus stop had a different resonance for a child who had spent a childhood imagining *over there* – the euphemism used by Holocaust survivors for their pre-war life-worlds in the east (Figure 83). These modern-day people walking and queuing thus became a reminder, an evocation of other queues, other streams of people passively waiting transport, a different kind of transport, to an unimaginable destination. Innocent and everyday, these scenes of urban life shared Akermanisms with the earlier film *News from Home* (1976) that had observed street life in Manhattan. Here these scenes in Eastern Europe were surcharged with menace, shaped not so much by actual or inherited memory; their charge came from a historical resonance created by *cinematic* memory. *D'Est* is intertextually in conversation with scenes of people walking with bundles, queueing in the street, with newsreel images of European people being rounded up for deportation made iconic by Alain Resnais's use of archive footage in his film *Night and Fog* (1955), impossible to escape in post-war film culture (Figure 84).[4]

In the installation format of 1995, the film *D'Est* was screened cinematically in the first room as a 35mm film. In the second room, the same film was streamed across 24 TV monitors choreographed by computer-generated timings and editings to make imagery flow, revealing its own symptomatic repetitions (Plate 16). Here was the beginning of a rewriting of the contained movement of the cinematic image into a spatializing stream that would relate to new technologies as much as it evoked older, modernist and psychoanalytical notions of fragmentation, seriality and symptom. The darkened room was crowded with grouped plinths bearing the luminous boxes that heightened the movements and the encounters with the faces and places of an Eastern Europe that Akerman had discovered, in the filming, that she already knew – she who was born in Brussels, spoke French, loved Godard and made French new-wave movies. She is the child of survivors of the Holocaust and in her Brussels home, the foods of Eastern Europe often, inexplicably until this moment of re-encounter, displaced the western European cuisine typical

of her Belgian school friends and neighbours. In making the film she was encountering some part of herself and a history she unknowingly carried even as she recorded its disappearance from its own landscape.

In her profound study of this film under the sign of 'transitive autobiography' Alisa Lebow links Akerman's mode with Walter Benjamin's unconventional concept of an autobiography 'concerned with "space, moments and discontinuities"' and his concept of the image as one in which the time of the Then and of the Now flash up as in a constellation'.[5] My question would be: is the autobiographical the ground for or the discovery made during filming? What autobiographical element that 'belongs' to the filming subject does the film disclose? The installation in the third part of the work addressed such questions in the artist/film-maker's own voice.

In the third room a single TV monitor, with two speakers like extended ears on each side, sat on the floor of an otherwise empty room (Figure 85). On its surface, cycled a repeating short showing a heavily grained and thus indistinct image of a night sky in the city punctuated by the odd street lamp. A cello plays. There is a voice over. It is the accented voice of Akerman herself. She begins by reading in perfect Hebrew the second commandment forbidding the making of graven images. Jewish law and the image, even as one that almost fails as such, collide. Akerman talks about making films and having to know, or not know, in advance what the film is about.

> You must always write when you want to make a film, although you know nothing of the film. Yet, you already know everything about it. But you don't realize this. Fortunately, I would say. Only when it is confronted with the act of making will it reveal itself.[6]

But what is revealed? The film's subject? The subject's film? Is it memory or something hitherto unknown, without form, until now, that again traces itself into the space and time of the film?

> And slowly we all realize that it is the same thing that is revealed. A little like a primal scene. And the primal scene for me, although I fight against it and end up in a rage. I have to face facts. It is far behind and always in front of all images barely covered by other luminous or even radiant ones. All images of evacuation, of walking in the snow with packages toward an unknown place, of faces and bodies placed next to one another … And it was always like that. Yesterday, today and tomorrow, there were, there will be, there are at this very moment people whom history (which no longer has a capital H) has struck down. People who were waiting there, packed together, to be killed, beaten or starved or who walk without knowing where they are going, in groups or alone. There is nothing to do. It is obsessive and I am obsessed. Despite the cello, despite cinema. Once the film is finished I said to myself, 'so, that's what it was; that again.'[7]

That, again. But this appears to be the first time that what *that* is, again and again, has taken form, has found its spaces in a historical landscape of Eastern Europe and found its faces in the others, still there, who cannot replace their Jewish neighbours who were disappeared after they were rounded up, and forced to walk with packages towards forms of transport and modes of dying.

That, again. That, like it, is indicated but not specified. Again reminds us of repetition. It is linked to obsession. Thus by taking the journey to the places and spaces of a history she had somehow, vicariously, known while being born and growing up in Brussels, and that her films had symptomatically registered as one of their many tenors, threads, tracks, pressures, Akerman returned to the primal scene of the sources of her anxiety: she located and faced what we now called intergenerational transmission of trauma.

Like many children of survivors, Akerman belongs to a second generation who experience the normal, unspoken transmissions between parents and children, except that what appears to be part of the cultural passing on is massive trauma: that which the parents do not tell, or even know to tell. Like the air she breathes, the parent's non-narrated past inhabits the child's psychological present with a permanent movie without images or words: a memory with holes. Images are obliquely supplied by other films and photographs. Surreptitiously the inhabited child borrowed from and her imagination is fed by real movies and images that offered themselves to give shape to shapeless intimations of unspoken experiences. The child lives inside memories of things she never experienced, or she is haunted by a sense of terror or anxiety, even sometimes experiencing hallucinatory images from another time and place. Writing in 1979, American Helen Epstein was one of the first to explore her troubling sensations of a box of darkness and horror buried within her by meeting with other children of survivor families.

> For years it lay like an iron box buried so deep inside me that I was never sure what it was. I knew I carried slippery, combustible things more secret than sex and more dangerous that any shadow or ghost. Ghosts had shape and name. What lay inside my iron box had none. Whatever lived inside me was so potent that words crumbled before they could describe. Sometimes I thought I carried a terrible bomb. I had glimpses of destruction. In school, when I had finished a test before time was up or was daydreaming on my way home, my safe world fell away and I saw things no little girl should see. Blood and shattered glass. Piles of skeletons and blackened barbed wire with bits of flesh stuck to it the way flies stick to walls after they are swatted dead. Hills of suitcases, mountains of children's shoes. Whips, pistols, boots, knives and needles.[8]

Resonating with my earlier discussion of encrypting of trauma, even of others' traumas in discussion of Alina Szapocznikow, Epstein writes:

The box became a vault, collecting in darkness, always collecting, pictures, words, my parents' glances, becoming loaded with weight. It sank deeper as I grew older, so packed with undigested things it finally became impossible to ignore.[9]

Writing in the mid-1990s of her experience of growing up in Britain as the child of Jewish survivors from Poland, sociologist Anne Karpf testified to another way of living with the Holocaust when the opposite occurs, namely when parents speak constantly of their own experiences which were so extreme as to render insignificant the ordinary struggles of the child's own growing up in the present.[10] Israeli novelist David Grossman made the survivor's child's troubled imagination about *over there* and a phantasized Nazi beast the topic of the first part of his novel *See Under Love*.[11] Israeli actor and writer Gila Almagor wrote it into her autobiographical novel *The Summer of Avia*.[12] Perhaps the most vivid and visual testament to second-generation-ness is Art Spiegelman's graphic novel *Maus*.[13]

The acknowledgement of the very possibility of intergenerational transmission of trauma first emerged, however, during the 1970s when psychoanalysts began to find themselves working with children of the surviving generation and identifying what psychoanalyst Judith Kestenberg first described as *transposition*:

Transposition describes the uncanny experience where the past reality of the parent intrudes into the present psychological reality of the child. Transposition is an anomalous version of the ordinary psychological processes whereby the wishes, desires, fantasies, ideals and experiences of a parent are unconsciously transmitted to a child. Transposition is generational transmission run amok.[14]

Transposition inverts the logic of time; but it also places history inside, hence structurally, the psychological formation of the child born after its occurrence:

Transposition turns the ordinary dimensions of time and space inside out ... Transposition also refers to reversals of ordinary time, whereby the temporal position of parent and child are exchanged. Since the parent's past occupies the psychological space that would ordinarily belong to the current life of the child, the child must give up its right to exist in its own present. What makes transposition so monstrous and preternatural is that it entails the transmission of *massive* trauma.[15]

What follows from such insights not only concerns the recognition of the transmission of history as trauma, as being occupied by what is missing, but also makes us explore the specific mechanisms and processes by which this inheritance of the traumatic void will be negotiated and may be aesthetically transformed, not through calculation but that openness to its moment of encounter.

Document to fiction and back

Preparing to make a gentle and comic fiction film *Tomorrow we Move* (2004) about a writer whose widowed mother moves into her apartment with chaotic effect, forcing her to put up her apartment for sale, Belgian film-maker Chantal Akerman visited her mother Nelly Akerman in Brussels one Sunday and asked her assistant, Renaud Gonzalez, to film an *impromptu* conversation. A piece of 'research' for a prospective scene that would later be scripted for and performed by two professional actors (Aurore Clément and Sylvie Testud) in the commercial movie, this informal encounter filmed on a little digital camera, which recorded Chantal Akerman and her mother on screen together for the first time, was subsequently reworked into a dual-screen projection and framed by a two-part sculptural installation, *Walking Next to One's Shoelaces Inside an Empty Fridge* exhibited in Marian Goodman's Gallery in 2004 in Paris and New York. (Figure 81)

By means of understated references, the film *Tomorrow we Move* opens itself to the issues of the intergenerational transmission of trauma and memory across the catastrophe of the Shoah through what Akerman calls 'the sacrificed generation'. This term refers to the young men and women who survived the *Shoah*, but had to sacrifice their own adolescent ambitions to ensure the resumed continuity of often desperate daily life. Their initial trauma, unmourned, and their sacrificed identities may pass, unspoken, onto the second generation, their children. But what is transmitted is, in this case, experienced as a void:

> People of my parents' generation told themselves: we are going to spare them the story of what happened to us. Because they did not transmit their histories, I searched for a false memory, a kind of imaginary, reconstructed memory rather than the truth.[16]

Like Akerman herself, many of these children became creative people, remaining haunted by the presence within their own psyches of a past not entirely their own. Of her maternal grandparents Chantal Akerman has written:

> Like two lambs, they let themselves be taken by the Germans. They believed the Red Cross card would protect them.

> What happened to them over there, afterwards? Like everyone else I try to imagine it, even if they say it's impossible to imagine. Yet, I let myself imagine something anyway, and the worst part of is imagining them naked. Him as well as her. 'Naked as a worm', as they say.

> Of him, my grandfather there is only an identity photo. At least, there's that, even if it's only that. There are also some phrases that escape from time to time from my mother. That is how I know that he was a wonderful man, very

religious, who closed his eyes to my grandmother's modern ways. It seems he let her do what she wanted. And of my grandmother there remains her young girl's notebook. My mother gave it to me. She said, it will protect you. She gave it to me when I was in need of being protected and she felt powerless. *She gave it to me instead of talking.* She gave it to me, that's the point. It's been mine since 1984, I think. In fact everything changed in 1984. I sang so hard I exploded. Since then I explode from time to time. (My emphasis)[17]

Explosion was the concluding gesture of Akerman's very first film: *Saute ma Ville: Explode my Town* (1968) in which a young woman returns to her apartment, barricades herself in the kitchen, begins to tape up doors and windows, cleans, cooks, sings and finally lays her head on the cooker, turns on the gas and awaits the explosion ignited by setting a bunch of flowers alight. In the blackness of the final frame, the explosion rumbles on suggesting a chain of explosions engulfing the entire city, while a singing voice finally returns, jarring with the enormity of the explosive event that is never allowed to be fully grasped by the film's tone. Mismatch of affect is the hallmark of this compelling short film.

In the text that I have just quoted, however, Chantal Akerman articulates three important dimensions of being a child of survivors of the Holocaust. The child grows up without grandparents.[18] The mystery of the orphaned parent transmits to the child an additional enigma to be deciphered by attempting to imagine both the beings of the parent's missing parents and, in the particularity of historical catastrophe that destroyed European Jewry in the middle of the twentieth century, the horror of their ending, namely their naked deaths in Auschwitz. Thus what has to be integrated is not merely the succession of generations within which the child 'normally' takes its place, but the traumatic, historical rupture – that takes places *over there* in the parlance of Jewish survivors from Poland – of which the child is the inheritor. She is not born into life and its reassuring cycles; it is untimely deaths that have somehow to be imagined if only to incorporate them into the grounds of living on *after*.

Secondly, the absence and the unimaginable but always to be imagined end of the parents of the mother are both marked, and compensated for, by fetishizing relics that function as both substitutive memorials of the missing and markers of their horrible absenting: an identity photograph in one case and a notebook-diary in the other. The photograph of the grandfather installs an image and supports what Marianne Hirsch in her analysis of the households of survivor families with their fractured family albums calls *post-memory*. Post-memory is mediated by the photographic index of another time, place, world and generation; it is a space in the child-subject that links it with a world and events it personally never knew but with which it acquires a dislocated, imaginary intimacy.[19] As in the case of Art Spiegelman, author

of the second-generation tale *Maus*, photographs punctuate the vast tracts of missing families and worlds from which the child is exiled while yet being inhabited through the intergenerational transmission of trauma.[20]

Of her grandmother, Chantal Akerman can hold in her hands a material object, a diary written by missing grandmother's own hand when she was herself a teenager and young woman. It contains her confessional writing and a watercolour portrait of a woman. Writing and painting mark the paper with two actions that defy the limited identities permitted to the religious Jewish woman in particular and to the Western bourgeois woman in general, neither of whom is expected to be or be accepted as a writer or an artist. Writing and painting mark ambition and desire for creative self-inscription, and the longing for that which is missing: someone with whom to speak so as to be recognized in what is experienced as the exiled condition of the thinking, feeling, creative – and above all modernizing – woman. Luce Irigaray's poignant evocation of the condition of the feminine subject in phallocentric culture as a 'derelict' figure abandoned in a cultural desert is evoked perfectly in the words with which this sole relic of the being of Sidonie Ehrenberg opens:

> I am a woman!
> That is why I cannot speak all my desires and my thoughts out loud. I can only suffer in hiding. So to you, this journal of mine I want at least to say some of my thoughts, my desires, my sorrows and my joys and I will be sure that you will never betray me because you will be my only confidant.[21]

How closely this tiny passage resonates with the writing of Virginia Woolf, who in the same decades of the early twentieth century would also ponder on the internal and external censorship on the full articulation of woman as desiring, thinking, imagining subject. Culminating in her essay of 1931, 'Professions for Women', Woolf famously imagined the deadly struggle waged by the would-be woman writer against the inner voice of patriarchal ideology that took the form of the 'Angel in the House': a bourgeois feminine ideal offered to women by that culture that forbade the woman to think for herself. The Angel, that threatened to take the heart and the body out of the woman's writing, had to be killed.

> Now that she had rid herself of falsehood, the young woman had only to be herself. Ah, but what is 'herself'? I mean what is a woman? I assure you, I do not know. I do not think that anybody can know until she has expressed herself in all the arts and professions open to human skill.[22]

Woolf continues to present her own experiences as a writer who, in following the free flow of imaginative creation, is catastrophically brought up against the hard wall of social censure when she dares to think about the body, desire, sexualities prohibited by the culture in woman. 'The first – killing the Angel in

the House – I think I solved. She died. But the second, telling the truth about my own experiences as a body, I do not think I solved. I doubt any woman has solved it yet.'[23] We can dare to reach across time to another, perhaps the most famous diary of the twentieth century, in which a young Jewish writer-to-be living in hiding in the early 1940s used the imaginative spaces of her diary, addressed to her invented phantom-friend named Kitty, to explore her own sexual awakening only to have these historically significant passages about feminine subjectivity and sexuality censored from the published form of *The Diary of a Young Girl* that appeared in 1947. I am, of course, thinking of the work of Anna Frank, returned to us in its full historical significance as a feminist text only in the 1990s, fifty years after her dreadful and lonely death in Bergen-Belsen.[24]

To find the traces in a fragmentary private diary of a young Jewish woman from Poland *c.*1920–22 of what we know to be the central tropes of emergent feminist modernism, emplots the larger cultural history of the twentieth century into the historical catastrophe of the Jewish world in Europe which passes through the intervening generation represented by Nathalia Akerman, both the mother of one of the most renowned contemporary film-makers of the later twentieth century and the embodiment of the traumatic breaching of historical succession from the lost woman artist who was her own mother.

The third aspect I want to note in this passage is that Akerman states that her mother gave her the diary in 1984 'instead of talking'. As Bracha Ettinger writes in her *Notes on Painting: Matrix Halal(a) Lapsus* in 1992:

> My parents are proud of their silence. It is their way of sparing others and their children from suffering. But in this silence, all is transmitted except the narra-tive. In silence, nothing can be changed in the narrative which hides itself.[25]

Silence was the mark of *Jeanne Dielman, 23 Quai du Commerce, 1080 Bruxelles* (1975), the film which made Akerman one of the major names of a new feminist counter-cinema. Lasting three and a half hours, the film tracks three days in the life of a single mother raising a son in emotionally desolate isolation, earning money by part-time prostitution. The mother's rigorous routines, which maintain this non-life, are disorganized by the eruption of a violence of unexplained 'feeling' during the second 'day'. The film ends with a woman sitting in silence for the last seven minutes, after killing her client in what I take now to be a gesture of resistance to and revulsion from her hitherto mute and routinized endurance (Figure 82). Critics then and since have always sensed that films such as this and *News from Home* were an ambivalent 'love letters' to the/her mother.[26] But that language fails to acknowledge the inhabi-tation, the *transcryptum*, that the pages of the multiply inscribed grandma-ternal diary already carry.[27]

Something could not be spoken; yet there was a transmission mediated by this text-object. Twenty years passed until Nelly and Chantal Akerman were

filmed together and the return to the diary enabled the beginning of talking, which is what we are invited to witness in the installation of 2004.

Walking Next to One's Shoelaces Inside an Empty Fridge is very different from the finely tuned, economic and affecting movie *Tomorrow we Move*, in which one of the many people who come to inspect the apartment of the heroine (who seeks to move, better to accommodate the arrival of her widowed mother) finds, secretly takes, and then returns a notebook forgotten in an overstuffed cupboard. Unable to sleep one night, the daughter begins to read it until she is joined by her equally insomniac mother. Together they peruse it, at first struggling to decipher and read out loud the Polish text and then reviewing its pages and drawing in silence until the mother reaches out, strokes her daughter's face and kisses her cheek. (Figure 86)

Let us turn back to the installation with this knowledge of that scene.

Full of words, framed by a fragile labyrinth through which the viewer accesses the installation, the filmic element of the installation is embedded in a sculptural structure that was also a temporal one. Filling the first space of the installation, there is a double spiral structure of transparent tulle on which are streamed words moving too fast to read but leaving poetic and suggestive traces of the thoughts, readings and reflections of the artist and the grandmother (Figure 87). This structure purposively invokes memories of minimalist sculptor Richard Serra's bare, iron spiralling construction, *Doubled Torqued Ellipse* (1997, DIA Art Foundation). Both Akerman and Serra exhibited at the Venice Bienale of 2000. (Akerman showed a multi-video-screened installation of *Woman Sitting After Killing*.) Yet Serra's monumentality is entirely reversed by the way in which the sculptural forms of Akerman becomes animated screens for moving flows of words that almost too literally illustrate Virginia Woolf's modernist and feminist concept of a stream of consciousness. Writing of this relation to Serra in 2005, Nathan Lee comments: 'But where Serra stages a cathedral encounter, overwhelming and uplifting the spectator through his monumental cast-iron sublimities, Akerman fashions a weightless envelopment, a dissolving of self amid whirling transparencies.'[28]

You can only access the installation by entering into the luminous, evanescent, curving, broken space that tensely balances both a modernist 'mother' and a minimalist 'father', movement and structure, text and surface. The viewer moves into a second room in the midst of which hangs a transparent tulle scrim in open space (Figure 88). On this scrim is projected a single painted head of a young woman in nineteenth-century costume, but dating from the 1920s (Figure 89). Then there is a moving image of a page of handwritten text that wanders across the scrim. The shared surface suggests a relation between the open pages of a notebook and this small painting of a woman. Looking through the punctuated scrim, the viewer sees a large, double-screen, out-of-focus video projection (Figure 90). Over a period of 24 minutes, this projec-

tion unfolds the story of the film-maker herself bringing to her mother a notebook/diary, asking her to read it, to translate its words from Polish, while the mother slowly comes to realize that she is reading the handwriting of her own mother, Sidonie Ehrenberg, who wrote this diary as a teenager and was murdered in 1942 in Auschwitz.

Having struggled with the poignant text that begins declaratively 'I am woman!' and tells the diary that she is, therefore, alone with the book as her only confidant, and lonely because she has no one to share her heart with, the mother of the film-maker falls silent and reads the returning words of her own mother written long before she herself was born. At this stage the viewer cannot know what she is reading when she falls silent and ceases to translate or comment. The effect of what she reads is, however, sufficiently moving to make her turn, weeping slightly, and to caress her daughter's cheek, and then to kiss it (Figure 81).

This gesture, enacted in silence in the middle of this manipulated double projection, functions as a hinge between the 'set-up' orchestrated by the film-maker as 'research' for her movie to come and a time-reversing moment in which, for this student of Akerman's cinematic career, everything from the beginning became plain.

Watching this work for the first time, I felt then and in a Benjaminian flash as if an entire career had been undertaken, movie after movie and, since 1995, art installation after installation, to arrive at that possibility, that moment, that gesture, captured not by the film-maker looking through the lens at the world waiting for its disclosures, but as its recipient, the skin brushed by the touch of the mother's hand and lips. That gesture was what I can only name a Warburgian *pathos formula*: a *form*-ulation for feeling in which the body and its gestures eloquently enact what cannot easily be said.[29]

What caused the gesture? What caused me to read it in a Warburgian way? It appears that in reading to the end of the written pages of the diary, Nelly Akerman discovered, as if for the first time, her own inscription made in 1945, as a bereaved eighteen-year-old, to her lost mother when, barely alive herself, she received this diary (she cannot remember how it came to her) as the only surviving relic of her murdered mother. She had written:

> This is the diary of my poor mother who disappeared so early, at the age of 40. I will never forget her young girl's life, I will always think of her as the best mother who ever lived. I am sorry that I did not love her more and love her better than I loved her. She was so good and so understanding that she will remain in my heart always, singular and unique, and no one will ever replace her for me. My dear little mother, *protect* me. Nelly

But the diary had been found by the daughter of Nelly, Chantal, when she was about ten (1960). She had found the inscription by her mother and added her

own into this unique object already overinscribed:

> Dear Mama, You can't imagine how I felt reading what you wrote in those few
> lines. I hope you feel *protected* and loved by all and that you are happy. Chantal

In turn, Chantal's younger sister also finds the diary and adds her own words:

> Dear Mama, I also felt something in my heart reading what you had written.
> No one can replace you dear Mama, I would have loved to know your beloved
> mother. Your daughter who loves you so much. Sylviane

I have highlighted the recurring word *protection*. It recalls the passage already
quoted:

> My mother gave it to me. She said, it will protect you. She gave it to me when I
> was in need of being protected and she felt powerless. *She gave it to me instead
> of talking.*

Protection signals its own opposite: anxiety and vulnerability. No one who has
not lived with or around survivors of the Holocaust or other utterly shattering
traumas can fully appreciate what it means to have to live in the world after
the sudden destruction of the trustworthiness of others, and after the resulting
loss of faith in the world, not to encompass your destruction. Non-survivors
cannot imagine just as those who have never been bereaved can imagine the
effect of the rupture that destroys an unquestioned confidence in persistence
and security in relation to others. Thus this anxious need to provide protection
is itself the deep symptom of the past passed onto the child who can never
experience unquestioned confidence in being in the world, but must always
sense an anxiety towards the world.

What is, moreover, intensely striking in this accumulation of inscriptions
is the deep compassion of the child *towards* the vulnerable parent, a compas-
sion so beautifully explored in the work of Bracha Ettinger and located in the
proto-ethical pre-birth encounter of mother-to-be and child-to-be in their
co-affecting yet unknowable matrixial severality.[30]

In *Walking* the tears and the kiss are wordless; they are a response that
returns to gesture as the movement towards, but also with and beside, another,
and returns to the touch, to a moment of affect and contact that does not
dissolve difference but marks a shared moment and creates a surface of
meeting, a space of connection. What follows from the gesture of touching her
daughter's face and kissing it, affirming her being there, is a long free-flowing
conversation between them about the past – first about the plans and pre-war
ambitions of Nelly and her artistic mother to work in some aspect of design,
couture perhaps, then the regrets of Nelly Akerman who returned from her
experience in the camps 'damaged and broken' unable to take up her studies,
and in need of the support offered by her husband, a leather merchant. Here is

evidence of the mother as part of 'the sacrificed generation', meaning men and women like her mother whose lives were so radically interrupted that mere survival after their experiences consumed their energies. Yet this conversation about what her mother had endured, how she had been supported through the devastating hunger of her time in the camps by a friend, and how she was liberated puts in place the long-missing 'story' without holes.

Born of a Polish-Jewish family settled in Belgium since the 1930s, Nelly Akerman had been arrested with her aunts and taken to Malines, known in Flemish as Mechelen where in 1942 the SS had established in the Kazerne Dossin a collection camp: *SS-Sammellager Mechelen*, from which 24,916 Jewish people and 351 Roma and Sinti people were deported to death camps in the east (Figure 91). Only 1,221 people survived from these transports from the transit camp. Protected by a woman named Frieda, moved from camp to camp across Germany in the final months of the war, Nelly was re-united with her aunts and aided initially by French deportees before being finally rescued and restored by American soldiers who gently fed the emaciated survivors with teaspoons of soup. The conversation also moves onto why Nelly Akerman supported her own daughter's artistic ambitions, even fighting her husband over his fears for his vulnerable girl-child in the shark-infested waters of the movie business. Thus we witness a historic moment when the traumatic past is opened up to words, to exchanges, questions and shared memories. We glimpse a new intimacy of stories shared and confirmed and spoken recollections.

Art, replay and transformation

In notes, Akerman tells us that Aurore Clément, who plays the mother in *Tomorrow we Move*, watched the 'raw' footage made on the visit home with Renaud Gonzalez filming. For the movie, the contents were fictionalized and words and names were changed. But Aurore Clément took over something extraordinary from the filmed exchange she had been shown. Akerman tells us: 'The Mother (Aurore) at one point says to her daughter in the film Charlotte (played by Sylvie Testud) "it's a miracle that I am here and that you're here, you know"'. That is to say that the mother-to-be's survival at all was such an accident, that the very existence of a new generation is marked by the contingency of a survival that escaped the genocidal death sentence that engulfed the millions and yet remains utterly marked by what should/could have in fact happened. Akerman adds: 'My mother did not say that, when Renaud and I filmed her. At one point, Aurore kisses her daughter. In the film, we do not know why.' Then she continues:

> In the images of my mother we do not know why either, why all of a sudden she kisses me. I know why; she has just discovered what I and my sister added.

First, what she had written following her mother's last words. She did not remember it. She no longer remembered what she had written.

The film preparation in 2004 creates the moment in present time for an anamnestic re-encounter with a forgotten, a repressed past held before them in material form of the diary, saved, forgotten, found, reinscribed, now read together. In another reversal, Akerman also tells us that her mother came to the set and watched Aurore Clément play the scene based on the filmed encounter between herself and her daughter.

> Suddenly I saw tears in her eyes. She tried to hold them back. But she could not. They were little tears, very discreet. The next day I telephoned and she said, you know I was a little overwhelmed yesterday, but I finally feel better.
>
> All these films have finally brought me to that. She finally feels better. She finally shed a tear. Thirty-three years of work with so many turns and detours, and she finally feels better. Is this what I was looking for?
>
> I have no idea.
>
> Maybe
>
> I'd like to believe it.
>
> But honestly not just that.

These words can hardly contain the immensity they register: that finally, after all these years, Nelly Akerman feels better. Did the translation of the 'event-encounter' that happened with the diary before the digital camera in her own home into a formal scene played by others 'transform' her own lived burden of history, relieve her of feelings, make change within her possible? How important is the trans*formation* where the *trans* dimension of the movements between mothers and daughters, and then actors, links in with the *metramorphosis*, the creation of a pathos formulation, through which the trauma that was always there as the equally constitutive void between mother and daughter is held now outside both of them by an aesthetic formulation precipitated by and disclosed through the 'research' filming one Sunday in Brussels?

There is a danger here. The reader might think that we are finally finding the key, and a biographical key, that unlocks the secrets of thirty-three years of Akerman's film-making. Reduction of a lifetime's work to one single, autobiographical causation is utterly ridiculous. It is true in one deep sense as Akerman admits, but she adds importantly, '*[b]ut honestly not just that.*' To this we have to pay acute attention.

Yes, we do have to make sense of the belated moment of realization when a single gesture *and its replay* and *revisioning* through the medium of digital recording and then cinematographic performance and registration appears to crystallize a shapeless haunting past into that which can be said, scripted,

performed, watched, and taken on and wept over. There were two moments. I suggest, when the 'trauma' – which is what we are dealing with – leaks out of the body in the flow of slight tearfulness. We are not confronting the wracking sobs of immediate, abreactive grief. Nelly Akerman's damp eyes that Sunday in Brussels and her 'discreet' tears on the film set are subtle moments when the body fluidly betrays its own frozen encrypted hoard. The relief of the tears is gentle in direct disproportion to the unspeakable enormity of the event these tears now appear to relieve. The disproportion is the very sign of trauma as is the belatedness of both scenes to their originary moment.

I am not suggesting that suddenly in Brussels before Renaud Gonzalez's camera the truth of Akerman's cinema was revealed as the long-secreted family history of destruction and survival in the Shoah. Secreted, it was always the shadow on their lives. Yet I am suggesting, as others before, that this is the historical ground that cannot be ignored in tracing the specific aesthetics and ethics of Akerman's long career to date precisely because its deepest core, by definition, could never be directly confronted.

I want here to stress its emergence across the sequence of events: the filming, the watching of that footage, the watching of its being turned into cinema, and after all three events, there is the moment of flowing words (later formalized by streams of them flowing over the convoluted sculptural forms through which the installation is accessed).[31] Conversation marks a different space, process and relation to past and future. There is the flow of words; unblocked, silenced burdens can find themselves uttered without destruction befalling the speakers. Yet before this moment, there was neither this flow of tears – feeling better – nor words. Indeed silence or violent explosion, missed communication and absence, even murder or manic musical gaiety marked the cinematic rhetoric of Akerman in ways which found acceptance and acknowledgement as part of an avant-garde at once Godardian, Warholian, Snowian and feminist. We accepted the signs of her cinematic intervention with its unexplained enigmas, but we knew not the specifics of their causation in a deeper trauma than that of the choked feminine voice in culture meeting a new cinematic formalism.

I want to draw attention to stories, or to the role of storytelling as a mediating process between a sensed dimension of unspoken pasts and a certain kind of structuration that parcels out this otherness in mediated doses. This opens onto two insights by scholars who work with the relations between traumatic history and cultural representation. Writing of the failure to mourn in the German context, Eric Santner identified two contrary strategies in cultural practices in the aftermath of trauma. The first he named 'narrative fetishism' invoking Freud's double structure of disavowal and memorialization.

By narrative fetishism I mean the construction and deployment of a narrative consciously or unconsciously designed to expunge the traces of the trauma or loss that called that narrative into being in the first place ... Narrative fetishism is the way an inability to mourn emplots traumatic events; it is a strategy of undoing, in fantasy, the need for mourning by simulating conditions of intactness, typically by situation the site and origin of loss elsewhere.[32]

The baulked disavowal of loss transferred to a monument, for instance, might have operated in the Akerman case through the repeatedly lost and refound diary. Santner contrasts this tendency to displace with the genuine process of the *work* of mourning, a process that must take place over time, through different sorties as it were:

The work of mourning is a process of elaborating and integrating the reality of loss or traumatic shock by remembering and repeating it in symbolically and dialogically mediated doses; it is a process of translating, troping and figuring loss, and, as Dominick LaCapra has noted in his chapter, may encompass, a 'relation between language and silence that is in some sense ritualized'.[33]

Drawing on Freud's major redirection of psychoanalytical theory around 1915 from cathartic abreaction from trauma to an economic model of psychodynamic work (working through and the work of mourning) which involves both time and a processing in dialogical encounters and mediated doses, Santner suggests that, in fact, trauma may take a long time to be worked through. That working through does not amount to a cure. It involves a process of reconfiguration of affects through symbolic articulations that *translate, trope and figure* loss. We do not ever get over loss, but loss can be worked into our systems for generating meaning and managing affects by formalisations that include symbolic language but also gestures and rituals.

If we focus on the negative moment in experience, the traumatic, the real, which apparently is encountered, again, but effectively for the first time in the art work as its *formulation*, in *pathos formulae* in Warburg's terms, we need to ask: What is the relation of aesthetic practice to the structural trauma of the archaic encounter which may condition its very possibility? At the same time, we have to ask about its historically traumatic events that may determine the subject's later actions that become the belated sites of the created memory of the primally unremembered. This double form is what Bracha Ettinger has termed 'the memory of oblivion'.[34] By this she is stressing the creation of a memory of that which, having never been known, cannot be said to have been forgotten and then remembered. Such a new form of memory, involving duration and reflection, opens then onto a future, a passage with the trauma that has remained latently at work for the lack of such delivery into forms by which we can transform its legacies. We can invoke Bracha Ettinger's concept of *fascinance*.

Fascinance is an aesthetic event that operates in the prolongation and delaying of the time of the encounter-event and allows a working-through of matrixial differentiating-in-jointness and co-poesis. Fascinance can take place only in a borderlinking within a real, traumatic or phantasmatic, compassionate hospitality.[35]

Ettinger's concept is elaborated through her re-reading of the core psychoanalytical case study of the daughter: Dora. Of Dora's dream/memory of gazing for two hours at Raphael's *Sistine Madonna* held in Dresden, Ettinger writes:

Dora constituted contemplative relations of fascination with the Madonna since this image served for her the function of *fascinance*. Dora created the moment of looking at the Madonna's painting as a matrixial encounter-event by her unconscious urge to produce transformation in the traces of imprints of earlier moments of encounter that had failed. The daughter solicits *fascinance* within the girl-mother relations.[36]

Ettinger affirms: 'In the matrixial encounter, the private subjectivity of the individual is momentarily unbounded. The psyche momentarily melts, and its psychic threads are interwoven with threads emanating from objects, images, and other subjects. In a matrixial encounter with an image, a transformation occurs.'[37] Thus instead of the biographical model in which we might confine Chantal Akerman, her mother and her grandmother, the cinema of Akerman can be read as a prolonged, durational, often incomplete and sometimes stymied staging of the time-space for a necessary *fascinance* addressed in a structural sense of the other mothers who offer grounds for feminine subjectivity and sexuality and in a historical sense to the lost artist-grandmother and the survivor-daughter-become-mother. *Fascinance* might help understand the unique affective quality of attention and duration in Akerman's cinema, ambivalent in its tones of love and violence and what was finally encountered in the little filming in Brussels.

The second Ettingerian concept is *transcryptum* and extends matrixial potentiality for transsubjectivity into aesthetics and trauma studies. Ettinger builds on the work of psychoanalysts Nicholas Abraham and Maria Torok who posited a psychic *crypt* in which is buried an unprocessed traumatic loss without memory. Not connected with actual loss, and not touched by either mourning or its stalling in melancholy, the crypt contains a haunting phantom occasioned, according to André Green, by the change – or shall we say failure – of the maternal imago because of the mother's own grieving, depression or unresolved losses that are not spoken but are nonetheless sensed by her uncomprehending but sensitized child. The child of such a parent is linked to the loss *in the parent*, identifying with what Green names the *psychologically* 'dead mother'.[38]

Thus we have on the one hand the idea of an individual living with an encrypted trauma or loss, and on the other the impact of that unmourned encryption on the child of such a subject, implying an intergenerational transmission of trauma. Ettinger expands both Green's and Abraham/Torok's thought to theorize how a child 'invests libidinally in the traces of someone else's trauma in the psychic apparatus'. Matrixially, the encrypted loss produces a *transcryptum* in which a subject not only assumes memories of pasts she did not live, but is shaped by non-memories, the traumatic holes of the other, and at the same time takes them on, working with them, sometimes creatively. Ettinger draws upon other Freudian concepts, namely the uncanny, in order to explore the ways in which aesthetic processes, which already function by undoing boundaries and transgressing borderlines between discrete subjects between which affects may be transferred, generate transsubjective transmissions.

> I submit that a crypt – with its unburied unthought of knowledge, with what cannot be admitted and signified by the m/Other as loss and is buried alive in an isolated nonconscious cavity, with the traumatism that caused it, with the signifiers that could have told the story, but instead remain detached and isolated, with the image that could have held together the scene, and with the affect that had accompanied it – can be transmitted from one subject to another by metramorphosis, because a capacity and an occasion for this kind of transmission, co-affectivity, co-acting, and co-making already occurred in the archaic relation between each becoming-subject and the m/Other.

My point is that specific aesthetic operations become the site of this psychic working that we sense as the distinctive difference effected in artworking we might claim as feminist because of that differencing.

> Metramorphosis turns the subject's boundaries into thresholds, and co-affectivity turns the borderlines between subjects in distance-in-proximity and between subject and object, into a shareable borderspace.[39]

Ettinger's insights point in two directions at once. Looking one way we can sense the structural condition of susceptibility to transmitted trauma: to the passing on of holes and voids that shaped several subjects' shared psychic terrain. But from another perspective – the Matrixial as aesthetic agency working through metramorphosis – this shareability opens up the possibilities of passages through which the blocked, repressed and repeating voids are transformed at a borderspace where translation may occur.

After the revelation of Akerman's installation *Walking* in Berlin in October 2007, I sensed that an entire cinematic journey had been undertaken by Akerman (and her viewers) to arrive at the moment when 'it' could happen, through her being *with* her mother in front of the camera's discovering

attention. Having seen and felt this work, I knew it would be necessary to review every previous Akerman film and now see in it another dimension. Not the encoding of this discovered truth, her cinema was continuously forming mediated, riddling, periphrastic doses of gentle and subtle movements backwards and towards this kernel of transgenerational losses that were also the source of creative energies, sometimes violently explosive, sometimes stilled and deadly, but always animated by a compassion for the suffering that was at once other and within the pre-occupied self. It is as if the work by Akerman, touching on many other subjects in a long and now truly appreciated career as one of Europe's leading film-makers working with sexuality, cultural difference, dislocation and storytelling, has finally found a means to confront the unspoken history not just of massive absence and terrible dying that was intimated in the railway scene in Germany in *Rendez-vous D'Anna* (1978) and more formally in the twenty-fifth screen of *D'Est* (1995) in which we learn of the 'primal scene', but of the one death that is her mother's loss, and is her own personal passageway to that historical rupture as personalized loss in the maternal line.

The spontaneous gesture, the mother's teary kiss, does not heal the breach. It does repair the rupture. It cannot erase the past. It is the moment that the past becomes the past, allowing a movement into narrative and into the flow of dialogical speech. The mother later says in this video, 'I am glad that I lived to see this day.' The enormity of two life-times is hardly contained in the simplicity of this statement. The filming allowed into that impossible space of mourning and compassion – feeling *with* the other on the part of the child for the parent who is herself a bereaved daughter – a solace that is as painful as it is the relief of a hitherto unspoken but now shared burden. The physicality of her hitherto unshed tears and her touch of the skin of her own daughter, for which the 'research' filming for the other movie set up the occasion, allowed the body to speak, so as to make possible the narrative that released the silent, encrypted trauma into aesthetically occasioned and shareable memory around which both can move. After that moment of tears and the gentle stroke and kiss, captured on the digital camera, mother and daughter begin to talk, about the past, about the mother's story, her experiences in the camp, making a new life afterwards, and how she allowed Chantal Akerman to become an artist not a dealer in leather-goods, to become the artist neither she nor her own mother had been able to become. They talk about her father's resistance to what he saw as a vulnerable career in film-making as a young woman. They mention the first screening of *Saute Ma Ville* on TV when her father was still alive.

Its invisible and illogical violence was not critically received at the time as an inscription of trauma, and certainly not related back to the burden of Jewish family history. I would contend, however, that *Saute Ma Ville* did register a traumatic inflection, in this gesture of absolute destruction that is not directed

against either her family or the hometown. Instead, the film's excess functions as a form of succumbing, by joining, to an unspeakable, senseless feeling of inherited destruction which – as is unprocessed trauma's habit – can only be mimetically acted out. Making the film with this powerful but inexplicable gesture of destruction functioned as the road to personal freedom to become the artist that 'she' (Chantal Akerman and her grandmother/mother) wished to become. It was the example of Godard in the 1960s, structuralist underground cinema in New York and feminism in the 1970s that would finally make possible such a becoming.

How long has it taken for us, or for her as the author of this work, not only to realize the traumatic core exploding into a future cinematic career but to be able to articulate it, non-reductively and with compassion? It is thus a cultural history of what can and cannot be said, in specific relation to the shadow of the Shoah in culture that can be tracked carefully through the work of Akerman. Talking with her mother in *Walking* of the TV screening of *Saute Ma Ville*, Akerman avows that she never again managed this perfect combination of the tragic and the comic that she relentlessly sought, a combination she suggests is born of the predicament of Holocaust survivorship that can only manage the violent pain through the deflection of comedy. The alternative model appears in *Tomorrow we Move* in which a reference to the lingering smell of gas in an apartment links both survivors, the estate agent and the mother, with the writer herself while the Marx Brothers elements of the comedy hold the replayed moment of the discovered and read notebook.

My conclusion is not that we can now retrospectively place Chantal Akerman in a category, genre or group sometime identified with the Shoah, for that would be to contain the *work performed by her artworking*. What I am left with is my question about the journey: I have been questioning whether we travel away from or towards trauma. If I can track a certain persistence that only retrospectively appears to us as having been the thread of continuity underlying a forty-year career, is it possible that the past only arrives once a future has been built to contain it?

Whose life does this body of film sustain?

In one reading, the work of Akerman belatedly reveals its deeply traumatic structuration to which her own comments bear regular witness. In a Matrixial reading, however, fidelity reveals more than obsession or repetition compulsion. Fidelity becomes *fascinance*: a necessary, prolonged contemplation of a certain enigma lying between mother and daughter precisely in those zones that are also mother as daughter with her missing mother. *Walking* is not the final key, anymore than *Child Abuse* was in the case of Louise Bourgeois. When independent cinema moved into installation time-based art, a space opened up. The Matrixial trauma of the lost mother/grandmother-matrixial

severality could be re-approached and transported through occasioning and being able to witness the Matrixial compassionate gesture of the daughter to her orphaned mother so that she could become the mother the daughter herself needed. Something happened that Sunday in Brussels that had waited long to occur in the intertwining lives of both women. In Nelly Akerman's silent return to the site of her own inscription to her mother and the discovery of her daughter's compassionate embrace of her and her loss, she makes a gesture accompanied by the soft seep of tears to reach out, touch, stroke and kiss her daughter. I remain myself caught in *fascinance* before this image that strokes and touches something in me of which I cannot speak, but by which I was transformed through writing of this other journey home.

Notes

1 I am grateful to Chantal Akerman and to Marion Goodman for providing me with English translations of the artist's statements.
2 Janet Bergstrom, 'Invented Memories', in Gwendolyn Audrey Foster (ed.), *Identity and Memory: The Films of Chantal Akerman* (Trowbridge: Flicks Books, 1999), 94–116; Alisa Lebow, 'Memory Once Removed: Indirect Memory and Transitive Autobiography in Chantal Akerman's *D'Est*', *Camera Obscura* 52, 18:1 (2003), 35–83.
3 Ivone Margulies, *Nothing Happens: Chantal Akerman's Hyperrealist Everyday* (Durham, NC: Duke University Press, 1996).
4 Sylvie Lindeperg, '*Nuit et brouillard': un film dans l'histoire* (Paris: Odile Jacob, 2007); Griselda Pollock and Max Silverman (eds), *Concentrationary Cinema: Aesthetics as Political Resistance in Alain Resnais's* Night and Fog (London and New York: Berghahn, 2011); Ewout van der Knaap, *Uncovering the Holocaust: The International Reception of* Night and Fog (London: Wallflower Press, 2006).
5 Alisa S. Lebow, *First Person Jewish* (Minneapolis: University of Minnesota Press, 2008), 3.
6 Transcript from the film reprinted in Lebow, 'Memory Once Removed', 6–7.
7 Lebow, 'Memory Once Removed', 7.
8 Helen Epstein, *Children of the Holocaust: Conversations with Sons and Daughters of Holocaust Survivors* (New York: Putnam Books, 1979), 9.
9 Epstein, *Children of the Holocaust*, 10.
10 Anne Karpf, *The War After: Living with the Holocaust* (London: Mandarin, 1997).
11 David Grossman, *See Under Love* (New York: Farrar, Straus & Giroux, 1989).
12 Gila Almagor, *The Summer of Aviya* (1985, released as a film, 1988).
13 Art Spiegelman, *Maus: A Survivor's Tale* (1986 and 1991).
14 Louise J. Kaplan, *Lost Children: Separation and Loss between Parents and Children* (London: HarperCollins, 1995), 223–4.
15 Kaplan, *Lost Children: Separation and Loss between Parents and Children*, 223–4.
16 Jean-Luc Outers, 'Histoires d'Amérique', *Cinérgie* (February, 1989),6; translated in Janet Bergstrom, 'Invented Memories', in Gwendolyn Audrey Foster (ed.), *Identity and Memory: The Films of Chantal Akerman* (Trowbridge: Flicks Books, 1999), 98.

17 Manuscript materials provided by Marion Goodman Gallery, Paris are the English translation of the materials printed in Chantal Akerman, *Neben seine Schnürsenkeln in einem leeren Kühlschrank Laufen* (Berlin: Jüdisches Museum und Laconic Press, 2007).

18 I owe this insight to Bracha Ettinger and I have written about its implications in my *Resonance/Overlay/Interweave: Bracha Ettinger in the Freudian Space of Memory and Migration* (Leeds: CentreCATH Documents, 2009).

19 Marianne Hirsch, *Family Frames: Photography, Narrative and Postmemory* (Cambridge, MA: Harvard University Press, 1997).

20 On Spiegelman's use of photographs in his otherwise illustrated work, see Marianne Hirsch, 'Surviving Images: Holocaust Photographs and the Work of Postmemory', *Yale Journal of Criticism*, 14:1 (2001), 5–37.

21 Luce Irigaray, 'Women's Exile', trans. Couze Venn, *Ideology and Consciousness*, 1 (1977): 62–76; Luce Irigaray, 'The Bodily Encounter with the Mother', in *The Irigaray Reader*, ed. Margaret Whitford (Oxford: Basil Blackwell, 1991), 34–46. For a beautiful cinematic exploration of the concept of woman as derelict and an exile in phallocentric culture, see Sally Potter, *The Golddiggers* (BFI, 1983; DVD, 2009).

22 Virginia Woolf, 'Professions for Women' [1931], in Virginia Woolf, *Women and Writing*, intro. Michèle Barrett (London: The Women's Press, 1979), 60.

23 Virginia Woolf, 'Professions for Women' [1931], 62.

24 Griselda Pollock, 'Stilled Life: Traumatic Knowing, Political Violence and the Dying of Anna Frank', *Mortality*, 12:2 (2007), 124–41.

25 Bracha Ettinger, *Matrix Halal(a)-Lapsus: Notes on Painting* (Oxford: Museum of Modern Art, 1992), 85.

26 Brenda Longfellow, 'Love Letters to the Mother: the Work of Chantal Akerman', *Canadian Journal of Political and Social Theory Annual*, 13:1–2 (1989), 84.

27 Bracha Ettinger, 'Transcryptum', in Linda Belau and Petar Ramadanovic (eds), *Topologies of Trauma: Essays on the Limit of Knowledge and Memory* (New York: Other Press, 2002), 251–72.

28 Nathan Lee, 'Pleasures of the Text', *Film Comment* (September/October, 2005), 17.

29 The sources for our understanding of this concept are Ernst Gombrich, *Aby Warburg: An Intellectual Biography* (Oxford: Phaidon Press, 1970) and Georges Didi-Huberman, *L'Image-survivante: Histoire de l'Art et temps des fantômes selon Aby Warburg* (Paris: Editions de Minuit, 2002).

30 Bracha L. Ettinger, 'From Proto-ethical compassion to Responsibility: Besideness and three Primal Mother-fantasies of Not-enoughness, Devouring and Abandonment', *Athena: Filosofijos Studijos*, no. 2 (2006), 100–36.

31 I am reminded here of the use of Irigarayan imagery of the frozen wasteland turning to flowing water as the structure for Sally Potter's *The Golddiggers* (BFI, 1983) which represents through landscape a journey undertaken by two women to deconstruct the patriarchal formation of femininity and come to their own, collaborative recognition of femininity under the sign of movement and fluidity.

32 Eric Santner, 'History beyond the Pleasure Principle: Some Thoughts on the Representation of Trauma' in Saul Friedländer (ed.), *Probing the Limits of Representation: Nazism and the 'Final Solution'* (Cambridge, MA: Harvard University Press, 1992), 144.

33 Santner, 'History beyond the Pleasure Principle: Some Thoughts on the Represen-
 tation of Trauma', 144.
34 Ettinger, *Matrix Halal(a)-Lapsus: Notes On Painting* (Oxford: Museum of Modern
 Art, 1993), 85.
35 Bracha L. Ettinger, '*Fascinance* and the Girl-to-m/Other Matrixial Feminine
 Difference', in Griselda Pollock (ed.), *Psychoanalysis and the Image* (Boston and
 Oxford: Blackwell, 2006), 60–93.
36 Bracha L. Ettinger, *Fascinance*, 61.
37 Bracha L. Ettinger, *Fascinance'*, 62.
38 André Green, 'The Dead Mother', in Gregorio Kohon (ed.), *On Private Madness*
 (London: Hogarth, 1986), 142–73; Nicholas Abraham and Maria Torok, *The Shell
 and the Kernel*, ed. and trans. Nicholas T. Rand (Chicago: University of Chicago
 Press, 1994).
39 Ettinger, 'Transcryptum', 166.

Conclusion

Having pursued the journey that this book undertook to arrive, through encounter with the challenge of its chosen artworks, at the questions with which I opened the Preface, I hope that the reader experienced not just a rethinking of art histories. Perhaps what I want to offer is a retuning of modes of attention and analysis towards the interface of affect and form. The affective turn is currently perceived as fundamentally a turn away from any kind of formalism. But the understanding of art's deep formal dimension achieved through the modernist revolutions should not be thrown out with the post-formalist bathwater. There is nothing wrong with formalism except its exclusivity as an approach to the study of art. Following in the footsteps of many astute feminist art historians such as Sigrid Schade, Margaret Iverson and Charlotte Schoell-Glass who saw potential for feminist analysis in the work of Aby Warburg, I have found a mediation between the apparent opposites through Warburg's concept of the *pathos formula*. Far from deviating from feminism, which is currently being entombed as only what it became when its initially renewed challenge for human decency and dignity re-emerged in the 1970s, the Virtual Feminist Museum seeks ever to retune its feminist antennae to the changing challenges of the present and our shifting perspectives on both past and future. At the junction, therefore, of a retrospective sense that Modernity laid on its successors a burden of castastrophe and trauma, with expanded psychoanalytical theorizations of subjectivity, sexual difference and the aesthetic dimension of both, I practice a feminist-inflected mode of art historical/cultural analysis that responds to the ways in which artists have been bringing interwoven personal and historical trauma to the surface of cultural attention.

Retuning elaborates a model of close-reading, attentive listening, tracing and opened encounter with the event of the other in both what lies before, is surfacing and finds formulation in *artworking*. Artworking insists on an economy and hence transformation. I stress the *form*-ulation dimension in this word as well as the *trans*subjective potential.

I have here worked closely with the artist Bracha Ettinger. I draw her into

the conversation to include in trauma studies her transsubjective concepts of *aesthetic wit(h)nessing*, as well as *fascinance* and *art as a transport station of trauma*. It has been my aim not only to shift art historical engagement with the impact of Modernity as trauma towards the entwinement of affect and the poietic inventiveness of art after the modernist and contemporary revolutions. By offering specifically feminist aesthetic and critical methods in so doing, I am also hoping to remind feminist thought of the continuing potentiality of expanded psychoanalytical resources in order to foster reparative engagements even with catastrophic events and legacies.

Beyond what I have tried to undertake in this book, and as a result of its attention to all of the above, other questions arise around any chosen focus.

Is the academic study of trauma a form of intellectual deflection doomed in itself to fail by attempted mastery or mere display of academic authority? Or can writing not so much about as *with* aesthetic transformations of dangerous encounters with untransformable psychic pain remain in touch with, and sustain the impact of, the affective charge, the traumatic impasse, the haunting after-affect? This has been the experiment here that remains for the reader to adjudge.

Trauma is now a major concept in the humanities, central to a range of explorations of the structural conditions of subjectivity and language as well as to the historical legacies of war, genocide and natural as well as man-made catastrophe. The field generates many new questions. Is trauma a transcultural, structural dimension of how human subjects are psychologically formed in relation to loss, abandonment, separation and above all castration: structural trauma? Or does the term refer to extreme experiences that are brought about by politics, history, economics, social relations: history as trauma? Is the manner in which human subjects suffer extreme events socially and culturally determined, hence different according to cultural modes already part of different societies? Is suffering, therefore, social? Is it on the other hand shaped by utterly singular and personal contingencies that make certain events unbearable for some but not for others? Is even structural trauma, as defined by psychoanalysis as a condition of subjectivity itself, coloured by phantasy, memory and other cultural accretions – at the individual as well as collective level? Can there be something called cultural or collective trauma if the term refers to a specific kind of *psychic* wounding?

When I was in India in 2011 as a Getty Visiting Professor at Jawaharlal Nehru University, I presented aspects of this book as a contribution to new directions in Western feminist histories of art and cultural analysis. My focus on trauma resonated with scholars working on India's trauma during Partition and more recent violence between Indian communities. My approach was also rigorously questioned. What, I was asked probingly by Geeta Kapur, one of India's leading art critics and cultural theorists, has become of our sense

that, in the post-colonial era, culture is an agonistic site, a locus for adversarial negotiation of real conflicts created in the colonial legacies of imperialist and capitalist modernity? Her deeply pertinent question challenged me to ask myself if the Western cultural turn towards 'Trauma Studies' represented an avoidance of the continuing struggle to negotiate shared but assymetrical histories of Modernity, a struggle in which the West cannot but face up to its role as perpetrator and beneficiary of relations of domination and exploitation? What if trauma studies functions as an alibi that allows everyone to become a victim in some way or other? What is lost if all difference of historical conflict and hardship is submerged in the abstracted notion of an unspeakable void of immemorial wounding instead of critical projects of engagement with the denunciation of violence and violation and the construction of common futures premised on our real work together? Does the ethics of our turn to suffering conflict with or extend our political responsibilities? Given the as yet unacknowledged and unprocessed trauma of both colonization and decolonization, let alone neo-colonization, what status has my focus on specifically European, and in many cases European-Jewish cases? For many peoples of the world, the trauma of the Middle East – Israel/Palestine – presses its urgent questions, complexly and sometimes in problematic ways, whenever the focus falls on the Holocaust. I want to make space here for these continuing questions that I cannot master but will not silence.

Furthermore, there are sceptics a-plenty today in the Western academy who write off what they dismiss as 'trauma envy', while others discern within the formation of trauma studies, especially in literature, a specific means of displacing unacknowledged collaboration with fascism. So how do I justify participation in the traumatic turn that emerged from the 1980s and found its academic formulation in the 1990s largely in the fields of literary studies and historiography? The answer must lie in more than the claim that trauma arrived in the study of the visual arts belatedly.

This book is offered as a part of my continuing process of rethinking art histories – our methods and procedures – and of reconfiguring what I have named art's histories, which defy the former's habits and classifications to open onto difference (s). Here I focus on artworking as a register of history that deals, willingly or not, with historically conditioned psychic inscription and encryption: trauma. Despite the devaluation of trauma's conceptual currency as a critical term through academic fashionability, we cannot allow ourselves to be deflected from remaining true to the evidence, both historical and aesthetic, of its continuing urgency as a conceptual resource and a historical legacy in the face of evidence not only of struggle but also of overwhelming affects that are the register and remnant of catastrophe. Attentiveness to trauma, and our changing modes of understanding what it means, registers our delayed but vital sensitivity to what we are inheriting – and continuing to inflict. It is a

powerful mirror, a warning and a challenge about the precarious condition of humanity today. But my aim is not to present artists as mere reporters, indices or reflexes of historical legacies as personal suffering.

I have been researching what artworking can itself offer us in understanding the condition of trauma and its potential transformation through aesthetic processing which involves both the artist and the responding other who consents to the encounter generated by art and the affective transmission involved. In shifting the orientation within the dialogue between aesthetic practice and psychoanalysis back towards learning from artworking itself, and in locating the debate about trauma in specific aesthetic enunciations that entangle the historical, the political and the subjective, as well as the formal, the material and the procedural, my aim has been, furthermore, to demonstrate a vitally important but currently menaced dimension of research.

I did not know in advance what the study of the artworks would teach me. I came to my questions through what I had discovered in my own sojourn and close reading of artworks assembled in this room of the Virtual Feminist Museum that considers sculpture, video/film, installation and text. Through overanxious and sometimes deadly institutional management, academic research is now so pre-formulated, pre-tested and pre-adjudged for its economic impact that we forget that it takes time and openness to find out anything. It involves self-fragilizing to the unknown other, unpredictability and courage. My study of selected artworks in the context of life-times of artistic creation is itself a recognition that art is a long-term form of research, defiant and different in the face of auditable cultural and regularized intellectual production.

Drawing on a very wide range of diverse theories of trauma, my aim has been to place what I have learnt from the artworking of Bracha Ettinger, in the form of the concepts to which her own historically situated work on trauma and aesthetic practice gave rise, into conversation with her theoretical and artistic peers in trauma studies. I have written extensively on and curated shows of her paintings over twenty years, and continue to do so as they themselves unfold in constantly new directions that also make clearer to the artist and to those who witness their becoming what they are constantly seeking to touch and know. The radical function of Ettinger's artworking as research takes its place here through its indirect contribution to the intersection of aesthetics and ethics that effect radical shifts in our understanding of sexual difference and subjectivity, also said by our faithless academy to have had its day.

Disavowal or premature declarations of feminism's decease indicate a final twist. Feminism itself has been a trauma for phallocentric culture, an undigestible shock demanding profound transformation in all of us, our ways of being and relating, doing, living, making, thinking, even artwriting and curating. It is on the side of life, and I consider feminism vital to the transformation

of our catastrophic human condition as we live it now. The historical trauma of feminism's political and intellectual revolutions, regularly reignited and constantly obliterated, are marked by repression. But the repressed returns. Feminist thought is virtual, dynamic and constantly transforming itself as it confronts and is refashioned by changing conditions to which it is by definition sensitive as a probe into some of our deepest formations and far-reaching cultural practices.

In this book on trauma and sexual difference, trauma and history, trauma and aesthetics, I seek a space for suggesting what feminist engagements can offer in terms of transformation. While locally rethinking art histories/art's histories, it should also be clear that I think that art is more than a fashionable plaything or good investment in the global circus. By reclaiming some of Aby Warburg's complex reflections on the image as *pathos formula* I have reconnected moments in the history of art history with art's place in dangerous moments in our historical pasts and present. I hope that readers will come away from this book with a sense of both the passion (in its old sense of what is suffered) of history that artistic inscription enframes and the passion (in the sense of intensity and commitment) of engagement that is the only adequate response to it.

Bibliography

Abraham, Nicholas and Torok, Maria. 'A Poetics of Psychoanalysis: "The Lost Object–Me"', *SubStance*, 43 (1984), 3–18.

—— and Torok, Maria. *The Wolfman's Magic Word*, trans. Nicholas Rand (Minneapolis: University of Minnesota Press, 1989).

—— and Torok, Maria. *The Shell and the Kernel*, ed. and trans. Nicholas T. Rand (Chicago: University of Chicago Press, 1994).

Ackerman, Chantal. *Neben seine Schnürsenkeln in einem leeren Kühlschrank Laufen* (Berlin: Jüdisches Museum and Laconic Press, 2007).

Adorno, Theodor. 'Commitment'[1962], in Andrew Arato and Eike Gebhardt (eds), *The Essential Frankfurt School Reader* (Oxford: Basil Blackwell and New York, Urizone Books, 1978).

——. *Negative Dialectics* (1966), trans. E.B. Ashton (New York: Seabury Press, 1973).

——. *Prisms*, trans. Samuel Weber and Sherry Weber (Cambridge, MA: MIT Press, 1983).

——. *Can One Live after Auschwitz? A Philosophical Reader*, ed. Rolf Tiedemann, trans. Rodney Livingstone et al. (Stanford, CA: Stanford University Press, 2003).

Agamben, Giorgio. *Remnants of Auschwitz: The Witness and the Archive*, trans. Daniel Heller-Roazen (New York: Zone Books, 1999).

——. 'Aby Warburg and the Nameless Science', *Potentialities: Collected Essays in Philosophy*, trans. Daniel Heller-Roazen (Stanford, CA; Stanford University Press, 2000), 89–103.

Almagor, Gila. *The Summer of Aviya* (1985, released as a film 1988).

Améry, Jean. *At the Mind's Limits: Contemplations by a Survivor on Auschwitz and its Realities* [1966], trans. Sidney Rosenfeld and Stella P. Rosenfeld (London: Granta Books, 1999).

Antelme, Robert. *L'Espèce humaine* (Paris: Gallimard, 1947); *The Human Race*, trans. Jeffrey Haight and Annie Mahler (Evanston, IL: Northwestern University Press, 1999).

Anzieu, Didier. *Le Peau-Moi et la psychanalyse des limites* (Paris: Editions Dunod, 1995).

Apel, Dora. *Memory Effects: The Holocaust and the Art of Secondary Witnessing* (New Brunswick, NJ: Rutgers University Press, 2002).

Arendt, Hannah. *Essays in Understanding 1930–1954: Formation, Exile, Totalitarianism*, ed. Jerome Kohn (New York; Schocken Books, 1994).

Augé, Marc. *Non-places: Introduction to the Anthropology of Supermodernity*, trans. Jon Howe (London: Verso Books, 1995).

Bal, Mieke. *Reading Rembrandt: Beyond the Word-Image Opposition* (New York: Cambridge University Press, 1991).

——. 'Reading Art?', in Griselda Pollock (ed.), *Generations and Geographies in the Visual Arts: Feminist Readings* (London, Routledge, 1996), 25–41.

——. 'Beckoning Bernini', in *Louise Bourgeois: Memory and Architecture* (Museo Nacional Centro de Arte Madrid Reina Sofía, 2000), 75–85.

——. *Louise Bourgeois's Spider: The Architecture of Art-Writing* (Chicago: University of Chicago Press, 2001).

——. *Quoting Caravaggio: Contemporary Art, Preposterous History* (Chicago: University of Chicago Press, 2001).

——. *What One Cannot Speak: Doris Salcedo's Political Art* (Chicago: University of Chicago Press, 2011).

Barron, Stephanie (ed.). *'Degenerate Art': the Fate of the Avant-garde in Nazi Germany* (Los Angeles County Museum of Art, 1991).

Barthes, Roland. *Camera Lucida* [1980], trans. Richard Howard (New York: Hill and Wang, 1981).

Bataille, Georges. 'Informe', *Documents*, 1 (December 1929), 382.

Bauman, Janina. *A Dream of Belonging: My Years in Postwar Poland* (London: Virago Press, 1988).

——. *Winter in the Morning* (London: Virago Books, 1986). Reprinted as *Beyond These Walls: Escaping the Warsaw Ghetto – A Young Girl's Story* (London: Virago Modern Classics, 2006).

Bauman, Zygmunt. *Modernity and the Holocaust* (Cambridge: Polity Press, 1989).

Bennett, Jill. 'The Aesthetics of Sense Memory: Theorising Trauma through the Visual Arts', in Peter Weibel (ed.), *Trauma and Memory: Cross-Cultural Perspectives* (Vienna: Passagen Verlag, 2000), 81–96.

——. *Empathic Vision: Affect, Trauma and Contemporary Art* (Stanford, CA: Stanford University Press, 2005).

Bergman-Carton, Janis. 'Sarah Bernhardt and the Possibilities of Jewishness', *The Art Journal*, 55:2 (Summer, 1996), 54–64.

Bergson, Henri. *The Creative Mind: An Introduction to Metaphysics*, trans. Mabelle Anderson (New York: Citadel Press, 1992).

Bergstrom, Janet. 'Invented Memories', in Gwendolyn Audrey Foster (ed.), *Identity and Memory: The Films of Chantal Akerman* (Trowbridge: Flicks Books, 1999), 94–116.

Bernadec, Marie-Laure. *Louise Bourgeois* (Paris and New York: Flammarion, 1996).

Bernheimer, Charles and Kahane, Claire (eds), *In Dora's Case: Freud-Hysteria-Feminism: Freud, Hysteria, Feminism*, 2nd edn (New York: Columbia University Press, 1990).

Bolland, Andrea. '*Desiderio* and *Diletto*: Vision, Touch and the Poetics of Bernini's *Apollo and Daphne*', *Art Bulletin*, 82:2 (2000), 309–30.

Bollas, Christopher. *The Shadow of the Object: Psychoanalysis of the Unthought Known* (New York: Columbia University Press, 1987).

Boltanski, Luc. *Distant Suffering: Morality, Media and Politics* (Cambridge: Cambridge University Press, 1999).

Bouchard, Camille. 'Louise Bourgeois: Interview with Bernard Marcadé', in *Louise Bourgeois* (Paris: Centre Pompidou, 1993).

Bourgeois, Louise. 'A Project by Louise Bourgeois: Child Abuse', *Art Forum*, XXI:4 (December, 1982), 40–7.

——. *Destruction of the Father/ Reconstruction of the Father: Writings and Interviews 1923–1997*, ed. Marie-Laure Bernadec and Hans-Ulrich Obrist (Cambridge, MA: MIT Press, 1998).

Boutibonnes, Philippe. 'En ce commun effroi …', *Fusées*, no. 17 (2010), 9–17.

Boyarin, Daniel. *Carnal Israel: Reading Sex in Talmudic Culture* (Berkeley, CA: University of California Press, 1995).

——. *Unheroic Conduct: The Rise of Heterosexuality and the Invention of the Jewish Man* (Berkeley and Los Angeles; University of California Press, 1997), 313–60.

Bradley, Fiona, Brown, Katrina and Nairne, Andrew. *Trauma* (London: Hayward Gallery Publishing, 2001).

Brennan, Teresa. *The Transmission of Affect* (Ithaca, NY: Cornell University Press, 2004).

Bronfen, Elisabeth. *The Knotted Subject: Hysteria and its Discontents* (Princeton, NJ: Princeton University Press, 1998).

Brown, Laura S. 'Not Outside the Range: One Feminist Perspective on Psychic Trauma', in Cathy Caruth (ed.), *Trauma: Explorations in Memory* (Baltimore, MD: Johns Hopkins University Press, 1995), 100–12.

Buchanan, Ian and Colebrook, Claire. *Deleuze and Feminist Theory* (Edinburgh: Edinburgh University Press, 2001).

Butler, Judith. *Precarious Lives: The Power of Mourning and Violence* (London: Verso Books, 2004).

Butler, Kristine. 'Bordering on Fiction: Chantal Akerman's From the East', in Gwendolyn Audrey Foster (ed.), *Identity and Memory: The Films of Chantal Akerman* (Trowbridge: Flicks Books, 1999), 162–78.

Cabanne, Pierre. 'Aline à corps perdu', *Le Combat*, no. 8986 (1973), reprinted in Jósef Grabski (ed.), *Alina Szapocznikow: Capturing Life: Drawings and Sculptures* (Cracow: IRSA, 2004), 125–7.

Caruth, Cathy, *Trauma: Explorations in Memory* (Baltimore, MD: Johns Hopkins University Press, 1995).

—— (ed.). *Unclaimed Experience: Trauma, Narrative and History* (Baltimore: Johns Hopkins University Press, 1996).

Cavarero, Adriana. *Horrorism: Naming Contemporary Violence*, trans. William McCuaig (New York: Columbia University Press, 2007).

Cesarani, David and Sundquist, Eric J. *After the Holocaust: Challenging the Myth of Silence* (London: Routledge, 2011).

Chare, Nicholas. *Auschwitz and Afterimages: Abjection, Witnessing and Representation* (London: I.B. Tauris, 2010).

Chasseguet-Smirgel, Janine. *The Body as Mirror of the World*, trans. Sophie Leighton (London: Free Association Books, 2005).

Cixous, Hélène. 'Clarice Lispector: The Approach – Letting Oneself (be) Read (by) Clarice Lispector', trans. Sarah Cornell and Susan Sellars, in Deborah Jenson (ed.), *Coming to Writing and other Essays* (Cambridge, MA and London: Harvard University Press, 1991).

Clough, Patricia (ed.). *The Affective Turn: Theorizing the Social* (Durham, NC: Duke University Press, 2007).

Cole, Ian (ed.). *Louise Bourgeois* (Oxford: Museum of Modern Art, Oxford Papers, Vol. 1, 1996).

Conley, Verena Andermatt. 'For Sarah Kofman: On *Rue Ordener, Rue Labat*', *SubStance*, 25:3 (1996), 153–9.

Corby, Vanessa. 'Don't Look Back: Reading for the Ellipses in the Discourse of Eva Hess[e]', *Third Text*, 57 (winter 2001/02), 31–42.

——. *Eva Hesse: Longing, Belonging and Displacement* (London: I.B. Tauris, 2010).

Creissels, Anne. 'From Leda to Daphne: Sacrifice and Virginity in the Work of Ana Mendieta', in Griselda Pollock and Victoria Turvey Sauron (eds), *The Sacred and the Feminine: Imagination and Sexual Difference* (London: I.B.Tauris, 2007), 178–88.

——. *Prêter son corps au mythe: Le féminin et l'art contemporain* (Paris: Editions de Félin, 2009).

Culbertson, Roberta. 'Embodied Memory, Transcendence and Telling: Recounting Trauma, Re-establishing the Self', *New Literary History*, 26:1 (1995), 169–95.

Cummings, Ashlee, M. *The Shelter of Philosophy: Repression and Confrontation of the Traumatic Experience in the Work of Sarah Kofman*, MA Thesis, University of Miami, 2009: http://etd.ohiolink.edu/view.cgi?acc_num=miami1248976254.

Czartoryska, Urzula. 'The Cruel Clarity', in Anda Rottenberg (ed.), *Alina Szapocznikow 1926–1973* (Warsaw: Zachęta Gallery, 1998), 12–25.

De Lauretis, Teresa. *Technologies of Gender* (Basingstoke: MacMillan, 1989).

de Preester, Helen (ed.). *Body Image and Body Schema: Interdisciplinary Perspectives on the Body* (Amsterdam: John Benjamins, 2005).

de Zegher, Catherine (ed.). *Anna Maria Maiolino: Vida Afora/Life Line* (New York: The Drawing Centre, 2002).

——. and Pollock, Griselda (eds), *Bracha L. Ettinger: Art as Compassion* (Brussels: ASA Publishers, 2011).

Delbo, Charlotte. *Days and Memories*, trans. Rosette Lamont (Marlboro: Marlboro Press, 1990).

Deleuze, Gilles. *Difference and Repetition* [1968], trans. Paul Patton (New York: Columbia University Press, 1994).

Derrida, Jacques. 'Sarah Kofman', in Pascale Anne Brault and Michael Naas (eds), *The Work of Mourning* (Chicago: University of Chicago Press, 2001), 165–88.

Des Pres, Terence. *The Survivor: Anatomy of Life in the Death Camps* (Oxford: Oxford University Press, 1976).

Deutscher, Penelope, and Oliver, Kelly (eds). *Enigmas: Essays on Sarah Kofman* (Ithaca, NY: Cornell University Press, 1999).

Didi-Huberman, Georges. *L'Empreinte* (Paris: Centre Pompidou, 1997).

——. *L'Image-survivante: Histoire de l'Art et temps des fantômes selon Aby Warburg* (Paris: Editions de Minuit, 2002).

Dolto, Françoise. *L'image inconscient du corps* (Paris: Seuil, 1984), 299–310.

Dompierre, Louise (ed.). *Likely Stories: Text/Image/Sound Works for Video and Installation Works by Vera Frenkel* (Queen's University at Kingston: Agnes Etherington Art Centre, 1982).

Edelman, Hope. *Motherless Daughters: The Legacy of Loss* (New York: Delta, 1994).

Edsel, Robert M. *The Monuments Men: Allied Heroes, Nazi Thieves and the Greatest Treasure Hunt in History* (London: Preface, 2009).

Epstein, Helen. *Children of the Holocaust: Conversations with Sons and Daughters of Holocaust Survivors* (New York: Putnam Books, 1979).

Ettinger, Bracha L. 'Matrix and Metramorphosis', *Differences: A Journal of Feminist Cultural Studies*, 4:3 (1992), 176–208.

——. *Matrix Halal(a)-Lapsus: Notes on Painting* (Oxford: Oxford Museum of Modern Art, 1992).

——. 'The Becoming Thresholds of Matrixial Borderspace', in George Robertson et al. (eds), *Travellers' Tales* (London: Routledge, 1994), 38–62.

——. 'The Matrixial Gaze' (1995), in Bracha L. Ettinger, *The Matrixial Borderspace*, ed. Brian Massumi (Minneapolis: University of Minnesota Press, 2006), 73–80.

——. 'Traumatic Wit(h)ness-Thing and Matrixial Co/in-habituating', *parallax*, 5:1 (1999), 89–98.

——. *Bracha Lichtenberg Ettinger: Artworking 1985–1999* with essays by Brian Massumi, Christine Buci-Glucksman and Griselda Pollock (Gent: Ludion and Brussels: Palais des Beaux Arts, 2000).

——. 'Art as the Transport-Station of Trauma', in *Bracha Lichtenberg Ettinger: Artworking 1985–1999* (Gent: Ludion, 2000), 91–115.

——. 'Wit(h)nessing Trauma and the Matrixial Gaze: From Phantasm to Trauma, from Phallic Structure to Matrixial Sphere', *parallax* 21, 7:4 (2001), 89–114.

——. 'Transcryptum: Memory Tracing in/for/with the Other', in Bracha L. Ettinger, *The Matrixial Borderspace*, ed. Brian Massumi (Minneapolis, MN: University of Minnesota Press, 2006), 163–72; also reprinted in Linda Belau and Petar Ramadanovic (eds), *Topologies of Trauma: Essays on the Limit of Knowledge and Memory* (New York: Other Press: 2002), 251–72.

——. 'From Proto-ethical Compassion to Responsibility: Besideness and three Primal Mother-fantasies of Not-enoughness, Devouring and Abandonment', *Athena: Filosofijos Studijos*, no. 2 (2006), 100–36.

——. '*Fascinance* and the Girl-to-M/Other Matrixial Feminine Difference', in Griselda Pollock (ed.), *Psychoanalysis and the Image: Transdisciplinary Perspectives* (Boston and Oxford: Blackwell, 2006), 60–93.

——. *The Matrixial Borderspace*, ed. Brian Massumi, pref. Judith Butler, intro. Griselda Pollock (Minneapolis: University of Minnesota Press, 2006).

Feliciano, Hector. *The Lost Museum: The Nazi Conspiracy to Steals the World's Greatest Works of Art* (New York: Basic Books, 1997).

Felman, Shoshana. *What does a Woman Want: Reading and Sexual Difference* (Baltimore, MD: Johns Hopkins University Press, 1993).

—— *The Juridical Unconscious: Trials and Traumas in the Twentieth Century* (Cambridge, MA: Harvard University Press, 2002).

—— and Laub, Dori (eds), *Testimony: Crises of Witnessing in Literature, Psychoanalysis and History* (London: Routledge, 1992).

Ferman, Nicole. 'Conversion and Oral Assimilation', *College Literature*, 28:1 (2001), 155–69.

Fitzpatrick, Tracy. *Gestures: Hannah Wilke* (Neuberger Museum of Art, 2009).

Foster, Hal. *The Return of the Real: The Avant-Garde at the End of the Century* (Cambridge, MA: MIT Press, 1996).

Frenkel, Vera et al. 'The Story is Always Partial: A Conversation with Vera Frenkel', *Art Journal*, 57:4 (1998), 2–15.

Freud, Sigmund. *The Interpretation of Dreams* [1900]. Penguin Freud Library, Vol. 4 (Harmondsworth: Penguin, 1976).

——. 'Fragments of an Analysis of a Case of Hysteria' (1905 [1901], *Standard Edition of the Psychological Works of Sigmund Freud*, ed. James Strachey, Vol. 7 (London: Hogarth, 1975), 1–122.

——. 'Fragments of a Case of Hysteria ("Dora")' [1905], Penguin Freud Library, Vol. 8, *Case Histories I* (Harmondsworth: Penguin, 1977), 31–166.

——. 'Creative Writers and Day-Dreaming,' [1908], in *Art and Literature*. Penguin Freud Library, Vol. 14 (London: Penguin, 1990), 129–42.

——. 'The Theme of the Three Caskets' [1913], *Standard Edition of the Complete Psychological Works of Sigmund Freud*, Vol. XII (1911–13), 291–301.

——. 'Totem and Taboo' [1913], in *The Origins of Religion*. Penguin Freud Library, Vol. 13 (London: Penguin, 1985), 43–224.

——. 'Our Attitude towards Death' [1915], *Civilization, War and Death: Selections from Three Works by Sigmund Freud*, ed. John Rickman (London: Hogarth Press, 1939), 14–25.

——. 'Mourning and Melancholia' [1917], Penguin Freud Library, Vol. 11: *On Metapsychology* (London: Penguin, 1984), 245–68.

——. Beyond the Pleasure Principle' [1920], in *On Metapsychology: The Theory of Psychoanalysis*, Penguin Freud Library, Vol. 11 (Harmondsworth: Penguin, 1984), 69–338, and 'Beyond the Pleasure Principle' [1920], *Standard Edition of the Psychological Works of Sigmund Freud*, Vol. 18 (London: Hogarth Press, 1955), 1–64.

——. 'On the Universal Tendency to Debasement in the Sphere of Love' [1925], in *On Sexuality*, Penguin Freud Library, Vol. 7 (London: Penguin, 1977), 243–60.

——. 'Some Psychical Consequences of the Anatomical Distinction between the Sexes' [1925], *Standard Edition of the Collected Works of Sigmund Freud*, Vol. 19 (London: Hogarth, 1950), 241–58.

Friedländer, Saul, *Quand vient le souvenir* (Paris: Editions du Seuil, 1978); *When Memory Comes* [1978], trans. Helen R. Lane (New York: Farrar, Straus & Giroux, 1979).

——. *Probing the Limits of Representation: Nazism and the 'Final Solution'* (Cambridge, MA: Harvard University Press, 1992).

G.Q.H., 'A la recherche d'Alina', *Journal de Genève*, no. 252 (1971), in Anda Rottenberg (ed.), *Alina Szapocznikow 1926–1973* (Warsaw: Zachęta Gallery, 1998), 135.

Geerardyn, Filip, and Walleghem, Peter. 'Françoise Dolto's Clinical Conception of the Unconscious Body Image and the Body Schema', in Helena de Preester (ed.), *Body Image and Body Schema: Interdisciplinary Perspectives on the Body* (Amsterdam: John Benjamins 2005).

Gibson, Ann. 'Louise Bourgeois's Retroactive Politics of Gender', *Art Journal* (Winter 1994), 44–7.

Gilman, Sander. *The Jew's Body* (New York: Routledge, 1991).

Giraud, Yves. *La Fable de Daphne* (Geneva: Droz, 1968).

Gombrich, Ernst. *Aby Warburg: An Intellectual Biography* (Oxford: Phaidon Press, 1970).

Grabski, Jósef (ed.). *Alina Szapocznikow: Capturing Life – Drawings and Sculptures* (Cracow: IRSA, 2004).

Green, André. 'The Dead Mother', in Gregorio Kohon (ed.), *On Private Madness* (London: Hogarth, 1986), 142–73.

——. *The Fabric of Affect in Psychoanalytical Discourse*, trans. Alan Sheridan (London: Routledge, 1999).

Grossman, David. *See Under Love* (New York: Farrar, Straus & Giroux, 1989).

Grosz, Elizabeth. 'Deleuze's Bergson: Duration, the Virtual and a Politics of the Future', in Ian Buchanan and Claire Colebrook (eds), *Deleuze and Feminist Theory* (Edinburgh: Edinburgh University Press, 2001).

Habermas, Jurgen. *Eine Art Schadenabwicklung* (Frankfurt am Main: Suhrkamp Verlag, 1987).

Halbreich, Kathy and Jenkins, Bruce (eds). *Bordering on Fiction: Chantal Akerman's D'Est* (Minneapolis: Walker Art Center, 1995).

Haraway, Donna. 'Situated Knowledge; The Science Question in Feminism and the Privilege of the Partial Perspective', *Feminist Studies*, 14:3 (1988), 575–99.

Harrison, Jane. *Themis: A Study of the Social Origins of Greek Religion* (Cambridge: Cambridge University Press, 1912).

Hartman, Geoffrey. 'On Traumatic Knowledge and Literary Studies', *New Literary History*, 26:3 (1995), 537–63.

——. 'Memory.com: Tele-Suffering and Testimony in the Dot Com Era', *Raritan*, 19: 3 (2000), 1–18.

Hecht, Thomas O. *Czech Mate: A Life in Progress as told to Joe King* (Jerusalem: Yad Vashem, 2007).

Herman, Judith Lewis. *Trauma and Recovery: From Domestic Abuse to Political Terror* (New York: Basic Books, 1992).

Hermann Fiore, Kristina. *Apollo e Dafne del Bernini nella Galleria Borghese* (Rome: Silvana Editoriale, 1997).

Hirsch, Joshua. *Afterimage: Film, Trauma and the Holocaust* (Philadelphia, PA: Temple University Press, 2004).

Hirsch, Marianne. *Family Frames: Photography, Narrative and Postmemory* (Cambridge, MA: Harvard University Press, 1997).

——. 'Surviving Images: Holocaust Photographs and the Work of Postmemory', *Yale Journal of Criticism*, 14:1 (2001), 5–37.

Hoft-Marsch, Eilene. ' Still Breathing: Sarah Kofman's Memoirs of Holocaust Survival', *The Journal of the Mid-West Modern Language Association*, 33:3–34:1 (2000/01), 108–21.

Irigaray, Luce. 'Women's Exile', trans. Couze Venn. *Ideology and Consciousness*, 1 (1977), 62–76.

——. 'Gesture in Psychoanalysis', in *Sexes and Genealogies*, trans. Gillian C. Gill (New York: Columbia University Press, 1983), 97–8.

——. 'The Bodily Encounter with the Mother', in *The Irigaray Reader*, ed. Margaret Whitford (Oxford: Basil Blackwell, 1991), 34–46.

Jacobs, Amber. *On Matricide: Myth, Psychoanalysis and the Law of the Mother* (New York: Columbia University Press, 2007).

Jacobus, Mary. *The Poetics of Psychoanalysis* (London: Oxford University Press, 2005).

Jacubowksa, Agata. *Portret wielokrotny dzieła Aliny Szapocznikow* (Poznan: Wydawnictwo Naukowe UAM, 2007).

—— (ed.). *Alina Szapocznikow: Awkward Objects* (Warsaw: Museum of Modern Art, Book No. 5, 2011).

Johnson, Anna. 'Nomad Words', in Antony Bryant and Griselda Pollock (eds), *Digital and Other Virtualities* (London: I.B. Tauris, 2010), 217–36.

Jones, Amelia. 'The Rhetoric of the Pose: Hannah Wilke and the Radical Narcissism of Feminist Body Art', *Body Art: Performing the Subject* (Minneapolis, MN: University of Minnesota Press, 1998), 151–97.

Julius, Anthony, *Transgression: The Offences of Art* (London: Thames & Hudson, 2002).

Kansteiner, Wulf. 'Genealogy of a Category Mistake: A Critical Intellectual History of the Cultural Trauma Metaphor', *Rethinking History*, 8 (2004), 193–221.

Kaplan, Louise J. *Lost Children: Separation and Loss between Parents and Children* (London: HarperCollins, 1995).

Karpf, Anne. *The War After: Living with the Holocaust* (London: Mandarin, 1997).

Kempkes, Anke (ed.), *Flesh at War with Enigma* (Basel: Kunsthalle, 2004).

Kenseth, Joy. 'Bernini's Borghese Sculptures: Another View', *Art Bulletin*, 63:2 (1981), 191–210.

Kleinman, Arthur, Das, Veena and Lock, Margaret. *Social Suffering* (Berkeley: University of California Press, 1997).

Kochheiser, Thomas K. (ed.), *Hannah Wilke: A Retrospective* (Columbia, MO: University of Missouri Press, 1989).

Kofman, Sarah. 'No Longer Full-Fledged Autobiogriffies', *SubStance*, 9:4 (1980), 3–22.

——. 'Sacrée nourriture', in Christiane Besson and Catherine Weinzaepflen (eds), *Manger* (Liège: Yellow Now, 1980); trans. Frances Bartkowski as 'Damned Food', in Thomas Albrecht, Georgia Albert and Elizabeth Rottenberg (eds), *Sarah Kofman: Selected Writings* (Stanford, CA: Stanford University Press, 2007), 247–8.

——. 'Autobiographical Writings', trans. Frances Bartkowski, *SubStance*, 15:1 (1986), 6–13.

——. *Paroles Suffoquées* (Paris: Galilée, 1986); *Smothered Words*, trans. Madeleine Dobie (Evanston, IL: Northwestern University Press, 1998).

——. *The Childhood of Art: An Interpretation of Freud's Aesthetics*, trans. Winifred Woodhull (New York: Columbia University Press, 1988).

——. *Rue Ordener, Rue Labat* (Paris; Galilée, 1994), trans. Ann Smock (Lincoln, NE and London: University of Nebraska Press, 1996).

——. *Selected Writings*, ed. Thomas Albrecht, Georgia Albert and Elizabeth Rottenberg (Stanford, CA: Stanford University Press, 2007).

Krauss, Rosalind and Bois, Yves-Alain. *Formless: A User's Guide* (New York: Zone Books, 1997).

Kristeva, Julia. 'Women's Time' ['Le Temps des Femmes', *Cahiers de recherche de sciences des textes et documents*, 5 (Winter, 1979), 5–19], in Toril Moi (ed.), *The Kristeva Reader* (Oxford: Basil Blackwell, 1986), 187–213.

——'Motherhood according to Bellini', *Desire in Language* (New York: Columbia University Press, 1980), 236–70.

——. *The Powers of Horror: An Essay on Abjection*, trans. Leon S. Roudiez (New York: Columbia University Press, 1982).

——. *Black Sun: Depression and Melancholia*, trans. Leon S. Roudiez (New York: Columbia University Press, 1989).

Kuspit, Donald. 'Louise Bourgeois: Where Angels Fear to Tread', *Art Forum* (March 1987), 120–1.

——. *An Interview With Louise Bourgeois* (New York: Elizabeth Avedon Editions for Random House, 1988).

Lacan, Jacques. 'The Gaze as petit objet a', in *Four Fundamental Concepts of Psychoanalysis*, trans. Alan Sheridan (Harmondworth: Penguin, 1977), 67–122.

——. *The Ethics of Psychoanalysis Book VII 1959–60*, trans. Dennis Potter (London: Routledge, 1992).

LaCapra, Dominick. *Representing the Holocaust: History, Theory, Trauma* (Ithaca, NY: Cornell University Press, 1994).

——. *Writing History, Writing Trauma* (Baltimore, MD: Johns Hopkins University Press, 2000).

Laplanche, Jean. *New Foundations for Psychoanalysis*, trans. David Macey (Cambridge, MA/Oxford: Basil Blackwell, 1989).

——. 'Notes on Afterwardness', in John Fletcher (ed.), *Essays on Otherness* (London: Routledge, 1999), 260–5.

——. and Pontalis, Bertrand. 'Fantasy and the Origins of Sexuality', in Victor Burgin, et al.(eds), *Formations of Fantasy* (London: Methuen, 1986), 5–28.

Larratt-Smith, Philip (ed.). *Louise Bourgeois: The Return of the Repressed: The Psychoanalytical Writings*, with essays by Donald Kuspit, Elisabeth Bronfen, Juliet Mitchell and Mignon Nixon (London: Violette Editions, 2012).

Lebow, Alisa S. 'Memory Once Removed: Indirect Memory and Transitive Autobiography in Chantal Akerman's D'Est', *Camera Obscura* 52, 18:1 (2003), 35–83.

——. *First Person Jewish* (Minneapolis: University of Minnesota Press, 2008).

Lee, Nathan. 'Pleasures of the Text', *Film Comment* (September/October, 2005), 17.

Legge, Elizabeth. 'Of Loss and Leaving', *Canadian Art* (Winter 1996), 60–4.

——. 'Analogs of Loss: Vera Frenkel's Body Missing', in Barbie Zelizer (ed.), *Visual Culture and the Holocaust* (New Brunswick, NJ: Rutgers University Press, 2001), 340–50.

Leibovici, Solange. 'Remembering, Acting Out, Working-through: The Case of Sarah Kofman'. http://www.clas.ufl.edu/ipsa/2003/Kofman.html. Accessed 22/07/09.

Leszkowicz, Pawel. 'In Search of Lost Space: À la recherche de l'espace perdu', in Agnieska Morawinska (ed.), *Louise Bourgeois: The Geometry of Desire* (Warsaw: Zachęta Gallery, 2003), 249–52.

Levi, Primo. *The Drowned and the Saved*, trans. Raymond Rosenthal (New York: Vintage Books, 1989).

Leys, Ruth. *Trauma: A Genealogy* (Chicago: University of Chicago Press, 2000).

Lindeperg, Sylvie. *Nuit et brouillard': un film dans l'histoire* (Paris: Odile Jacob, 2007).

Lippard, Lucy. 'Louise Bourgeois: From the Inside Out', *Artforum*, 13:7 (March 1975), reprinted in *From the Center: Feminist Essays on Women's Art* (New York: Dutton, 1976), 238–49.

——. 'The Blind Leading the Blind', *Bulletin of the Detroit Institute of the Arts*, 59:1 (1981), 24–9.

Liska, Vivian. 'Parricidal Autobiographies: Sarah Kofman between Theory and

Memory', *European Journal of Women's Studies*, 7 (2000), 91–101.

Longfellow, Brenda. 'Love Letters to the Mother: the Work of Chantal Akerman', *Canadian Journal of Political and Social Theory Annual* 13:1–2 (1989), 73–90.

Luckhurst, Roger. *The Trauma Question* (London: Routledge, 2008).

Lyotard, Jean-François. *The Differend: Phrases in Dispute* [1983], trans. Georges Van Den Abeele (Minneapolis: University of Minnesota Press, 1988).

——. *Heidegger and 'the jews'*, trans. M.S. Roberts (Minneapolis: University of Minnesota Press, 1990).

——. 'Newman: The Instant', in Andrew Benjamin (ed.), *The Lyotard Reader* (Oxford: Blackwell, 1992), 240–9.

——. *Postmodern Fables*, trans. Georges Van Den Abeele (Minneapolis: University of Minnesota Press, 1999).

Maccoby, Hyam. *Antisemitism and Modernity: Innovation and Continuity* (London: Routledge, 2006).

McDonald, Christie. 'Sarah Kofman: Effecting Self-Translation'. *TTR: traduction, terminologie, rédaction*, 11:2 (1998), 185–97.

Margulies, Ivone. *Nothing Happens: Chantal Akerman's Hyperrealist Everyday* (Durham, NC: Duke University Press, 1996).

Massumi Brian. *Parables for the Virtual: Movement, Affect, Sensation* (Durham, NC and London: Duke University Press, 2002).

Massumi, Brian (ed.). *A Shock to Thought: Expression after Deleuze and Guattari* (London and New York: Routledge, 2002).

Ménard-David, Monique. *Hysteria from Freud to Lacan: Body and Language in Psychoanalysis*, trans. Catherine Porter (Ithaca, NY: Cornell University Press, 1989).

Merleau-Ponty, Maurice. 'Eye and Mind' [Paris: Gallimard, 1964], in Galen A. Johnson (ed.), *The Merleau-Ponty Aesthetics Reader: Philosophy and Painting* (Evanston, IL: Northwestern University Press, 1993), 121–50.

Metz, Christian, *The Imaginary Signifier: Psychoanalysis and Cinema* (Basingstoke: Macmillan, 1986).

Mitchell, Juliet. *Mad Men and Medusas: Reclaiming Hysteria* (London: Basic Books 2001).

——. *Siblings, Sex and Violence* (Cambridge: Polity Press, 2003).

——. 'The Sublime Jealousy of Louise Bourgeois', in Philip Larratt-Smith, (ed.) *Louise Bourgeois: The Return of the Repressed*, Vol. 1 (London: Violette Editions, 2012), 47–67.

Montrelay, Michèle. 'Inquiry into Femininity', first published in *l'Ombre et le nom* (Paris: Editions de Minuit, 1977), trans. Parveen Adams, *m/f*, 1 (1978), 83–102.

Moore, John. *A View of Society and Manners in Italy* [1781], 6th edn (London: A. Strahan and T. Cadell, 1795).

Morawinska, Agnieska. *Louise Bourgeois: The Geometry of Desire* (Warsaw: Zachęta Gallery, 2003).

Morgan, Diane. 'Made in Germany: Judging National Identities Negatively', in Penelope Deutscher and Kelly Oliver (eds), *Enigmas: Essays on Sarah Kofman* (Ithaca and London: Cornell University Press, 1999), 219–34.

Mowitt, John. 'Trauma Envy', in *Theorizing Trauma: The Cultural Politics of Affect in and beyond Psychoanalysis* (New York: Other Press, 2007), 349–76.

Mulvey, Laura and Wollen, Peter. *Frida Kahlo and Tina Modotti* (London: Whitechapel Gallery, 1982).

Nancy, Jean-Luc. 'Cours, Sarah!', *Les Cahiers du Grif*, no. 3 (Paris, 1997), 29–38.

Nicholas, Lynn H. *The Rape of Europa: The Fate of Europe's Treasures in the Third Reich and the Second World War* (London: Macmillan, 1994).

Nixon, Mignon. *Fantastic Reality: Louise Bourgeois and A Story of Modern Art* (Cambridge, MA: MIT Press, 2005).

O'Sullivan, Simon. *Art Encounters: Deleuze and Guattari – Thought beyond Representation* (Basingstoke: Palgrave Macmillan, 2006).

Pagé, Suzanne. *Louise Bourgeois: Sculptures, environnements, dessins: 1938–1995, Paris: Musée d'Art moderne de la Ville de Paris, 23 juin–8 octobre 1995* (Paris: Paris musées: Editions de la Tempête, 1995).

Peirce, C.S. 'A Sketch of Logical Critics' [1911], *The Essential Peirce: Selected Philosophical Writings*, Volume 2 (1893–1913) (Bloomington, IN: Indiana University Press, 1998), 451–62.

Pels, Marsha. 'Louise Bourgeois: A Search for Gravity', *Art International,* 23:7 (October 1979), 46–54.

Petropoulos, Jonathan. *Art as Politics in the Third Reich* (Chapel Hill, NC and London: University of North Carolina Press, 1996).

Pollock, Griselda. 'Territories of Desire: Memories of an African Childhood', in George Robertson et al. (eds), *Traveller's Tales: Narratives of Home and Displacement* (London: Routledge, 1994), 63–92.

——. 'Gleaning in History or Coming After/Behind the Reapers: the Feminine, the Stranger and the Matrix in the Work and Theory of Bracha Ettinger', in Griselda Pollock (ed.), *Generations and Geographies in the Visual Arts: Feminist Readings* (London: Routledge, 1996), 266–88.

——. 'Inscriptions in the Feminine', in Catherine de Zegher (ed.), *Inside the Visible: an Elliptical Traverse of Twentieth Century Art in, of and from the Feminine* (Cambridge, MA: MIT Press, 1996), 67–88.

——. 'Old Bones and Cocktail Dresses: Louise Bourgeois and the Question of Age', *Oxford Art Journal*, 22:2 (1999), 73–100.

——. *Differencing the Canon: Feminist Desire and the Writing of Art's Histories* (London: Routledge, 1999).

——. 'Deadly Tales', *Looking Back to the Future: Essays on Art, Life and Death* (London: Routledge, 2001), 371–90.

——. 'Thinking the Feminine: Aesthetic Practice as Introduction to Bracha Ettinger and the Concepts of Matrix and Metramorphosis', *Theory, Culture and Society*, 21 (2004), 5–64.

——. *Encounters in the Virtual Feminist Museum: Time, Space and the Archive* (London: Routledge, 2007).

——. 'Stilled Life: Traumatic Knowing, Political Violence and the Dying of Anna Frank', *Mortality*, 12:2 (2007), 124–41.

——. 'Seeing Red: Drawing Life in Recent Works on Paper by Louise Bourgeois', *Parkett*, No. 82 (2008), 54–62.

——. 'The Visual Poetics of Shame', in Claire Pajaczkowska and Ivan Ward (eds), *Shame and Sexuality: Psychoanalysis and Culture* (London: Routledge, 2008), 109–28.

——. 'Art/Trauma/Representation', *parallax*, Issue 50, 15:1 (2009), 40–54.

——. *Resonance/Overlay/Interweave: Bracha Ettinger in the Freudian Space of Memory and Migration* (Leeds: Centre CATH Documents, 2009).

——. 'The Long Journey: Maternal Trauma, Tears and Kisses in a Work by Chantal Akerman', *Studies in the Maternal*, 2:1 (2010), n.p.

——. 'Aby Warburg and Mnemosyne: Photography as *Aide Mémoire*, Optical Unconscious and Philosophy', in Costanza Caraffa (ed.), *Photo Archives and the Photographic Memory of Art History* (Munich: Deutscher Kunstverlag, 2011), 73–100.

——. *Art in the Time-Space of Migration and Memory: Bracha L Ettinger at the Freud Museum* (2013).

—— (ed.). *The Visual Politics of Psychoanalysis: Art in a Post-traumatic Era* (London: I.B. Tauris, 2013).

—— and Corby, Vanessa (eds). *Encountering Eva Hesse* (London and Munich: Prestel, 2007).

—— and de Zegher, Catherine (eds). *Bracha L. Ettinger: Art as Com-passion* (Brussels: ASA, 2011).

—— and Silverman, Max (eds), *Concentrationary Cinema: The Aesthetics of Political Resistance in Alain Resnais's* Night and Fog (London and New York: Berghahn, 2011).

Préart de Chantelou, Paul. *Diary of the Cavalieri Bernini's Visit to France*, ed. Anthony Blunt, trans. Margery Corbett (Princeton: Princeton University Press, 1958).

Prévost, Claude. 'La déportation dans la littérature et l'art: entretien avec Charlotte Delbo', *La Nouvelle Critique*, 167 (1965), 41–4.

Princenthal, Nancy. *Hannah Wilke* (London and Munich: Prestel, 2010).

Radstone, Susannah (ed.). *Memory and Methodology* (New York: Berg, 2000).

Rampley, Matthew. 'Iconology of the Interval: Aby Warburg's Legacy', *Word and Image*, 17:4 (2001), 303–24.

Rancière, Jacques. 'Are Some Things Unrepresentable?', in *The Future of the Image*, trans. Gregory Elliott (London: Verso, 2007), 109–38.

Rashkin, Esther. *Family Secrets and the Psychoanalysis of Narrative* (Princeton, NJ: Princeton University Press, 1992).

Restany, Pierre (ed.). *Alina Szapocznikow 1926–1973: Tumeurs, Herbier* (Paris: Musée Moderne de la ville de Paris, 1973).

——. 'The Eternal Language of the Body', trans., *Alina Szapocznikow 1926–1973*, ed. Anda Rottenberg (Warsaw: Zachęta Gallery, 1998), 26–8.

——. 'Forma miedzy, cialem a gra', *Alina Szapocznikow: Rzezba* (Warsaw: Zachęta, 1967); trans. *Alina Szapocznikow 1926–1973*, ed. Anda Rottenberg (Warsaw: Zachęta Gallery, 1998), 26–8.

Ricoeur, Paul. *Freud and Philosophy: An Essay on Interpretation* (New Haven, CT: Yale University Press, 1970).

Rimmel, Victoria. *Ovid's Lovers: Desire, Difference and the Poetic Imagination* (Cambridge: Cambridge University Press, 2006).

Ringelheim, Joan. 'Women and the Holocaust: A Reconsideration of Research', *Signs*, 10:4 (Summer, 1985), 741–61.

Rizzuto, Nicole. 'Reading Sarah Kofman's Testimonies to *les années noires* in *Rue Ordener, Rue Labat*', *Contemporary French and Francophone Studies*, 10:1 (2006). 5–14.

Robinson, Hilary. 'Louise Bourgeois's *Cells*: Looking at Bourgeois through Irigaray's

Gesturing Towards the Mother', *N. paradoxa*, 3 (May 1997), 17–28, and in Ian Cole (ed.), *Louise Bourgeois* (Oxford: Museum of Modern Art, *Oxford Papers*, Vol. 1, 1996), 21–30.

——. *Reading Art: Reading Irigaray* (London: I.B. Tauris, 2007).

Robson, Kathryn. 'Bodily Detours: Sarah Kofman's Narratives of Childhood Trauma', *Modern Language Review*, 99:3 (2004), 608–21.

Rogoff, Irit. 'Moving On: Migration and the Intertextuality of Trauma', *Vera Frenkel: '… from the Transit Bar'* (Toronto: The Power Plant and Ottawa: National Gallery of Canada, 1994).

Rosler, Martha. 'Video: Shedding the Utopian Moment' [*Block* 11 (1985–6),] reprinted in *Decoys and Disruptions: Selected Writings 1975–2001* (Cambridge, MA: MIT Press, 2004), 53–88.

Rothberg, Michael. *Multi-directional Memory: Remembering the Holocaust in the Age of Decolonization* (Stanford, CA: Stanford University Press, 2009).

Rottenberg, Anda (ed.). *Alina Szapocznikow 1926–1973* (Warsaw: Institute for the Promotion and Art Foundation and Zachęta Gallery, 1998).

Rousset, David. *L'Univers concentrationnaire* (Paris: Editions du Pavois, 1946).

Saltzman, Lisa and Rosenberg, Eric. *Trauma and Visuality in Modernity* (Dartmouth College, 2006).

Scarry, Elaine. *The Body in Pain: The Making and Unmaking of the World* (Oxford: Oxford University Press, 1987).

Schade, Sigrid et al. (eds). *Kunstraub: Zur symbolischen Zirkulation von Kulturobjecten* (Vienna: Verlag Turia +Kant, 2000).

Schoell-Glass, Charlotte. '"Serious Issues": The Last Plates of Warburg's Picture Atlas', in Richard Woodfield (ed.), *Art History as Cultural History: Warburg's Projects* (New York: GB Arts and London: Routledge, 2001), 183–208.

Schor, Naomi. *Reading in Detail: Aesthetics and the Feminine* (London and New York: Routledge, 1987).

Sedwick, Eve Kosofsky. 'Paranoid Reading and Reparative Reading; or, You're so Paranoid You Probably Think this Essay is About You', *Touching, Feeling: Affect, Pedagogy and Performativity* (Durham, NC: Duke University Press, 2003), 123–51.

Selzer, Mark. 'Wound Culture: Trauma in the Pathological Cultural Sphere', *October*, 80 (1997), 3–26.

Simpson, Elizabeth (ed.). *The Spoils of War: World War II and its Aftermath: The Loss, Reappearance and Recovery of Cultural Property* (New York: Harry N. Abrams, 1997).

Sliwinski, Sharon. 'New York Transfixed: Notes on the Expression of Fear', *Review of Education, Pedagogy, and Cultural Studies*, 30:3 (2008), 232–52.

Smith, Paul. 'Mother as Site of Her Proceedings: Mary Kelly's *Post-Partum Document*', *Parachute*, no. 26 (1982), 29–30.

Sontag, Susan. *Illness as Metaphor* [1978] (Harmondsworth: Penguin, 1983).

——. *Regarding the Pain of Others* (London: Penguin, 2003).

Spence, Jo. *Beyond the Family Album*. Hayward Photography Annual, *Three Perspectives on Photography* (London: Hayward Gallery, 1980).

Spiegelman, Art. *Maus: A Survivor's Tale*, Vol. 1, *My Father Bleeds History* (New York: Pantheon, 1986); Vol. 2, *And Here My Troubles Began* (New York: Pantheon, 1991);

boxed 2-vol. set (New York: Pantheon, 1993).

Spotts, Frederic. *Hitler and the Power of Aesthetics* (London: Overlook TP, 2004).

Stanislawski, Michael. *Autobiographical Jews: Essays in Jewish Self-fashioning* (Seattle: University of Washington Press, 2004).

Stechow, Wolfgang. *Apollo und Daphne* (Leipzig-Berlin 1932; Studien der Bibliothek Warburg, ed. F. Saxl, XXIII; reprinted with appendix, Darmstadt, 1965).

Steedman, Carolyn. *Landscape for a Good Woman* (London: Virago, 1986).

Stein, Ruth. *Psychoanalytical Theories of Affect* (New York: Praeger, 1991).

Stiles, Kristine. 'Shaved Heads and Marked Bodies: Representations from Cultures of Trauma' [1993], in Jean O'Barr et al. (eds), *Talking Gender: Public Images, Personal Journeys and Political Critiques* (Chapel Hill, NC: University of North Carolina Press, 1996), 36–94.

Storr, Robert, Herkenhoff, Paolo and Schwartzman, Allan (eds), *Louise Bourgeois* (London: Phaidon 2003).

Tatay, Helena et al. (eds), *Anna Maria Maiolino* (Santiago de Compostela: Centro Galego Arte Contemporánea, 2010).

Tomlinson, Gary A. 'Ancora su Ottavio Rinuccini', *Journal of the American Musicological Society*, 28:2 (1975), 351–6.

Tuer, Dot. 'Worlds Between: An Examination of Themes of Exile and Memory in the Work of Vera Frenkel', in *Vera Frenkel: Raincoats, Suitcases, Palms* (Toronto: Art Gallery of York University, 1993).

van Alphen, Ernst. *Caught by History: Holocaust Effects in Art, Literature and Theory* (Stanford, CA: Stanford University Press, 1997).

——. *Art in Mind: How Contemporary Images Shape Thought* (Chicago: University of Chicago Press, 2005).

van der Knaap, Ewout. *Uncovering the Holocaust: The International Reception of Night and Fog* (London: Wallflower Press, 2006).

Wachtmeister, Marika (ed.). *Louise Bourgeois: Maman* (Sweden: Wanås Foundation, 2007).

Wagner, Anne M. 'Bourgeois Pre-Histories or the Ransom of Fantasies', *Oxford Art Journal*, 22:2 (1999), 2–23.

Wajda, Andrzej. 'Szapocznikow', *Projekt*, no. 5 (1973), 22–7.

Warburg, Aby. 'Sandro Botticelli's *Birth of Venus* and *Spring* (1893)', in Kurt Forster (ed.), *Aby Warburg: The Renewal of Pagan Antiquity: Contributions to the Cultural History of the European Renaissance*, trans. David Britt (Los Angeles: Getty Research Institute Publications, 1999), 89–156.

——. *Der Bilderatlas Mnemosyne*, ed. Martin Warnke and Claudia Brink (Berlin: Akademie Verlag, 2000).

——. 'Images from the Region of the Pueblo Indians of North America', *Journal of the Warburg Institute*, 2 (1938–39), 277–92. Retranslated complete in *Images from the Region of the Pueblo Indians of North America*, ed. and trans. Michael Steinberg (Ithaca, NY: Cornell Univeristy Press, 1995).

Wardi, Dina. *Memorial Candles: Children of the Holocaust* (London: Routledge, 1992).

Warwick, Genevieve. 'Speaking Statues: Bernini's *Apollo and Daphne* at the Villa Borghese', *Art History*, 27:3 (2004), 353–81.

Weigel, Sigrid. 'The Symptomatology of a Universalized Concept of Trauma: On the Failing of Freud's Reading of Tasso in the Trauma of History', *New German Critique*, 90 (2003), 85–94.

White, Hayden. 'The Modernist Event' [1999], in Neil Levi and Michael Rothberg (eds), *The Holocaust Reader* (Edinburgh: Edinburgh University Press, 2003).

Wilson, Elizabeth A. *Psychosomatic: Feminism and the Neurological Body* (Durham, NC: Duke University Press, 2004).

Wittkower, Rudolf. *Gian Lorenzo Bernini: The Sculptor of the Roman Baroque* (Oxford: Phaidon, 1981).

Wölfflin, Heinrich, 'Wie Man Skulpturen Aufnehmen Soll [Pt. I]', *Zeitschrift für bildende Kunst* (1896), 224–8.

Woolf, Virginia. 'Professions for Women' [1931], in Virginia Woolf, *Women and Writing*, intro. Michelle Barratt (London: The Women's Press, 1979).

Wye, Deborah, 'Louise Bourgeois: "One and Others"', in *Louise Bourgeois* (New York: Museum of Modern Art, 1982).

Xenakis, Mâkhi. *Louise Bourgeois: The Blind Leading the Blind* (Paris: Actes Sud, 2008).

Zakiewicz, Anna. 'On Alina Szapocznikow's Drawings', in Jósef Grabski, (ed.), *Capturing Life: Alina Szapocznikow Drawings and Sculptures* (Warsaw, IRSA, 2004).

Index

Page numbers of figures are indicated in italics followed by the figure number; plates between pp. 192 and 193 are indicated by 'Pl.' with the plate number; 'n.' following a page reference indicates the number of a note on that page.